Public Monuments and Sculptur
National Reco

Public Sculpture of Birmingham

including Sutton Coldfield

Already published in this series

PUBLIC SCULPTURE OF LIVERPOOL
by Terry Cavanagh

In preparation

PUBLIC SCULPTURE OF GLASGOW
by Ray McKenzie

PUBLIC SCULPTURE OF NORTH-EAST ENGLAND
by Paul Usherwood and Jeremy Beach

PUBLIC SCULPTURE OF BIRMINGHAM

including Sutton Coldfield

George T. Noszlopy

EDITED BY
Jeremy Beach

UCE

University
of
Central England
in
Birmingham

LIVERPOOL UNIVERSITY PRESS

First published 1998 by LIVERPOOL UNIVERSITY PRESS,
Liverpool, L69 3BX

This book has been produced as part of the University of Central
England Public Sculpture Project with financial assistance from the
Birmingham Institute of Art and Design, UCE
Project Director: George T. Noszlopy
Research Co-ordinator: Jeremy Beach
Research Assistants: John Bennett, Marie-Louise Bolland, Robert
Burstow, Kate Child, Rachael Edgar, Sian Everitt, Marion Edwards,
Shirley Green, Doris Rohr, Philip Tring, Samantha Watkins

The National Recording Project is supported by the
National Lottery through the Heritage Lottery Fund

HERITAGE LOTTERY FUND

British Library Cataloguing-in-Publication Data
A British Library CIP record is available

ISBN 0-85323-682-8 (cased)
ISBN 0-85323-692-5 (paper)

Design and production, Janet Allan

Typeset in 9½/11pt Stempel Garamond
by XL Publishing Services, Lurley, Tiverton, Devon
Origination by Radstock Reproductions Ltd, Midsomer Norton
Printed and bound in Great Britain by
Butler & Tanner Ltd, Frome and London

Preface

Since its foundation in 1991 the Public Monuments and Sculpture Association's main aim has been the raising and maintenance of public awareness of our national heritage of public monuments and sculpture. It soon became clear however that to perform this function effectively it was necessary to establish a public record of the objects we were concerned with, that is to provide an accessible information resource to underpin any programme of conservation, research, education and enhanced appreciation. While there existed a number of local and limited national surveys – as well as a specific project, the National Inventory of War Memorials – these varied very much in scope and nature, and it was clear that no single, fully comprehensive record existed.

To meet this need, at my suggestion the PMSA set up the National Recording Project. Under the energetic commitment and inspired leadership of Ian Leith of the Royal Commission on the Historical Monuments of England, Chairman of the Project and of Jo Darke, the National Project's Co-ordinator based at the Courtauld Institute of Art, a system of Regional Archive Centres was established, based at host institutions in selected cities across Britain. With the invaluable support of these pioneering RACs, and with the award of a substantial grant from the Heritage Lottery Fund the practical implementation of the national survey has become a realistic objective which will build up a public archive on database and in book form.

We were fortunate in being able to incorporate into our scheme major local surveys that already existed in some form. That covering Merseyside and beyond, initiated by the Walker Art Gallery in Liverpool, was worked up as our pilot by Terry Cavanagh to form the first published volume. This appeared in 1997. At the same time we were able to make provision for the publication of the already established survey covering Birmingham as second in the series, prepared by the University of Central England under the overall authority of Professor George Noszlopy. This is what forms the present volume and includes, in this instance, ecclesiastical sculpture. We are most grateful to the University of Central England and Professor Noszlopy for their agreeing to be associated with our national project in this way and for providing us with so worthy an element.

We should also like to thank the Henry Moore Foundation and its Director Tim Llewellyn for providing the financial means of supporting the National Co-ordinator Jo Darke in the first crucial period of the project's development. In addition I would like to thank our publisher Robin Bloxsidge of Liverpool University Press for his courageous support of our project.

BENEDICT READ
Chairman PMSA, University of Leeds

Contents

Preface by Benedict Read v

Maps viii

Introduction xi

The Catalogue xxiv

Abbreviations xxv

Sources of Illustrations xxv

Acknowledgements xxvi

PUBLIC SCULPTURE OF BIRMINGHAM

including Sutton Coldfield

Extant Works 1

Lost Works 159

Unrealised Works 176

Glossary 177

Biographies of Sculptors and Architects 183

Bibliography 210

Index 218

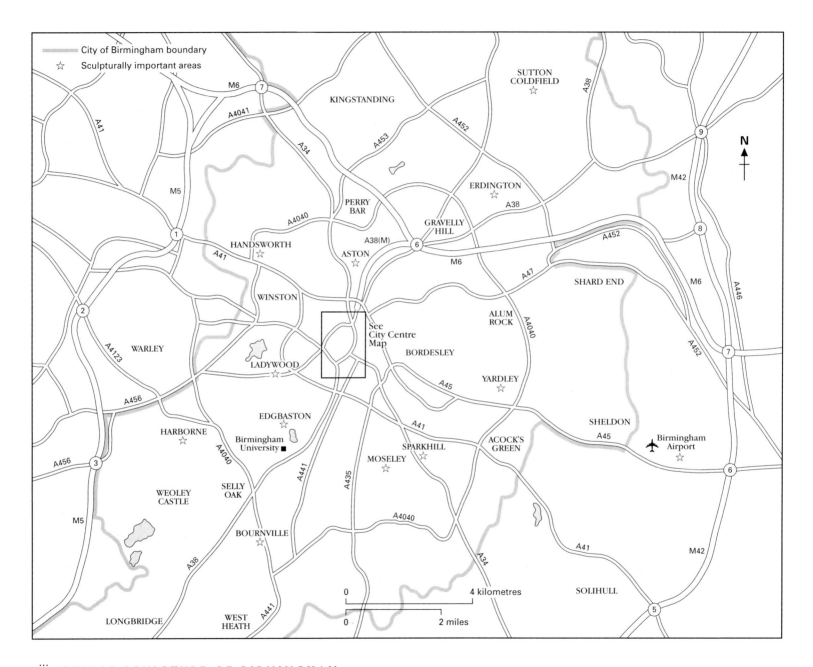

City of Birmingham boundary

☆ Sculpturally important areas

SUTTON COLDFIELD ☆

KINGSTANDING

PERRY BAR

ERDINGTON ☆

GRAVELLY HILL

HANDSWORTH ☆

ASTON ☆

WINSTON

See City Centre Map

SHARD END

ALUM ROCK

WARLEY

LADYWOOD ☆

BORDESLEY

YARDLEY ☆

EDGBASTON ☆

Birmingham University ■

SHELDON

HARBORNE ☆

SPARKHILL ☆

ACOCK'S GREEN

Birmingham Airport ☆

MOSELEY ☆

WEOLEY CASTLE

SELLY OAK

BOURNVILLE ☆

SOLIHULL

LONGBRIDGE

WEST HEATH

N

0 — 4 kilometres

0 — 2 miles

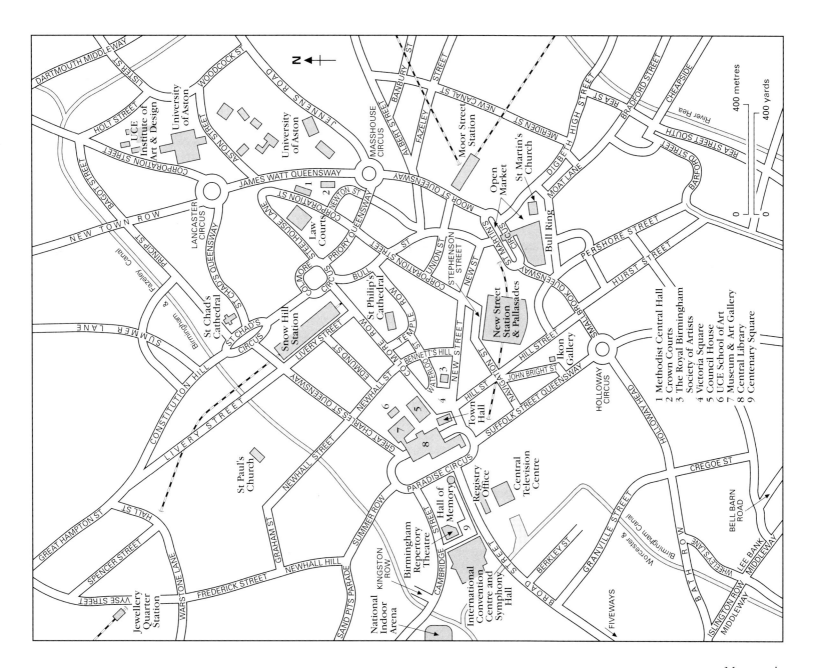

N

1 Methodist Central Hall
2 Crown Courts
3 The Royal Birmingham
 Society of Artists
4 Victoria Square
5 Council House
6 UCE School of Art
7 Museum & Art Gallery
8 Central Library
9 Centenary Square

DARTMOUTH MIDDLEWAY

LISTER STREET

HOLT STREET

WOODCOCK ST

JENNENS ROAD

ASTON STREET

UCE Institute of Art & Design

University of Aston

University of Aston

MASSHOUSE CIRCUS

ALBERT STREET

BANBURY ST

FAZELEY STREET

NEW CANAL ST

Moor Street Station

MERIDEN ST

REA ST

DIGBETH HIGH STREET

REA STREET SOUTH

CHEAPSIDE

BRADFORD STREET

BARFORD STREET

River Rea

400 metres

400 yards

0

0

CORPORATION STREET

JAMES WATT QUEENSWAY

LANCASTER CIRCUS

NEW TOWN ROW

BAGOT STREET

PRINCIP ST

Fazeley Canal

Birmingham Canal

SUMMER LANE

St Chad's Cathedral

ST CHAD'S QUEENSWAY

ST CHAD'S CIRCUS

CONSTITUTION HILL

LIVERY STREET

NEWTON ST

STEELHOUSE LANE

CORPORATION ST

Law Courts

1

2

PRIORY QUEENSWAY

BULL ST

COLMORE CIRCUS

UNION ST

STEPHENSON STREET

NEW ST

St Philip's Cathedral

BULL ST

COLMORE ROW

TEMPLE ROW

BENNETT'S HILL

WATERLOO ST

NEW STREET

NEW ST

HILL ST

MOOR ST QUEENSWAY

ST MARTIN'S CIRCUS

ST MARTIN'S QUEENSWAY

MOAT LANE

Open Market

St Martin's Church

Bull Ring

New Street Station & Pallasades

PERSHORE STREET

HURST STREET

SMALLBROOK QUEENSWAY

HILL STREET

SUFFOLK STREET QUEENSWAY

NAVIGATION ST

JOHN BRIGHT ST

Ikon Gallery

3

4

HOLLOWAY CIRCUS

HOLLOWAY HEAD

CREGOE ST

Snow Hill Station

LIVERY STREET

EDMUND STREET

GREAT CHARLES ST QUEENSWAY

NEWHALL STREET

Town Hall

6

5

7

8

St Paul's Church

NEWHALL STREET

GRAHAM ST

NEWHALL HILL

SUMMER ROW

KINGSTON ROW

Birmingham Repertory Theatre

CAMBRIDGE STREET

Hall of Memory

9

Registry Office

Central Television Centre

BROAD STREET

BERKLEY ST

GRANVILLE STREET

Worcester & Birmingham Canal

BELL BARN ROAD

WHEELEYS LANE

LEE BANK MIDDLEWAY

BATH ROW

ISLINGTON ROW MIDDLEWAY

FIVEWAYS

PARADISE CIRCUS

National Indoor Arena

International Convention Centre and Symphony Hall

GREAT HAMPTON ST

HALL ST

SPENCER STREET

WARSTONE LANE

FREDERICK STREET

VYSE STREET

Jewellery Quarter Station

SAND PITS PARADE

Introduction

Birmingham in 1996 has over 370 works of sculpture in the public domain, one of the highest concentrations in the country. Widely scattered across the city, the pieces date from 1709 to 1996 and cover a great variety of styles and subject matters, with many free-standing monuments and abstracts, as well as a great deal of architectural sculpture. The main reason for the continuing success of this art form is the prosperity and self confidence of the city from its zenith as the 'workshop of the world' in the Victorian era, through to a period of re-evaluation as an international meeting place at the end of the twentieth century. There has been a steady growth in the numbers of public art works sited per decade from the beginning of the nineteenth century to a peak in the 1960s, with the exceptions of the periods of the two World Wars (see Figure 1 overleaf).

After a downturn in commissions through the 1970s and 1980s, there has been a resurgence of public art works in the 1990s which has gone hand in hand with the city's redevelopment. The aim of this catalogue is to document and critically analyse this rich heritage as fully as possible, not forgetting pieces which have been removed yet live on in the memory of the city.

The catalogue lists 272 works, using a broadly based definition of public sculpture as follows: (1) The work should be in a public place – including interiors; (2) Work is included irrespective of ownership by corporate or private bodies; (3) All three- and two-dimensional (relief) work, including architectural decoration is included, provided that the work was not a mass produced item; (4) 'Ready made' pieces are included, such as the beam engine erected at Dartmouth Circus; (5) Tomb sculpture is included, provided that the work was not a mass produced item.

The research undertaken which has resulted in this catalogue stands as an example of 'grass roots' art history, highlighting artistic figures such as Peter Hollins, Benjamin Creswick and William Bloye whose importance has not been acknowledged until now, and about whom little is known outside Birmingham. Except in the case of lost works, each item in the catalogue has been systematically identified, measured, photographed, and thoroughly researched where possible. Background work to place each piece into its historical context has used contemporary sources such as council minutes, building plans, official documentation and newspaper reports, as well as drawing on the work of respected experts in the field. Many of the living artists have been contacted in person to contribute notes on their works and biographies. In addition, the researchers have had a close and fruitful relationship with staff at the Museum and Art Gallery, responsible for the maintenance and conservation of a number of pieces, and at the locally based Public Art Commissions Agency, which acts as a facilitating agency in the commissioning of new works.

Production of Sculpture: Birmingham Workshops

An early nineteenth-century visitor to Birmingham, Comte de Tocqueville, wrote:

> The town itself has no analogy with other English provincial towns. It is an immense workshop, a huge forge, a vast shop. One only sees busy people and faces brown with smoke. One hears nothing but the sound of hammers and the whistle of steam escaping from boilers.[1]

While, apart from London, other major cities in England have had a sporadic spread of local sculptors, Birmingham had an unbroken tradition of active sculpture workshops from the mid-eighteenth to the mid-twentieth century. Post-medieval centres of sculpture generally stemmed from places of well established masons' (stone-cutters) and smiths' work. Described already by William Camden, the sixteenth-century antiquarian, as 'Bremicham swarming with inhabitants, and echoing with noise of anvils for here there are great numbers of smithies',[2] the sculptural workshops of Birmingham do not seem to be an exception.

Although examples of medieval sculpture in Birmingham are scarce, there is ample evidence for stonecutting activity from about the fourteenth century. Admittedly the best preserved Gothic and Renaissance pieces were imported from Belgium and Germany to give a more authentic appearance to Neo-Gothic church interiors in the middle of the nineteenth century (see below, p.108 and p.110), but there are the remains of a fair number of medieval funerary monuments within the city, Aston and Sutton Coldfield. The most important of these were commissioned by the de Bermingham family (whose tombs can be found in Aston Church), from whom it is

generally held that the city gets its name.

The continuation of this tradition of sculptural activity and related qualities of sound craftsmanship was assured in post-medieval Birmingham by the richly carved Jacobean architectural decoration of Aston Hall (see below, p.2) and the emotionally charged Baroque ornamentation of the windows of St. Philip's cathedral (see below, p.113). On the other hand, rooted in medieval blacksmith and precious metal work, the production of wrought and cast imagery in Birmingham remained closely tied to the aims and needs of the rapidly growing local industry. For example, a lock by Johannes Wilkes of Birmingham (in the collection of Birmingham Museums and Art Gallery) is richly ornamented with decoratively spread branches of naturalistic leaves and flowers, and not only proudly carries its maker's signature and domicile, but also typifies the quality of seventeenth-century Birmingham craftsmanship.

By the mid-eighteenth century, Birmingham had become an important manufacturing and cultural centre, in strong competition even with London, attracting such outstanding personalities as the printer and Japanwear manufacturer John Baskerville (1706–75), the enamel manufacturer John Taylor (1711–75) and the owner of the largest manufactory in Europe, Matthew Boulton (1728–1809). Figurative sculpture, though still applied and at a relatively small scale, was given a new humanistic significance in Boulton's designs for the *Pattern Books* (Birmingham Museums and Art Gallery) and especially in the Neo-Classical silver and gilt-bronze clocks and metalworks executed in his celebrated Soho Manufactory. For example, his *Minerva Clock* (c.1770–82, Metropolitan Museum of Art, New York) can be read as a potential free-standing monument to Time. It certainly shows

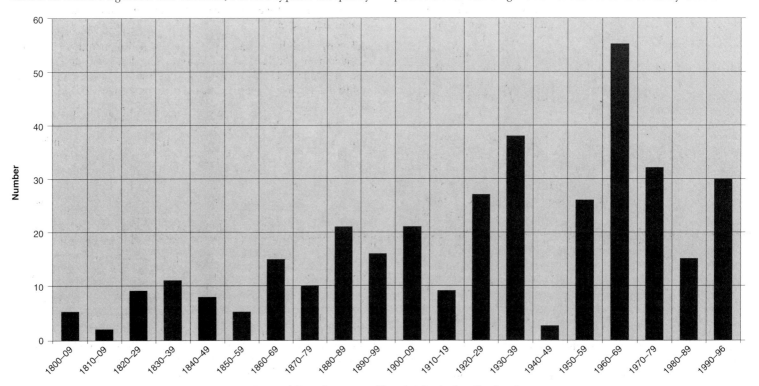

Fig. 1 Public sculpture unveilings in Birmingham by decade

Boulton's artistic vision for statuary and his skill in both areas of modelling: the three-dimensional figure of the goddess in classicising garb; and the relief of a libation scene on the vase showing Prudence making a sacrifice to Chronos.

However, the more regular and organised production of sculpture in the city was closely connected with the growth of emerging wealthy Birmingham families' needs. There is ample evidence to show that from the middle of the eighteenth century the sculpture workshops of Birmingham were producing work in almost all genres: from architectural, garden ornaments and sculpture, to funerary monuments, free standing and niche statues, as well as portrait busts and commemorative medals. Edward Grubb of Birmingham (1740–1816) seems to be the first high art professional stone carver and statuary whose activities are recorded in the town from about 1769. He rented a house and studio at the top of Henley Street from the Corporation, where together with his brother, Samuel, he carved a boy and a girl for the Bluecoat School (see below, p.119) and several extant signed funerary monuments in the region, including two at Sutton Coldfield. Although he seems to have established a reputation for working from life, a practice well established by Bernini since the mid-seventeenth century,[3] an adherence to the fundamental principles of a classicising taste is equally evident in his work.

More prolific and versatile was the busy workshop of the self-taught William Hollins (1763–1843) and his son Peter (1800–86). The elder Hollins must have had a world wide reputation, for he refused an offer to become personal architect to Catherine the Great, consequently designing a number of important buildings in Birmingham (see Biography), as well as a number of monuments to be found in churches throughout the city. His son, nicknamed the 'Birmingham Chantrey', trained under the famous London sculptor. On his return he continued the family stonemasonry business, being responsible for twenty works in Birmingham including that of Sir Robert Peel (1855), cast in the local foundry of Elkington's, with the base produced by Mason's of Newhall Street.

The workshops of Grubb and the two Hollins were part of the general manufacturing and cultural *milieu* of Birmingham, with their style showing the transition from the Baroque to Neo-Classicism and Romanticism. While Grubb and Peter Hollins were leading representatives of a loosely-related community of artists, craftsmen and intellectuals conforming to the liberal ideology of the English Enlightenment, the next generation of Birmingham sculptors were

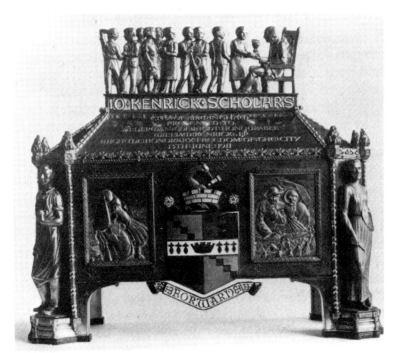

Fig. 2 *The Kenrick Casket*, 1911, designed by Robert Catterson-Smith. The plaques of details from Pre-Raphaelite paintings were modelled by Thomas Spall

aligned with the newly founded Municipal School of Arts, the first one in the country. Founded on ideas allied to Ruskinite and Pre-Raphaelite naturalism and Morrisian Arts and Crafts principles, this became the generating force in the visual arts of the city. The close relationship between high art and craft work is manifest in pieces such as the Kenrick Casket, which combines metal and woodwork with relief and three-dimensional sculpture in a design closely tied to a municipal iconographical programme. William Kenrick's role in funding scholarships, and civic support for arts and crafts, are symbolised by Catterson-Smith's personifications of Architecture, Sculpture, Painting and Metalwork on the casket sides, with scholars on its lid (see Figure 2).[4] Benjamin Creswick (1853–1946) practised in London before becoming the master of modelling and modelled

design at the School of Art 1889–1918. He was extremely versatile and an innovator in iconography, introducing the working man to the subject-matter of Birmingham art within the full range of genres such as architectural decorations, shop signs and iron work. Described as a 'vital Victorian', his work was deemed 'as fine as any work that Italy can boast of', comparable to that of the della Robbias in Florence.[5] He completed eleven of his thirteen works in Birmingham during his period at the School of Art, all of which were sculptural decoration on corporation buildings like libraries and offices. Many of his finely carved reliefs deal with the relationship between arts, crafts and learning, such as the series of reliefs in the tympana of William Martin's 1893 extension to the School (see below, p.86), yet it has been noted that Creswick's potential to participate in large civic commissions such as the Law Courts was not brought to fruition.

The relationship between the city and its school of art was further strengthened by the ascendancy of William Bloye (1890–1975), who despite his extensive activity and importance in his day is now completely unknown outside the city. Studying at the School from 1904–9 and becoming Head of Modelling from 1919 to 1956, Bloye became Birmingham's unofficial civic sculptor and ran a busy medieval style workshop, undertaking work from monumental pieces to pub signs and architectural decoration. Students of the School such as John Poole, Raymond Kings and Alan Bridgwater became his apprentices and then continued to work in their own right. While continuing Arts and Crafts principles, the style of sculpture produced by his workshop became part of the English avant-garde style, influenced by his mentor Eric Gill. Bloye's sculptural work encapsulated the style of monumental mural paintings undertaken at the School, an example of which can be found in Joseph Southall's scene of Corporation Street, 1915–16 (see Figure 3). Bloye's carved reliefs and lettering are found on libraries, offices and public buildings throughout the city and he was also responsible for seven major freestanding figure sculptures, being commissioned by the council or the Civic Society to restore a number of nineteenth-century memorial figures and recast them in bronze to ensure their longevity.

By the end of the 1950s this local tradition was at an end, coinciding with the acceptance of abstract art by the establishment. The next Head of Sculpture, John Bridgeman, came from outside Birmingham, and since the 1960s no one from the School of Art has been induced to contribute to the city's public statuary.

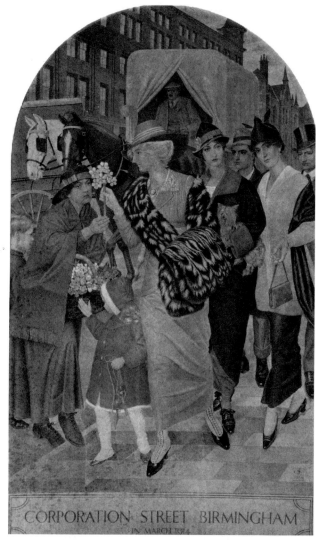

Fig. 3 Joseph Southall (1861–1944) *Corporation Street, Birmingham* 1915–16
Fresco mural painting in Birmingham Museum and Art Gallery, Chamberlain Square

National Heroes and Local Worthies

Statues of national and local worthies were clearly the commemoration of an individual's services to the country or the town, and the monument was regarded as an exemplar that might inspire future generations to similar deeds. In 1885 the *Birmingham Daily Mail* took stock of the statues erected in Birmingham, in an article which is revealing of the nineteenth-century ethos which generated them:

> The statues of Birmingham are of men who are beyond the ephemeral praise of their age... They point their moral and adorn the tale the civic sculpture tells in the streets to all who do not pass heedlessly by. The story of their lives is the history of Birmingham. They are monuments, not only of men, but of the material and moral progress of the town, which not only recall memories of the past, but stimulate to new aspirations for the future.[6]

However, with its endless number of run-of-the-mill public monuments, the sculpture of the nineteenth century appeared to be barren in style, banal in subject matter, frivolously commercialised in professional practice and outdated in its socio-cultural message by the advent of the twentieth century. Already in 1901, the anonymous writer of the article 'Monuments as we know them and as they should be' claimed:

> From the 'monuments' which have been erected in recent times it is evident that it is little realised what a memorial to a person it is desired to honour should be. The elements required for the making of a memorial are skill, beauty and use. Leave out one of these and the object is lost. Now, do the 'monuments' of our city answer to this simple test?... Are they not just statues on pedestals – a sort of glorified head or tail piece – without the 'tale'?[7]

The article continues to bemoan the attitude of London based sculptors who know nothing of their provincially based subjects, resulting in 'at best merely a scholarly but often meaningless figure, which will soon be out of fashion', and concludes that 'Birmingham has suffered too long and at the same time neglected her own sons'.

In fact, since the *Nelson Memorial* of 1809 by Richard Westmacott the Elder (1747–1809), the first publicly funded memorial statue to be erected in Birmingham and the first figurative memorial to the naval hero to be erected in Britain (see below, p.116), only two, the statues of Robert Peel and Rowland Hill, were commissioned from a local sculptor, Peter Hollins. The memorials to Thomas Attwood (1859)

and Joseph Sturge (1862) were both by John Thomas, a London based sculptor, but with strong family and professional connections in Birmingham. The rest of the nineteenth-century public memorial statues in the city were not only commissioned from fashionable London sculptors with no local associations, but were also executed in the metropolis rather than in the well established local foundries and stoneyards of monumental masons.

In contrast to pompously patriarchal Victorian imagery, local sculptors of the period had a restrained figurative style and used emblematic devices in a naturalistic way. For example, Peter Hollins's statue of Robert Peel was originally surrounded by a bronze railing (now lost) fashioned like clustering ears of wheat, symbolising the effects of his repeal of the Corn Laws. Hollins's *Memorial to Rowland Hill* (see below, p.75) had a narrative low relief on its pedestal depicting the social effect of the postal system, in addition to classical symbols such as the caduceus. Thomas's *Memorial to Joseph Sturge* combines a rather low-key statue with two more florid allegorical figures which, combined with inscriptions, allude to his role in the temperance movement, the abolition of slavery and the funding of local schools (see below, p.70).

In overview, nineteenth-century public memorial sculpture in Birmingham includes one equestrian statue, twenty-three free-standing statues, one fountain featuring a portrait medallion, and two portrait busts. Of these works, fifteen were erected during the reign of Queen Victoria (reigned 1837–1901), indeed two of the works are statues of the Queen herself. Another history of Birmingham's famous people can be read through funerary monuments in and outside churches, and particularly in the major cemeteries, which are outside the scope of this volume. The nineteenth century generally saw a proliferation of public memorial statues, particularly in metropolitan London, which boasts far more such statues than any provincial city. In fact, there are more memorial portrait statues in Westminster Abbey alone than in the whole of Birmingham.

The sculptural monuments included in this catalogue are all of marble or bronze and commemorate a variety of individuals. Some are of national importance, such as figures of royalty, or politicians such as Robert Peel and Joseph Chamberlain and the scientists James Watt and Joseph Priestley, who all nevertheless had strong local connections. Other figures are of more local fame and are commemorated for their particular contributions to the life of Birmingham; in brief, they are generally non-conformist philanthropic liberals.

Though the only statues of women in the city are the two of Queen Victoria, this is not particularly because memorials were not erected to women – the only statue in nearby Walsall is that of *Sister Dora* by Francis John Williamson (1833–1920) – nor because Birmingham was lacking suitable female candidates. In 1881, whilst the provision of a memorial to Sir Josiah Mason was being discussed, it was suggested that there should also be a statue to his wife who had led as philanthropic a life as her husband. However, the proposal was modified and a painted portrait was commissioned instead to hang as a pendant to that of Josiah in Aston Hall. Upon the death of Louisa Anne Ryland, one of Birmingham's most generous benefactors, there was an immediate call for a memorial to her services, and a statue was amongst the proposals. However, it transpired that Miss Ryland had left a note expressly forbidding the raising of any memorial to her, and after lengthy discussion it was decided that in view of her wishes they could not even change the name of Cannon Hill Park, one of her gifts to the town, to Ryland Park.

Most of the statues erected were of marble, but these have not weathered well in Birmingham's industrial atmosphere: see for example the state of the statue of Thomas Attwood (see below, p.72). Three of the marble statues by F.J. Williamson, those of John Skirrow Wright, Josiah Mason and George Dawson, have weathered badly and been scrapped, though their busts were first copied in bronze by William Bloye. The statues of Priestley (Williamson) and Queen Victoria (Thomas Brock, 1847–1922) have been translated from marble to the more durable but more expensive medium of bronze, in order to preserve them from the deleterious atmosphere. The statues of Rowland Hill, John Bright and Robert W. Dale are presently in store and not on public view. Extensive Gothic canopies which raised up and framed commemorative statues have also been lost or abandoned as ideas. The memorial to Prince Albert by John Foley (1818–74) was originally meant to go under a canopy (see below, p.142), and the fate of Francis Williamson's canopy over his statue of George Dawson – echoing that of the *Albert Memorial* in London – was to be demolished with the sculpture it contained (see below, pp.174–5). The fine equestrian statue of George I (see below, p.131), the oldest public sculpture in the city, is something of an oddity because it was brought here as an antique, having originally been erected in Dublin in 1722.

The majority of these memorials were erected by a system of public subscription. Prompted either by the death of an individual or by some significant point in their lives, a public meeting was called, usually by the Lord Mayor, to consider the desirability of commemorating the services of that person. If the feeling of the meeting was in favour of a memorial then a Committee would be elected for the purposes of deciding upon a suitable memorial and of carrying the proposal into effect. The memorial could take a number of forms, the most common being a statue, a portrait bust, a painted portrait, an inscribed plaque or a scholarship of some form to be administered by an appropriate educational body. Once the memorial committee had decided its objectives, these would be advertised and voluntary donations of money solicited in order to carry them out. If a statue or portrait bust had been decided upon, then it was up to the memorial committee to find a suitable sculptor to undertake the commission. Occasionally the commission would be thrown open to competition, more usually it was given to someone who had already produced a likeness of the individual concerned or who had already executed satisfactory portrait statues for the city: see for example the number of statues executed for Birmingham by the London sculptor F.J. Williamson. After a sculptor had been commissioned he would be instructed to prepare a number of small scale models of the subject which would be submitted to the committee for approval. The sculptor would then produce the preferred design to full- or half-size in clay. Most public statues of the nineteenth century were produced to a scale 50% larger than life, a scale usually described as colossal. All such statues in Birmingham are between 2.7 and 3.3 metres tall, except those of Bishop Gore (see below, p.40) and of Lord Nelson, which are life-size.

When the clay version was completed it could be translated into marble or bronze. To be cast in bronze the model would have to be made to full-scale and then cast first in plaster, this copy then being sent to the foundry for casting in bronze. If the final version was to be in marble, the clay model could be to half-scale, the size of which could be doubled by the use of a complex measuring instrument known as a pointing machine. Using this device, a series of points were plotted on the model, the machine was then transferred to the block of marble and the same points were then located within the block with the aid of a drill. Once a sufficient number of these points had been marked, then the stonemasons employed by the sculptor, often apprentices or assistants, would chip away the excess marble to leave the figure in a roughly 'blocked out' form. The work would then be given over to the master mason who would carve the figure

even further to the likeness of the model, using callipers to take further measurements. Finally, the sculptor himself would return to the work to add the final touches, giving texture to the draperies and adding other life-like detail. After polishing with pumice the statue was ready for siting.

A site for the memorial was usually decided in conjunction with the Public Works Department. In Birmingham this is now divided into the City Planning Department and the City Engineers Department, the latter together with the Museums and Art Gallery now being responsible for the custody and maintenance of public sculpture and monuments in the city. Favoured sites were important civic and commercial centres, at the head of major streets or in major squares of the city centre.[8] In some cases such as the *Memorial to Joseph Sturge* on the east side of Edgbaston, the statue was erected near to the commemorated person's favourite place of activity or residence.

After agreement on a site, a date would be fixed for an unveiling ceremony and an appropriate dignitary would be invited to officiate. At this event the memorial would be formally handed over by the dignitary on behalf of the subscribers to the Lord Mayor, who would accept it on behalf of the city.

The Unveiling Ceremony

New roads are 'opened', buildings are 'inaugurated', boats are 'launched'; only statues and plaques are unveiled as part of the modern ceremony of their dedication and first public display. The choice of concept and word can hardly be accidental: veiling and unveiling refer to a living tradition of the talismanic quality of carved and modelled images. While the sculptor wraps up his/her secret creation to conceal it from the unfit viewer, the public proclaims the hidden image by unveiling it. The former seems to be the remnant of image making as an act of magic, the latter, on the other hand, seems to be the affirmation of the attitude that E.H. Gombrich has described as a change from the 'archaic act of image making … [to] the more subtle magic we call "art" '.[9]

Sculpture is more 'real' than painting and the free-standing figure, almost an idol by definition, still carries a belief in the magic potency of imagery. Even when and where the belief in the magic of images has been partly overcome, it is still reflected by the widely spread notion that images give power over what they depict.[10] By idealising the figure to look 'immortal', sculpture aims to awake virtue and patriotism in the public. The concept originated in Classical Greece and Imperial Rome and was revived in France in the early nineteenth century, but it was in the Temple of British Worthies at Stowe that it was first fully realised in modern times.[11]

Unveiling was also a social act. Its ceremony traditionally involved all strata of society: from statesmen and municipal dignitaries to bankers, manufacturers and working people. Civic art was considered the expression of corporate wealth and community spirit. In Birmingham, already in the early nineteenth century, the Street Commissioners were eager not only to improve public amenities, but also to embellish the city centre in competition with rival towns and cities. The unveiling ceremony was the most accentuated expression and culmination of public support and enthusiasm, which had usually started with voluntary subscription and continued with public discussions of the presentation drawings and models, before choosing the final design.

Newspapers of the time give detailed accounts of each unveiling ceremony. Comment is made, first, on the weather for the occasion; it was considered to be most propitious for the sun to shine brightly at the appointed hour. Second, comment is made about the pomp and the manner in which the veiled figure was (customarily) surrounded by Venetian masts, trophies or flags and heraldic shields; next, about the platform, built at the foot of the veiled figure, for the dignitaries. Fourthly, description is lavished upon the procession of state and municipal authorities led by the Mayor, members of the memorial committee and usually the sculptor. Fifth comes comment about the size and enthusiasm of the crowd that lined the barriers on the processional route; and sixth, the rhetoric and substance of the lengthy eulogies were reported verbatim and occasionally published separately in commemorative booklets. Finally, comment was usually made on the success of the whole assemblage in presenting a 'gala scene'.

At least two of the official unveiling ceremonies lived up to these high expectations in Victorian Birmingham. The unveiling of the Peel memorial statue was reported in *Aris's Birmingham Gazette* as taking place:

> in the presence of the Municipal authorities and a large concourse of spectators, who completely blocked up the space at the top of New Street, along Congrave Street and Ann Street, and in the front of the Town Hall. The space within the railings of Christ Church, and all the windows of the adjacent houses were completely filled, and hundreds

of persons retired from inability to obtain a position near enough to witness the proceedings. About a quarter before twelve the Mayor, the Hon. and Rev. G.M. Yorke, Mr. Peter Hollins, several members of the Council and of the Peel Statue Committee, walked in procession from the Waterloo Rooms to the site, where a small platform had been erected for their use.[12]

Describing the statue as 'a worthy memorial of a good and great man' which should be 'esteemed and preserved', the Statue Committee's chairman recommended it to the Mayor:

> not only as a most impressive memorial of the great and illustrious Statesman whose statue it is, but as a symbol of the genius, high art, and great manufactoring skill that distinguish our fellow-townsman… Birmingham may well feel proud that it has produced such men as Mr. Peter Hollins (the sculptor) and Messrs. Elkington and Mason (the foundry)… But… the advantages of this noble work do not end here – it will be a most valuable and ever-present example, inviting the imitation and stimulating the worthy ambition of our youth, to whom in the present and all succeeding generations it cannot fail to give rise to those virtuous and patriotic emotions, which lead to generous and noble action, and are alike conducive to the advancement of the subject and the prosperity and glory of the state.

Almost half a century later, the *Birmingham Magazine of Arts and Industries* recorded Birmingham's Queen Victoria memorial as 'the good genius of the British Empire…, the "Great White Queen" which was the first Diamond Jubilee statue to be unveiled and the last to be erected during her record reign.'[13] In two days over 200,000 people passed along the barriers. This statue had become a public monument through private initiative. The patron was a local solicitor and philanthropist, W. Henry Barber, who selected a London based artist, Thomas Brock. He also determined the style and iconography of the monument, as well as its heroic size and materials: Sicilian marble for the figure and grey Cornish granite for the pedestal. In order that the patron's 'native city should have the finest possible presentment of the Queen in stone', it was reported, 'he made a point of seeing the most notable of existing memorials.'

The *Magazine* described in great detail that the Lord Mayor's procession – the Lord Mayor wearing his chain of office – crossed from the Council House to the richly decorated platform at the foot of the veiled figure to the strains of *Rule Britannia* played by the Police Band. Then, amid rounds of cheers and applause, Barber presented his gift to the Mayor on behalf of the city of Birmingham and asked his daughter to unveil it. To 'ringing cheers' the statue was exposed to view and the Lord Mayor promised that 'it shall be preserved in its present position for all future time'. He praised the 'graceful generosity' of the patron as an expression of loyalty and 'filial piety', and affirmed that 'the statue is a work of art which, if possible, enhances the reputation of the distinguished sculptor who has produced it'. Finally, a telegram was sent to the Queen. Then the 'Police Band again played *Rule Britannia* as the Lord Mayor and party, at his invitation, returned to the Council House to partake of tea'.

With the abatement of the commemorative portrait memorial and its gradual replacement with memorial figures, fountains and architectonic structures, all with lightly concealed allegorical or emblematic meanings, the unveiling ceremony began to loose its pomp and universal social appeal in the early twentieth century. The unveiling was transformed into a presentation ceremony when the employees of Cadbury's Bournville factory handed over their gift of a memorial fountain to the firm, celebrating its hundred years anniversary on 28 June 1933 (see below, pp.13–14). The ceremony, described in detail in *The Bournville Works Magazine*, still had echoes of earlier unveilings. The arrangements were in the hands of a joint committee of the Works Council. The ceremony was planned to commence:

> immediately after the general closing time, the date being chosen as affording the greatest number of employees the opportunity of being present, as it coincided with the Travellers' Conference and the presence at Bournville of representatives of other outside staffs, including some from the Gold Coast and elsewhere abroad.[14]

This time, light music was played by the works' Silver Band while the company assembled. The presentation speech was delivered by the secretary of the Pension Fund, who paid tribute to the 'progress of the Firm' and its founders, the Cadbury family, 'magnificent Birmingham Quaker(s)'. Family, firm, city, nation, empire and the world were called upon:

> The glorious tradition of the English family is, I think, one of our greatest national assets… the name of Cadbury stands among the highest in the City. We are particularly proud of the fact that they belong to the City and may be correctly described as an old

Birmingham family. We are also very proud of their achievements in many directions connected with the communal life of the City… We are today, naturally feeling particularly proud of their achievements as a Firm in the world of business. Their fame is worldwide.

The Directors of the Firm were praised for 'their hard work, their transparent honesty, their foresight, and their colossal energy', as well as for 'the attitude they always adopted for their workpeople', claiming 'it is quite correct to regard ourselves as one family'.

Accepting the gift on behalf of his fellow directors and other members of his family, W.A. Cadbury paid tribute to the Birmingham sculptor William Bloye, whom he quoted on the allegorical meaning of his work as 'The Spirit of Youth', placing it in the context of the recurring revivals of classical art and reminding the audience that 'Youth had played a very big part in the creation and progress of this business of ours'. Finally, the hymn 'Oh God, our help in ages past' was sung and a verse of the national anthem was played by the band.

Birmingham was probably the first city in Britain where the percentage for art principle (one percent of the original capital costs of buildings or redevelopment sites) was put into major practice in major civic schemes. The International Convention Centre with the surrounding redeveloped Centenary Square was opened by the Queen in June 1991, while the whole redevelopment of Victoria Square was opened by the Princess of Wales in May 1993. None of the newly erected sculptures were covered and individually unveiled in the presence of the public. In a different context, it has rightly been observed that 'more recent unveilings become rather modest affairs…, not so much unveiled as installed without ceremony'.[15]

Architectural Sculpture

Some of the finest examples of public sculpture in Birmingham can be viewed by looking up, for many buildings have such work, often high above eye level. Sometimes the works are stipulated in original plans for buildings, on others the works were added later. The earliest surviving example is a pair of portrait medallions, added to the façade of the Theatre Royal on New Street between 1777 and 1780, now in the Library (see below, p.38). In common with the free-standing works, civic pride and commercial acumen were celebrated in nineteenth-century architectural sculpture, nowhere more clearly than in the important iconographical programmes in the tympana of the Council House and on the façade of the Victoria Law Courts,

Corporation Street.

Such schemes had their apotheosis in the pedimental group on the south face of St. George's Hall Liverpool, designed by C.R. Cockerell and sculpted by W.G. Nicholl c.1845–54, in which Britannia was depicted accepting homage from the four quarters of the globe, extending 'her protecting spear over her own productions – agriculture, sciences, domestic happiness, the plough, the loom, and the anvil'.[16] Birmingham's Council House has five pediments, the middle one also centred on Britannia. However, its elaborate iconographical programme designed by Yeoville Thomason with monumental pedimental reliefs by Robert Boulton and Sons 1874–5, is devoted to Birmingham's place in the nation and her concern for the arts in relation to manufacture, the city becoming a modern Athens or Florence. The central pediment clearly reflects the social hierarchy of the city, Britannia rewarding factory owners with laurel wreaths whilst their workmen and wares are depicted to either side (see below, pp.139–42).

With the opening of the Law Courts in 1891, the Victorian concept of law and order was fully synthesised in a building, with architectural sculpture conveying its function. Designed by Aston Webb, E. Ingress Bell and Walter Crane, the idea of having sculpture integral to the building was certainly not unusual at the time. The grand scheme incorporated finely modelled pieces by known artists, including the magisterial form of Queen Victoria in full regalia, blind-folded Justice and St. George slaying the Dragon. Yet, even here, high up in the gables, are representations of Art and Craft, Modelling and Design, Gun Making and Pottery, all industrial skills crucial to the success of Birmingham in the nineteenth century (see below, pp.49–50).

Quality architectural sculpture has continued into the twentieth century through the work of Benjamin Creswick and subsequently William Bloye. A fine example of his craftsmanship are the four relief figures representing *Wisdom*, *Fortitude*, *Charity* and *Faith*, c.1932, high on the walls of the Legal and General Assurance Building at 7–8 Waterloo Street. The influence of Eric Gill is easily discerned in the clean lines of the carving and the subjects are allegorical and self-contained (see below, pp.153–4). Bloye and his workshop were also responsible for a number of other works which are often overlooked: elegantly carved pub signs can be found throughout the city, retaining some style in areas which are now distinctly run-down (see for example the pubs on Stratford Road, below, pp.124–5). Derived from the medieval tradition of emblematic shop signs, sculptured pub signs

are quite rare in Britain, but unusually common in Birmingham thanks to Bloye's commissions. He was given a relatively free hand in the carving style used and subject matter chosen, which was not only appropriate to the name of the pub but often had local associations as well.

Another architectural genre that has continued from pre-Corporation days is that of the coat of arms. The equal status of *Art* and *Industry*, shown by their position in the city's arms, is of particular importance to many iconographical programmes in Birmingham, notably in the early free-standing group by S.F. Lynn (1834–76), made twenty years before either the shield or supporters were authorised (see below, pp.8–9). Since then, the coat of arms has taken an important central place in municipal building façades: see the magnificent examples on the swimming baths at Moseley (Hale and Son, 1907, p.88 below) and Nechells (Creswick, 1910, p.91 below). A small polychrome incised relief of the arms was included on the retaining wall to the refurbished Victoria Square scheme in 1993.

More recent art on buildings tends not to be so integral to the overall conception. Bianca Rossoff's large bronze can be seen as representative of this 'brooch' approach of the 1960s, typified by Barbara Hepworth's sculpture on the side of John Lewis, Oxford Street, London. Yet it retains a stark power, the dark metal standing out spikily against the white of its supporting office block (see below, p.100). Visible across Centenary Square, a quarter of a mile away and separated by 30 years, is one of the most innovative of architectural artworks in the city, Ron Haselden's *Birdlife* (1991). Barely visible by day, at night the canopy of the International Convention Centre is transformed into a kinetic display of neon light, flashing red, yellow and blue. The work not only draws the eye, it defines the entrance to the ICC and sets the tone for the modern, jaunty confidence of the development.

Modernism and Post Modernism

The break to modernism in sculptural production has been identified by Rosalind Krauss as the change from the 'inescapable logic of the monument' to that of 'essentially nomadic' work. Sculpture in the late 1960s then becomes 'one term on the periphery of a field in which there are other, differently structured possibilities' such as the combination of architecture and landscape, essentially a post modernist stance.[17] As with many other cities, Birmingham's public sculpture since the Second World War has reflected this movement, although

lagging behind the American examples that Krauss quotes. British developments can be generally characterised by Arts Council support for 'sculpture in the open air' through the 1950s and 1960s, the consequent burgeoning of modernistic pieces in urban spaces through the 1970s, with a shift towards the mutuality of art and social and physical environments in the 1980s. Finally, large regeneration schemes in the 1990s have given opportunities for artists to combine with architects and urban planners in the redesign of previously rundown areas, whilst one-off commissions continue to be placed around the city.

However, Birmingham has retained a distinctive local character to its twentieth-century public sculpture. Firstly, the continued work of Bloye and his pupils into the 1960s meant that there is a historical link with the pre-War period. Secondly, in many ways the concerns of the modern works still reflect issues bound up with the city's self-image. Local industrial strength and corporate pride may no longer be shown by monuments to great industrialists and inventors, but instead through abstract works celebrating locally produced materials or pieces symbolising the entrepreneurial spirit within Birmingham's multi-cultural society. In this period the term 'public art' has become a key term of art discourse, and its role within the city hotly debated, yet it has been a time of fruitful collaborations between artists and urban designers. Many works have been placed as a result of the road building schemes in the late 1960s and early 1970s, particularly in subways and at pedestrian crossing points. *Impulse* by Alex Mann (b. 1923) acts as focus for the Five Ways roundabout, but also as a paean to local steel-tube manufacturers (see below, p.59); the vast reliefs by William Mitchell (b. 1925) on the walls of Hockley Circus underpass have motifs derived from mechanical parts, located as they are in a still-industrial part of the city (see below, p.73).

However, some works have been sited with little concern for the character of the *locale* or the understanding of the viewer. One example is that of *Gate Construction* by Robert Carruthers (b.1925). This ambitious piece was erected in 1972 as part of the Arts Council *Sculpture in the City* programme, placing works in cities such as Cardiff and Newcastle on a test basis.[18] Unfortunately the form, based on Japanese temple gates, and the materials – wood and sail cloth – did not fit in with the busy central location of Colmore Circus, and the rotting work now languishes on open ground some way from the centre (see below, p.8). Yet, as is the case with many *causes célèbres*, adverse criticism soon blows over. Indeed, opinion often reverses as is evidenced by the original outcry over Nicholas

Monro's *King Kong* (also a *Sculpture in the City* piece), reported dead-pan as attracting 'overwhelming public response and involvement… (doing) more than any other city sculpture to arouse popular comment and debate'.[19] This centred on whether such a piece had suitable connotations for modern Birmingham. Yet the aggressive stance of the giant fibreglass ape was oddly appropriate to its time, characterised by the city's demolishing of swathes of the inner city to make way for road schemes. Since its removal after six months in central Birmingham, *King Kong* has remained high in the public consciousness with constant demands for its return at the expense of more recent commissions (see below, p.170).[20]

As is clear from the graph, there was a drop in public sculpture sitings during the 1980s, with most pieces best described as 'modernist' (see Figure 1). But at the beginning of the 1990s, a new spirit was abroad in planning circles within the city, and since the inception of the Centenary Square scheme there has been a continued effort to revitalise the city centre through cultural and commercial redevelopment which has included a great many works of art. Working in concert with the Public Art Commissions Agency, the city pioneered the use of 'percent for art' funds in its development of the International Convention Centre and its surroundings. Tess Jaray's scheme mapped out a space within which other artists' works were placed, rather as a room would be the setting for furniture and decoration which reflect personal character. This inter-textual approach, with contrasting mediums and methods of dealing with subject matter, make the square into a quintessential work of post-modernist art in itself. The 'contents' reflect Birmingham's character, and it is noteworthy how the works define a return to civic, commercial and post-industrial meanings. The serious intent of *Monument to John Baskerville*, by David Patten (b. 1954), is to conceptually sum up many aspects of art and industry, and its siting directly outside the Council offices points to the continuing involvement of civic ideals in Birmingham's development. The inscription on the end block of the work, taken from an eighteenth-century poem, neatly sums up this feeling: 'Industry and Genius – A Fable'. However, this could be seen as a sly comment on the state of Birmingham as being 'fabulous' in the sense of unbelievable, whereas the work itself is more obviously celebratory (see below, p.25).

The variety of styles of works sited in Centenary Square, and subsequently in the remodelled Victoria Square, shows an admirable eclecticism on the part of their commissioners. In contrast to the nineteenth-century subscription committees, these works have been made possible through private patronage (as with Antony Gormley's *Iron:Man*: see below, p.146) or through selection processes that have to all intents and purposes been carried out behind closed doors. The Council has used the Public Art Commissions Agency for Centenary Square and an independent consultant at Victoria Square to shortlist artists, co-ordinate selection, siting and erection. It has been up to the Museum and Art Gallery to publish a series of fact sheets on the works some time after their installation. The pieces range from Raymond Mason's monumental fibreglass historical tableau, *Forward*, in the centre of Centenary Square (see below, p.26) to Sioban Coppinger (b. 1955) and Fiona Peever's anti-heroic *Monument to Thomas Attwood*, sited at ground level behind the Town Hall (see below, p.34). The ultimate expression of this approach is the grand scheme for the remodelled Victoria Square by Dhruva Mistry (b.1957) which combines four dissimilar elements into a formal whole, somehow managing to bundle the past, present and future together in an iconographically complex evocation of universal and more localised concerns. Although *River* has entered popular parlance as 'The Floozie in the Jacuzzi' and the two *Guardians* have been derided for supposedly having faces reminiscent of Thomas the Tank Engine, the scheme is successful because it provides a pedestrian focal point for the city centre as well as a spectacular visual corridor up to the Council House (see below, pp.147–150).

According to *The Magazine of Art* in 1887, 'far from being the centre and hot-bed of all that is inartistic and ugly, the Birmingham of today is perhaps the most artistic town in England'.[21] Allowing for nineteenth-century hyperbole, this century-old description is an accurate reflection of the aesthetic forces currently at work in Birmingham: the sheer amount of art commissioned for public places in the 1990s has led to a complete transformation of the city centre as well as the brightening of far-flung suburbs.

The State of Birmingham's Public Sculpture

Despite the hopes of patrons, sculptors and the public, works that upon their unveiling were meant to last *ad infinitum* have often suffered a great many indignities through alteration, neglect, decay or change of location. Changing ideas and attitudes, and especially the periodic replanning of the city centre, meant the resiting of most of the free-standing monuments and sculpture from inner city sites to new locations through the twentieth century. Works have also been

moved into storage, made into exhibits for the Museum and Art Gallery, truncated to make busts or transformed from one medium to another.[22] The reader will find many examples of works that are no longer part of original visual contexts which had often shared specific socio-political connotations, resulting in a 'dilution' of the city's historical heritage. Yet as some pieces have been sidelined, others have been commissioned to take their place, and the city centre still has a vibrant sculptural environment in which modern works relate to their nineteenth- and early twentieth-century precursors.

Despite this recognition that the urban environment cannot remain static, it is disheartening to note that many of the city's most famous works have suffered from considerable neglect. A case in point is the *Memorial to Thomas Attwood* by John Thomas, 1859, moved from its original position at the very core of the city on New Street to a state of isolated and forgotten decay in Sparkbrook (see below, p.72). In addition, this malaise is not confined to older works, as modern materials used in sculptural production have been found to be lacking when exposed to the still fume-ridden atmosphere of Birmingham. The importance of maintaining older statues has been underlined by the listing of many of them or their related architecture: over half of the 192 extant works erected before 1945 in this catalogue are listed, though the condition of 32 of them has been recorded as only 'fair' or 'poor'. For post-war works, 18 of the 166 pieces have been lost, with the condition of 13 recorded as 'fair' or 'poor', and no free-standing works listed at all. The condition of some relatively recent pieces is particularly worrying: note the cracks in the fibreglass hull of Raymond Mason's *Forward*, and the rapidly deteriorating surface of the *Memorial to Tony Hancock*, by Bruce Williams (see below, p.44). Nor is much attention paid to some of the finer architectural sculpture that the city possesses: the façade of the Methodist Central Hall on Corporation Street is covered with green algae (see below, pp.47–8) and the two grand *Allegorical Figures* on the roof of 18–19 Bennett's Hill are discoloured and eroded through pollution damage (see below, p.11).

Although listing of buildings or monuments does not imply a pro-active approach to their conservation, it does mean that the importance of the work is recognised and that any plans for refurbishment, movement or demolition have to be specially approved. To this end, it is felt that the following works should be considered for listing as soon as is practicable: Albert Toft's *South African War Memorial*, 1905, Cannon Hill Park (see below, p.106); the Hall of Memory by

Cooke and Twist, 1925, Centenary Square, with its associated sculpture by Albert Toft and William Bloye (see below, pp.21–4); and *Compassion*, 1963, by Uli Nimptsch (see below, p.96).

In addition to the poor state of many works, many have been removed from public display altogether, and this catalogue contains a section devoted to them. Quite apart from older sculpture that has not withstood the test of time, a number of twentieth-century works have also disappeared. It has been felt important to record them here because of their place in the urban environment of past decades, and so that details of these fine pieces should not be lost to future historians.

In addition, since the research for this volume was completed in 1996 there will have been changes in condition of many of the pieces in the catalogue. New plans for the pedestrianisation of Old Square and the redevelopment of the Bull Ring mean that Kenneth Budd's *Memorial to Old Square* (see p.45 below) and Trewin Copplestone's *Bull Forms* (see below, p.115) have been removed, with their ultimate fate unknown. UCE Public Sculpture Project would be pleased to hear of any other changes in location or condition, or suggestions for listing relating to works in this catalogue.

GTN
JB

Notes

1. Alexis de Tocqueville, *Journeys to England and Ireland*, ed. Mayer, London 1958, p.94 (1835).
2. *Britannia*, 1586; see especially the enlarged and improved edition of 1600.
3. See *Gentleman's Magazine*, 1816, p.475.
4. See A. Crawford (ed.), *By hammer and hand: The Arts and Crafts Movement of Birmingham*, Birmingham, 1984, pp.36–7.
5. Anon, 'Vital Victorian', *The Contract Journal*, 26 December 1888, pp.811–14.
6. *Birmingham Daily Mail*, 12 November 1885.
7. *Birmingham Magazine*, vol.3 (1901–3), pp.171–5.
8. See J. Beach and G.T. Noszlopy, 'Public art and planning in Birmingham', *Planning History*, vol.18, no.1, 1996, pp.21–7.
9. E.H. Gombrich, *Art and illusion*, London and New York, 1960, p.115.
10. See Ernst Kris, *Psychoanalytic explorations in art*, London, 1953, pp.47–56; and Ernst Kris and Otto Kurz, *Legend, myth and magic in the image of the artist*, New Haven and London, 1979, pp.61–84.

11. See H.W. Janson, *Nineteenth century sculpture*, London, 1985, pp.16–17.

12. *Aris's Birmingham Gazette*, 3 September 1855.

13. 'Birmingham's statue to the greatest Queen that ever reigned', *Birmingham Magazine of Arts and Industries*, vol.3, no.3, 1901.

14. *The Bournville Works Magazine*, vol. XXXI, no.8, August 1933, pp.232–8.

15. Terry Cavanagh, *Public sculpture of Liverpool*, Liverpool, 1997, p.xvi.

16. Royal Academy of Arts, 1846, quoted in *ibid*., p.305; now lost, this work is described in detail pp.305–9.

17. Rosalind Krauss, 'Sculpture in the expanded field', *October*, no.8, Spring, 1979.

18. See Arts Council of Great Britain, *City sculpture*, London, 1972.

19. *Evening Mail*, 19 June 1972.

20. See T. Grimley, 'Last laugh from the king of the Bull Ring', *Birmingham Post*, 29 July 1991.

21. A. St. Johnston, *The Magazine of Art*, 1887.

22. See Jo Darke, *The monument guide to England and Wales*, London and Sydney, 1991, pp.161–3.

The Catalogue

The catalogue is arranged in alphabetical order by road name. There are three sections: *Extant Works*, for those pieces which still exist; *Lost Works*, for major pieces which are relatively well documented but no longer to be found; and *Unrealised Works*. Each entry consists of the following headings.

Sculptor: The architect or designer of a piece is given if different from the person making it. The foundry or associated craftsmen are also given if known. There are very few works for which no maker is known.

Date: The date is given as that of the unveiling or final siting, where this is known. Information on original commissioning dates is given in the descriptive text.

Materials: The types of materials used for each work are known either from close examination or from documentation. This can lead to an imbalance between works for which quite specific information is available (for example, 'White Carrara Marble'), and those for which generic terms only are possible (for example, 'Stone').

Dimensions: Each extant piece has been measured on site by research staff and compared to documentary evidence where possible. The dimensions of some lost works are known through contemporary records or can be surmised from illustrations.

Signatures and Inscriptions: A signature is the mark of the sculptor, whether actually signed or carved somewhere on the piece. This also includes marks of foundries and associated craftsmen. Inscriptions refer to raised, carved or attached lettering on the work. Modern plaques which describe the work are dealt with in the descriptive text.

Ownership: Ownership of many works of art in public areas has been difficult to establish. Most free-standing works on public land come under the Council's duty of care, but some areas where there is public access are in fact privately owned. There are many architectural works in particular for which the owners of the building could not be traced. Works in the grounds of churches, hospitals and universities are assumed to be the responsibility of the institutions concerned.

Condition: Each extant work has been examined by a researcher and its physical state assessed. Whilst this is not a technical evaluation, consistent standards have been applied. In most cases, this was undertaken in 1995 and early 1996.

Listing Status: The Department of Culture, Media and Sport publishes a list of protected buildings and other structures, of which there are three grades: I, which is the highest state of listing, II*, and II which is the lowest grade. The last list available for Birmingham was published in 1982. The author is extremely grateful to Ian Leith for help in identifying listed monuments.

Descriptive text: Description of the work is split into two main parts. Firstly a physical outline, which records the main components of the work. There follows as much historical background to the commissioning, siting and subsequent fate of the work as has been possible to discover.

References: Where information has been found in published material, whether newspapers, documents or books, a note number is given in the text for which the reference can be found beneath. For often quoted material, this reference is shortened (see Abbreviations), and a full bibliography can be found after the main catalogue. Extensive use has been made of contemporary newspaper reports, for which a complete archive exists in Birmingham Reference Library. The project's researchers have been particularly fortunate in corresponding with and meeting many of the artists who have work in Birmingham. These notes are held on file at the University of Central England and can be consulted by appointment with the research team. The Museum and Art Gallery and the Public Art Commissions Agency have also allowed access to their records of correspondence and commissioning, providing useful information not readily available to the public.

Abbreviations

The following abbreviations have been used in the catalogue:

1. References
Beattie: S. Beattie, *The new sculpture*, London, 1983
Bloye, *Ledger*: W.H. Bloye, *Sales Ledger 1932–68*
BRBP: *Birmingham Register of Building Plans*
Dent: R.K. Dent, *Old and new Birmingham*, Birmingham, 1880
Graves: A. Graves, *Royal Academy Exhibitors 1769–1904*, vols.I–VIII, London, 1905–6
Gunnis: R. Gunnis, *Dictionary of British sculptors 1660–1851*, London, 1964
Harman: T. Harman, *Showell's dictionary of Birmingham*, Birmingham, 1885
Hickman: D. Hickman, *Birmingham*, London, 1970
Pevsner: N. Pevsner, *Warwickshire*, Buildings of England series, London, 1966
Strachan: W.J. Strachan, *Open air sculpture in Britain, a comprehensive guide*, London, 1984
WWA: *Who's who in art*, 6th–26th editions, London, Eastbourne and Havant, 1952–94
RAE: *Royal Academy exhibitors 1905–1970*, vols.I–VI, Wakefield and London, 1973–82
Birmingham Information Bureau: Birmingham Information Bureau, *Statues, public memorials and sculpture in the City of Birmingham*, May 1977

2. Newspapers
Despatch: *Birmingham* or *Evening Despatch* (1902–60)
Express and Star: *Birmingham Express and Star* (1990–94)
Gazette: *Birmingham* or *Aris's Gazette* (1851–1965)
Mail: *Birmingham* or *Evening Mail* (1910–96)
Post: *Birmingham Post* (1883–1996)

3. Institutions or Awards
ARA: Associate of the Royal Academy
ARBS: Associate of RBS
BMAG: Birmingham Museums and Art Gallery
FRBS: Fellow of RBS
FRIBA: Fellow of RIBA
FRS: Fellow of the Royal Society
PACA: Public Art Commissions Agency
RA: Royal Academy / Member of the Royal Academy
RBA: Royal Society of British Artists
RBS: Royal Society of British Sculptors
RBSA: Royal Birmingham Society of Artists
RCA: Royal College of Art
RIBA: Royal Institute of British Architects
RSA: Royal Society of Arts
RSMA: Royal Society of Marine Artists
SLTAS: South London Technical Arts School
UCE: University of Central England
UCEPSP: University of Central England Public Sculpture Project

Sources of Illustrations

The illustrations for the main catalogue have been taken by various photographers working for the UCE Public Sculpture Project in the period 1983 to 1996: it is unfortunately impossible to assign a photographer's name to each image. Grateful acknowledgement is made to the sources of the following images: Birmingham Libraries Service p.16 (right), p.22 (middle), p.30 (left), p.40 (right), p.44 (middle), p.76 (left), p.86, p.98 (right), p.117 (left), p.145 (right), p.161, p.171 (right), p.172 (left), p.175; *Birmingham Evening Mail*, p.170; Birmingham Museum and Art Gallery, p.xiv; University of Central England, p.xiii.

We should be grateful if any individual or organisation, inadvertently not acknowledged, would draw the fact to the author's attention so that an appropriate amendment may be made in any future edition.

Acknowledgements

The University of Central England's research into Birmingham's public art began in 1983, when a team of research assistants and photographers started a comprehensive street by street survey. An unpublished typescript catalogue was produced, and it was not until the early 1990s that the project was revived, given fresh impetus by the formation of the PMSA's National Recording Project (NRP) committee. UCE's project has had two main strands: (a) the continual research and updating of information on Birmingham's public sculpture; (b) the transfer of the information onto a computerised database for publication on CD-ROM. This work has been funded by the Institute of Art and Design at UCE and by the Leverhulme Trust. The results are now published in this catalogue, and original material can be accessed at the University by appointment with the research team. The project's staff have an ongoing commitment to the study of public art of any kind, and as a PMSA Regional Archive Centre they are currently extending their survey of sculpture and monuments to the West Midlands and surrounding counties.

The UCE Public Sculpture Project has been generously funded in two distinct phases. From 1983 to 1985, a grant from the Manpower Services Commission allowed five research assistants and two photographers to undertake initial work. Film and photographic paper was generously provided by Kentmere Ltd. Birmingham Institute of Art and Design's Research Committee was responsible for a fresh funding impetus from October 1993 to April 1994, when the Project was fortunate enough to receive a grant from The Leverhulme Trust until April 1995. Recent work has been financed by further help from the Faculty Research Committee (November 1995 to June 1996). We cannot overstate our gratitude to these institutions for their interest over the life of the Project.

We would like to thank the following people, who have played such key roles in supporting our research. Firstly Evelyn Silber who, when she was Deputy Director of Birmingham Museums and Art Gallery, had the idea of surveying the city's public art and jointly undertook initial supervision of the project; subsequently, many members of BMAG have helped with information and ideas, notably Dr. Michael Diamond and Tessa Sidey. We are deeply grateful to the Trustees of the Barber Institute of Fine Arts, University of Birmingham, and especially the then Director, Professor Hamish Miles, who kindly agreed to photograph sculptures in the University's collection and provided much information about them. Vivian Lovell and Geoff Wood at the Public Art Commissions Agency have never wavered in their interest. Ben Read, Ian Leith, Jo Darke and Edward Morris, all members of the PMSA National Recording Project Committee, have always been helpful and encouraging. At UCE we are particularly grateful for the academic, administrative and financial support provided by Professor Mick Durman, Professor Nick Stanley and Dr Ken Quickenden. Last but not least thanks are due to Robin Bloxsidge, the publisher, at Liverpool University Press, who had the faith to take on the series of NRP catalogues, and Janet Allan who has been so helpful in the production of this volume.

This catalogue is the result of the labour of many people over the years, some of whom have been employed by the project, others who have worked in a voluntary capacity. Their names are listed on the inside front page of this volume in recognition of the great debt we owe to the corpus of material gathered over the life of this project. However, special thanks are due to Samantha Watkins, Rachael Edgar, Marie-Louise Bolland and Sian Everitt for their help as the book entered its final production stages.

GEORGE NOSZLOPY
University of Central England

JEREMY BEACH
University of Northumbria

Perry Barr Greyhound Track, formerly Birchfield Harriers stadium, on top of the stand

Running Stag

William Bloye

*c.*1929
Stone, polychrome
100cm high × 280cm wide
Inscription: FOUNDED 1877 / FLEET AND FREE
Status: not listed
Condition: Good
Owned by: Perry Barr Stadium

Attributed to Bloye who also carved lettering at the stadium which was later destroyed,[1] the relief shows a stag in flight, modelled in low relief very similar to Bloye's *Antelope* of this period (Stratford Road, q.v.). It is silhouetted against a plain background, like an emblem, framed by a ribbon bearing the club's motto. A smaller copy of this design exists on the outside of the main stand at the Alexander Sports Stadium, Perry Park,

though it is not known who made this version.

1. Information supplied by D. Hickman, 13th November 1985.

Boar's Head public house, forecourt, on top of signpost

Boar's Head

William Bloye

*c.*1938
Painted wood
90cm high, on a 1000cm high post
Status: not listed
Condition: good
Owned by: Boar's Head Public House

The Boar's Head public house was rebuilt in 1938 for Ansell's brewery by F.J. Osborne,[1] who commissioned a considerable amount of decoration including this carved head from Bloye.[2] It was most probably completed ready for the opening at Christmas 1938. Painted gold, and finely modelled, the motif

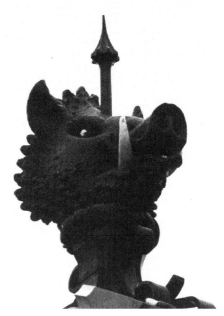

Bloye, *Boar's Head*

is derived from the heraldic crest of the Gough and Gough-Calthorpes, who lived at Perry Hall to the south-west until the 1920s.[3] Although an unusual work to be attributed to Bloye, in that it is of wood carved fully in the round, it is similar in conception to the model for the *Spirit of Birmingham*, a project that Bloye was involved with in the same year but which was never realised. The bold features of the head as well as its setting on top of a tapering, square-sectioned and brightly decorated post provide an unusual advertisement for the pub behind.

1. Letter from J.P. Osborne, chartered architects, 10th April 1985; 2. Bloye, *Ledger*, 21st December 1934, p.21, invoice no.120; 3. D. Rhodes, *Brum trail 3*, Birmingham, 1975.

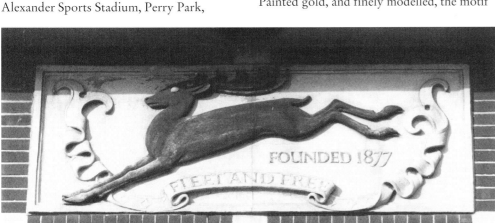

Bloye, *Running Stag*

Aston Park  ASTON

Aston Hall was built by Sir Thomas Holte between 1618 and 1635, and stands in 40 acres of parkland to the north of the city centre. Although remodelled during the 17th and 18th centuries, it survives as one of the least altered Jacobean houses for which contemporary plans exist. From 1819 to 1848, the Hall was home to James Watt junior, son of the famous local engineer, and it was opened as a museum in 1858, then purchased by the Corporation in 1864. Now run by Birmingham Museums and Art Gallery, the Hall is furnished according to 17th- and 18th-century inventories and is a Grade I listed building. The grounds have undergone considerable alteration, but gardens near the Hall retain some of the style of the early 20th century.

Aston Hall, west gardens

Pan

William Bloye

1934
Portland stone
205 cm high
Status: not listed
Condition: poor. Details have been smoothed away and water spouts are missing
Owned by: Aston Hall, Birmingham Museums and Art Gallery

Designed and paid for by the Birmingham Civic Society,[1] this figure of the god Pan was originally intended for a fountain that formed part of the restoration plans for the grounds of Aston Hall, begun in 1924 at the request of the Parks Committee. Designs

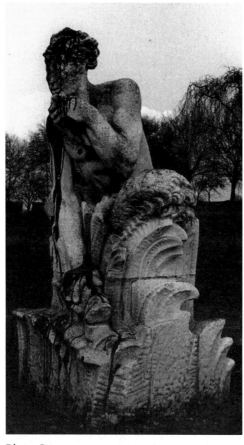

Bloye, *Pan*

showing the fountain as a central feature of the gardens are dated 1927.[2] Although the landscaping was paid for by government grants, given to create work for the large number of unemployed, no such provision was made for features such as the fountain. The Civic Society granted £150 towards its

cost in January 1929 and on the approval of the Parks Committee, Bloye, a member of the Technical Committee of the Civic Society, received the commission. Eventually £250 was provided and in April 1934 a photograph of Bloye with his 'almost completed' fountain appeared in the *Birmingham Mail*.[3] The finished work was presented to the Parks Committee and unveiled at the end of the month by the vice-president of the Civic Society, Sir Gilbert Barling, Bart., CB, CBE, who considered the sculpture 'admirably' done.[4] The base, carved as rushes, originally had water spouts and the sculpture, now disfigured with paint, stood in a small pool which has since been filled in.

1. W. Hayward, *The work of the Birmingham Civic Society*, Birmingham, 1946, pp.67–81; 2. Birmingham Civic Society, *Annual reports*, Birmingham, 1927–9; 3. *Mail*, 11th April 1934, p.10; 4. *Mail*, 26th April 1934.

Vases

William Bloye

1937
Portland stone
180 cm high
Status: not listed
Condition: good
Owned by: Aston Hall, Birmingham Museums and Art Gallery

These two great vases were placed on the upper terrace before the west façade of the Hall and a short distance from where Bloye's fountain statue of Pan was later located. Carved with decorative borders and an ornate flower design, they added distinction to the gardens but were neglected and

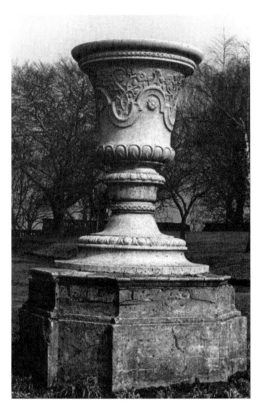

Bloye, *Vase*

Founded in 1895 as a College of Science at the Birmingham and Midland Institute, Aston University's present-day 40-acre site at Gosta Green was acquired in 1933. The College of Technology, Commerce and Art was designed by the architects, H.V. Ashley and Winton Newman in 1937 but not completed until after the war, being officially opened by H M the Queen in November 1955. Aston University was incorporated in 1966, specialising in science subjects. The grounds contain a main building, several departmental complexes, library, sports hall, halls of residence and open spaces, all of which are publicly accessible.

became dilapidated. However, both vases were restored in 1995 and now stand in their original locations. Bloye's ledger records the cost as £69 12s. 0d.,[1] although the Civic Society states it to be £200.[2]

1. Bloye, *Ledger*, 27th July 1937, p.52; 2. W. Hayward, *The work of the Birmingham Civic Society*, Birmingham, 1946, p.73.

University of Aston, entrance lobby of main building

Science and Technology

Esmund Burton

1953
Portland stone
Each: 92cm high × 190cm wide
Status: not listed
Condition: good
Owned by: University of Aston

These figurative panels and a *Coat of Arms* (now removed) were commissioned from Burton to decorate the main entrance of the new College of Technology[1] and he carved the panels in his studios in Red Lion Street,

Burton, *Science*

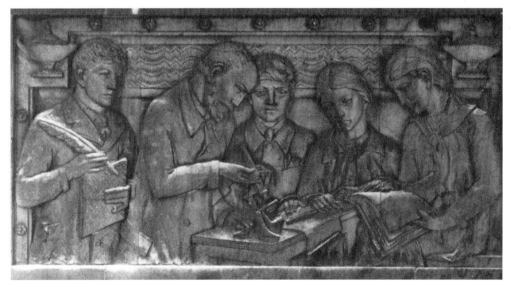

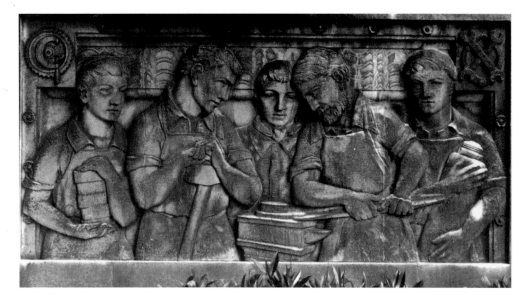

Burton, *Technology*

London.[2] The left panel represents Science and depicts a classroom scene with two lamps in the upper corners as emblems of knowledge; on the right the panel depicts the teaching of Technology and is accompanied by emblems of industry in the upper corners.

1. City of Birmingham Education Committee, *The inauguration of the building for the colleges of technology, commerce and art, Gosta Green by Her Majesty Queen Elizabeth II Accompanied by His Royal Highness the Duke of Edinburgh, 3rd November 1955*, Birmingham 1955, programme; 2. 'Royal inauguration of Birmingham colleges of technology, commerce and art', *Post*, 4th November 1955, p.vi.

Maine, *Aston Stones* (detail)

University of Aston, campus grounds

Aston Stones

John Maine

1975–7
Portland Whitbed stone, in five parts
Heights range from 105cm to 135cm
Status: not listed
Condition: good
Owned by: University of Aston

The scheme to commission open-air sculptures at the university was launched when its library was opened in 1975.[1] As a total scheme they were financed by the Arts Council of Great Britain, who were promoting the work of young sculptors (£1,500 contribution), the University of Aston (£1,500) and donations from Members of the Convocation, now Aston Graduates Association (£1,000).[2] Purchased singly, the first of the five works was installed on 19th November 1976.[3]

Originally the Aston Stones were placed along two axes which intersected the site known as the Old Cross. Whilst following the pattern of a cross, this also emphasised the interconnection of the disciplines and activities of the campus: from each site at least one of the other stones was visible. The stones have since been re-arranged because of campus redevelopments. According to the artist the five geometric designs each explore a different kind of symmetry by connecting eight equidistant discs in a variety of ways. The large stone, on a brick base, is carved in eight identical parts, each precisely fitted. The other four are cut from single blocks of Portland Whitbed stone.[4] Some of the sculp-

tures have been smoothly finished while others reveal claw chisel marks. This group is similar to John Maine's *Six Markers on the Foreshore*, Portsmouth, 1974.

1. *Aston Observer*, no.9, October 1975; 2. Aston Stones, file, University of Aston, Central Filing Unit; 3. *Aston Observer*, no.15, December 1976; 4. Strachan, 1984, p.10.

Lake between halls of residence, University of Aston. Formerly at The Ackers, Small Heath

Peace Sculpture

William Pye

Originally sited 1985; re-sited 1991
Stainless steel, with fountain mechanism
600cm high
Status: not listed
Condition: good
Owned by: University of Aston

Originally placed on the site of a bombed-out factory at the Ackers, Sparkbrook, this water sculpture was commissioned by the West Midlands County Council on the suggestion of Councillor Sparks, Chairman of the Strategic Planning Committee in 1983. The piece was the result of an open competition organised by the Arts Council of Great Britain and West Midlands Arts,[1] which stipulated that the sculpture should symbolise (1) the commemoration of those civilians who had died in a bomb raid in 1941 at the former BSA motorcycle works adjacent to the Ackers; (2) the celebration of Peace Year in 1984 and long term peace in the world; (3) the transformation of the Ackers site from a derelict wasteland to a new recreational

Pye, *Peace Sculpture*

facility for the nearby community.[2] From twelve entrants, Pye was shortlisted with two others who were invited to submit maquettes, each being paid £500. A subcommittee of the County Council subsequently selected Pye's design.

According to the artist, the sculpture acted as a symbol for Ackers Park. A simple inverted 'V' frame structure, it incorporates sixteen directed jets which form a water trellis within the triangle image: the require-ments of the sculpture brief were fulfilled during the different stages of the programmed cycle of water movements. As the water reaches maximum pressure and the water trellis is complete, the water would represent 'the different cultures striving to meet in a state of peace and harmony'. As the pressure drops and the jets sink to a point of stillness, 'the cycle of life and contemplation of man's mortality is evoked' which is suggestive of Commemoration. Finally, as the water re-emerges 'a consciousness of re-birth and renewal is suggested which

symbolises the transformation of dead and derelict land to a new life as a beautiful park.'[3]

His *Peace Fountain* and its instalment amounted to £25,000, details of which were published in the local press.[4] It was successfully unveiled on 20th December 1985, but soon afterwards the fountain mechanism ceased to work due to shortcomings of enabling works and an absence of maintenance following the abolition of West Midlands County Council, and in 1986 Pye was obliged to carry out £2,000 of emergency repairs.[5] The fountain worked again for several weeks before being vandalised. Due to the support of Michael Diamond, then Director of Birmingham City Art Gallery, the sculpture was successfully resited in the middle of a landscaped lake on the Aston University site in 1991, overlooked by its halls of residence, and acts as a harmonious focal point for the area.[6]

1. Letter from Alan Cave, County Planner, 24th June 1985; 2. West Midlands County Council, *Sculpture Commission, The Ackers, Small Heath*, Brief 9153G/AH/ICAP; 3. W. Pye, 'Peace Sculpture for The Ackers, Small Heath, Birmingham', press release provided by WMCC; 4. *Post*, 2nd August 1984; 5. *Mail*, 11th July 1985, p.14; W. Pye, 'Untitled: sculpture at the Ackers', *Art and Artists*, no.218, November 1984, p.4 [reproduction of original state]; 6. Letter from the artist, 19th February 1996.

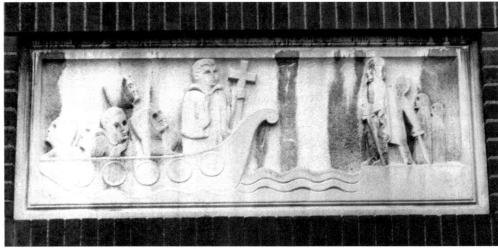

Bohn, *St. Augustine's arrival in England*

St. Augustine's church, over the west door

St. Augustine's arrival in England

Peter Bohn

1958
Portland stone
80cm high × 220cm wide
Status: not listed
Condition: good
Owned by: St. Augustine's church

This low relief panel depicting St. Augustine, with his attributes of a Bible and a cross, shows him in his role as missionary bishop when he was sent with a band of monks to preach the gospel to the heathen English c.605.[1] The carving is simplified and has an emphasis on flat modelling and linear shapes. The panel was included in the original church plans of 1938 by the architect G.B. Cox,[2] but was not executed until twenty years later.[3]

1. D. Attwater, *Penguin book of saints*, Harmondsworth, 1965, p.56; 2. *BRBP*, 14th March 1938, no.1833, sheet no.2; 3. Information provided by the artist, 6th April 1985.

The Gun Barrel Proof House

Group of Trophies

William Hollins

1813
Stone, polychrome
340cm wide
Inscribed: CAVENDO TUTUS
Status: II
Condition: good
Owned by: Gun Barrel Proof House

This unique and splendid sculpture, fully in the round and set in a niche, is a bold central feature of a contrastingly red brick building that was probably designed by William Hollins,[1] or the architect John Horton.[2] By the beginning of the 19th century, so extensive and important had the gun trade become in Birmingham that, in place of the usual practice of sending guns and components to London to be tested, an Act of Parliament in 1813 established for the Birmingham gun makers a governing authority of their own. The foundation stone of this, the only official Proof House outside London, built conveniently near to the Fazeley canal, was laid on 4th October. The trophies are displayed in a dramatic, fan-shaped arrangement. They consist of the Lictor's fasces (ceremonial rods) in the centre, surmounted by a Roman helmet and armour plate, which all look back to the ancient origins of trophies hung up as

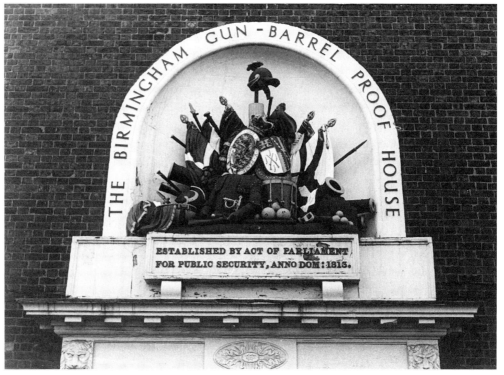

W. Hollins, *Group of Trophies*

monuments. Alongside the Hanoverian *Coat of Arms* and the Birmingham shield incorporating the cross swords proof mark of the Birmingham gunmakers are contemporary weapons such as a flintlock musket, pistols, gun-barrels and cannon balls, representing locally-made products. The flags and drums exemplify the military pride of this period of victory in the Napoleonic wars. The Latin inscription translates as 'Public Safety'.

1. F.W. Greenacre, *William Hollins and the Gun Barrel Proof House 1813*, Victorian Society, West Midlands Group, Birmingham, 25th May 1968; 2. Department of the Environment, *List of buildings of special architectural or historic interest*, London, 1982.

Bell Barn Road, Lee Bank, open ground

Gate Construction

Robert Carruthers

1972
Timber, galvanised chain and sailcloth
1200cm high × 1200cm wide
Status: not listed
Condition: poor. Cloth components and
wooden struts missing
Owned by: City of Birmingham

This sculpture was commissioned in 1972 by
the Peter Stuyvesant Foundation for the City
Sculpture project organised in collaboration
with the Arts Council of Great Britain.[1] The
project arranged for modern sculptures to be
erected for six months in eight provincial
cities and each artist received a grant of
£1,000 towards the cost. Carruthers' sculp-
ture originally comprised three parts which
were erected in the Colmore Circus precinct
in Autumn 1972, remaining there until
January 1973.[2] The City turned down the
option to purchase the sculpture which
became known locally as 'The Telegraph
Poles' and the centre piece was subsequently
given to Birmingham by the artist;[3] it was
resited to its present location by the Leisure
Services Committee.[4]

The sculpture displays an oriental influ-
ence, being loosely based on the design of a
Japanese Shinto gate. It originally had a
yellow cloth canopy and a brown hanging
sail between the two tall posts, similar to a
Japanese *noren*, or room divider. Two lower
wooden constructions flanked this piece and
together they created repeating geometric
shapes which related to the enclosed precinct
area. Cheap materials were used for their

Carruthers, *Gate Construction*

convenience, non-durable appearance, and to
'encourage the public to refer to them in all
changes of weather'. The sail, for example,
was made of heavy material for rough
weather and was coloured for grey days. It
was the artist's intention for it to be changed
in the summer to a lighter sail which was
more sensitive to wind and light. The sculp-
ture now stands out of its intended inner city
context and the sailcloth and all of the
canopy cloth are missing. Birmingham's
other work commissioned for this project
was Alexander Monro's controversial fibre-
glass *King Kong*, first sited in Manzoni
Gardens (q.v.).

1. *City Sculpture*, Arts Council of Great Britain,
London, 1972; 2. *Studio International*, vol.184,
July/August 1972, p.17; 3. G. Linscott, 'Art among
the telegraph poles', *Post*, 4th August 1972; 'Sculpture
offered as a gift to the city', *Mail*, 6th October 1972;
4. 'Moving work', *Mail*, 4th January 1973.

*National Westminster Bank, 8 Bennett's Hill,
over the entrance on a parapet*

Birmingham Coat of Arms and Supporters

Samuel Lynn

1869
Stone
260cm high
Inscribed: S.F. Lynn
Status: II*
Condition: fair. Surface damage due to
weathering
Owned by: National Westminster Bank Plc

When the original building by C.R.
Cockerell of 1833 was rebuilt in 1869 by
John Gibson,[1] the National Provincial Bank
(now the National Westminster Bank)
commissioned S. F. Lynn to produce the
monumental free-standing *Coat of Arms*,
together with the four finely carved reliefs in
the porch representing the industry and
crafts associated with the city. High on the
roof, above the main entrance, the shield of
the *Coat of Arms* flanked by supporters
personifying Art and Industry is a character-
istic expression of civic pride in
Birmingham's industrial and commercial
achievement. Banks not only had an all-
important financial overview and contribu-
tion to this development, but indirectly, they
also had an ideological role, spreading and
implanting the notion of permanent and
powerful economic progress.

In the midst of the series of 19th-century
banking crises which caused the demise of so
many country banks, architecture and sculp-
ture were often used to convey an image of

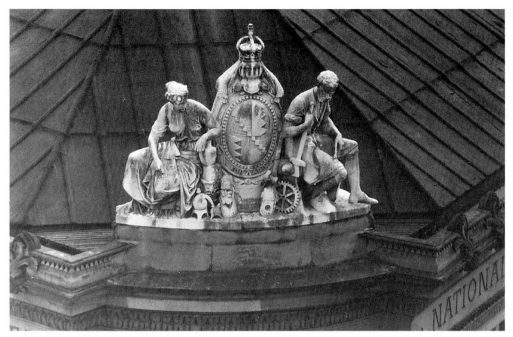

security by municipal and imperial authority. The fact that the *Coat of Arms* over the Bank was made twenty years before either the shield or the supporters were authorised, shows the Bank's concern to associate itself equally with the nation and the city. Although the shield of the *Coat of Arms* was only adopted by the Corporation in 1867, to replace others which had been used at random ever since Birmingham was incorporated as a Borough in 1838, the honour of the supporters was only officially granted in 1889 when the title of City was conferred on Birmingham. Yet this early unofficial design quite closely resembles the later official version. Art, on the left in classical robes, leans her arm on a pitcher of classical shape and proportion, with a bust of a bearded man at her feet. Industry, on the other hand, in contemporary working clothes with sleeves rolled up, leans a hammer on an anvil and holds a pair of dividers in his lap. However, in some significant details they depart from the fundamental tenets of traditional heraldry. By reversing the usually standing left-hand position of the male and the right-hand position of the female figure, by representing them seated with their heads looking down to the street and by placing a helmet with a flowing tasselled veil and a regal cross over the shield of the *Coat of Arms*, Lynn adapted his sculpture to its iconographical, functional, architectural and environmental context. Her attributes, the classical dress, antique pitcher and the sculpted bust, but without her customary brushes and palette, seems to suggest the contemporary Arts and Crafts idea that the origin of Art is in ancient craftsmanship.

Such a shift in emphasis towards crafts in this personification of Art through the city's emblem, together with the modern workman appearance of Industry, must have been relevant to the Bank's clientele in Birmingham. By representing Art and Industry seated, Lynn not only changed their emblematic role as standing supporters, but also transformed them into a three-dimensional monumental free-standing sculptural group. In contrast to the figures, the imposing splendour of the *Coat of Arms* with the unorthodox use of a helmet with a flowing, tasselled veil and a regal crown, shows the extent to which the new industrial middle-class society continued to use the decorative vocabulary of the fundamentally aristocratic Baroque. The position of the crown over the shield was to signify the power of the nation upheld by Birmingham's industrial and manufacturing success which grew rapidly in the 19th century.

1. Photographs and notes held at the National Westminster Bank, Bennett's Hill showing the original building of 1833 and the re-design in 1869.

National Westminster Bank, 8 Bennett's Hill, corner entrance

Industry and Manufacturers in Birmingham

Samuel Lynn

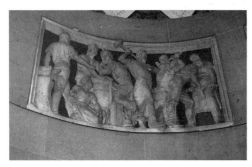

Lynn, Industry and Manufacturers (detail)

1869
Stone
Four reliefs, each: 70cm high × 155cm wide
Inscribed: S.F. LYNN
Status: II*
Condition: good
Owned by: National Westminster Bank Plc

The four reliefs decorating the apse-shaped corner entrance illustrate industries associated with Birmingham: metal working, metal

Lynn, Industry and Manufacturers (detail)

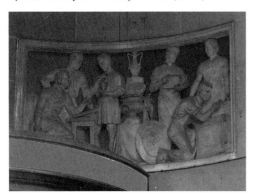

plating, glass blowing and gun making. They clearly show the connection drawn by the Bank (which was originally the National Provincial Bank) between its own prosperity and that of Birmingham. Executed when the bank was rebuilt in 1869 in an opulent classical style, the figures are realistically detailed, carved almost in the round. The plain backgrounds compress the scenes to form classically inspired friezes and thereby emphasise their symbolical purpose, signifying Birmingham's industrial and manufacturing success.

Sun Alliance Insurance office, 10 Bennett's Hill, above ground floor windows on front façade

Sun Emblem and Lettering

Sculptor: William Bloye

Designed by: S.N. Cooke

c. 1927–8
Stone and gilt
Sun: 100cm diameter
Lettering on left-hand panel: SUN /

Bloye, Sun Emblem and Lettering

Lettering on right-hand panel: FOUNDED / 1710
Status: not listed
Condition: good

The building was designed in May 1927 by the architect S.N. Cooke, whose drawings show the sun and the lettering on either side of it.[1] The design of the sun, notably its facial features and sinuously modelled rays, was largely dictated by the existing emblem which the Insurance company had displayed on a hanging sign over the entrance to the previous office on this site. Although Bloye's carving closely follows the original graphic image, the boldly outlined details are filled out and subtly modelled, like the lettering which is carved with a restrained serpentine line that betrays Bloye's hand.

1. *BRBP*, 1927, no.44512.

18–19 Bennett's Hill (corner of New Street), formerly London and Lancashire Fire Insurance Company, on roof

Allegorical Figures

Sculptor: Robert Bridgeman & Sons

Designed by: Riley & Smith (architects)

1907
White Hollington stone
Each 120cm high × 60cm wide
Status: not listed
Condition: fair. Surface discolouration and erosion

These two female allegorical figures are posi-

Left Bridgeman & Sons, *Security*
Above Bridgeman & Sons, *Providence*

tioned on top of what was formerly the London and Lancashire Fire Insurance Company building (now housing a variety of offices) overlooking Bennett's Hill. One figure is seated and holds a shield with three lion emblems on it, which possibly represents the House of Lancaster. She also holds a sword, representing Security, and this is reflected in her resolute and determined expression and stance which is in marked contrast to the other, more conventionally feminine figure who kneels and makes a

generous and open gesture. With a pile of fruit as her attribute, this figure represents Providence, and the figures, being contemporary with the building, allude to the two qualities that the insurance company would wish to convey to its clients. Bridgeman carried out all the stone carving on this building.[1]

1. *The Builder's Journal and Architectural Engineer*, 2nd October 1907, pp.166–7.

Birmingham International Airport, on main roundabout at approach road

Take Off

Walenty Pytel

1985
Steel
140cm high, with pedestal, approx 1000cm high.
Status: not listed
Condition: good
Owned by: Birmingham International Airport

Just outside the city boundary, this piece is included in this catalogue because of its high profile at the expanding international gateway of Birmingham Airport. The sculpture is located on a traffic island on the main approach road to the airport terminals, representing the phenomenon of flight, and it was designed to commemorate 40 years of peace in Europe.[1] Pytel depicts three egrets frozen in the act of taking off, mounted on a tall, slender pedestal, all of rough and unpolished steel.[2] The physical mass and industrial materials of the piece are belied by the illusion of weightlessness and the elegance of birds in flight.

1. M. Ellis, 'Sculpture may become airport showpiece', *Post*, 20th June 1984; 2. Letter from the artist, February 1996.

Pytel, *Take Off*

Polish Catholic Centre, Katyn House

Mother and Child

Tadeuz Zielinski

1966
Ciment fondu, bronzed
365cm high
Status: not listed
Condition: good
Owned by: Polish Catholic centre

This sculpture was commissioned to decorate the main entrance of Katyn House, also known as Millennium House, which was opened in 1962 to commemorate one thousand years of Christianity in Poland.[1] The building cost £28,000, which was raised by voluntary contributions among Polish immigrants in Birmingham.[2] The greatly elongated and stylised figure is reminiscent of the work of Epstein and is mounted against the plain brick wall of the centre, facing the road below. The artist also executed ten relief panels of Coats of Arms of the principal cities in Poland, which are located inside the building.

1. *Mail*, 8th August 1962; 2. Birmingham Information Bureau, May 1977, p.25.

Zielinski, *Mother and Child*

The firm of Cadbury has had a pivotal role in the development of the Bournville area of Birmingham since Richard and George Cadbury moved their chocolate manufacturing business to what was a rural site in Warwickshire in 1879. W. Alexander Harvey developed the model village which surrounded the factory from 1895, with the aim of providing adequate, hygienic accommodation in a pleasing environment. Nowadays the bulk of the factory overlooks a large playing field, with the village centred on the nearby green, which the junior school, Friends' Meeting House, Rest House and former Day Continuation Schools (now University of Central England) all face on to. See also entries under Linden Road.

Cadbury factory grounds, in front of the dining hall terrace

Terpsichore

William Bloye

1933
Bronze
Sculpture: 185cm high; pedestal bowl: 200cm high
Inscribed: FROM THE EMPLOYEES TO THE FIRM OF CADBURY IN COMMEMORATION OF THEIR CENTENARY 1831–1931 / ONE HUNDRED TIMES THE SWALLOWS TO THE EAVES
Status: not listed
Condition: fair. Brown staining at base of sculpture. Graffiti and dirt on pedestal
Owned by: Cadbury Schweppes

In 1931, Bloye, the 'well-known Birmingham sculptor' was commissioned to produce a

Bloye, *Terpsichore*

fountain for the centenary of the Cadbury factory as a gift from the employees to the firm.[1] To this end, he designed a bronze figure of the goddess Terpsichore, the Muse of Choral Dance and Song, represented as a young woman singing and holding a lyre and a coronal of palms. She stands in a large stone bowl decorated with gargoyle spouts, and this is placed in the centre of a ground-level stone basin. This is the first of Bloye's fountains with female figures, begun in 1932, and is an interpretation of the spirit of youth,

showing that, as Bloye wrote, 'the loveliness of seventeen is centuries old'.[2] W.A. Cadbury, a director of the firm, considered that youth had 'played a very big part in the creation and progress of this business of ours'.[3] The inscription carved around the rim of the pool includes an indirect quotation from a passage in Theodore Dreiser's novel *Jennie Gerhardt* (published 1911).

1. Bloye, *Ledger*, 30th June 1933, p.5, invoice no.26; 2. J.A. Williams, *The firm of Cadbury 1831–1931*, London, 1931; 3. *Bournville Works Magazine*, vol.XXXI, no.8, August 1933, pp.232–8.

Brindleyplace has been developed since the successful opening of the International Convention Centre on its eastern border, and combines restaurants, shops and offices with quality housing.

Brindleyplace Plaza, off Broad Street, next to 5 Brindleyplace

Aquaduct (sic)

Miles Davies

1995
Bronze, phosphor
610cm high × 30cm wide × 1150cm long
Status: not listed
Condition: good
Owned by: Brindleyplace Plc

This piece was the result of a design competition held by Brindleyplace Plc in conjunction with the Royal Society of British Sculptors.[1] Davies won with designs for three sculptures to be erected on the site. *Aquaduct (sic)* was the first to be unveiled, in August 1995, to the north of the fountains and overlooking the canal. This piece derives directly from the form of an aqueduct, and as such closely relates to the network of canals upon which the Brindleyplace development is centred. It is a hollow construction in two sections as if broken in the middle, one with two arches, one with three, and at each end the beginnings of a further arch is suggested, thus implying a continuation of the piece beyond the plaza. It stands on a low stepped base

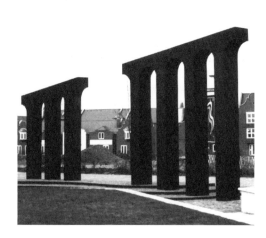

Davies, *Aquaduct*

filled with gravel. Its stark black forms dominate the canal side of the plaza, drawing the eye across the fountains from the main shopping area, and at night it is dramatically illuminated from below by recessed lighting. The surface patination will gradually change in response to weathering over time.[2] Both works were manufactured by Burleighfield Arts, and supported by ABSA (Association for Business Sponsorship of the Arts).

1. Brindleyplace press release, 10th August 1995; 2. Letter from the artist, 12th February 1996.

Gates

Miles Davies

1995
Bronze, phosphor
Two gates, each: 400cm high × 30cm wide × 380cm long
Status: not listed
Condition: good
Owned by: Brindleyplace Plc

The second work resulting from the competition, this two-part piece relates to Brindleyplace's canalside location by using the forms of traditional lock gates. Its minimalist forms flank the western entrance to the complex and are similar in construction to Davies' other piece, *Aquaduct*, being hollow in construction with its black patination designed to change over time.[1]

1. Letter from the artist, 12th February 1996.

Central Television Building, formerly the Masonic Temple, frieze running along top of façade

Building of King Solomon's Temple

Gilbert Bayes

1927
Portland stone frieze
Two parts, each 61cm high and 980cm long
Status: not listed
Condition: fair. Surface dirt and some weathering
Owned by: Central Television Ltd.
Exhibited: Royal Academy, 1928

In 1923 Rupert Savage won a competition, open only to architects who were Freemasons in Warwickshire, for the design of the new Masonic temple in Birmingham. His design, which originally did not make provision for sculpture, was not realised owing to a lack of subscription but in 1925 he produced more economical plans, in which a sculpted frieze was incorporated. Bayes, also a freemason, was given the commission and it was completed by the formal opening on 23rd September 1927.[1] The following year he exhibited a portion of it at the Royal Academy.[2] The two panels illustrate the building of King Solomon's Temple,[3] considered by Freemasons to be the origin of their practices. Bayes used a neo-Assyrian style in which the tightly grouped imagery, compressed in a flat space against a plain background, appears appropriate to the austere façade of the building. Other sculptural details originally included two large Ionic columns framing the entrance, above which was a seated figure with two globes

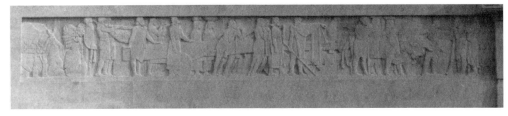

Above Bayes, *King Solomon's Temple* (left section) *Below* Bayes, *King Solomon's Temple* (right section)

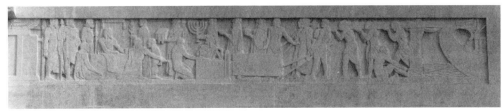

symbolising 'Masonry Universal'; a lintel bearing the inscription AUDI VIDE TACE (See, Hear and Be Silent), and a plaque in the centre of the parapet bearing the dates '1914–1918', indicating that the Temple also served as a War Memorial.[4] These were all removed when the Freemasons moved to a new building on the Hagley Road. The Masonic Temple became the Engineering and Building Centre in 1961 and now houses the offices of Central Television.

1. *New Masonic Temple for the Masonic province of Warwickshire*, Birmingham, 1926; 2. *Royal Academy exhibitors 1905–1970*, vol.I, Wakefield, 1973, p.103; 3. *Kings*, Chapter 1 verses 5–9; *Chronicles*, Chapter 1 verse 22; *Chronicles*, Chapter 2 verses 2–6; 4. 'The new Masonic Temple, Broad Street, Birmingham', *Architectural Review*, vol.62, 1927, pp.178–81.

Broad Street, in front of the Registry Office

Boulton, Watt and Murdock

William Bloye

1956
Bronze group statue, with a gold finish, on a stone pedestal
Statue: 290cm high × 300cm wide; Pedestal: 180cm high
Inscribed on front of pedestal: 1728 – MATTHEW BOULTON – 1809 / 1736 – JAMES WATT – 1819 / 1754 – WILLIAM MURDOCK – 1839
Inscribed on rear of pedestal: THIS MEMORIAL UNVEILED BY SIR PERCY MILLS, B.T., K.B.E., SEPTEMBER 14 1956 / COMMEMORATES THE IMMENSE CONTRIBUTION MADE BY BOULTON, WATT / AND MURDOCK TO THE INDUSTRY OF BIRMINGHAM AND THE WORLD / THE CONCEPTION OF RICHARD WHEATLEY, A LEATHER GOODS MANUFACTUR- / ER OF THIS CITY, COUPLED WITH HIS GENEROSITY AND A CONTRIBUTION / BY THE CITY COUNCIL, ENABLED THESE STATUES TO BE EXECUTED BY WILLIAM BLOYE / SCULPTOR.

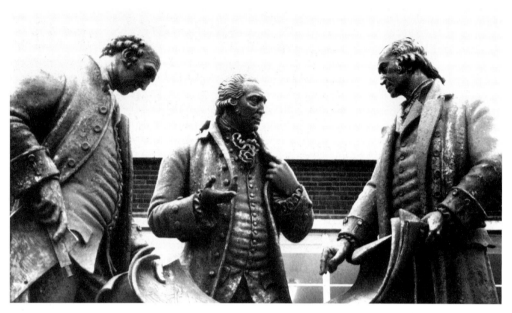

Status: not listed
Condition: fair. Surface discolouration on both sculpture and pedestal
Owned by: City of Birmingham

Three over life-size figures wearing 18th-century clothes stand together upon a large pediment of Portland stone, the details of which derive largely from Bloye's study of the dress of earlier statues of Watt (1736–1819) and Boulton (1728–1809) in Birmingham.[1] They are represented discussing drawings of mechanical devices held out by Boulton and Murdock (1754–1839), with Watt standing in the centre. They have often been described as 'Messrs Lee and Longland discussing a roll of wallpaper', after the furnishing shop just up the road.

Above Bloye, *Boulton, Watt and Murdock*
Right Bloye in his studio with figure of *Watt*

In 1939 Richard Wheatley bequeathed £8,000 to embellish the layout of Birmingham's intended Civic Centre on Broad Street. The City Council agreed to make up the amount, eventually £7,500, to erect a monument to 'The teamwork of these men which brought such great advances'.[2] Although Bloye was asked to submit preliminary designs in 1938 and again in 1943,[3] the project was shelved until 1950. Bloye then began to make the figures in earnest, beginning the final casts in 1953.[4] In 1956 the monument was unveiled in its present 'temporary' site. The intention was to place it

in front of a Planetarium to be built as part of the Civic Centre on the other side of Broad Street. However, the statue has remained where it was originally sited. Bloye was assisted in his carvings by Raymond Kings who worked with him between 1946 and 1960.

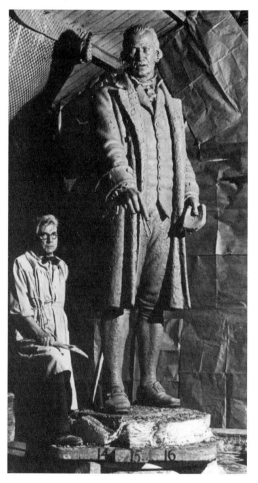

1. Flaxman's monument to Matthew Boulton, and Chantrey's monument to James Watt, both St. Mary's Church, Hamstead Road, Handsworth; 2. *Mail*, 24th March 1953, p.1; 3. *Annual Report of the Birmingham Advisory Art Committee*, 1936–43; 4. Letter from John Kings, 13th November 1985.

Broadgate House, façades facing onto Berkeley Street and Gas Street

Untitled

William Mitchell

1965
Sandblasted concrete
Each, approx: 250cm high × 100cm wide
Status: not listed
Condition: good
Owned by: not known

Mitchell was commissioned by the developers of Broadgate House, Laing Development Company Ltd. and City Properties Ltd. to produce nineteen relief panels for the first storey of this office and showroom complex.[1] The overall scheme was designed by 1964: an advertising brochure of that date shows an artist's sketch of the main elevation together with the panels.[2] Of similar dimensions, each relief follows the lines of the architecture and fills a space between the windows, extending the height of the overhanging first storey. The centre panel of Broad Street is twice as wide as the others, to match the main entrance directly below. Four panels face onto Berkeley Street, ten face the main frontage of Broad Street and five face onto Gas Street, the bold abstract designs providing a decorative contrast to the glass frontage of the ground floor and the stark office tower above.

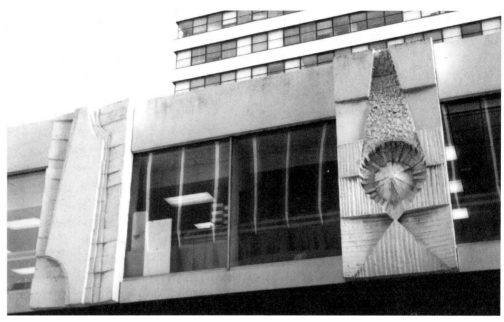

Mitchell, *Untitled* (detail)

Composed of varying geometrical shapes and textures, the panels were made from casts of sandblasted concrete aggregate. Mitchell's reliefs are reminiscent of the abstract relief constructions of Ben Nicholson and Victor Pasmore.

1. Information provided by Henry Joseph of Allied Artists, in conversation; 2. *Broadgate House, Broad Street*, Birmingham, 1964.

Auchinleck House, on exterior of office block above Five Ways Shopping Centre

Untitled

Trewin Copplestone

1960–2
Mosaic, glass and electric light
Each: 910cm high × 366cm wide
Status: not listed
Condition: good
Owned by: not known

Commissioned by the architects of the shopping centre, J. Seymour Harris and Partners, the designs were made by Copplestone and the sculptures erected under his supervision. Located on two panels at the tapering end of the office block they make a striking feature over the main entrance of the complex, their height emphasising the architectural form. Lines of coloured mosaic, punctuated by coloured glass boxes of differing height and shapes arranged geometrically, take colour

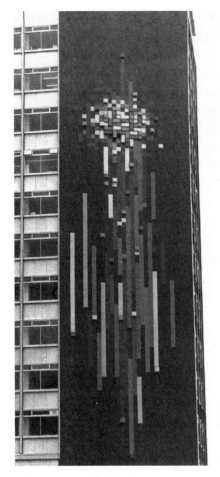

by electric lights in the glass boxes, the sculpture functions by day and night. Copplestone also designed the *Abstract with Sun* motif mosaic in the shopping centre plaza, above the shop fronts.[1] There is a large ciment fondu mural by John Bridgeman in the entrance hall to the office complex, commissioned by Allied Artists in 1964.

1. Letter from the artist, 12th August 1985.

Five Ways Shopping Centre, Broad Street, inner plaza

Field Marshal Sir Claude Auchinleck

Fiore de Henriques

1965
Bronze
235cm high
Signed on base: FIORE
Status: not listed
Condition: good
Owned by: not known

This standing figure of Sir Claude Auchinleck (1884–1981) in a relaxed pose was commissioned and paid for by the Murrayfield Real Estate Company Ltd., the developers of Five Ways Shopping Centre, and unveiled on 27th April 1965. The Field Marshal, a distinguished officer in World Wars I and II,[1] had been the Chairman of Murrayfield's since 1958.[2] It was the idea of the Managing Director,[3] who had served under Auchinleck in the desert war, to erect the statue and name the plaza after him. It is believed that Auchinleck sat for a bust, the rest being taken from photographs.[4] The

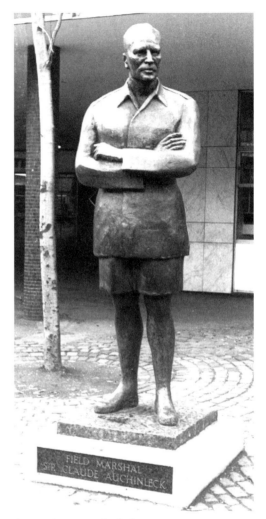

de Henriques, *Auchinleck*

facial features have been rendered naturalistically, while the broad surfaces of the body

Copplestone, *Untitled*

contrasts as their theme. The panel facing Broad Street is composed of mainly red, yellow and orange colours, while the opposite panel on Islington Row is of the 'cooler' colours such as blue and green. Transformed

are treated in an impressionistic manner. It is the only known statue of Auchinleck.

1. P. Warner, *Auchinleck, the lonely soldier*, London, 1981; 2. *International who's who*, London, 1981; 3. Letter from the Deputy Chairman of Murrayfield's, Sir Frank Price, 26th June 1985; 4. *Gazette,* 27th April 1965; *Evening Mail*, 27th April 1965.

Exterior of Martineau Square overlooking Bull Street

Untitled

Hans Schwarz

1966
Plastics and reinforced glass
Twelve panels, each: 250cm high × 500cm wide
Status: not listed
Condition: good
Owned by: not known

Each of these twelve panels shows an aspect of Birmingham, past, present and future, taken from old and new town maps and aerial photographs of the city. The commission came from J. Seymour Harris Partnership of Birmingham, architects of Martineau Square Shopping Centre, and the panels were manufactured by David Gillespie and Associates of Farnham, Surrey. They show: St. Philip's Cathedral; the Bull Ring; Gas Street Canal; New Street Station; the Motorway junction at Gravelly Hill; University of Birmingham, Edgbaston; Victorian back-to-back housing; the Old Jewellery Quarter; Bournville factories and gardens; contemporary housing development; car factories at Longbridge; and Corporation Street / Bull Street.

Schwarz, *Untitled*

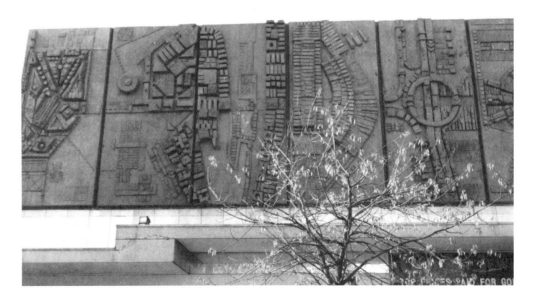

Burney Lane ALUM ROCK

Christ Church, over the main south entrance

The Good Shepherd and Latin Cross

William Bloye

*c.*1935
Stone
The Good Shepherd: 230cm high; Cross:
490cm high
Inscribed over the door: INTROITE ATRIA
ETUS IN HYMNIS
Status: not listed
Condition: fair. Some surface discolouration
Owned by: Christ Church

Designed by Hobbiss in November 1933,[1] this brick church is decorated by a figure of Christ, the Good Shepherd, carrying a lamb and staff and accompanied by two seraphim, set in the tympanum facing the main road. High above this is a large plain cross with a relief panel at its crossing depicting a lamb and cross. Both were made by Bloye for which he was paid £254.[2] Carved flat and stark, the figure of Christ emerges directly from the stone plinth on which it stands, the folds in the robe emphasising its rigid verticality which, in keeping with the rectilinear design of the church and in full relief against it, characterises the statue as an emblem of the church. The inscription translated means 'Enter this hall and sing praises' and is also by Bloye: his style shows in the confident placing of well-cut lettering within a constricted space.

1. *BRBP*, 1933, no.59065; 2. Bloye, *Ledger*, 31st July 1935, p.28, invoice no.60.

Bloye, *The Good Shepherd and Latin Cross*

Nowakowski, *Sleeping Iron Giant*

Cattell Road

Centenary Square

Junction of Cattell Road and Garrison Lane

Sleeping Iron Giant

Ondré Nowakowski

1992
Sintered iron and polyester resin, on a steel reinforced frame
140cm high × 244cm wide
Status: not listed
Condition: fair. Nose painted blue
Owned by: City of Birmingham

This sculpture was designed as one of a number of 'gateways' to the Birmingham Heartlands. A statement produced at the time of its unveiling says that it 'reflects a history of metal industrial activity, recently fallen into decline. As he sleeps [he is] a symbol of dreams and hopes for the future.'[1] It was unveiled by a group of local school-children in conjunction with a creative writing project about its meaning. The ten times life-size head lies on its side on a specially prepared mound and presents a 'rusted' look similar to that of the *Iron:Man* by Antony Gormley in Victoria Square (q.v.). Both pieces deal with the city's industrial heritage using the human form as a metaphor. It is situated at a busy junction in an indus-trial area of the city and seems unaware of the clamour all around. The sculpture has been defaced with blue paint on its nose by supporters of Birmingham City Football Club, whose ground is nearby.

1. Public Art Commissions Agency records; *Post*, 27th November 1991; *Post*, 17th January 1992; *Post*, 28th March 1992.

The building of the International Convention Centre and the redevelopment of the area to its east as Centenary Square, completed in 1991, provided an opportunity for the commissioning of many new sculptures, murals and other decorative pieces in a 'per cent for art' scheme, which used one per cent of the Centre's capital costs for this purpose. Working with the City Architects Design Team and Tom Lomax, Tess Jaray had overall responsibility for the design of Centenary Square, including the geometrical paving,

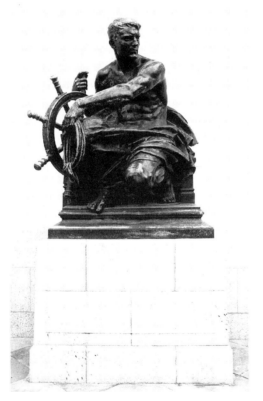

railings and street furniture, with the inten-tion of forming a fully unified decorative whole. Within this scheme are sited several works from the early 1990s, as well as the octagonal Hall of Memory which dates from the early 1920s, and the whole concept won the Civic Trust Award (Woodhouse Landscape award) in 1994, alongside the Victoria Square scheme.

Hall of Memory, exterior

Allegories of Army, Navy, Air Force and Women's Services

Albert Toft

Designed by: S.N. Cooke and W.N. Twist

1923–4
Bronze
Each: 214cm high × 143cm wide
Inscribed, on *Army*: ALBERT TOFT Sc / 1923
On *Navy*: Albert Toft Sc
On *Air Force*: ALBERT TOFT / Sc 1924
On *Women's Services*: ALBERT TOFT Sc / 1923
Status: not listed
Condition: good
Owned by: City of Birmingham
Exhibited: Royal Academy, 1925

These allegorical statues of the services were designed an integral part of the Hall of Memory, erected to commemorate the deaths of 12,320 citizens in the Great War.[1]

In a competition of 1920, designs for the memorial were invited from Birmingham architects and in November 1921 the winners, S.N. Cooke and W.N. Twist of

Toft, *Navy*

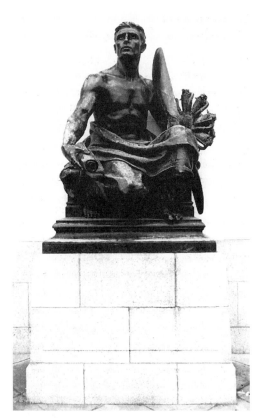

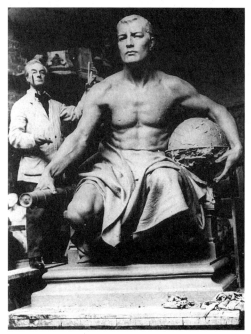

Left Toft, *Air Force*
Above Toft in his studio, with figure of *Army* in progress

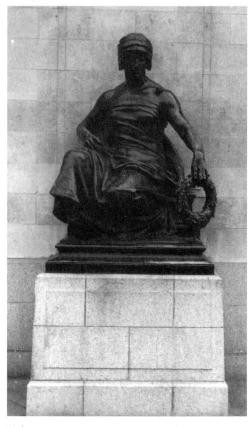

Toft, *Women's Services*

Paradise Street, were announced.[2] In 1922 their building plans were passed and these clearly show provision for the four statues, although no indication of their nature is given.[3] The harmony and poise of Toft's monumental and idealised figures, semi-nude and classically draped, complement the classical proportions of the octagonally shaped Hall. In 1926 a critic wrote 'it can truthfully be said that the sculpture is in harmony with the spirit of the architecture. Neither is

violent, extravagant or small in its parts.'[4] The statues stand on pedestals of Cornish granite which also forms the base of the building.

The completed Hall of Memory, costing £60,000 paid wholly by public subscription, was officially opened on 4th July 1925 by HRH Prince Arthur of Connaught. Models of two of the statues were shown at the RA in the same year.[5]

1. City of Birmingham, *Public Works and Town*

Planning Department report, 1st January 1915 – 31st March 1935, p.141; 2. J.T. Jones, *History of the Corporation of Birmingham*, vol.V, pt.1, Birmingham, 1940, pp.41–6; 3. *BRBP*, 1922, no.34132; 4. L.B. Budden, 'The Birmingham Hall of Memory', *Architectural Review*, vol.59, February 1926, pp.50–5; 5. *Royal Academy exhibitors 1905–1970*, vol.VI, Wakefield, 1982, p.151.

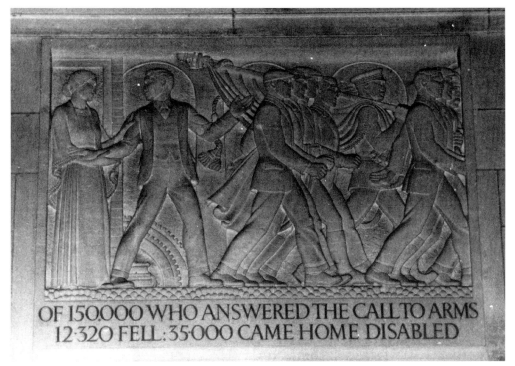

OF 150000 WHO ANSWERED THE CALL TO ARMS
12·320 FELL: 35000 CAME HOME DISABLED

Hall of Memory, interior

Call, Front Line and Return

William Bloye

1925
Portland stone
Each: 155cm high × 223cm wide
Call inscribed: OF 150000 WHO ANSWERED
THE CALL TO ARMS / 12320 FELL: 35000
CAME HOME DISABLED
Front Line inscribed: AT THE GOING DOWN
OF THE SUN AND IN / THE MORNING WE
WILL REMEMBER THEM
Return inscribed: SEE TO IT THAT THEY
SHALL NOT HAVE / SUFFERED AND DIED IN
VAIN
Status: not listed

Condition: good
Owned by: City of Birmingham

No interior reliefs were provided for on
Cooke and Twist's original drawings,[1]
though the reliefs were in place at the Hall's
opening in 1925.[2] The panels decorate the
interior space above each of the three door-
ways. These are the first of several architec-
tural panels by Bloye and they show his
stylised linear manner emerging, emphasising
the tightly compressed pictorial spaces and
creating patterns in the repetition of shapes.
The first panel, *Call*, shows young men in
civilian clothes marching to war, whilst at the
left a man takes leave of his wife. *Front Line*,
the second panel, shows the battle front with

Left Bloye, *Call*
Below Bloye, *Front Line*

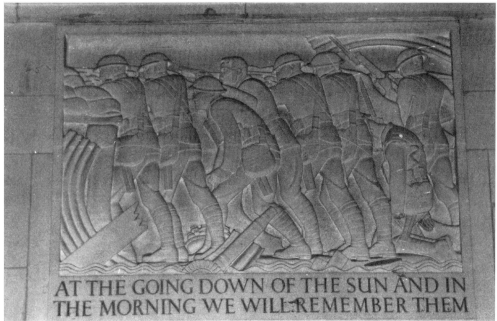

AT THE GOING DOWN OF THE SUN AND IN
THE MORNING WE WILL REMEMBER THEM

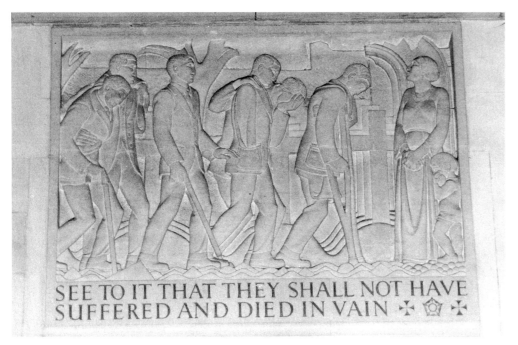

SEE TO IT THAT THEY SHALL NOT HAVE SUFFERED AND DIED IN VAIN ✠ ⬠ ✠

Bloye, *Return*

soldiers compressed together, whilst wounded colleagues slump out of line. The three scenes' compositions change from a compact, futuristic march to the slow halting step of the third panel, *Return*, which shows the aftermath of war, with wounded soldiers returning home.

1. *BRBP*, 1922, no.34132; 2. Hickman, 1970, p.59.

Birmingham Repertory Theatre, Centenary Square, foyer

Sir Barry Jackson

William Bloye

1957
Bronze bust
42cm high
Signed: W. Bloye 1957
Accompanying plaque, not by Bloye, is inscribed: He poured his fortune and his talent into the theatre with no thought of gain, taking nothing from it except some quiet satisfaction in the knowledge that the Drama in every aspect had been faithfully served.
Status: not listed
Condition: good
Owned by: Birmingham Repertory Theatre
Exhibited: Royal Academy, 1957

Sir Barry Jackson (1879–1961) founded the Birmingham Repertory Theatre on Station Street in 1913. He had a distinguished career in the Theatre, becoming the Governor of the Old Vic, Sadler's Wells and Stratford Festival Theatre (director 1946–8), as well as taking over the Court Theatre, London, in 1924 and Kingsway Theatre, London, in 1925.[1] Bloye may have already been acquainted with Jackson as they were both members of the Civic Society. Bloye exhibited the bust at the RA in 1957[2] and presented it to the theatre in October.[3] Modelled directly from life, the head is very freely executed, capturing in the deeply lined face the age of the sitter, then 78 years old. There is a second bust of Jackson by Daphne Dare, also made in 1957, in the Central Reference Library.

1. *Birmingham Post year book and who's who 1961–62*, Birmingham, 1962; 2. *Royal Academy exhibitors 1905–1970*, Wakefield, 1973; 3 . Bloye, *Ledger*, 24th October 1958, p.164.

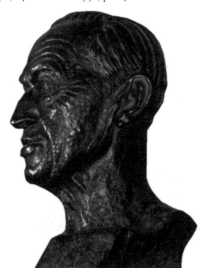

Bloye, *Sir Barry Jackson*

Centenary Square, on the north side of the Hall of Memory

Industry and Genius: Monument to John Baskerville

David Patten

1990
Portland stone and bronze
150cm high × 100cm wide × 650cm long
Inscribed on end block: INDUSTRY / AND / GENIUS
Status: not listed

Patten, *Industry and Genius*

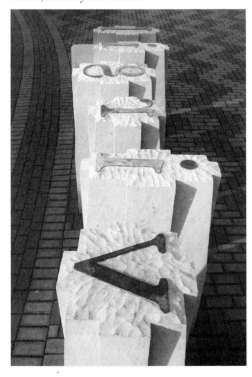

Condition: good
Owned by: City of Birmingham

Centrally placed to reflect the portico of Baskerville House, Patten's eight free-standing blocks are dedicated to the 18th-century Birmingham printer and typographer John Baskerville (1706–75).[1] Sculpted from Portland stone, reversed bronze letters are embossed on each, forming type-punches that make the word 'Virgil', the later name of one of his typefaces, so named because it was first used for a translation of Virgil's poetry. The title *Industry and Genius* derives from a poem in the *Birmingham Gazette* of 21st January 1751 dedicated to Baskerville. Patten was assisted by Michael House when making this piece.[2]

1. B. Tilson, 'Art for the People', *RIBA Journal*, vol.98, November 1991, pp.40–4; 2. Birmingham Museums and Art Gallery, *Public art in Birmingham, information sheet*, no.10, Birmingham, 1994; Public Art Commissions Agency, *Art at the International Convention Centre*, Birmingham 1995.

Centenary Square

Spirit of Enterprise

Tom Lomax

1991
Bronze fountain
Overall: 400cm diameter × 300cm high; each dish: 300cm diameter
Status: not listed
Condition: good
Owned by: City of Birmingham

This fountain acts as an allegory of modern multicultural Birmingham in its representation of different heads cast from bronze, to match the material of Toft's figures on the nearby Hall of Memory.[1] The sculptor also uses non-traditional materials such as wire in conjunction with traditional exploitation of the light and reflective qualities of water. The first head signifies Industry (looking towards the Hall of Memory) through the vice and coin and is based on a classical portrait, with water spouting like the language necessary to keep technology advancing. The second head of Enterprise (looking north) leaps from its bowl in hope and rides on a wave of water thrown up behind it. The head of Commerce (looking towards the International Convention Centre), with an open book behind, identified by the artist as a Ledger, has hands made of wire gesturing in an act of giving, whilst water anoints the head with prosperity. Each head is ringed by a dish whose circular form, like the ever-flowing water, is symbolic of eternity.[2]

This work was commissioned as part of the overall Centenary Square scheme, which Lomax worked on in collaboration with Tess Jaray.[3] The Museum and Art Gallery have the maquette for the fountain in store at Chamberlain Square.

1. *Express and Star*, 1st March 1991; *Mail*, 28th February 1991; *Post*, 29th August 1991; B. Tilson, 'Art for the People', *RIBA Journal*, vol.98, November 1991, pp.40–4; 2. Public Art Commissions Agency records; 3. Letter and CV from the artist, 21st January 1996.

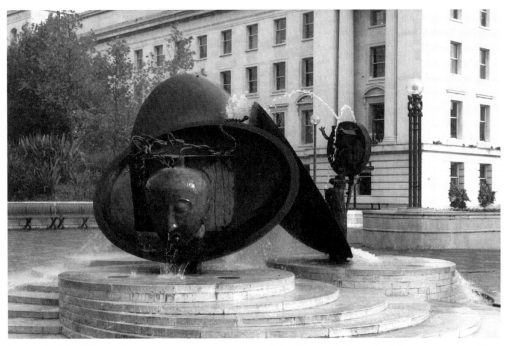

Lomax, *Spirit of Enterprise*

Centenary Square, facing the International Convention Centre

Forward

Raymond Mason

1991
Polyester resin
400cm high × 350cm wide × 850cm long
Status: not listed
Condition: fair. Cracks in base; surface discolouration
Owned by: City of Birmingham

Made from fibreglass, painted in cream and pink, *Forward*'s bold bulk has a cartoon-like appearance which is antithetical to the 'traditional' sombre colours of monumental sculpture. The group is well sited against the relatively low buildings around it, and takes as its subject matter the advancement of Birmingham people across the ages. The most striking figure at the front of the group holds up his hand which, according to the artist, signifies industry, whilst his other hand folded on his chest signifies Birmingham as the 'Heart of England'.[1] Behind him on his left, a woman personifying the Arts from the City's coats of arms, throws a kiss to the past, and on his right, another drops a curtsey to the Repertory Theatre. Behind them, figures diminish in a dramatically exaggerated perspective and 'disappear in the mists of smoke and of time', each supposedly based on real historical figures, such as Joseph Chamberlain (with a monocle) and Josiah Mason, clutching a pile of books. The formula incised at the front of the sculpture relates to the genetic formula of DNA and represents continuous advances of scientific discovery.

This sculpture was greeted with a lot of critical and public indignation on its installation (only surpassed when Gormley's *Iron:Man* was unveiled), being variously described as being made of margarine, marzipan or marshmallow.[2] One of the figure's heads was sawn off (since replaced) and children use it as a sort of climbing adventure area. However, despite its bad press, and continued attacks on it by established art world figures, *Forward* has now become an icon of the renewal of Birmingham's inner spaces and serves as an important link between the International Convention Centre and the spaces beyond.[3] There are sketches and correspondence relating to *Forward* in Birmingham Museums and Art Gallery archives.[4]

1. Birmingham Museums and Art Gallery, *Public art in Birmingham information sheet 9*, Birmingham, 1994; 2. P. Weideger, 'Larger-than-life tribute to Brum's golden age', *The Independent*, 5th June 1991; J. Rees, *Mail*, 6th June 1991; 3. Letter from Raymond Mason to Editor, 'Sculpture subjected to simplistic criticism', *Post*, 8th June 1991; T. Grimley, 'Sculptor answers his critics', *Post*, 12th June 1991, p. 13; J. Hamilton, 'The culture virus', *Spectator*, 10th August 1991, p.34; 4. Birmingham Museums and Gallery records; M. Wykes-Joyce, 'Birmingham Museum and Art Gallery, exhibition', *Arts Review*, vol.41, 2nd June 1989, p.453.

International Convention Centre, Centenary Square

The International Convention Centre (ICC) was designed by Renton Howard Wood Levine with the Percy Thomas Partnership and was opened by HM the Queen in June 1991. It contains Symphony Hall, home of the City of Birmingham Symphony Orchestra under Sir Simon Rattle, as well as a number of conference suites and exhibition spaces. The mall connecting Centenary Square with Brindleyplace is open to the public throughout the day and contains a number of works bought either as part of the 'per cent for art' scheme or by private dona-tion, and a full-colour guide is usually available from the information desk. Besides the sculptures listed below, other art works inside the ICC include: a mural exploring architectural themes by Deanna Petherbridge on the external drum wall of Symphony Hall; the *Diamond Jubilee Tapestry*, donated by the Townswomen's Guilds, depicting the 'emergence of women in the 20th century' and a painting on the theme of music by Norman Perryman called *The Mahler Experience.*

Mason, *Forward*

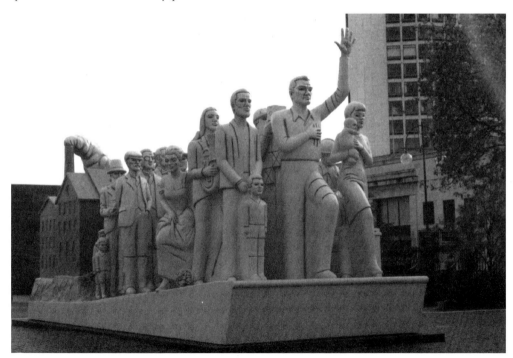

Within canopy over entrance to International Convention Centre

Birdlife

Ron Haselden

1991
Neon light tubes
800cm square overall
Status: not listed
Condition: good
Owned by: City of Birmingham

Although an imposing building, the International Convention Centre required a 'feature' to draw attention to its entrance to the west of Centenary Square, and also to make the Centre visible at night. Haselden's neon sculpture within the canopy over the entrance fulfils this function by creating a shifting display of colour and form which is visible from across the square. The sculpture uses computer sequencers to light up different neon tubes in various colours to make constantly shifting multi-coloured patterns on themes of birdlife and travel, which reflect the joy and freedom which are traditionally associated with music.[1] This work is best viewed at night, when the yellow and blue bird forms flitting around the central red tree motif provide a striking kinetic display. The Public Art Commissions Agency, which was responsible for the commissioning of the piece as part of the Square's 'per cent for art' scheme, has a working model of the lighting sequences at its offices in the Jewellery Quarter.[2]

1. Public Art Commissions Agency, *Art at the International Convention Centre*, Birmingham 1995; 2. Public Art Commissions Agency records.

International Convention Centre, in the entrance foyer

Construction

Vincent Woropay

1990
Bronze, coated in chrome
180cm high × 50cm square
Inscribed round base: CONSTRUCTION
Status: not listed
Condition: good
Owned by: City of Birmingham

This piece was sponsored by the contractors for the Centre's construction, Robert Douglas Holdings, as their part in the 'per cent for art' scheme that accompanied the re-development of the area and building of the ICC. The three tiers of this 180cm-high work are symbolic expressions of the advance in building techniques.[1] At the top is the 'paradigm for all architecture', the primitive hut, and below are nine Doric columns on the central tier signifying the Greek achievement which dominated European architecture through many classical revivals. Four modern building-props support the work. With its human scale, this work is suggestive of architecture as man.

1. Public Art Commissions Agency, *Art at the International Convention Centre*, Birmingham 1995.

Woropay, *Construction*

International Convention Centre, high on an internal wall in central atrium

Convention

Richard Perry

1992
Lime wood
200cm high × 300cm wide
Status: not listed
Condition: good
Owned by: City of Birmingham

Perry, *Convention*

Commissioned by Pinsent & Co., solicitors, and presented to Birmingham City Council, this is an abstract design based on woodland forms. Young plant shoots are mixed with winged seeds and buds. Carved from ancient lime wood (which contrasts with the modern materials of the Centre) its vertical elements evoke a gathering of people, whilst its pale colouring is restful to the eye amongst the chrome and blue colourings of the building.

International Convention Centre, courtyard outside at rear, at the side of the canal

Battle of the Gods and the Giants

Roderick Tye

1990
Bronze
210cm high × 310cm wide × 430cm long
Status: not listed
Condition: good
Owned by: City of Birmingham

The *Battle of the Gods and the Giants* is a large two-piece bronze sculpture, patinated green on the outside with a more steely grey colour on the insides, although at one time the whole piece was to have been patinated white. It was sponsored by Ingersoll Publications, and the Birmingham Post and Mail newspapers.[1] The sculptor intended the piece to be a figurative interpretation of an abstract subject, a cloud,[2] and as an artistic statement, it contrasts with the populist and political stance of Mason's *Forward* at the opposite end of the Centre. Its swirling forms are foreshadowed in drawings which Tye made in Rome, where he was inspired both by Classical and Baroque sculpture, and by the culture and atmosphere of the city.

Tye claims a purely 'poetic association' between its form and title,[3] the title deriving directly from the ancient Greek epic poet Hesiod. In his *Theogony*,[4] Hesiod relates the 'War of the gods and giants' to the creation of order in the universe in which Zeus gained the mastery of the heavens and earth. In this mythological conflict, the Olympian gods defeat the earthbound race of giants who attempt to overthrow Zeus by building a staircase of mountains to the clouds where the gods are traditionally depicted as living. The broken cloud motif of the sculpture symbolises this struggle between mundane and divine, earth and heavens. Tye has also indicated the mythological parallel with the biblical 'Fall of the rebel angels'.[5]

1. Public Art Commissions Agency, *Art at the International Convention Centre*, Birmingham 1995; 2. Letter from the artist, 19th January 1996; 3. Public Art Commissions Agency records; 4. Hesiod, *Theogony*; 5. T. Grimley, *Post*, 3rd December 1992, p. 10; *Mail*, 5th December 1992.

Tye, *Battle of the Gods and the Giants*

Chamberlain Square

Chamberlain Square was named after Joseph Chamberlain upon the erection of the memorial fountain in 1880. In addition to the works currently there, it has contained *John Skirrow Wright* by Francis Williamson as well as his version of *George Dawson* (see the section of this catalogue on Lost Works); and the *Royal Warwickshire Regiment Memorial*, now in the information foyer of the Birmingham Reference Library.

Chamberlain Memorial Fountain

John Chamberlain

1880
Portland stone, with gilded mosaic, glass and copper details
1950cm high
Inscribed on red granite plaque at rear of monument: THIS MEMORIAL / IS ERECTED IN GRATITUDE / FOR THE PUBLIC SERVICE / GIVEN TO THIS TOWN BY / JOSEPH CHAMBERLAIN, / WHO WAS ELECTED / TOWN COUNCILLOR IN NOVEMBER 1869, / MAYOR IN 1873 / AND RESIGNED THAT OFFICE IN JUNE 1876, / ON BEING RETURNED AS ONE OF THE REPRESENTA-TIVES OF THE BOROUGH OF / BIRM-INGHAM IN PARLIAMENT, / AND DURING WHOSE MAYORALTY / MANY GREAT WORKS / WERE NOTABLY ADVANCED, / AND MAINLY BY WHOSE ABILITY & DEVOTION THE GAS & WATER UNDERTAKINGS / WERE ACQUIRED FOR THE TOWN, / TO THE GREAT AND LASTING BENEFIT / OF THE INHABITANTS.
Inscribed in gilt on pool walls: THIS MEMO-RIAL WAS RESTORED AND NEW POOLS WERE CONSTRUCTED TO COMMEMORATE

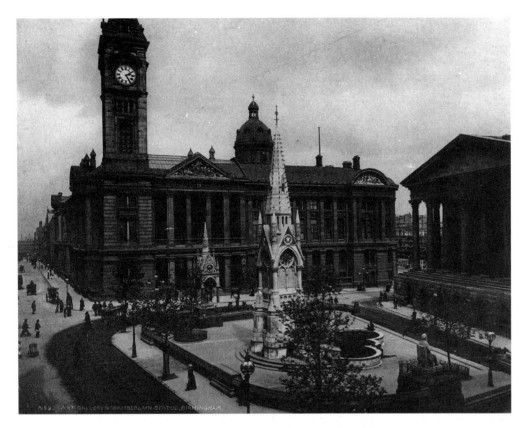

Left Chamberlain Square at the end of the 19th century, showing the *Chamberlain Memorial Fountain*
Above Woolner, Portrait medallion of *Joseph Chamberlain* on *Chamberlain Memorial Fountain*

THE DIAMOND JUBILEE OF THE BIRM-
INGHAM CIVIC SOCIETY 1978
Status: II
Condition: good
Owned by: City of Birmingham

Following the 1873–6 mayoralty of Joseph Chamberlain (1836–1910), the Council decided to erect a memorial in recognition of his great services, which included slum clearance and improvement schemes, and the opening of civic amenities such as parks, gardens, libraries, baths and schools. In view of his acquisition of the local gas and water concerns it was agreed that a memorial in the form of a fountain would be suitable. As an architect of public buildings, J.H. Chamberlain (no relation) was an obvious choice for the commission.

Paid for by a public subscription fund which raised £3,000, the fountain was complete by 20th October 1880.[1] The fountain is in a neo-Gothic style, in the form of a ciborium infilled with tracery and a miscellany of elements. The south side incorporates a portrait medallion of Joseph Chamberlain by Thomas Woolner (50cm diameter). The architectural details, including the carving of the capitals and crocketted spire, were executed by the architect's favourite sculptor, S. Barfield of Leicester. The mosaics, which mostly represent water-loving plants, were by Salviati Burke and Co. of Venice. John

Roddis, a local sculptor, viewed it unfavourably in *The Dart* as an 'architectural scarecrow'[2] and a 'singular hash of ornamental details' and more recently Pevsner dismissed it as an 'ungainly combination of shapes'.[3] The spire's Portland stone was thoroughly cleaned in 1994 and its whiteness sets off the detailing of the plant life very effectively, though the 1978 replacements for the original fountains below remain weak elements in the overall composition.[4]

1. Dent, 1880; *Post*, 1st November 1883; *Post*, 12th January 1884; Harman, 1885; 2. J. Roddis, *The Dart*, 23rd April 1881, p.11; 3. Pevsner, 1966, p.121; 4. D. Hickman, *Joseph Chamberlain memorial*, Birmingham Museums and Art Gallery, 1980.

Between Council House and Gas Hall

George Dawson

Thomas Woolner

1881
Carrara marble
180cm high
Status: II
Condition: good
Owned by: City of Birmingham

George Dawson (1821–76) was a preacher, lecturer and politician who first came to Birmingham in 1844 to preach at Mount Zion Baptist Chapel. His sermons proved immediately popular but some doctrinal conflict led to his resignation after one year. However, his followers and friends united to build a chapel for him which was opened as the Church of the Saviour in 1847. Outside of chapel he lectured on a wide variety of topics, particularly English literature, and

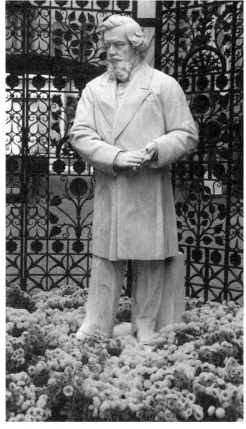

Woolner, *George Dawson*

many of these lectures were printed. He was a founder of the Shakespeare Memorial Library and an advocate of free public libraries. After his death in November 1876 a public meeting was held on 3rd January 1877 where a George Dawson Memorial Committee was formed and resolved to erect a statue to his memory. They decided to erect

the statue under a canopy in emulation of the memorial to Sir Walter Scott at Edinburgh. Woolner was chosen to execute the work and J.H. Chamberlain was asked to prepare a design for the canopy. A site for the statue was reserved in the space behind the Town Hall which was being laid out to receive the Chamberlain Memorial Fountain. The statue and canopy were completed in 1881 and formally unveiled on 5th October.[1]

The statue was intended to represent Dawson in an attitude of speaking as if giving one of his lectures. The Gothic canopy rose to a height of twelve metres and its gables featured portrait heads of Bunyan, Carlyle, Cromwell and Shakespeare, chosen because they were the favourite subjects of Dawson's lectures and for their symbolic references to the four elements of Religion, Letters, Governments and Poetry.

Shortly after the unveiling an unfortunate situation arose – considerable dissatisfaction was expressed with the statue. The objections seem to have centred on the general agreement that it was not a good likeness, while the heavy overcoat and wide trousers give little sense of the figure beneath and generally give it a rather squat appearance. A meeting of the Memorial Committee took place and after much deliberation it was decided to commission a new statue from F.J. Williamson (which was in turn scrapped in 1951: see separate entry under Lost Works).[2]

Woolner's statue was put into a niche in the Old Central Library when the new statue was erected. It then went into store in 1973 and was re-erected between the Museum and the Gas Hall in 1975. When the area was upgraded in 1995 it was temporarily

removed, and a new site was found for it behind the Library in an area opened to pedestrians. The statue remains in good condition having been indoors for most of its life.

1. *The Dart*, 14th October 1881; 2. W. Ainsworth, 'In search of George Dawson', *The Birmingham Historian*, no.5, Autumn/Winter, 1989.

Museum and Art Gallery, Chamberlain Square, pediment over main entrance

Allegory of Fame Rewarding the Arts

Francis Williamson

1884
Stone
200cm high at highest point × 2000cm wide
Status: II*
Condition: good
Owned by: Birmingham Museums and Art Gallery

This allegorical figure group contains a personification of Fame, seated in the centre, with personifications of Painting and Architecture on the left and of Sculpture on the right. The corners are filled with putti engaging in the relevant activities. The large figures are well composed and can be clearly seen from ground level. The attractive frieze below the pediment is the work of the firm of John Roddis.

Pedestrian area outside Paradise Forum

James Watt

Alexander Munro

1868

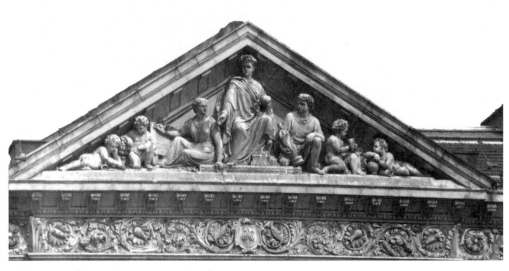

Williamson, *Allegory of Fame Rewarding the Arts*

Sicilian marble statue on pedestal of Darley stone
Statue: 200cm high; pedestal: 420cm high.
Inscribed on pedestal: WATT
Status: not listed
Condition: good
Owned by: City of Birmingham

James Watt is chiefly remembered as the inventor of the separate condenser – the greatest single improvement ever made to the steam engine.[1] In 1774 he joined Matthew Boulton, Birmingham's leading manufacturer, in order to market his invention, a partnership which has become one of the most famous in world economic history. Here he is shown in a relaxed pose holding a pair of upturned compasses in his right hand with his left arm leaning on the cylinder of a steam engine.

The suggestion of a public memorial to Watt was made in 1865 by the Institute of Mechanical Engineers to Mayor Henry Wiggin.[2] It was felt that Birmingham (unlike other major cities such as London, Manchester and Glasgow) had been slow to acknowledge 'her greatest benefactor' and a petition was duly sent to the Council who eventually decided that a memorial in the form of a statue be erected. A public subscription fund raised nearly £1,000 and donors included Matthew Boulton's grandson and the men of his Soho factory, who gave £100 and £20 respectively. Donations from the workmen of other local industrialists provided the remaining sum.[3] A

managing committee voted unanimously to give the commission to Munro, who had produced a statue of Watt for the Oxford University Museum of Science in 1863. By September 1866, Munro had submitted a sketch defining Watt's pose and, although a completion date for the statue was given as summer 1867, it was not ready until September 1868[4] when it was placed on a pedestal designed by J.H. Chamberlain.

The unveiling attracted a large crowd and

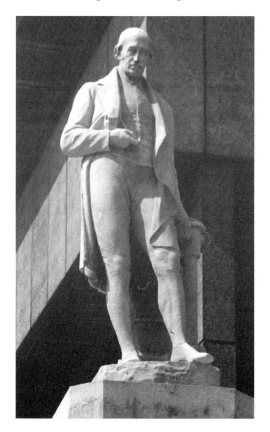

took place on 2nd October 1868 during the session of the Social Science Congress on a site in Ratcliffe Place originally intended for a statue of the Prince Consort. Mayor Thomas Avery received the statue on behalf of the town and expressed a hope that it would redeem the people of Birmingham from the charges of an era accused of 'ardent idolatry of wealth'. The statue was well received both by the Council and the press. In an inaugural speech, Alderman Timmins called it 'the greatest portrait statue in Birmingham's possession' and commented that it was a mark of respect to Watt that no debt remained on the cost of the statue. The *Birmingham Daily Post* called it a 'great and glorious work' of remarkable likeness and dignity, showing Watt at rest, 'secure in the knowledge of his greatest invention'.[5] Twelve years later R.K. Dent praised it as 'a noble addition' to Birmingham's art treasures,[6] and even after almost twenty years it was regarded as 'undoubtedly the finest statue in our town'.[7] The statue was moved following the demolition of the Central Free Library in 1973 and now overlooks the Chamberlain Memorial Fountain.

1. A. Briggs, *The power of steam*, London, 1982; E. Robinson, and A.E. Musson, *James Watt and the steam revolution: A documentary history*, London, 1969; 2. 'The Watt memorial, Birmingham', *The Builder*, vol.24, September 1st 1866, p.655; 3. 'Monumental', *The Builder*, vol.24, April 7th 1866, p.255; 4. Letter from Henry Wiggin to Council, 31st August 1868, in *Council Proceedings 1867–1869*, 1st September 1868; 5. *Post*, 3rd October 1868; 6. Dent, 1880; 7. W. Wallis, 'Sculpture', in British Association, *Handbook of Birmingham*, 1886.

Munro, *James Watt*

Joseph Priestley
Francis Williamson

1874
Bronze statue on a stone pedestal
Statue: 200cm high; pedestal: 420cm high
Status: not listed
Condition: good
Owned by: City of Birmingham

Joseph Priestley (1733–1804) was born at

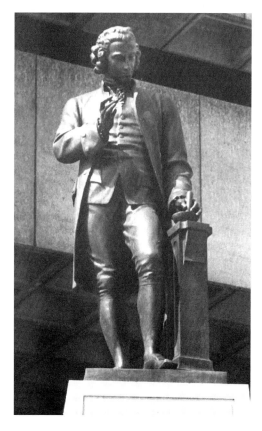

Williamson, *Joseph Priestley*

Birstall, Yorkshire. He received a dissenting theological education and was ordained in 1762 at Warrington. He continued a life-long enquiry into theology and the history of Christianity, and from 1758 began equally serious scientific experiments, discovering oxygen in 1774. He came to Birmingham in 1780 and became the minister of the New Meeting. He reorganised the Birmingham Public Library in 1782 and dined once a month with the Lunar Society. On 14th July 1791 a mob antagonistic to Priestley's dissent and presumed republicanism attacked his house and destroyed his papers and apparatus. Priestley was forced to flee the town never to return, dying in America.

A Priestley Memorial Committee was formed in Birmingham in 1871 and it was decided that subscriptions should be solicited to provide a tablet to mark the site of his house, to erect a portrait statue and to establish a prize fund in his name. The statue, originally carved in marble, was produced at a cost of £972 by Williamson and was unveiled on the eastern side of the Town Hall on 1st August 1874.[1] This statue shows the scientist at the age of 41 making the experiment which led to his discovery of 'dephlogisticated air' – oxygen as we now know it. He is shown directing the rays of the sun through a lens onto some redoxide of mercury in a crucible over which he holds an inverted test-tube. The statue is unusual in its self-containment and in its narrative element. Priestley is absorbed in his own activity, he does not acknowledge the spectator as many monumental statues do.

This was the first monumental statue by Williamson and his first public work for the city.[2] In 1951 the statue was removed and cast in bronze and in 1980 it was placed in its present position alongside the statue of James Watt by Munro.[3] The 'modello' for this piece is in store at the Birmingham Museum and Art Gallery.

1. Dent, vol.3, 1880, p.572; 2. Harman, 1885, p.293; 3. *Sunday Mercury*, 13th May 1980.

At rear of Town Hall

Thomas Attwood

Sioban Coppinger and Fiona Peever

1993
Bronze and reinforced re-constituted stone
200cm long
Inscriptions on steps:
Prosperity; The Vote; Reform.
Inscriptions on papers:
Prosperity Restored; Demand for Change; The Remedy; Votes for All; Full Employment; Free Trade.
Status: not listed
Condition: good
Owned by: City of Birmingham

Thomas Attwood (1783–1856), the son of a Birmingham banker, achieved renown in Birmingham by agitating for the repeal of Parliamentary Orders restricting trade, and for Parliamentary reform that culminated in the formation of the Birmingham Political Union in 1829. This body influenced the passing of the Reform Bill of 1832 and lead to the appointment of Attwood with James Scholefield as Birmingham's first Members of Parliament. Attwood retired in 1840 for health reasons.[1]

Coppinger and Peever's work contrasts importantly with two existing public sculptural monuments: John Thomas's memorial to *Attwood* in Sparkbrook of 1859, and John Chamberlain's *Chamberlain Memorial Fountain* of 1880, beside which this modern piece is sited. Coppinger and Peever's piece is a consciously non-heroic statement, with Attwood reclining casually on the steps of Chamberlain Square, his papers left to lie at the base of the soap-box off which he has presumably just stepped. Indeed, the soap-box acts as a reminder of the pedestal which these artists have rejected as a base for their sculpture: Thomas's *Attwood* is raised on a pedestal as an examplar to the masses; Coppinger and Peever's is a man of the people, at their level. The contrast with the Chamberlain Memorial is also marked. The memorial is a grand scheme, with plenty of detail taking up a lot of space; Attwood also uses space but in a completely different manner – the public may walk through the different components, and the detailing is left to the impressionistic modelling of Attwood's face and clothes. Three steps have had one of the slabs replaced with a key tenet of Attwood's inscribed ('Reform', 'The Vote' and 'Prosperity'), and each of the bronze 'papers' has a slogan written on them reflecting his views. Coppinger did the sculptural work, while the lettering and 'papers' were modelled by Peever.[2] Set low down to one side of the square, at the back of the Concert Hall, it is a source of surprise to many pedestrians when they come on the figure, sitting on the steps as anyone else might do on a summer's day.[3] However, it has been the object of vandalism and calls for its removal by some councillors have had to

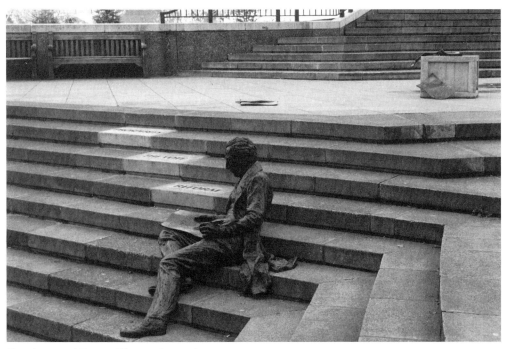

Coppinger and Peever, *Thomas Attwood*

be resisted by the Department of Leisure Services.[4]

The work was commissioned and donated to the city by Mrs. Priscilla Mitchell, the great-great-granddaughter of Thomas Attwood. The maquette for this piece is in store at the Birmingham Museum and Art Gallery.

1. D.J. Moss, *Thomas Attwood: The biography of a radical*, Montreal and London, 1990; 2. *Post*, 15th January 1993; 3. *Express and Star*, 28th June 1991; *Post*, 17th July 1992; *Mail*, 12th June 1992; 4. *Mail*, 15th January 1993.

Birmingham Museum and Art Gallery, in storage

Although there are many remarkably good pieces of sculpture within the Museum and Art Gallery, only those which were publicly commissioned or had a former, publicly accessible, location are listed here.

William Scholefield

Peter Hollins

1868
Marble
78cm high

Status: not listed
Condition: poor. Nose chipped; considerable surface discolouration
Owned by: Birmingham Museums and Art Gallery

In January 1868, Thomas Avery, then Mayor of Birmingham, commissioned Hollins to make this bust of Scholefield (born 1809), Birmingham's first Mayor after the Incorporation of the town in 1838, and then its borough MP for twenty years until his death in 1867. Scholefield is portrayed as a classical figure, although after a good likeness,[1] draped in loosely bound robes. The head is turned away, and despite the dirt and its poor condition – the nose is chipped – the carving is bold and skilfully rendered, typical of Hollins' romantic style of portraiture. When completed later that year it was one of the first works accepted into the collection of the new Art Gallery then housed in the Central Library.[2]

1. *Birmingham Morning News*, 17th April 1871; 2. Dent, 1880, p.518.

Hygeia

William Hollins

*c.*1808
Artificial stone
120cm high
Inscribed around arch: OF THE MOST HIGH COMETH HEALING
Status: not listed
Condition: fair
Owned by: City of Birmingham

Originally part of a classical aedicule over the

W. Hollins, *Hygeia*

entrance to the General Dispensary on Union Street, Hygeia, the Greek goddess of health, is carved in bold relief below the inscription picked out in gold, seated holding out a saucer from which a serpent is traditionally supposed to drink. Hygeia is associated with Aesculapius, the god of Medicine, whose motif, a caduceus and a snake, lies at her feet. There is an urn on either side, one set in an elaborate stand, burning, the other abundantly filled with flora, both signifying the services of the Dispensary to maintain life. Founded in 1792, the General Dispensary was designed by Hollins in 1806 at a cost of £3,000 and opened two years later.[1] The stone is artificial, made from a cement invented at about this time by one of the Wyatt family of architects.[2]

1. F.W. Greenacre, *William Hollins and the Gun Barrel Proof House 1813*, Victorian Society, West Midlands Group, 25th May 1968; 2. Information supplied by Dr. F.W. Hetherington, telephone conversation.

Allegory of Hope

William Hollins

*c.*1831
Cast iron, painted
50cm high
Status: not listed
Condition: poor
Owned by: City of Birmingham

Formerly located on Dowell's Almshouses on Warner Street, Bordesley, this ogee-shaped panel shows a female figure, possibly Hope, kneeling in classical dress next to a ship's anchor and holding a spear. It was originally one of a series of panels decorating the doorways of these almshouses, probably built by William Hollins in 1831.[1] The buildings were demolished in 1967, although several of these panels still exist. Two are on gate posts to flats opposite the Dovecote Inn, Moseley Road, two are in the Ironbridge Museum and two more are in the possession of Douglas Hickman, architect and local architectural historian.[2] The design and its 'curious mingling of Gothic...and the classical' has been attributed to William Hollins as architect of the almshouses, although his son Peter may have been responsible for the panels.

1. T. Edwards, *A Birmingham treasure chest*, Birmingham, 1955, p.7; 2. Information supplied by Douglas Hickman, 13th November 1985.

John Bright

Albert Joy

1887
Seravezza Carrara marble
230cm high
Status: not listed
Condition: fair
Owned by: Birmingham Museums and Art Gallery
Exhibited: Royal Academy, 1893

This statue was commissioned by the Birmingham Liberal Association in 1883 in honour of John Bright (1811–89), a national hero associated with Richard Cobden in the Anti-Corn Law League and an MP for Birmingham from 1857 to 1889. It marked Bright's twenty-five years of service to the city and was intended as a permanent memorial to him to be displayed in the new city art

gallery.[1] Joy was chosen as a reputable portrait sculptor, whose statue of Gladstone for Bow Church, London, in 1881 was 'universally applauded as one of the finest modern portraitures of its kind'.[2] Joy's statue of Bright depicts him in a naturalistic style wearing contemporary dress, a buttoned-up frock coat over which a light overcoat hangs. His left hand is in the breast of his frock coat and the other arm hangs down, which was a pose reputedly taken from life sketches when 'Mr Bright had been distributing prizes to the pupils of the College of the Blind'.

The clay model, seen by a contemporary critic as 'emblematic of the Christian charity so characteristic' of him was approved by Bright himself. The statue was carved from a 27-cwt, faultless block of 'that vein of carrara marble most prized by sculptors' and took four years to complete. After some difficulty in its siting, it was presented to the Council on 6th June 1887[3] and unveiled in the art gallery on 11th April 1888. The local press considered it an 'admirable likeness' which expressed the 'mingled strength, power and refinement of Mr Bright's face' although, perhaps due to the length of the commission, the statue was considered 'younger in figure and expression than he now appears to be'. The rather stern facial expression was not intended by the artist who was dissatisfied with the statue's location in the gallery. He had designed it for a niche position where light would fall on it diagonally, fearing that otherwise the overhead light would turn it into an 'eyesore'.[4] The statue has been subsequently placed in store. The model was exhibited at the Royal Academy in 1893.[5] Joy made a replica of this statue for the Houses

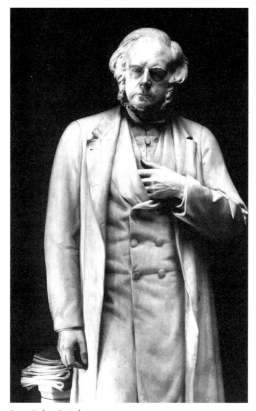

Joy, *John Bright*

of Parliament which, installed in 1902, replaced a less portrait-like one by Alfred Gilbert, and he executed another figure of Bright for Manchester Town Hall, signed and dated 1891.[6]

1. Harman, 1885, pp.291–2; 2. *Post*, 12th April 1888, p.4; 3. *City of Birmingham council minutes*, no.14455, Birmingham, 1887, p.325; 4. Birmingham Museum and School of Art, *Committee minutes*, No.714, p.446: letter from the artist to the Chairman, Birmingham Central Reference Library, 16th April 1888; 5. Graves, 1906, p.134; 6. B. Read, *Victorian sculpture*, London, 1982, pp.75, 363.

Birmingham Central Reference Library, ground floor, in information centre

Royal Warwickshire Regiment War Memorial

Sculptor not known

*c.*1899
Bronze and marble
60cm square × 180cm high
Inscribed on front face: IN MEMORY OF / ALL RANKS OF THE / ROYAL WARWICKSHIRE REGIMENT / WHO FELL IN BATTLE, / DIED OF WOUNDS OR SICKNESS, / IN THE COURSE OF THE / SOUDAN CAMPAIGN / 1898. 'DULCE ET DECORUM EST PRO PATRIA MORI' / THIS FOUNTAIN IS ERECTED BY SUBSCRIPTION / AMONGST ALL RANKS / PAST AND PRESENT / OF THE REGT.
Status: not listed
Condition: good
Owned by: Birmingham City Council

This memorial originally stood upon a base opposite the entrance to the Museum and Art Gallery in Chamberlain Square, until the area was redesigned for the Festival of Britain in 1951. Its grey marble slab supports a bronze likeness of the regiment's badge, a gazelle, along with bronze lions' heads within arches on each side, and the role of honour on the reverse. The original monument served as a drinking fountain, with a semi-circular bowl under each lion's mouth.[1]

1. K.Turner, *Central Birmingham 1920–1970*, Stroud, 1995, p.87.

Birmingham Central Reference Library, first floor landing

Garrick and Shakespeare

Coade and Sealy

1777–80
Coade Stone
102cm diameter
Inscribed on rim: Coade Lambeth
Status: not listed
Condition: fair. Surface discolouration
Owned by: City of Birmingham

These portrait medallions adorned the façade of the Theatre Royal, New Street, added between 1777 and 1780 by the architect Samual Wyatt to the original New Street Theatre built by the local builder Thomas Saul in 1774. The elegant neo-Classical façade

had an open arcade, an upper loggia of Ionic columns and, placed at first floor level, the medallions of Garrick on the left and Shakespeare on the right. They remained *in situ* despite the two theatre fires of 1792 and 1820 and were removed when the building was demolished in 1957.[1] Preserved by Philip Rodway, they were presented to the central library by his daughter, Phyllis Bushill-Matthews, in 1973.[2] The finely modelled details achieved in Coade stone, a material similar to terracotta, are most notable in the treatment of hair and facial features.

1. B. Little, *Birmingham buildings*, Birmingham, 1971, p.16; 2. Birmingham Information Bureau, May 1977, p.18.

Coade and Sealy, *Garrick and Shakespeare*

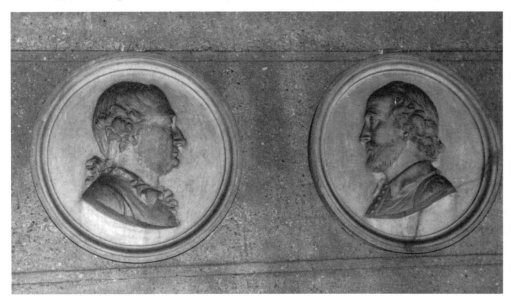

Perry Common public library, tympanum over the entrance

Lamp of Knowledge

Carved by: Tom Wright

Designed by: William Bloye

1934
Stone
135cm wide
Signed: CARVED APRIL 1934 T.H.W.
Inscribed on the central book: ALL HAIL TO THE FOUR HIPS AND QUICKENING PEG THAT DID BEGET US...
Status: not listed
Condition: fair. Some discolouration
Owned by: Perry Common library

The building was designed in January 1933 by F.J. Osborne,[1] whose 'practice undertook all the new public libraries in Birmingham from 1924 onwards'.[2] The tympanum design was left blank on the architectural drawings although Bloye produced all of the relief sculpture for Osborne's libraries. Consisting of an array of books, one clearly marked 'Chaucer', this relief shows a lamp whose light burns before an open book upon which are the inscriptions. The monogram T.H.W. refers to the name of an assistant carver of Bloye's, Tom Wright, who had also studied under Bloye at the Birmingham School of Art.[3] His style of carving is clearly influenced by Gill through Bloye, seen in the sexual allusion of the inscription (which is almost impossible to read from below) and also stylistically, by the compressed space and clear, simplified imagery, contrasting with the marked texture and grain of the stone.

1. *BRBP*, 1933, no.57874; 2. Letter from John Osborne Partnership, Chartered Architects, 10th April 1985; 3. Bloye, *Ledger*, 31st August 1934, p.18, invoice no.985.

Wright, *Lamp of Knowledge*

Snow Hill Station, off Colmore Row, entrance vestibule

The Commuter

John McKenna

1996
Aluminium
180cm high
Inscription: Plaque reads: 'The Commuter' / by / John McKenna A.R.B.S. / Sculptor / Unveiled by / The Rt Hon Neil Kinnock / European Commissioner for Transport / February 9th 1996
Status: not listed
Condition: good
Owned by: Centro

This piece was commissioned by the Midlands transport company Centro as part of the refurbishment programme for Snow Hill station. Since 1991, Centro have worked closely with artists on station refurbishment schemes and this life-size figure of the popular image of a 'typical' commuter was originally devised for Canley station in Coventry.[1] The male figure wears a bowler hat and a three-piece suit, and carries an umbrella and suitcase. The statue is hollow, supported on a flat metal base and is entirely painted in a metallic silver colour. It was decided, however, that this image was not

McKenna, *The Commuter*

appropriate for its location, since Canley is not a business area. Consequently, *The Commuter* was erected for Snow Hill station, which is in the middle of the business quarter of Birmingham. The total cost of the piece was approximately £5,500, and was funded entirely by Centro.[2] It was unveiled on 9th February 1996 by the Rt. Hon. Neil Kinnock, as inscribed on the accompanying plaque.[3]

1. Information given in conversation with Mark Wiles, Principal Planner, Centro, 13th June 1996; 2. *Birmingham Post*, 7th February 1996; 3. *Neil Kinnock to meet mystery commuter*, Centro press release, 5th February 1996.

St. Philip's Square, in front of the entrance to the cathedral

Bishop Gore

Thomas Stirling Lee

1914
Bronze
170cm high
Status: II
Condition: good
Owned by: St. Philip's Cathedral

This bronze, life-size statue of Charles Gore, the first Bishop of Birmingham 1905–11, was paid for by public subscription and was unveiled on 6th March 1914 by the Archbishop of Canterbury.[1] It shows Gore wearing his convocational robes and carrying the pastoral staff, raising his right hand in the sign of the episcopal blessing. Both his pose and the folds in the robes appear rather rigid, for Stirling Lee was more accustomed at this period to making portrait busts rather than

Stirling Lee, *Bishop Gore*

Stirling Lee at work on *Bishop Gore*

statues. The pedestal is an unusual design, having three convex faces between pilasters in a Baroque fashion. The *Coat of Arms* on the front face is that of the See.[2]

1. 'Unveiling of the statue of Bishop Gore', *Birmingham Diocesan Magazine*, vol.IX, no.4, April 1914, pp.139–43; 2. Birmingham Information Bureau, May 1977.

Phoenix Chambers, 78–90 Colmore Row, above doorway

Phoenix

Sculptor unknown

Architects: Ewen H. and J. Harper

*c.*1917
Stone
80cm high × 90cm wide
Inscribed on base: PHOENIX
Status: not listed
Condition: good
Owned by: not known

The emblem of the Phoenix Assurance Company existed as a large bronze pediment at its London offices, and this smaller version adorns the lintel to the main door into the company's Birmingham premises. Building records show designs dating from 1914,[1] but the completion date is unknown. The Phoenix is framed between two classical columns and is depicted in standard form, rising from the flames with outstretched wings.

1. *BRBP*, no.26089, 3rd October 1914.

79–83 Colmore Row, the corners of the attic storey

Ghiberti and Cellini

Julius Chatwin

*c.*1872
Stone
140cm diameter
Status: II
Condition: good
Owned by: not known

These two roundels contain half-figures representing the famous Florentine Renaissance sculptors and silversmiths, Lorenzo Ghiberti (1378–1455) on the left, and Benvenuto Cellini (1500–71) on the right.[1] Their presence here relates to the original occupant of this building, William Spurrier, a reputable silversmith, cutler and electroplater

Anon, *Phoenix*

Chatwin, *Ghiberti*

Chatwin, *Cellini*

whose showrooms were here from 1872–1916.[2] The roundels on either side of a colonnaded row of windows ensure the balance of the overall façade with its arched and rusticated ground floor, an impressive *piano nobile* with segmental pediments over the windows decorated with ornate Renaissance-styled vases. An elaborate cornice completes the effect of a 16th-century Italian palazzo, one of several buildings in a similar style erected when Colmore Row was redeveloped from 1866. The portrait roundel was used in 1425 by Ghiberti for a series of portraits, including his own, on the second bronze doors of Florence Baptistry, known as the 'Gates of Paradise'. Chatwin's figures are expressive: the bearded Cellini gestures outwardly, calling for attention, in keeping with his boastful and quarrelsome nature, whilst Ghiberti, in a skullcap and plain shirt, gazes down to passers-by on Colmore Row.

1. A.G. Sheppard Fidler, 'More about Cellini', *Post*, 12th December 1953; 2. Professor Archer, 'On the progress of our art industries, works in metal: Spurrier's art-metal works', *Art Journal*, vol.XIX, 1875, pp.135–6.

124 Colmore Row, Bank of Scotland, top of the façade

Eagle Crest

Lethaby & Ball

*c.*1900
Stone
120cm high × 200cm wide
Status: I
Condition: good
Owned by: Bank of Scotland

This relief of an eagle with spreading wings, taken as the emblem of the Eagle Insurance Company, the original occupant, is the central and most prominent sculptural element decorating this building designed by Lethaby and Ball in 1898–9.[1] Surrounded by a chequerboard pattern of plain blank circles and panels of brickwork, the eagle is portrayed in detail, although its profiled pose gives it an emblematic appearance. Placed high on the attic of the façade, the whole of which was designed in a restrained yet wonderfully inventive classical idiom with Lombardy Renaissance motifs, its presence is underlined by the undulating eaves immediately above.

1. *BRBP*, no.14657, 10th March 1899.

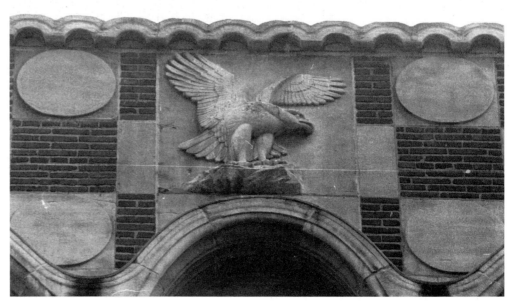

Lethaby & Ball, *Eagle Crest*

All Saints church, north façade

Christ

William Bloye

1951–5
Cast stone
228cm high
Status: not listed
Condition: fair. Thumbs broken off and
other splitting of stone has led to deteriora-
tion of detail
Owned by: All Saints church

Designed by F.J. Osborne in 1951, this
church was the first to be built in
Birmingham after World War II and replaced
All Saints, Small Heath, which had been
destroyed during the war. The figure of
Christ was in place when the church was
consecrated in 1955.[1] Painted and bearing a
copper halo, the statue shows Christ penitent
in a simple coat tied loosely with a rope at
the waist, under a canopy unusually shaped
like an oriental minaret. Slightly over life-
size, the figure stands in the round against a
plain brick wall and upon a stone corbel
which juts out and forms the keystone to an
arched entrance. Although not made by
Bloye, it was produced by his assistants in his
studios, who cast it from his design.[2] More
naturalistic than his figure of Christ for
Christchurch Burney Lane, made in 1935
(q.v.), this statue retains a distant and bland
expression which, with the simple open arm
pose, is suggestive, like the earlier figure, of
an emblem.[3]

1. *Gazette*, 2nd November 1955; 2. Bloye, *Ledger*, 8th
November 1955, p.150; 3. Information supplied by
John Poole, 12th July 1985.

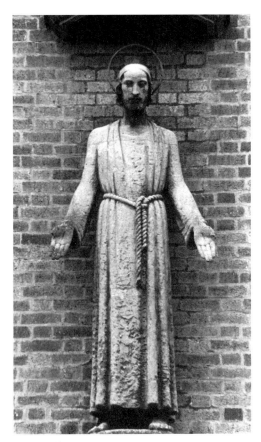

Bloye, *Christ*

*Above 6 Corporation Street, to each side of
first floor window*

Sir Walter Scott and William Shakespeare

G.E. Pepper (architect)

1923
Terracotta, painted white
Two reliefs, each: 80cm high × 50cm wide
Status: not listed
Condition: good
Owned by: not known

These two portrait reliefs adorn a building
which once housed the booksellers and
stationers W.H. Smith & Son. The building

Pepper, *Scott*

Pepper, *Shakespeare*

was altered in 1923 by Pepper, when the heads were added, and there were probably two other heads on the inner sides of the pillars, but these are now hidden. This use of sculpture to show a function of a building was a particularly 19th-century custom and is reflected on a number of other buildings in the area.

6 Corporation Street, 1930s, showing original state of building

Corner of Corporation Street and Priory Queensway, overlooking Old Square

Memorial to Tony Hancock

Bruce Williams

1996
Bronze with glass rods
300cm high × 366cm wide
Inscribed on plinth: (facing west) I DO NOT THINK I EVER MET A MAN AS MODEST AND HUMBLE
(facing east) NEVER HAD A MAN LESS REASON TO BE HUMBLE ABOUT HIS TALENT
Status: not listed
Condition: poor. Severe deterioration of surface, peeling of patina
Owned by: City of Birmingham

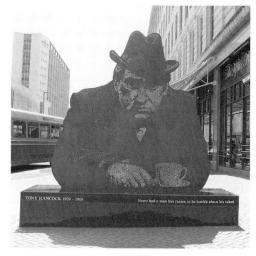

Williams, *Tony Hancock*

Tony Hancock (1924–68) was born in Hall Green, Birmingham, and became one of the most innovative comedians of the 1960s, though he was always uncertain of his talents. The Public Art Commissions Agency handled the commission which was proposed by the Tony Hancock Statue Appeal, and Ansell's brewery funded the project in recognition of the charity Turning Point which rehabilitates people with drug, drink and mental health problems – referring to Hancock's own drink and drug related suicide in 1968.[1] The quotes on the base are by an Australian TV commentator immediately after Hancock's death.

After a shortlist of artists was drawn up, Williams' designs for the monument were only considered when one of the original candidates dropped out, yet his idea was selected unanimously on the basis of its inno-

vative approach. The artist has declared that the memorial's material is a 'new form of presentation synonymous with the medium [of television]'.[2] The main sheet is made of bronze, with details picked out by innumerable small glass rods which run through the metal, as the dots on a TV screen go to make up a picture.

The image of Hancock is based on the well-known photograph taken by Joan Williams (1960), in his familiar coat and homburg hat, holding a cup of tea. The plinth is seen as a place for the public to sit and eat, becoming familiar with the memorial through contact. Originally to be placed in New Street, a temporary site on Corporation Street was chosen, and the piece is intended to be eventually relocated in Old Square. It was unveiled on 13th May 1996 by Sir Harry Secombe.

1. Birmingham Museums and Art Gallery, *Public Art in Birmingham, Information sheet*, no.26, 1996; 2. *Public Art Commissions Agency records*.

Old Square subway pedestrian area beneath junction of Corporation Street and Priory Queensway

Old Square

Kenneth Budd

1967
Cast brass and iron on a fibreglass backing
152cm high × 793cm wide
Each unit is inscribed with details of the motif depicted
Status: not listed
Condition: good
Owned by: City of Birmingham

This is one of seven murals made by the artist in Birmingham. It was commissioned by the Public Works Department and paid for from the Capital Account (£940) as a memorial to Old Square, which was a casualty of the Corporation Street improvement scheme and was finally effaced with the Queensway development in the 1960s.[1] It was unveiled on 21st April 1967 by Alderman C.V. Simpson, Chairman of the Public Works Committee.

The interlinking sections depict personalities and buildings associated with Old Square, originally on this site.[2] Panels from left to right show in text and image: an Augustinian Friar and Gothic-style building representing the Priory that stood on the site

Budd, *Old Square*

in the 13th century; the Arms of the de Bermingham (*sic*) family who subsequently owned land there; a bull's head to represent The Bull Tavern and later the Saracen's Head Posting and Coaching Inn, dating from the 16th century; the Square as designed by William Westley and built by Thomas Kenny in 1713; a rectangular panel inserted represents the famous lock-maker, John Wilkes, who lived at No.9 between 1713 and 1734; a beehive, an early bank emblem, representing Lloyd the Banker, who lived at No.14 in 1770; a double portrait representing Mr. Edmund Hector, surgeon and doctor, who lived at No.1, and Dr. Johnson, who was frequently a guest there; below this is a group of dancers and musicians at a ball held in 1765 for the Duke of York at the 'Great Room', No.11; a roundel referring to Samuel Galton who lived at No.13 in 1780 and who, with Priestley, Boulton, Watt and others, was a member of the Lunar Society; below this is a small scene showing Miss Lloyd, one of the 16 children of Samuel Lloyd, who reputedly eloped from No.14 in 1774; at the top is a scene of rioters in 1791, who marked homes for destruction, notably No.15, the residence of Dr. Withering, which was subsequently saved after hard fighting; below, a seated figure represents William Scholefield who became the first Mayor of Birmingham in 1838 and lived at No.1; finally a workman holding a pick-axe represents the transformation of the square from residential to a commercial centre during the 19th century, the last of the original houses being demolished in 1896.

1. P. Cox, *Mail*, 16th June 1967; *The Birmingham Sketch*, June 1967; 2. J. Hill and R.K. Kent, 'The memorials of Old Square', *Notices of the Priory of St. Thomas in Birmingham*, 1897.

Dean and Pitman Building, 153–61 Corporation Street, first floor balustrade

Carpenters and Diners

Benjamin Creswick

*c.*1896
Buff terracotta
90cm high × 600cm wide
Status: II*
Condition: good
Owned by: City of Birmingham

This frieze runs continuously across the façade of both chambers forming a balustrade in front of the windows. Creswick was responsible for all of the terracotta dressings here that contrast with the red brick elevation, including two city coats of arms, quoined window arch surrounds and a string-course wittily modelled as a length of rope and held at either end by two putti. The subject matter of the frieze reliefs refers to A.R. Dean, well-known house furnishers, and Pitman's Birmingham Vegetarian Hotel and Restaurant, which originally occupied

Creswick, *Carpenters and Diners*

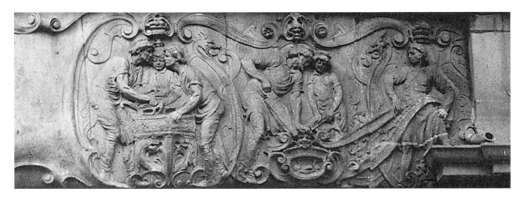

Creswick, *Carpenters and Diners* (detail)

these premises. The scenes show carpenters at work and diners being served at table. They are framed by elaborately attenuated and voluted scrollwork. Typical of Creswick, there is a contrast between the decorative framework and the realistically detailed figures.[1]

1. V. Bird, 'Birmingham's neglected statuary', *Birmingham Weekly Post*, 19th February 1954; Pevsner, 1966, p.125; A. Crawford, *Tiles and terracotta in Birmingham*, Birmingham, 1978.

Dean and Pitman Building, 153–61 Corporation Street, above the main gable

Allegory of Birmingham and Industry

Benjamin Creswick

1897
Buff terracotta
160cm high
Inscribed: B. CRESWICK & SONS 1896
Status: II*
Condition: fair. Parts missing; held together with an iron band

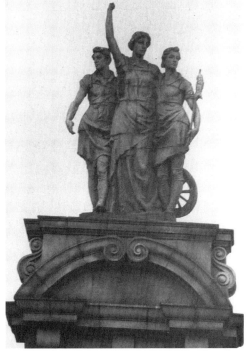

Creswick, *Allegory of Birmingham and Industry*

Creswick made this free-standing group statue during the erection of the Dean and Pitman Chambers, built by Crouch and Butler 1897–9. It was probably placed on its decorative podium in 1897 when the left section of the building was completed. The female figure on the right represents the industrial arts of Birmingham. She holds a distaff, and a spinning wheel can be seen behind her. The male figure on the left is similar to Industry, the supporter in the City *Coat of Arms*, although the hammer he holds is now missing. They flank a female figure in classical robes representing Birmingham, which once held aloft an object which was perhaps a torch, sword, hammer or, more appropriately, a laurel branch as a symbol of victory. This demonstration of civic pride was popular, as Birmingham had only recently received a charter as a city in 1889.

Methodist Central Hall, Corporation Street, over the main entrance

This entrance to the Central Hall is now used as the door to the 'Que Club'

Allegories of Methodist Teaching

Gibbs & Canning

*c.*1900–3
Red terracotta
130cm high × 350cm wide
Status: II*
Condition: fair. Discoloured with extensive green algal growth
Owned by: Methodist Central Hall

These two reliefs of terracotta groups show allegories of teaching, an important function

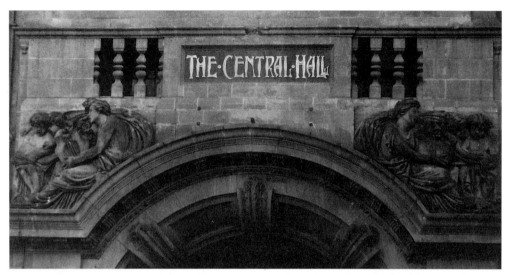

Gibbs & Canning, *Allegories of Methodist Teaching*

of the Methodist Church and its schools. A compact design, fitting into the architectural scheme, the large figure on the left holds a lyre and that on the right, a book. Each is accompanied by two attentive, naked and cherubic children. Although the terracotta for this building, designed by the architects E. & J. Harper, was supplied by Gibbs and Canning, it is also possible that the modelling was the work of their chief modeller, John Evans.[1]

1. *List of Gibbs and Canning terracotta façades*, Tamworth Castle Museum, undated; A. Crawford, *Tiles and terracotta in Birmingham*, Victorian Society, Birmingham Group, 1975.

Events in the Life of John Wesley

Gibbs & Canning

*c.*1900–3
Buff terracotta
Each: 150cm high × 200cm long
Status: II*
Condition: fair. Discoloured with green algal growth

Owned by: Methodist Central Hall

Set inside the entrance porch to the Methodist Hall, these panels were designed in the manner of a 15th-century narrative frieze. With a sharply delineated architectural background set in a foreshortened perspective, these two relief panels depict two events in the life of John Wesley, the founder of the Methodist Movement. On the right is a scene showing the young Wesley being rescued from a fire in his father's house. On the left, forbidden to preach in his church, Wesley preaches from his father's gravestone in the churchyard, attended by a large congregation. Although unsigned, like the figures flanking the main pediment, these panels could possibly be to the design of John Evans at Gibbs and Canning.[1] Unfortunately, the small size, high position and dull colour of these panels mars their effect, in contrast to the more elaborate architectural decoration that surrounds them.

1. A. Crawford, *Tiles and terracotta in Birmingham*, Victorian Society, 1975.

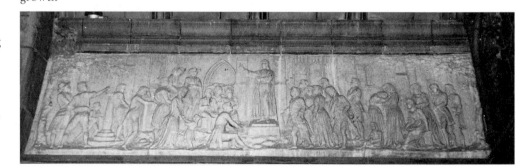

Gibbs & Canning, *Events in the Life of John Wesley*

Queen Victoria and related Allegory of Law and Order

Sculptors: Harry Bates, W.S. Frith, William Aumonier and others

Designed by: Aston Webb; E. Ingress Bell; Walter Crane

1887–91
Red terracotta
Queen Victoria: 150cm high × 60cm wide;
Justice: 150cm high × 80cm wide
Status: I
Condition: good
Owned by: City of Birmingham

The decoration on the Law Courts, perhaps the most outstanding civic structure of late 19th-century Birmingham, includes an elaborate programme of sculpture to convey Victorian ideals of Law and Order and to clarify the function of the building.[1] The sculptural programme was conceived by the London architects Aston Webb and Ingress Bell, who won the competition for the design of the new assize courts in 1886. It was the first building in Birmingham to be entirely clad with terracotta, a material which had been used since the 1860s in conjunction with brick. Dark red terracotta, in this case supplied by Edwards of Ruabon, was popularised by the assessor of the competition, Alfred Waterhouse. He considered it by far the best material for withstanding the city's polluted atmosphere.

The building is a mixture of Gothic, Flemish and Renaissance elements, typical of the eclectic style of late 19th-century archi-

Bates, *Queen Victoria*

tecture. Sculpture is located around and merged with the main architectural features including the gables and the entrance arch. It presents an intricate show of detail, playing the same role as decorative, architectural features such as pinnacles, string-course and tracery windows.

The sculpture, however, is also symbolic of a carefully worked out idea reminiscent of

that used in medieval cathedral architecture. The figure of Queen Victoria is central: she laid the foundation stone in 1887 and subsequently gave the Law Courts its name. In full regalia, holding an orb with a winged Victory and a sceptre, she is seated like a judge and alludes to the certainty of justice to be found

in a British court of law. At her feet, this national justice is endorsed by the figure of St. George, patron saint of England, who slays the dragon in obvious reference to Good conquering Evil. On either side in the spandrels are inscribed figures personifying Patience, Mercy, Truth and Temperance, all attributes of Justice. The theme is expanded above the portal arch where, to both sides of the clock face, appear relief symbols of Time and Eternity in reference to the proverb 'VERITAS FILIA TEMPERIS' (Truth is the daughter of Time). Further up, in the gables, specific reference is made to the trades of Birmingham in the representations of 'Art' and 'Craft'. The left gable includes a canopied personification of 'Art' and emblematic figures representing 'Modelling' and 'Designing'. On the right gable 'Craft' is accompanied by figures occupied with 'Gun-making' and 'Pottery'. On the roof line and presiding over the whole building, the universal idea of Justice is personified as a blindfolded classical figure holding scales.

Although the sculptural theme is unified, Webb introduced several specialist sculptors to achieve a high standard of modelling for this prestigious building in the spirit of the Arts and Crafts movement prevailing in England at the time. The statue of Queen Victoria was finely modelled by Harry Bates, a well-known London sculptor, and the free-standing figure of Justice was produced by the sculptor and modeller, W.S. Frith. The spandrel figures were also modelled by him to the designs of Walter Crane, a leading designer, illustrator and founder of the Art Workers' Guild. The relief gable sculpture, as well as the spectacular interior sculptural

Frith, *Justice*

decoration, was modelled by William Aumonier and his London firm, specialising in architectural decoration. *The Builder* admired his contribution and noted the great care that was taken as he worked 'in the open air on a gallery above the clay pit at Mr Edward's Terracotta Works at Ruabon. This was done expressly that he might go continually 60 or 70 feet below the work while it was in progress so as to judge what its effect would be when fixed in its proper position on the building.'[2] The overall effect of the sculpture is exuberant and restless. It gives

character to the grandeur of the building and demonstrates Birmingham's growing civic pride at the time, and her desire to rival London's recently completed Law Courts on the Strand.

1. 'The Victoria Courts, Birmingham', *Building News*, vol.61, 24th July 1891, p.128; 2. 'Sculpture: new law courts, Birmingham', *The Builder*, vol.57, 21st December 1889, p.442.

Birmingham Institute of Art and Design, University of Central England, Gosta Green

Formerly Birmingham Polytechnic, the University of Central England has several sites around the city. This location, just to the rear of Aston University's main building, houses departments of applied arts such as fashion, industrial design and visual communication, as well as theoretical and historical studies.

Untitled

Hubert Dalwood

1974
Bronze and steel
195cm high
Status: not listed
Condition: good
Owned by: University of Central England

Sited at the rear of the main building and visible both from the car park and the students' canteen, this work was commissioned as a result of the Arts Council's 'Art in Public Places' scheme which began in the mid 1960s to encourage local authorities, universities and private bodies to collaborate on a long-term programme of patronage of

the arts.[1] In 1969 Birmingham Polytechnic selected a maquette by Dalwood from a shortlist of four works. The cost of the sculpture was shared equally by the Polytechnic and the Arts Council. The sculpture consists of three moulded abstract objects with smooth, fluted and (in places) nicked surfaces. Its conception has associations with plant-life, the result of influences from Dalwood's years in Japan. There is another cast of this work at the Queen's Medical Centre, University of Nottingham.[2]

1. D. Farr, 'The patronage and support of sculptors', *British sculpture in the twentieth century*, Whitechapel Art Gallery, London, exh.cat., 1981, p.33; 2. Strachan, 1984, p.168.

Dalwood, *Untitled*

Judas Figure

Dame Elizabeth Frink

1963
Bronze
190cm high
Status: not listed
Condition: good
Owned by: University of Central England
Exhibited: Waddington Galleries, 1963

This piece is sited in a small courtyard next to the Faculty administration offices. First exhibited at the Waddington Galleries in 1963,[1] the John Feeney Charitable Trust in Birmingham offered to purchase it for the new College of Art in May 1964. It was gratefully accepted for, although no funds were available for purchasing sculptures, it was felt that the College should contain examples of 'original works of art by distinguished modern artists'.[2] After casting, the sculpture remained in Frink's possession until a site was prepared. She visited the college on 8th March 1965 and approved an outdoor location for the 150 kilo sculpture on a low stone plinth, which was constructed in July 1965 and the work installed shortly afterwards. The statue was damaged in October 1980 when the legs were fractured. Sent for repair at the artist's foundry, Frink had another cast made for herself before it was returned to Birmingham in April 1982, as she considered it one of her most important figures of that period.[3]

The *Judas Figure* is one of a series of large, disquieting male figures, including warriors, soldiers and assassins, produced between 1961 and 1964 which portray the idea of

Frink, *Judas Figure*

villainy or tragedy. Commenting on the work she said 'The figure of Judas had absorbed me for some time as a formal, figurative embodiment of the idea of betrayal, with the inherent formal problem of how this could be expressed without any obvious histrionics. Judas as a final work is primitive in feeling and somewhat brutish in character: the neck and shoulders are thickset and the body has a coarseness. There were shields over the eyes,

almost like dark glasses. This was just before I started making big heads and figures with goggles.'[4]

The pose of the barrel-chested figure, together with its rough texture, shows the influence of the work of Germaine Richier, whom the artist admired, and it is particularly reminiscent of her *Thunderstorm* figure of 1947–8. There is another cast of *Judas* at Sutton Manor Arts Centre.[5]

1. G.S. Whittet, 'Richier casts her shadow', *Studio International*, vol.167, no.850, February 1964, p.84; 2. Birmingham School of Art, File 294, *The New College of Art*, August 1964 – June 1965; 3. Letter from E. Frink to Peter Field, Faculty of Art Office Records, 6th November 1980; 4. E. Frink, *Catalogue Raisonné*, Salisbury, 1984; 5. Strachan, 1984, fig.137.

The Court Oak public house, sign in front and relief sign above front entrance

Court Oak

Sculptor: Robert Bridgeman & Sons

Designed by: George Bernard Cox (architect)

1931
Free-standing sign: wood; relief sign: painted stone
Free-standing sign: 150cm high; relief sign: 270cm high
Status: not listed
Condition: good
Owned by: Court Oak public house

The Court Oak public house was designed by G.B. Cox, who also designed the oak tree sign in front of the building and the carved sign above the front entrance.[1] In the original plans of 1930 the front façade was to have been timbered, and no sculpture was allowed for.[2] These were revised in 1931, and the new plans show the Tudor double window incorporating the relief oak tree sign of the final design. The trunk of the oak tree stretches up between the two leaded windows and the foliage has been 'flattened out' to fill the window niche perfectly, in a manner very similar to George Frampton's detail of carved relief decoration on his Düsseldorf fireplace of 1895–6.[3] The source for Frampton's tree details was Burne-Jones' design for the Tree of Life mosaic of 1888. The trunk is painted pale blue and the foliage is green with pale blue acorns. The lettering for the name of the public house is placed over the foliage. The sign in front of the building is carved fully in

Bridgeman & Sons, *Court Oak* (relief)

the round and depicts a man and a woman in early 19th-century costume standing beneath an oak tree with gold acorns. This wooden sculpture is placed on top of a stone post.

1. *Mail*, 1st February 1934; 2. *BRBP*, 1930, no.51680; 3. *The Studio*, vol.9, October 1896, p.53.

The Wheatsheaf Hotel, Coventry Road, over the main entrance

Wheatsheaf

William Bloye

*c.*1937
Stone, painted
128cm high
Status: not listed
Condition: good
Owned by: Wheatsheaf Hotel

Bloye, *Wheatsheaf*

Originally a late Victorian building in the Arts and Crafts tradition owned by Showell's brewery, Hobbiss drew up plans to make alterations and additions to the Wheatsheaf Hotel in September 1933.[1] His drawings show no allowance for a carved panel over the new Coventry Road entrance and, although Bloye produced other works, including plasterworks in 1936, he did not complete this panel until well into the following year.[2] It depicts a wheatsheaf, a red poppy and a green thistle all typically carved in low relief and set against a plain background. Simple, yet carefully detailed, it forms the only pictorial sculpture decorating the exterior of this large corner building.

1. *BRBP*, September 1935, no.63970; 2. Bloye, *Ledger*, 19th November 1936, p.41, invoice nos. 253 and 310.

St. John Fisher church, junction of Cropredy Road and Cofton Road, exterior west wall

St. John Fisher (see illustration p. 54)

Jonah Jones

*c.*1963–4
Concrete
290cm high
Status: not listed
Condition: good
Owned by: St. John Fisher church

Commissioned for the Roman Catholic Church which was built in a neo-Romanesque style between 1962 and 1964 by the architect E. Bower Norris,[1] of Sandy and Norris (Stafford), and opened in April 1964,[2] the figure of St. John Fisher (1469–1535) represents him in his role as Bishop of Rochester, in cope and mitre and giving blessing. His attribute, a pen quill, held in the left hand, refers to his academic life and theological writings. The facial features have been modelled naturalistically and contrast with the stiff and elongated treatment of the body, reminiscent of a reclining tomb figure.

1. *Catholic Pictorial*, no.195, 5th April 1964, p.3; 2. Opening leaflet, St. John Fisher R.C. Church, March 1964.

Jones, *St. John Fisher* (see p. 53)

City Engineer's Department, *Beam Engine*

On roundabout island, in pedestrian area

Beam Engine

City Engineer's Department

1965
Cast iron
960cm wide
Status: not listed
Condition: good
Owned by: City of Birmingham

Erected by the City as a monument to Birmingham's industrial past when the inner ring road was completed, this 'ready made' was originally a beam engine from the Netherton foundry of Grazebrook & Whitehouse and was in working order when presented to the City by the Grazebrook family and dismantled in 1964.[1] Although there is a traditional belief that this engine was made at Boulton and Watt's Soho factory, there is no certain evidence for this. A typical example of an early 19th-century engine, it comprises a vertical double-acting steam cylinder coupled via an 8-metre rocking beam to a double-acting air cylinder. It has been erected to monumental effect with rocking beam in mid-stroke, the cast iron components painted green, contrasting with the evenly spaced red-brick supports.

1. Information supplied by the City Engineer's Department, 1985.

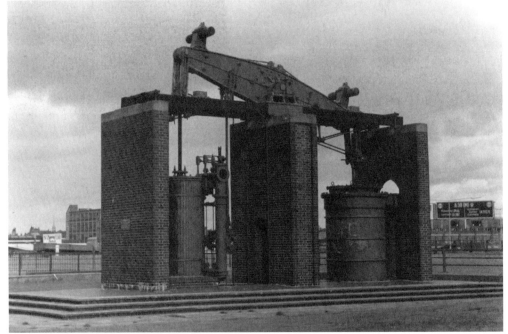

Dartmouth Middleway

CENTRAL EAST

Corner of Richard Street and Dartmouth Middleway, north of Aston Business Park

White Curl

Suzi Gregory

1992
Mild steel, painted white
700cm high × 200cm wide
Status: not listed
Condition: fair. The lower part of the curl is heavily marked and the whole piece is dirty
Owned by: City of Birmingham

Designed as one of a number of 'gateways' to the Birmingham Heartlands, this massive sculpture evokes the shape of a wave or a chipping curling off a block of wood. Constructed in several sections by a metal-working foundry, there were problems with the final construction on site which delayed its completion, and the artist had to finish the work herself. The piece has been covered in a paint which is supposed to be illuminated with ultra-violet light to be seen at its best effect, but the lighting has never been put in place. The sculpture has been defaced with graffiti at its base.

1. *Express and Star*, 14th April 1992; 2. P. Keenan, *Mail*, 24th July 1992.

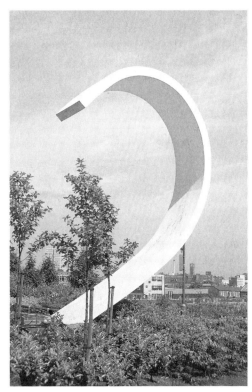

Gregory, *White Curl*

Digbeth High Street

CENTRAL SOUTH

Digbeth Institute, façade

Allegorical Figures

Gibbs & Canning

*c.*1909
Terracotta
Each: 165cm high
Status: not listed
Condition: fair. Some disintegration of surfaces
Owned by: Digbeth Institute

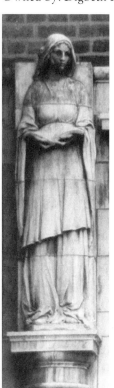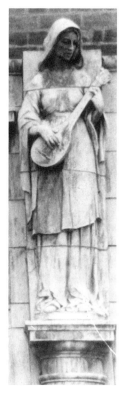

Gibbs & Canning, *Allegorical Figures*

Six female figures, each placed upon a pilaster, bear attributes indicating the social purpose for which the Institute, opened in 1908, was intended. Two hold opened books and two have musical instruments. There is a third musician but her instrument is now missing. The other figure holds a purse, representing the public charity that enabled Carrs Lane Church to build the Institute.[1] Modelled in stone-grey terracotta, graceful in a late Symbolist, almost Art Nouveau style, attenuated and gently curvaceous, they are most probably the work of John Evans, chief modeller for Gibbs & Canning. The original architectural drawings, designed by the architect Arthur Harrison, do not include the figures.[2] It is probable then, that these were added to the design the following year.

1. *Official Opening Programme*, Birmingham, 16th January 1908; 2. *Proposed central mission for south Birmingham in connection with Carr's Lane Chapel*, Birmingham, 1906.

(See illustrations p. 55)

Dudley Road WINSON GREEN

Dudley Road Hospital, Casualty and Out-patients Department, exterior wall

Compassion

John Bridgeman

1968
Bronze
366cm high
Inscribed on plaque beneath: COMPASSION / By John Bridgeman / Unveiled & presented to Dudley Road Hospital / by the Right Honourable Edward Short, M.P.I.P; on the 10th November 1968 / This sculpture was made possible by the special / personal appeal of Mr. J. Birkmyre Rowan, T.D., J.P; President of the League of Friends / with donations largely from within the Hospital
Status: not listed
Condition: good
Owned by: Dudley Road Hospital

This monumental bronze sculpture of a Mother and Child is prominently placed on an external wall of the extension to Dudley Road Hospital, which was opened in 1966. As figurative sculpture it is one of the most traditional subjects and yet its form and relation to architecture show how this tradition has been interpreted in a modern way. The idea of a statue to give character to the new extension was suggested by the Hospital Management Committee in 1964. Originally to be placed in the planned Garden of Serenity, a wall location was eventually chosen.

Bridgeman, then Head of Sculpture at the College of Art, received the commission. Having a strong sense of tradition, he often worked on mother and child compositions using contemporary techniques. A maquette

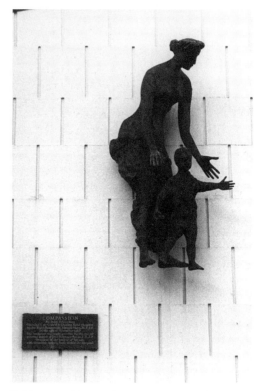

Bridgeman, *Compassion*

was produced in 1965, with the full-scale work being cast in 1968[1] and unveiled on 15th November of that year. Made of bronze, it is a rare example of architectural sculpture in this expensive medium. Costing £3,500, the work was paid for from a public subscription fund organised by the hospital's League of Friends over a period of three years.

Traditionally, a mother and child group has a Christian, religious association. However, here the arrangement of forms is suggestive of the sculpture's title which is more appropriate to a modern hospital. Instead of holding the child, like a Madonna figure, the woman stands behind the small

boy as he steps hesitantly away. Bending over him protectively, and with large, open hands, she appears to guide him gently out into the world. The woman's monumentality, together with her semi-classical appearance, notable in her Grecian hair-style, closely draped dress and serene expression, help to convey a universal idea of humanity. The impressionistic treatment of the figures, showing the coarse grain of the plaster model from which the bronze was cast and the spareness of detail, without allusion to realistic representation, places the work in the modern period.

Certain elongations and exaggerations of proportions also allow the work to be viewed from below. Located five metres above ground level, there is a strong contrast between the dark patina of the bronze against the white Portland stone wall facing. Without a specific setting, the sculpture has been pinned like a badge to the structural framework of the building. This use of sculpture on a building, made possible by new construction techniques, is similar to that made by Jacob Epstein in his architectural commissions of the 1950s, such as the figures of *Madonna and Child*, Cavendish Square, London, 1950 and *St. Michael and the Devil*, Coventry Cathedral, 1957. Bridgeman's figures, sculpted fully in the round, appear to defy the law of gravity and hover with no support from below. This independent relationship between the architecture and the sculpture makes little concession to the building, not being subordinate to the architectural scheme, but an individual contribution.

1. *Post*, 3rd October 1968.

The University of Birmingham obtained its charter in 1900, with its first buildings erected at Edgbaston 1901–9 on land given by Lord Calthorpe and his son. Centred around Chancellor's Court (see entries for University Road), the grounds cover at least 200 acres north-eastwards from Bristol Road, designed according to a 1957 plan by Hugh Casson and Neville Conder. Departmental buildings, sports fields and halls of residence are set amongst landscaped lanes and open spaces, all of which is publicly accessible.

Students' Union building, façade

Mermaid

William Bloye

1960
Clipsham stone
215cm high
Status: not listed
Condition: good
Owned by: University of Birmingham

Bloye was commissioned by the University to decorate the new extension of the Students' Union building, in a square that became appropriately known as Mermaid Court. He had been responsible previously for carving coats of arms elsewhere on University buildings. This relief was erected in July 1960, when Bloye described it as a 'free interpretation of the heraldic motif which forms part of the University *Coat of Arms*'.[1] Instead of the traditional comb and looking glass, the mermaid looks into a shell while combing her hair with a fishbone. The position of the body, with open arms and profile head together with simplified details

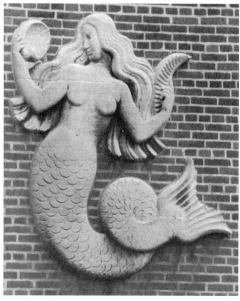

Bloye, *Mermaid*

of hair, face, bust and scales, emphasises the flatness of the relief which is only 6cm deep. Bloye was assisted with the carving of this piece by Raymond Kings.

1. *Mail*, 15th July 1960.

Students' Union building, Mermaid Court

Mermaid Fountain

William Bloye

1960
Bronze
Figure: 200cm high
Status: not listed
Condition: good
Owned by: University of Birmingham

Bloye was commissioned to design this fountain[1] as well as the Mermaid relief on completion of the extension of the Students' Union building in 1960.[2] A free interpretation of the mermaid from the University *Coat of Arms*, this figure has a blissful expression on her face which, together with the upward surge of her body and open arms worshipping the sun, expresses joy. The figure stands atop an elaborate two-tiered bowl, shaped like a scallop, which itself is in the centre of a shallow water-filled basin. Bloye was assisted in the carving by Raymond Kings,[3] and the piece was erected in 1961.

1. Bloye, *Ledger*, 9th August 1960, p.167; 2. *Guild news*, 22nd June 1961, p.3; 3. Letter from John Kings, 13th November 1985.

Grounds of Vale halls of residence

Two Figures

Dame Barbara Hepworth

1968
Bronze, partially coloured
245cm high
Status: not listed
Condition: good
Owned by: University of Birmingham

This sculpture was loaned to the University in 1971, arranged by the then Director of the Barber Institute, Professor Hamish Miles.[1] It consists of two over-life-size, attenuated figures, each of three sides, one pierced by two and the other by three holes. Typical of Hepworth's sculpture, they stand in close proximity and 'facing' each other. In such figure groups the artist is stated as hoping 'to discover "some absolute essence in sculptural terms giving the quality of human relationships"'.[2] Arrangements of two figures can be traced back to the first work of that name by Hepworth in 1947–8, although earlier versions date back as far as 1935. Painted blue in the hollows and with an applied patina streaking the surfaces, the work expresses the artist's abiding interest in

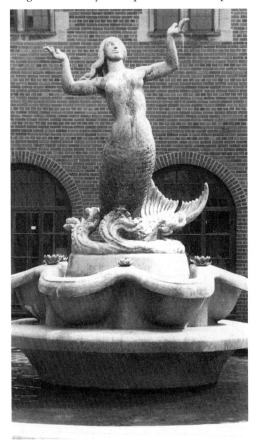

Bloye, *Mermaid Fountain*

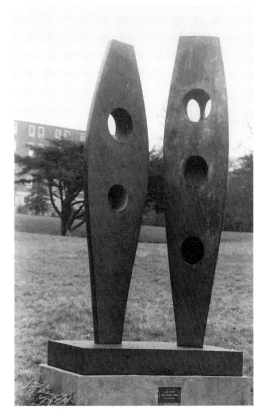

Hepworth, *Two Figures*

polished and patinated surfaces. Other casts of *Two Figures* are in the possession of the University of Southampton,[3] Wakefield Museum, the University of Oklahoma, the Hakona Museum, Japan and the National Development Commission, Canberra.

1. *University of Birmingham Bulletin*, no.138, 29th November 1971; 2. *Barbara Hepworth: retrospective exhibition 1927–1954*, Whitechapel Art Gallery, London, 1954, p.5; 3. Strachan, 1984, p.72.

Edmund Street CENTRAL CITY

Louisa Ryland House, entrance hall

Family Group

William Bloye

1959
Bronze
90cm high
Signed on pedestal: William Bloye 1959
Status: not listed
Condition: good
Owned by: City of Birmingham

This group statue was commissioned at the end of 1958 for the new Housing Management Department at Bush House, Broad Street, which had opened on 27th March that year.[1] It was moved to its present site in February 1990. When the sculpture was unveiled in 1960 the nudity of the figures caused a slight upset, recorded in the local press,[2] though the work was awarded the Otto Beit medal. It shows an idealised representation of a nuclear family – the father protective, the mother attentive – and it was undoubtedly intended to echo the optimism of the welfare function of the department. Although there were no directly similar groups in Birmingham at this time, it is interesting to note a tendency to incorporate a social symbolism in public sculpture (see Epstein's *Social Consciousness*, a bronze group of 1956, now in Fairmount Park, Philadelphia). Although in a fairly naturalistic style, the mother's facial features in particular are represented with a bold and simple classical appearance. The baby in front is very similar to *Childhood*, carved in 1934 for the Carnegie Welfare Institute.[3] The

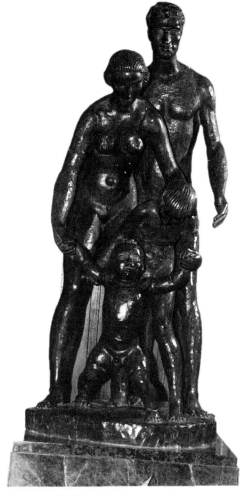

Bloye, *Family Group*

original plaster mould is in store at the Birmingham Museum and Art Gallery.

1. *Despatch*, 9th December 1958; Bloye, *Ledger*, 5th February 1960, p.166; 2. *Despatch*, 27th April 1960; *The Times*, 28th April 1960; 3. Royal Society of British Sculptors, *Annual Report and Supplement*, 1960, p.8 and ill. p.23.

Five Ways CENTRAL WEST

Five Ways roundabout, sunken pedestrian piazza

Impulse

Alex Mann

1972
Stainless tubular steel, on concrete plinth
1500cm high
Status: not listed

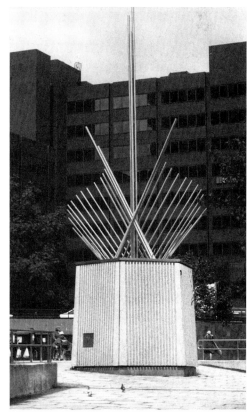

Mann, *Impulse*

Condition: good
Owned by: City of Birmingham

Commissioned as part of the Five Ways road development scheme, half the estimated cost of £10,000 was paid for by local industrial sponsors, T.I. Stainless Tubes Ltd., and the remainder by the City Council under the direction of the Public Works Committee and the City Engineering Surveyor and Planning Officer. Completed in 1972, it was unveiled on 29th June 1973.[1] Intended to represent the engineering and industrial image of Birmingham, renowned for its tube manufacture, the rods are displayed at differing lengths and angles and underlit at night to reflect their metallic surface. Forming a fan shape, they express, according to the artist, the 'Impulsive, most modern city in Europe, thrusting forward, upward...its Ringways, over and underpasses, the Bull Ring, etc.'.[2]

1. Birmingham Information Bureau, May 1977, p.26; *Post*, 30th June 1973; 2. Letter from the artist, 22nd April 1985.

Fire Station exterior
Fire Fighters

Robert Pancheri

1954
Stone
100cm high
Status: not listed
Condition: good
Owned by: Birmingham Fire Brigade

This sculpted panel was commissioned by the City Architect A.G. Sheppard-Fidler for the new fire station.[1] Although twenty-nine years separate the work of master and pupil, Pancheri's design strongly recalls William Bloye's *Front Line* (Hall of Memory, Centenary Square, q.v.) in the pose of the firemen leaning into the flames at the left. The convex ladder wheel is a reflection of *Front Line*'s concave trench debris and each has a rhythm of legs and equipment on a diagonal across the composition.

1. Information provided by the artist, 24th February 1986.

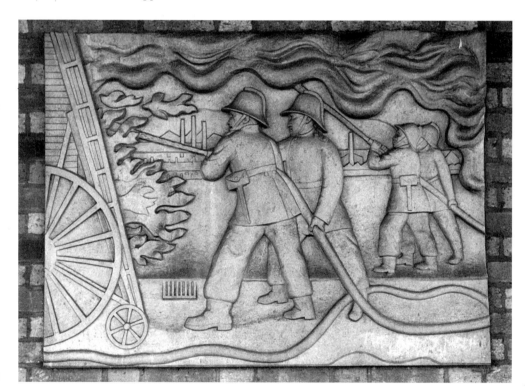

Pancheri, *Fire Fighters*

Custard Factory, interior courtyard on wall above pool

Dragon

Tawny Gray

1993
Mild steel
1500cm long
Status: not listed
Condition: good
Owned by: Custard Factory

Commissioned by the Custard Factory, an arts centre developed in the former Bird's factory buildings, Digbeth, this sculpture was started in February 1993 and completed in May.[1] Inspired by the ancient derivation of the word Digbeth from 'dragon's breath',[2] it is constructed out of mild steel parts, which were then sanded down before being painted with multiple layers of acrylic to create the iridescent green and gold effects. Local school children were invited to the unveiling of the work, when custard pies were the main menu item and members of staff from the Custard Factory performed a story about dragons for the children.[3] Clinging to the wall like a lizard, the dragon is a finely detailed piece providing an interesting focal point for users of the work spaces around the courtyard.

1. *Mail*, 18th June 1993; 2. *The Custard Factory Manifesto*, no.1, Birmingham, 1996; 3. Letter from the artist, 8th February 1994.

St. Mary and St. John's church, on top of tower

St. John

Raymond Kings

1962
Ciment fondu

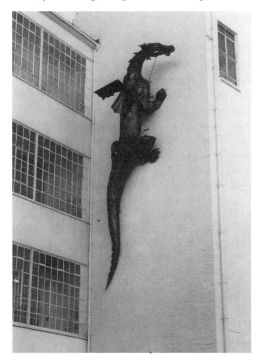

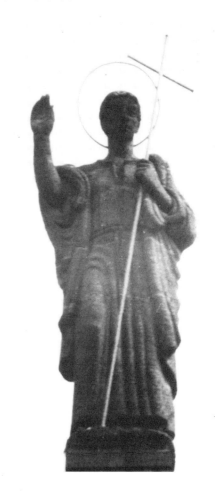

Gray, *Dragon* Kings, *St. John*

490cm high
Status: not listed
Condition: good
Owned by: St. Mary and St. John's church

Commissioned by Allied Artists, the statue decorates the tower, which, together with the south transept, was added to the original church by the architect G.B. Cox in 1961–2. The figure of St. John, holding a cross in his right hand, was modelled and cast by Kings who had a local studio.[1]

1. Letter from Henry B. Joseph, Allied Artists, 15th April 1985; Letter from Canon Withers, Cathedral House, 13th October 1983; Letter from the artist's son, John Kings, 13th November 1985.

St. Mary and St. John's church, over south transept door

Madonna and Child

Raymond Kings

1962
Artificial stone
100cm high × 70cm wide
Status: not listed
Condition: good
Owned by: St. Mary and St. John's church

This relief plaque was commissioned to decorate the south transept, added to the existing church in 1961–2 by local architect G.B. Cox.[1] It was cast from a wood carving designed by Cox in 1953 for St. Peter's School, Bromsgrove, which was originally produced by Bridgeman and Sons of

Kings, *Madonna and Child*

Lichfield.[2] It was probably based on a 16th-century Netherlandish depiction of the Virgin and Child.

1. Letter from Canon Withers, Cathedral House, 13th October 1983; 2. Information provided by Harrison and Cox, architects, 1985.

Birmingham Museum and Art Gallery, Feeney Gallery extension

Allegories of Art and Industry

William Bloye

c.1919
Stone
280cm high
Status: II*
Condition: fair. Some discolouration
Owned by: Birmingham Museums and Art Gallery

The figures, placed either side of the Birmingham *Coat of Arms* shield, decorate the Great Charles Street entrance to the Feeney Gallery extension which was built as a result of a bequest of £50,000 for that purpose by John Frederick Feeney in 1912. The extension was designed by the architects H.V. Ashley and Winton Newman, the first section being completed in 1912 and discussed in the *Architectural Review* of July.[1] At this time the Great Charles Street entrance was not finished. The Minutes of the Museum and Art Gallery Committee noted the satisfaction at the completion of the buildings in 1917,[2] after interruption by World War I; Pevsner gives the final date of completion as 1919.[3] Attributed to Bloye by one of his students,[4] these figures were thus produced at the beginning of his teaching career in Birmingham and reflect the training he received at the Royal College of Art a few years earlier, pre-dating his studies with Eric Gill. The monumental, largely symmetrical female figures complement the Edwardian Renaissance style of the building.

Bloye, *Allegories of Art and Industry*

Aesculapius

William Bloye

*c.*1931
Stone
75cm high × 220cm wide
Status: not listed
Condition: good
Owned by: Birmingham Chest Clinic

Decorating the portico to this plain building designed in 1930 by F.J. Osborne,[1] this panel shows Aesculapius, the Greco-Roman god of medicine, bearded and seemingly winged, holding a caduceus, which is commonly confused with his proper attribute, a staff. He also holds a bowl from which a serpent drinks, which is more properly the attribute of Hygeia, the goddess of health who was

Bloye, *Aesculapius*

The allegorical figures probably represent Art and Industry, considering their positions on each side of the Birmingham *Coat of Arms*; on the right, the woman holds a palette, while the figure on the left, which should conventionally be male, holds an unidentified mechanical object behind which is a globe.

1. 'Birmingham Council House extension', *Architectural Review*, vol.32, July 1912, pp.37–47; 2. Birmingham Museums and Art Gallery, *Committee minute book*, November 1912 – November 1917, March 1917, p.2; 3. Pevsner, 1966; 4. Robert Pancheri, in conversation.

believed to be Aesculapius' daughter and then later his wife. Earlier than Bloye's relief of Aesculapius on the Medical School, Vincent Drive (q.v.), this panel is a more simple representation carved in bold relief. Stylistically attributed to Bloye,[2] the details are clear and characteristically expressive, the deportment of hands and the overlapping layers of the wings and robe are well carved, as is the name of the clinic inscribed on the lintel below.

1. *BRBP,* 1930, no.51751; 2. Information supplied by D. Hickman, 13th November 1985.

Charles House

Relief Portraits

Sculptor unknown

Based on photographs by A.E. Harris

*c.*1939
Stone
Each 80cm high × 30cm wide
Status: not listed
Condition: good
Owned by: not known

Six low relief portraits decorate the lower façade of this office block, a few doors eastward from the Chest Clinic. Clockwise from top left, the portraits are of: George A. Beatton; C.B. Hearne; Sir John Barran; John Walter Hills; Clement Kinloch-Cooke; and Lord Rathcavan.

Mail, 12th July 1939; *Birmingham Weekly Post*, 13th August 1954.

Anon, *Relief Portraits* (detail)

St. George's Gardens, formerly St. George's churchyard

Monument to Thomas Rickman

R.C. Hussey

1845
Sandstone
450cm high
Status: II
Condition: poor. Badly weathered with lettering obliterated and moss covering the crumbling stonework
Owned by: City of Birmingham

Hussey, *Monument to Thomas Rickman*

Subscribed for by several of his friends and designed by Hussey, Rickman's partner, this monument is suitably in the Gothic style. Rickman (1778–1841) was an expert on Gothic architecture, having had published in 1817 the first ever treatise discriminating styles of English Gothic architecture, employing for the first time the familiar terms of Norman, Early English, Decorated, etc. Beginning his career in Liverpool in 1807 he became a well-known church builder, especially in the West Midlands, moving down to Birmingham in 1820. He designed several public buildings in particular, in the classical style, notably the Midland Bank, Bennett's Hill (1830). This monument is located in the churchyard of his first church in Birmingham, which was demolished in 1960, as have been so many other of his buildings. Very dilapidated, it consists of a single pointed canopied arch beneath which is a slab mounted upon a base carved with a simple waving band.

1. H. Colvin, *A biographical dictionary of British architects 1600–1840*, London, 1978, pp.688–93.

St. George's Church of England Comprehensive School, forecourt

Untitled

Graham Slann

*c.*1970
Concrete
150cm high
Status: not listed
Condition: good
Owned by: St. George's Church of England Comprehensive School

Slann, *Untitled*

A joint project, this abstract sculpture composed of three similarly pierced slabs of concrete on a cheese-shaped base was designed by Graham Slann, head of the art department at the school, which was built in 1968. It was cast by the head of crafts, possibly with the help of some of the school children.[1] It shows the influence of Barbara Hepworth, particularly works such as her *Two Forms (Divided Circle)*, 1969 (Dulwich Park).

1. Information provided by the Headmaster of St. George's, 1985.

Great Hampton Street

Rooftop of Pelican Works

Pelican

Sculptor unknown

White terracotta
130cm high
Status: not listed
Condition: fair. Dirty, with some pitting of
the surface
Owned by: not known

This large carving of a pelican adorns the
rooftop of the Pelican Works, built *c.* 1871, a
major factory on Great Hampton Street. The
general state of repair of the building is not
good, though the pelican itself seems to be in
good shape despite being dirty and to some
extent covered in guano. Depicted as a rather
fearsome bird, with a drawn-back neck and
outstretched wings, its long term safety is
probably at some risk.

Anon, *Pelican*

Gregory Avenue

Our Lady and St. Rose of Lima church,
exterior west wall

St. Rose of Lima

Michael Clark

1959
Portland stone
168cm high
Status: not listed
Condition: good
Owned by: Our Lady and St. Rose of Lima
church

Placed above the main entrance to the
church, this sculpture was commissioned by
the architect of the church, Adrian Gilbert
Scott,[1] with whom Clark had previously
worked.[2] He visited the site before carving
the statue in his London studio. The
columnar statue of Rose of Lima (1586–
1617),[3] a recluse who dedicated her life to
following Christ in his spirit and his suffer-
ings, is shown according to convention,
holding a crucifix, symbolic of her contem-
plation, and stands on a circle of thorns in
reference to the cruelty of her self-inflicted
penances.

1. Information provided by Revd C.J. Reily, 12th
March 1985; 2. Letter from the artist, 4th February
1985; 3. D. Attwater, *The Penguin Dictionary of
Saints*, Harmondsworth, 1965, p.300.

Clark, *St. Rose of Lima*

St. Mary's parish church

This church dates from the 13th century, though it was extensively altered in 1820 by William Hollins, and then enlarged 1876–80 by J.A. Chatwin. Best known as the resting place of Birmingham's three most famous industrialists, Boulton, Murdock and Watt, the church also contains a number of other quality monuments, principally by Peter Hollins or the Bennett company: *Memorial to John Freer*, William Hollins, 1808; *Memorial to Thomas Fletcher*, Peter Hollins, *c.*1827; *Memorial to Mary Maria Newton*, J. and W. Bennett, *c.*1833; *Memorial to Ann and Humphrey Evett*, J. and W. Bennett, *c.*1833; *Memorial to Nathaniel Gooding Clarke*, Peter Hollins, 1833; *Memorial to Joseph Grice*, Peter Hollins, 1834; *Memorial to Mary Whateley*, Peter Hollins, *c.*1836; *Memorial to Samuel Partridge*, J. and W. Bennett, *c.*1840; *Memorial to James Hargreaves*, J. and W. Bennett, *c.*1841; *Memorial to Sarah Russell*, *c.*1843, Edward Baily. The church is Grade II listed.

North aisle

Monument to Matthew Boulton

John Flaxman

1810–13
Marble
Bust: 57cm high; overall: 128cm high
Inscribed on plaque: SACRED TO THE MEMORY OF MATTHEW BOULTON F.R.S. / BY THE SKILFUL EXERTION OF A MIND TURNED TO PHILOSOPHY AND MECHANICS, / THE APPLICATION OF A TASTE CORRECT & REFINED, / AND AN ARDENT SPIRIT OF ENTERPRISE, HE IMPROVED, EMBELLISHED, AND EXTENDED / THE ARTS & MANUFACTURES OF HIS COUNTRY; / LEAVING HIS ESTABLISHMENT OF SOHO A NOBLE MONUMENT OF HIS / GENIUS, INDUSTRY AND SUCCESS. / THE CHARACTER HIS TALENTS HAD RAISED, HIS VIRTUES ADORNED AND EXALTED. / ACTIVE TO DISCOVER MERIT, AND PROMPT TO RELIEVE DISTRESS. / HIS ENCOURAGE-MENT WAS LIBERAL, HIS BENEVOLENCE

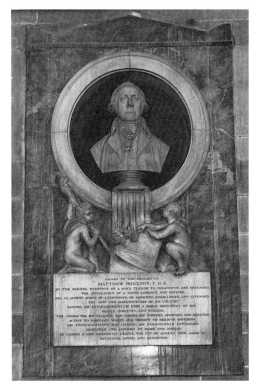

Flaxman, *Monument to Matthew Boulton*

UNWEARIED. / HONOURED AND ADMIRED
AT HOME AND ABROAD. / HE CLOSED A
LIFE EMINENTLY USEFUL THE 17TH
AUGUST 1809 AGED 81. / ESTEEMED,
LOVED AND LAMENTED.
Status: church listed Grade II
Condition: good
Owned by: St. Mary's church

The monument to Matthew Boulton, entre-
preneur, engineer and mechanical inventor,[1]
was commissioned by his son in February
1810.[2] Flaxman quoted 120 guineas as his
usual price for a bust in 1812 and the total
cost of the monument amounted to 300
guineas, which was paid by 1813.[3] The classi-
cally inspired monument shows Flaxman's
love of simplicity; the fine bust of Boulton in
contemporary dress is set within a tondo
below which are two winged baby angels.
One of them holds a lighted torch, an
emblem of immortality, and the other holds a
topographical low relief of Boulton's famous
Handsworth factory, inscribed SOHO,
together with a branch of olive, an emblem of
the peaceful arts.
 Flaxman had worked for Boulton since the
1770s[4] and elements of the Boulton monu-
ment were reproduced in an anonymous and
undated commemorative medal, struck at the
Soho mint. On the obverse of the medal is
depicted a draped profile bust of Boulton
which was taken from a wax model of 1803
by Peter Rouw. Beneath this are two cherubs,
one holding a torch and the other a palm
branch over a model of the Soho Mint
Factory. On the reverse is the monumental
inscription.[5] Gunnis noted a replica of
Flaxman's marble bust located in Tew Park.[6]

1. E. Delieb, and M. Roberts, *Matthew Boulton,
master silversmith, 1760–1790*, New York, 1971; H.W.
Dickinson, *Matthew Boulton*, Cambridge University
Press, 1937; 2. Letters in the Assay Office Library,
Birmingham; 3. N. Penny, *Church monuments in
romantic England*, London, 1977, p.177ff; 4. D. Irwin,
John Flaxman 1755–1826, London, 1979, p.231;
5. J.G. Pollard, 'Matthew Boulton and Conrad
Heinrich Kuchler', *Numismatic Chronicle*, 1970,
p.132; 6. Gunnis, 1964, p.149.

Watt Chapel

Monument to James Watt

Sir Francis Chantrey

1824–5
Marble statue on marble pedestal
Statue: 140cm high; overall: 284cm high
Signed on the left side of the chair:
CHANTREY SC1825
Inscribed on the pedestal: JAMES WATT /
BORN 19 JANVARY 1736 DIED AVGVST 1819
/ PATRI OPTIME MERITO F.M.P.
Status: church listed Grade II
Condition: good
Owned by: St. Mary's church
Exhibited: Royal Academy, 1824

This memorial statue of James Watt, famous
engineer and inventor of the separate
condenser who lived in Handsworth,[1] was
commissioned in 1820 by Watt's son,
'persuant to an approved sketch in clay'. It
cost £2,000 and was paid for in two instal-
ments by 26th May 1824.[2]
 This was the first of five statues of Watt by
Chantrey although he had already made a
much admired bust of him in 1814 which was
replicated in 1816, 1817 and 1822.
Acknowledged as one of Chantrey's finest

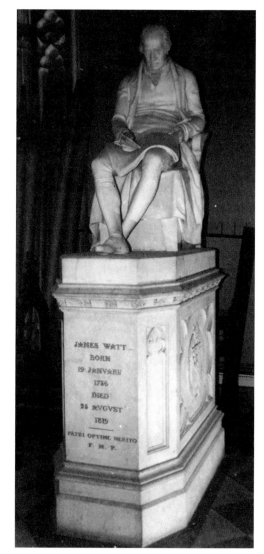

Chantrey, *Monument to James Watt*

works it was also his own favourite monument.[3] He portrayed Watt with a noble expression, deep in thought, holding dividers (now broken) in one hand and measuring a steam engine which is depicted on a large sheet of paper resting on his lap. The paper device which joins the legs, together with the simplified rendering of contemporary dress created the large, unbroken forms which Chantrey loved to use.[4] After exhibiting the statue at the RA in 1824,[5] Chantrey probably gave it some finishing touches, inscribing it in 1825. It was placed in Handsworth church in September 1827 on a neo-Gothic pedestal in a specially prepared chapel of the same style, both designed by the architect Thomas Rickman and carved by Williams and Peter Hollins.[6]

Contrasting with Chantrey's usual love for naturalistic detail, the pedestal has intricate, carved details and elaborate lettering and includes the only allegorical reference in the monument: Watt's crest, which comprises the club of Hercules crossed with the caduceus of Mercury as emblems of his power, commerce and ingenuity. The work has a quality of noble grandeur and in its setting was described by Pevsner as 'a genius left alone with his ideas'.[7]

Other marble statues of Watt by Chantrey are at Westminster Abbey, completed 1832; Glasgow (Hunterian Gallery), completed 1833; Greenock, 1835; a bronze statue was also produced for Glasgow in 1832.[8] The statue of Watt has undergone restoration and cleaning, and the fabric of the chapel was strengthened, in 1994–5.

1. E. Robinson, and A.E. Musson, *James Watt and the steam revolution: a documentary history*, London, 1969; 2. *Chantrey Ledger*, Royal Academy of Arts, London; 3. Gunnis, 1964, pp.91–6; 4. M. Whinney, *Sculpture in Britain 1530–1836*, Harmondsworth, 1964, p.221; 5. Graves, 1905; 6. Harman, 1885; 7. Pevsner, 1966; 8. N. Penny, *Church monuments in romantic England*, London, 1977, p.198.

Chancel

William Murdock

Sir Francis Chantrey

1824–7
Marble
75cm high
Status: church listed Grade II
Condition: good
Owned by: St. Mary's church

This bust, set on a low base, portrays Murdock (1754–1839), the famous inventor and pioneer of coal-gas lighting,[1] when aged about seventy, with hair receding from his temples and a noble and serious expression. His shoulders and chest are enveloped in a cloak and his throat left bare, a typical device used in romantic portraiture. The Chantrey Ledger records an order of a marble bust received on 31st March 1824 from Thomas Murdock of Soho, Birmingham, and its completion as a 'present to Mr Watt' on 23rd December 1827.[2] Chantrey executed only one bust of Murdock and as there is no record of a Thomas Murdock in Birmingham, it is generally assumed that the subject of this bust is William.[3] It was probably erected in Handsworth church shortly after Murdock's death in 1839. Placed on an inscribed shelf which bears his name and those of his sons, William (died 1831) and John (died 1862), it is framed within a

Chantrey, *Monument to William Murdock*

pointed blind-arch, the neo-Classical style of the bust contrasting with its neo-Gothic memorial setting. It is similar to the Matthew Boulton bust by Flaxman that faces it across the chancel. Another bust of Murdock, by Papworth after Chantrey, is in the Museum of Science and Industry, Birmingham.

1. J.C. Griffiths, *The third man, The life and times of William Murdock, 1754–1839*, London, 1992; 2. *Chantrey Ledger*, Royal Academy of Arts, p.168; 3. N. Penny, *Church monuments in romantic England*, p.182.

Five Ways, in front of the Swallow Hotel

Joseph Sturge

John Thomas

1862
Portland stone statue on a Portland stone
pedestal
180cm high
Status: II
Condition: fair. Some discolouration due to
weathering
Owned by: City of Birmingham

Joseph Sturge (1793–1859) was born into a
wealthy Quaker family in Gloucester and did
not move to Birmingham until 1822 when he
set up as a corn merchant. Elected an
alderman in Birmingham's first Borough
Council of 1838, it was his philanthropic
work towards the abolition of the negro slave
trade, his support of temperance, Sunday
schools and the establishment and funding of
the Midlands' first reformatory, which
earned him public commemoration and the
epithet 'Apostle of Peace'.[1]

 Costing £1,000,[2] this memorial was
unveiled on 4th June 1862, in front of 12,000
onlookers at the junction of the city and
Edgbaston, the district where he had lived.[3]
The sculptor died before completing the
figure of Sturge, who is shown as if teaching,
his right hand resting on a Bible. Set upon its
original base, a rare example in Birmingham,
the figure groups, carved in Portland stone,
consist of Charity, shown here as a woman
suckling a negro child (a reference to the
struggle against slavery), and Peace, shown

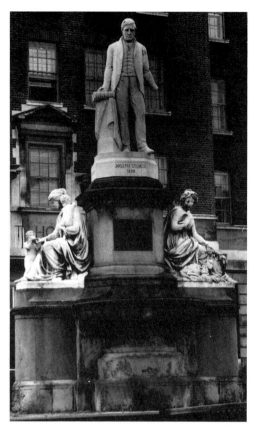

J. Thomas, *Joseph Sturge* (detail)

J. Thomas, *Joseph Sturge*

holding an olive branch, with a lamb
symbolic of innocence. The basin inscribed
'Temperance' is a symbol of the act of
charity, whilst the fountain dispenses a pure
and harmless drink. A newspaper article of
1885 tells how the right hand of the figure
fell off around ten years earlier, but makes
reference to Sturge being one of a number of
men 'who are beyond the ephemeral praise of
their age'.[4] The memorial was moved to its
present position in 1925, still near the orig-
inal site.

1. *Illustrated London News*, 14th June 1862; 2. Dent,
1880, p.563; 3. 'The Sturge memorial at Birmingham',
The Builder, vol.20, 21st June 1862, p.445; 4. *Mail*,
12th November 1885.

The Green Man public house, sign projecting over corner

Huntsman and Dog

William Bloye

c.1940
Wood, painted
Figure: 90cm high
Status: not listed
Condition: good
Owned by: Green Man pub

Although free-standing, this pub sign is set upon a corbel carved in approximation of a classical architrave and supported by a scrolled console, all of which is brightly painted. The figures of a man with a gun and a retriever with a dead bird in its mouth are carved as if compressed within the shallow

Bloye, *Huntsman and Dog*

space of a low relief panel. Bloye was paid £60 5s. 0d. for the sign, as part of the alterations to the pub from designs by the architect C.E. Bateman.[1] However, Alan Bridgwater, a former assistant, has also been credited with the carving of this work.[2] Both the dress of the man and the neo-primitive style of the carving refer to the early beginnings of this public house as a country village inn.

1. Bloye, *Ledger*, 23rd August 1940, p.94, invoice no.520; 2. Letter from Mrs B. Bridgwater, 22nd March 1986.

St. John the Baptist church, west wall exterior

Cross

John Poole

1975
Mild steel in box sections
300cm high × 335cm wide
Status: not listed
Condition: good
Owned by: St. John the Baptist church

In 1973 the new church (built 1959–60) was extended by the architects Kelly and Surman, using funds raised by the congregation. At this time Poole was commissioned to inscribe the text 'JESUS IS LORD' onto a stone panel for the newly arranged hall, and two years later, in 1975, he was asked to produce this cross for the west wall.[1] In style and material it is similar to his earlier cross at St. Mark's,

Poole, *Cross*

Kingstanding (1971), although the horizontal and vertical elements create a more severe geometrical shape which is enlivened by the decorative use of bolts and square-ended rods clustered around the centre.

1. Letter from the artist, 13th April 1984; Information provided by Mr. Clement, 12th November 1985.

Yardley Wood Public Library, tympanum over entrance

Spirit of Knowledge

William Bloye

c.1936
Stone
130cm high
Inscribed on book: SAPERE / AUDE
Status: not listed
Condition: good
Owned by: Yardley Wood Public Library

The library was designed by F.J. Osborne whose architectural drawings, dated April 1935, although not passed by the City Surveyor's office until November, show the tympanum blank except for the words 'carved pediment'.[1] Bloye charged £75 for the carving, completed by November 1936.[2] The most prominent image is the globe, supported below by two putti, one on either side of an open book carved with the inscription. The inscription translates as 'Dare to be wise'.[3] Although the compact, symmetrical

design is similar to that for Perry Common library (q.v.), the style of carving lacks the incisive quality of this earlier panel, and as there is no carver's mark it can only be surmised that it was carried out by one of Bloye's studio assistants.

1. *BRBP*, 1935, no.64474; 2. Bloye, *Ledger*, 27th November 1936, p.42, invoice no.255; 3. Horace, *Epistles*, I.ii.40.

Bloye, *Spirit of Knowledge*

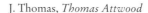

J. Thomas, *Thomas Attwood*

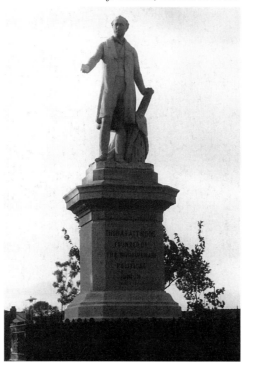

Larches Green

Thomas Attwood

John Thomas

1859
Sicilian marble statue on stone pedestal
Sculpture: 270cm high; pedestal: 500cm high × 200cm wide × 200cm deep
Inscribed on pedestal: THOMAS ATTWOOD / FOUNDER OF / THE BIRMINGHAM / POLITICAL / UNION
Status: II
Condition: poor. Badly weathered, fingers missing and other details lacking on figure; pedestal cracked and covered with green mould
Owned by: City of Birmingham

Although based in London, it was through his brother, a Birmingham architect, that the sculptor John Thomas had connections with the city, having already worked on King Edward VI Grammar School, New Street, and on St. Martin's church in the Bull Ring. Unveiled on 7th June 1859, his statue of Attwood cost £900,[1] considerably less than Peter Hollins' statue of Peel unveiled four years earlier. The figure stands on a granite column set on a base of York stone, in an oratorical pose. The marble has worn badly, due no doubt to pollution at its original site of Stephenson Place. Facial and other features are now irreparably damaged, including the lettering on a scroll which reads 'Reform' and the bands on the Roman *fasces*, a symbol of authority used to convey the idea of strength through unity, inscribed 'Liberty, Unity, Prosperity'. The statue was removed to Calthorpe Park in 1925 and

moved again to its present location, being 'unveiled' on 23rd September 1975 at a site near the house once occupied by Attwood.[2]

See the entry on Coppinger and Peever's *Attwood*, Chamberlain Square, for biographical details on Thomas Attwood.

1. Harman, 1885, p.291; Dent, vol.3, 1880, p.561; 2. Birmingham Information Bureau, May 1977, p.4; *Mail*, 30th August 1974.

Pedestrian underpass

Untitled

William Mitchell

1968
Concrete relief panels
All, approx: 300cm high; various widths from 1000cm to 2000cm wide
Status: not listed
Condition: fair. Some discolouration due to moss and vandalism
Owned by: City of Birmingham

Commissioned by the Public Works Department in conjunction with the architect J.A. Roberts, the abstract panels were intended to 'contrast with the rigidness and precision environment created by the viaduct and subways'[1] built as part of the development to improve the traffic route from Birmingham to Wolverhampton, which was opened in April 1968. Three design teams were invited to submit proposals and William Mitchell Design Consultants were selected. The panels cost £4,750 and were paid for from the Capital Account.[2] The decorative abstracts, composed of a variety of geometric shapes in relief, were formed by casting concrete *in situ* into expanded polyurethane moulds. When the moulds were removed the surface was treated with bush-hammers and then sandblasted and lacquered to make them weather- and vandal-proof. Two of the panels are made from Portland Whitestone cement and the third from terracotta-coloured cement.

1. 'They're the oddest and toughest', *Post*, 22nd March 1968, p.3; 2. *Sculpture in a city*, Cannon Hill Trust, Birmingham, May 1968, p.6.

Mitchell, *Untitled* (detail)

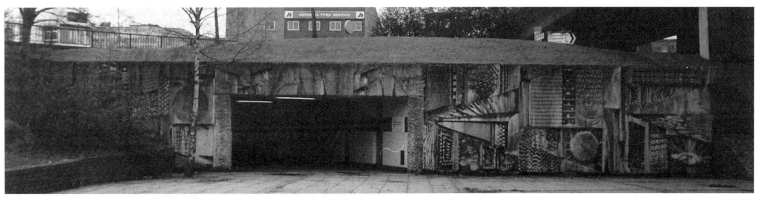

Pedestrian area in centre of roundabout
Hebe
Figure by Robert Thomas. Fountain designed by L.A. Howles

1966
Bronze
170cm long
Status: not listed
Condition: good
Owned by: City of Birmingham

This statue was erected by the Public Works Committee to commemorate the start of the inner ring road scheme around Birmingham, which began in 1957. The fountain as a whole was designed by L.A. Howles of the City Architect's Department. The figure was designed and made by the sculptor R.J. Thomas,[1] modelled on a young London dancer, Katterina Williams.[2] The total cost was £9,000. Hebe was a Greek goddess, the daughter of Zeus and Hera, the wife of Hercules and cupbearer to the gods of the Greek pantheon. She was also the personification of youth with the power to restore youth and vigour. Although the name has no clear association with the ring road, Hebe was chosen from names submitted by the public via a survey in the *Birmingham Mail*.[3] The statue was unveiled on 23rd April 1968 by the Lady Mayoress, Mrs Charles Simpson. It was removed for repairs to damage caused by vandalism in September 1981, completed by July 1982, and reset on a modified base on 20th May 1983.[4]

1. Birmingham Information Bureau, May 1977;
2. *Sunday Mercury*, 15th March 1981; 3. *Mail*, 20th July 1967; 4. Notes from the City Engineer's Department, 1982–3.

R. Thomas, *Hebe*

*Carnegie Welfare Institute, niche in the
centre of the façade*

Maternity

William Bloye

*c.*1923–6
Painted mahogany
170cm high
Stone tablet below the plinth is inscribed:
THE / CARNEGIE / INFANT / WELFARE /
INSTITUTE
Status: not listed
Condition: good
Owned by: Carnegie Welfare Institute

Designed in 1922 by a local architect, J.L.
Ball,[1] the Institute was opened in October
1923.[2] A photograph of the façade taken at
this time shows the niche empty, yet an
article in the *Architectural Review* of 1926
illustrates the statue 'designed and carved by
Bloye'.[3] The statue should therefore be dated
between these two dates. The carving of the
figure is well crafted with good details
sharply defined in the hard wood. It was
originally painted in subtle colours, the dress
decorated with a fine floral pattern, although
these are well hidden under the present,
rather crude paintwork. Like the statue,
whose hair and long shawl give it the appear-
ance of an Indian squaw, the carved lettering
below shows a concern for good craftsman-
ship. The *Coat of Arms* on the exterior was
also most likely executed by Bloye at the
same time as his commission for *Maternity*.
Though there is no evidence that it is his
work, it has stylistic similarities to other
coats of arms he executed.

Bloye, *Maternity*

1. *BRBP*, 1922, no.34109; 2. *Mail*, 28th August 1923,
p.2; 3. 'A craftsman's portfolio', *Architectural Review*,
vol.LX, no.361, December 1926, p.260.

Post Office, in store

Sir Rowland Hill

Peter Hollins

1868
Carrara marble
198cm high
Status: not listed
Condition: fair. Discolouration
Owned by: City of Birmingham
Exhibited: Royal Academy, 1868

This statue of Rowland Hill (1795–1879),
who was the instigator of the Penny Post in
1840, stands in contemporary dress holding a
roll of 'Queen's Heads' penny postage
stamps.[1] On the pedestal is a carved narrative
relief showing a postman delivering a letter,
and also a caduceus, an attribute of Mercury
the messenger of the gods. Rowland Hill
received many awards, including the Gold
Medal of the Society of Arts and the
Freedom of the City of London. The idea for
a statue of Hill came from James Lloyd, a
member of the Birmingham banking family,
in 1867, the same year a bust of Hill's brother
Matthew Davenport Hill had been sculpted
by Hollins. After the sum of £1,500 was
raised by public subscription, the commis-
sion was entrusted to Hollins who,
completing it in 1868, exhibited the statue
that year at the Royal Academy.[2] It was orig-
inally placed in the Exchange buildings,
Stephenson Place, in September 1870, but in
1874 it was removed to the main hall of the
newly-built head Post Office in Paradise
Street.[3] Subsequently placed in 1891 in the
new Post Office in New Street, in 1934 it was
erected on the forecourt of the Postmen's

P. Hollins, *Sir Rowland Hill*

Office, Edgbaston. Finally, in 1940, the statue was placed in storage for safety. The statue was 'rediscovered' in the early 1990s and briefly displayed in Victoria Square. However, it was subsequently removed and returned to store once more.

1. *Gazette*, 10th September 1870, p.7; 2. Graves, 1906, p.134; 3. Dent, 1880, p.571.

At the northern end of John Bright Street, near junction with Navigation Street

Untitled

Lee Grandjean

*c.*1986
Lepine lime stone
210cm high × 150cm wide × 60cm deep
Status: not listed
Condition: good
Owned by: City of Birmingham

This piece is placed at the entrance to John Bright Street, providing a focal point for the pedestrian walkway. The figure with massive legs and relatively small head is framed by toppling columns, like Samson grasping the pillars in the Philistine temple,[1] in celebration of his 'true God' over theirs. The sculpture may also refer to the struggle of the worker, as the artist was noted for his previous populist pieces. It also demonstrates how Grandjean 'allows human form to evolve and melt with other organisms and with other solid matter'[2] so that the individual is not seen as distinct from his or her setting.

1. *The Bible*, Judges 17 v.28; 2. D. Lee, 'The human touch', *Arts Review*, vol.40, 12th and 26th August 1988, p.585; T. Grimley, *Post*, 3rd December 1991; *Mail*, 17th February 1988.

King Edward Square
SUTTON COLDFIELD

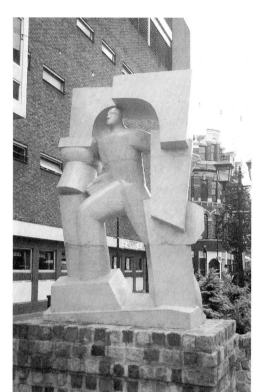

Grandjean, *Untitled*

In centre of square

War Memorial

Francis Doyle-Jones

1922
Bronze figure on a Dalbeattie granite
pedestal
Figure: 180cm high; pedestal: 460cm high
Inscribed on pedestal: ERECTED TO THE
GLORIOUS MEMORY OF THE MEN OF
SUTTON COLDFIELD WHO GAVE THEIR
LIVES IN THE GREAT WAR 1914–1919;
and THEY DIED THAT WE MIGHT LIVE
Status: not listed
Condition: good
Owned by: Sutton Coldfield District
Council

This memorial includes a statue of a soldier,
portrayed naturalistically in full battle dress,
on a stepped plinth which bears the inscribed
names of the town's war casualties together
with a carved emblem of crossed torches
entwined with a wreath, symbolising
freedom and fame. After much public debate
about the form of the memorial, this design
was selected by a Council Committee,
appointed in November 1919.[1] The figure
was intended to represent a 'private soldier,
the type of those who have gone from nearly
every home in the place and the symbol of
our common sacrifice. He should be graven
as he went up into the trenches and as he
came home on leave, with rifle, bayonet and
full kit, each thing an emblem of what he had
to do and to bear.'[2] The cost of the monu-
ment was met by a Voluntary Subscription
Fund, which had been inaugurated in May,
1919.[3]

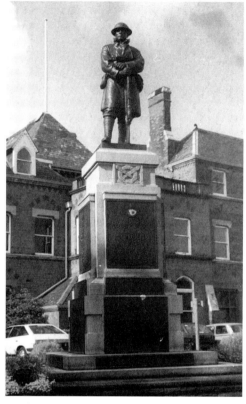

Doyle-Jones, *War Memorial*

After winning a competition, Doyle-
Jones, an established sculptor of war memo-
rials, prepared his full-sized clay model by
March 1922.[4] The commission included the
statue 'of the finest bronze', together with up
to three hundred name inscriptions as well as
the preparation of the site and plinth. He
agreed not to provide a similar statue
anywhere else in Warwickshire and no more
than two additional similar statues in any

part of the United Kingdom. Contracted to complete the memorial by 31st August 1922 he was paid £1,650.[5] The bronze was finished by July 1922[6] and, after a delay on the part of the stonemason, the memorial was officially unveiled on 1st November 1922, the sculptor being present.[7] Having suffered damage, the memorial was last restored in 1979.[8]

1. *Sutton Coldfield News*, 8th November 1919; 2. Letter from K. Rathbone, *Sutton Coldfield News*, 22nd July 1919; 3. 'Voluntary fund inaugurated', *Sutton Coldfield News*, 10th May 1919; 4. Letter on file from the artist to Mr. Ellison, 14th March 1922, in Sutton Coldfield Reference Library, *Francis William Doyle-Jones, Correspondence – Sculptor of Memorial in King Edward Square*; 5. Draft agreement for the erection of a War Memorial or Statue at Sutton Coldfield, between F.W. Doyle-Jones and the Mayor, George Richard Hooper, datable to March 1922, ibid.; 6. Letter on file from the artist, 7th July 1922, ibid.; 7. 'War memorial, Sutton Coldfield's tribute to the glorious dead – impressive scene', *Sutton Coldfield News*, 4th November 1922, p.7; 8. 'Monument to be Cleaned', *Mail*, 12th October 1979.

Ladywood Middleway
LADYWOOD

Opposite junction to St. Vincent Street West, on central reservation

Blondin

Paul Richardson

1995
Steel plate, patinated with zinc and bronze spray
Figure: 300cm high; pedestal: 450cm high
Raised lettering on both sides of sign hanging from sculpture: SHOPS
Status: not listed
Condition: good
Owned by: City of Birmingham

This statue of Charles Blondin, the 19th-century French stuntman, was commissioned in 1992 by the Ladywood Community Forum, a residents' group, as part of the Ladywood regeneration project which began in 1990. Blondin was internationally famous for stunts including crossing Niagara Falls on a tightrope. His connection to Birmingham was that on 6th September 1873, he tightrope walked across the Edgbaston reservoir. There is a story which claims that the 3,000 metre-long rope was not tight enough and during the crossing it sagged so low that Blondin had to cross part of the way underwater.

The commission was handled by Joe Holyoak of Axis Design, who was the architect responsible for the refurbishment project.[1] Birmingham artist Paula Woof was commissioned by the Ladywood Community Forum to carry out various pieces of artwork for the shopping centre. She worked on the overall concept of local legends, and subcontracted artist Paul Richardson to design and fabricate this particular piece.[2] It was made

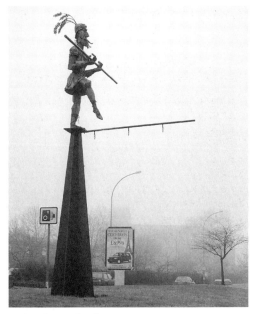

Richardson, *Blondin*

by Richardson at Floodgate Studios, Birmingham, by welding steel plate which was then metallised and patinated.[3] It is a caricature image of the famous stuntman, derived from Richardson's interest in cartoon imagery and satirical artists such as John Heartfield and George Grosz and as such is a theatrical and eye-catching feature.

The cost of the statue was £5,000,[4] and the funding for the project came from the now defunct Inner City Partnership and BIOP (Birmingham Integrated Operations Programme). It now carries a sign directing people to the shopping centre which is on the other side of the road.

1. Information supplied by Joe Holyoak, Axis Design, Birmingham, telephone conversation, December 1995; 2. Letter from Paula Woof, 7th February 1996; 3. Letter from the artist, 20th February 1996; 4. *Express and Star*, 12th February 1994.

90 Lancaster Street, Children's Hearing Assessment Centre, over the main entrance

Mother and Child and Young Child Playing

William Bloye

*c.*1935
Stone
Two panels, each: 84cm square
Status: not listed
Condition: good
Owned by: Children's Hearing Assessment Centre

These two panels form the only sculptural decoration on the exterior of the square-fronted brick building, which was designed by the architects Ewen Harper and Brother in 1933.[1] The building was opened in May 1935 when Bloye charged the architects £59 16s. 3d. for his carved panels, which depict a mother holding up a baby, and a young child playing.[2] Both panels project forward of their plain stone surrounds, which are framed by bricks placed end on to the panels, drawing attention to them. Although uncoloured, the sculpture is rhythmically and intensely linear, and the sinuous shapes contrast with the background and rectilinear brick façade. Quite possibly carved by one of Bloye's assistants, they still portray Bloye's usual tight and considered composition and subtle gradation of relief.

1. *BRBP*, 1933, no.57877; 2. Bloye, *Ledger*, 9th May 1935, p.25, no.144.

Ladywood Community Centre, exterior wall

Untitled

John Poole

1967
Concrete panel
325cm high × 285cm wide
Status: not listed
Condition: good
Owned by: Ladywood Community Centre

Commissioned by the City Council in 1967, Poole worked in collaboration with the architect of the community centre, Frank Norrish.[1] The concrete relief clads the cantilevered wall end and was cast *in situ* from polystyrene moulds. The angular

Bloye, *Mother and Child*

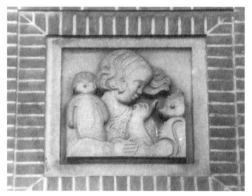

Bloye, *Young Child Playing*

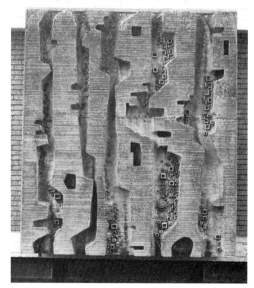

Poole, *Untitled*

vertical elements of the design, left with a rough texture, are contrasted with the deep furrows in between which have been decoratively clustered with small jewel-like images, made from impresses of mechanical parts such as springs, nuts and square-ended tubes. Although abstract, the vertical forms are suggestive of a group of figures, perhaps in reference to the function of the building as a community centre.

1. Letter from the artist, 13th April 1984.

Holy Trinity Roman Catholic church, in tympana above west, south and north doors

Holy Trinity, St. Peter, Virgin and Child

Sculptor: Robert Bridgeman & Sons

Designed by: George Bernard Cox

1933
Stone
Trinity: 150cm high × 210cm wide; St. Peter, and Virgin and Child, both: 100cm high × 125cm wide
Inscribed below Holy Trinity: SANCTA TRINITAS VNVS DEVS
Inscribed around figure of St. Peter: UBI PETRVS / IBI ECCLIA
Inscribed either side of figure of Virgin and Child: MATER / SALVATORIS
Status: not listed
Condition: good
Owned by: Holy Trinity Roman Catholic church

The Holy Trinity Church was built by J.R. Deacon of Lichfield, and these three tympanum reliefs were designed by the architect G.B. Cox and executed by Keyle of Bridgeman and Sons. The largest of the three is over the west door and depicts the Holy Trinity, with two seated figures and the descending dove in the centre, while around the central group are angel heads and emblems of the Four Evangelists.[1] Over the south door is a half-figure relief of St. Peter bearing the key of heaven, standing behind an altar and in front of a large shell form, bearing the inscription. In the background to the left is depicted a ship in rough seas, and to the right the sun rising over mountains. The carving over the north door is a similar vignette of the Virgin Mary holding the infant Jesus, surrounded by flowers.

1. *Church Opening Leaflet*, 1934.

See entries under Bournville Lane for a general introduction to Bournville.

St. Francis of Assisi church, lunettes over north and south doors

Sermon to the Birds

William Bloye

1933
Oak wood
107cm high × 170cm wide
Status: II
Condition: good

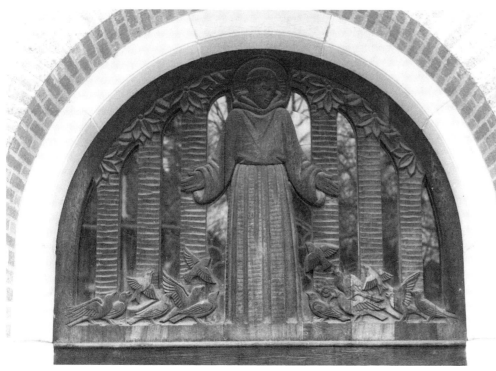

Bloye, *Sermon to the Birds*

Owned by: St. Francis church

In 1933[1] Bloye was commissioned by the Bournville Trust to carve the first of two lunettes over two porches which had been added to the main church that year, for which he charged £34.[2] Bloye had provided internal decorative sculpture, including the neo-Byzantine carving of the first four capitals in 1926, as well as architectural models and interior decoration for several buildings in Bournville, through his association with the Trust's consultant architects, Harvey and Wicks, who had built the church of St. Francis in 1923–6.[3] The tympanum shows the saint, in this well-known scene from his life, at the centre of a rigid though subtle symmetrical design. Three trees on either side create six lancet windows, whilst the branches overhead echo the round shape of the arch. Like his capitals inside, Bloye's carving is in low relief, showing a shallow yet continuously inflected surface detail, notably in the complex arrangement of fluttering birds and textured tree trunks, in keeping with the neo-Byzantine style of the church.

1. Bloye, *Ledger*, June 30th 1933, p.5, invoice no.28;
2. List of work from John Poole, 13th April 1984;
3. Pevsner, 1966, p.157.

St. Francis' Canticle to the Sun

John Poole

1964
Oak wood
107cm high × 170cm wide
Status: II
Condition: good
Owned by: St. Francis church

This pierced lunette relief decorating the south porch was commissioned by the Bournville Village Trust in 1964 to complement the lunette on the north porch.[1] Framed within the rounded neo-Romanesque arch, the glazed lunette depicts St. Francis gardening and illustrates his famous poem 'Canticle to Brother Sun'[2] in which he praises God for the Creation.[3] The cycle of nature is represented in the panel, the eye being directed from the left: the sun and fire heat the air, causing wind to blow

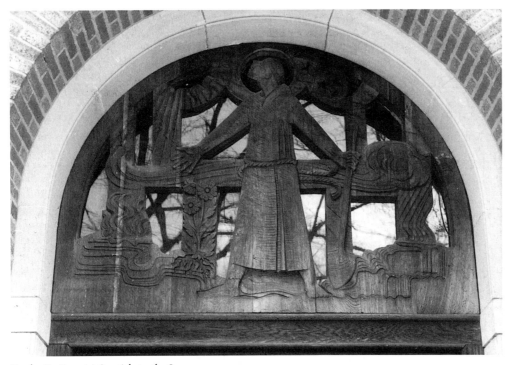

Poole, *St. Francis' Canticle to the Sun*

Bournville Junior School, beneath the first floor bay window

Dancers

Benjamin Creswick

c. 1905
Portland stone
84cm high
Status: II
Condition: good
Owned by: Bournville Junior School

There are five decorative panels in a frieze, each one framed by stone mullions continuing those of the windows above and below. Four of the panels show individual, classically draped female figures and the centre panel shows two female figures, all of whom dance amidst vines, flowers and fruits, celebrating the fertility of nature. This was an ideal central to the Arts and Crafts Movement which was a major influence on W. Alexander Harvey, the architect of Bournville Village, who built this school in 1902–5.[1] In his carving, Creswick exploited the hardness of stone to produce a concentration of finely incised details, notably in the folds of drapery. These encrusted details help the figures to stand out, contrasted against insignificant, plain backgrounds and emphasising their full-bodied roundness which is characteristic of Renaissance sculpture and typical of Creswick's style at this time.

1. W.A. Harvey, *The model village and its cottages*, Bournville, London, 1906; M. Durman and M. Harrison, *Bournville 1895–1914: the model village and its cottages*, Birmingham, 1996.

and rain to fall; a stream forms which nourishes the earth to produce flowers. It is significant that Poole chose to represent a sunflower, itself a symbol of the sun, which reaches up towards the sun and thus completes the cycle. The elements of the design are simplified and boldly stylised, producing a finely balanced and sophisticated composition. Often deeply carved, the grain of the wood has been used in an expressionistic way, characteristic of direct carving and the Arts and Crafts tradition.

1. Letter from the artist, 13th April 1984; 2. Italian text: *Ms.338*, Assisi Library, dated 1225, translated by Fahy, *Omnibus*, pp.130–1, reproduced in A. Fortuni's *Francis of Assisi*, New York, 1981, pp.567–8; 3. *Focus*, incorporating *Birmingham Christian News*, February 1965, p.6.

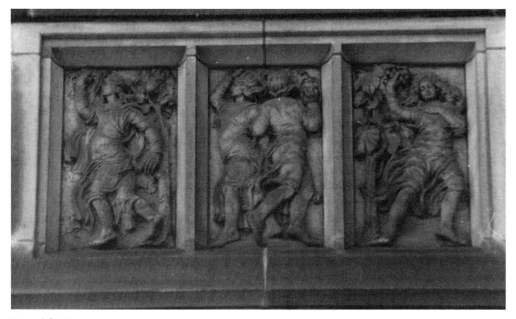

Creswick, *Dancers*

Friends' Meeting House, Bournville village green, alcove of outside wall

George Cadbury

Francis Wood

*c.*1922
Bronze
67cm high
Inscribed on pedestal: GEORGE CADBURY
1839–1922
Inscribed on slate slab below the pedestal:
BENEATH THIS STONE / LIES THE ASHES /

OF THE FOUNDER / OF THIS VILLAGE
Status: not listed
Condition: good, though pedestal
discoloured by staining
Owned by: Bournville Village Trust

Erected on 19th September 1924 in memory
of George Cadbury, who died in 1922. With
his brother Richard, he took over the family
firm in 1861 and in 1879 they moved it out to
Bournville, a rural site, and set about
building a model village for the Cadbury
workers.[1] The bust looks out from the

Wood, *George Cadbury*

Meeting House over the village green
towards the Cadbury factory.

1. A.G. Gardiner, *Life of George Cadbury*, London,
1923; I.A. Williams, *The firm of Cadbury 1831–1931*,
London, 1931; M. Durman and M. Harrison,
*Bournville 1895–1914: The model village and its
cottages*, Birmingham, 1996.

St. John's church, corner of Longbridge Lane and Turves Green, west front window mullions

Elijah, Isaiah, John the Baptist, Ezekiel, and Jeremiah

Sculptor: Robert Pancheri

Designed by: George While

1957
Oak wood
Five statues, each: 122cm high × 30cm wide × 25cm deep
Status: not listed
Condition: good
Owned by: St. John's church

These statues were designed to a small scale by George H. While, the architect of the church.[1] With their appropriate attributes they represent, from left to right: Elijah (with a raven); Isaiah (with a branch of a tree); John the Baptist (holding a Cross together with a lamb lying on a book); Ezekiel (with a double wheel symbolising the Old and New Testaments); and Jeremiah (with a scroll).[2] The arrangement of the four prophets leading upward towards a central figure of St. John was intended by While to be a visual expression of 'the gathering impetus of the Old Testament prophetic message which reaches fulfilment in the Baptist "making straight the way of the Lord"'.[3] Pancheri carved the designs at full size.

1. G.H. While, 'Design of the Church', *Contact*, no.21, December 1957, p.3; 2. J. Hall, *Hall's dictionary of subjects and symbols in art*, London, 1974, *passim*; 3. Letter from the artist, 27th August 1985.

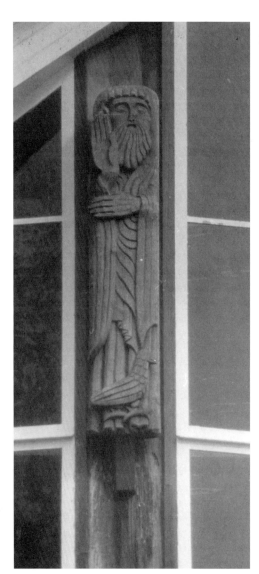

Pancheri, *Elijah*

Pancheri, *Isaiah*

Royal Oak public house, entrance tympanum

Royal Oak

William Bloye

c.1926
Painted stone
105cm high × 126cm wide
Inscribed below: THE ROYAL OAK
Status: not listed
Condition: good
Owned by: Royal Oak pub

Bloye, *Royal Oak*

The Royal Oak was designed in 1926 by the architect Holland Hobbiss[1] for Frederick Smith's brewery as new licensed premises.[2] Because the architectural drawings show details of a fanlight in the tympanum the carved relief was presumably made at a later date, probably at the instigation of the client. The branches, leaves and acorns are individually shaped, yet intricately worked to form a spreading oak tree whose rounded crown fits snugly into the shape of the arch. Superimposed on the tree is a regal crown, both projecting forward of a rising sun, a popular motif in this period. All these images are brightly painted, forming a good decorative foil to the red brick neo-William and Mary style building, as well as providing a suitably bold emblem. The inscription on the lintel below is well carved with a fine flourish at the end of the final letter. In all, this is a carefully considered and well-made relief.

1. *BRBP*, 1926, no.41157; 2. A. Crawford and R. Thorne, *Birmingham pubs 1890–1939*, Birmingham, 1975, p.25.

University of Central England School of Art, left-hand gable

Rose Window

Modelled by Samuel Barfield; King & Co. of Stourbridge

Designed by John Chamberlain

c.1885
Buff terracotta
364cm diameter

Chamberlain, *Rose Window*

Status: I
Condition: good
Owned by: University of Central England

In 1881, £20,000 and a site were donated to build a new School of Art, previously based in leased rooms in the Midland Institute in Paradise Street. As Chairman of the School

Chamberlain, *Elevation drawing of School of Art Building, Margaret Street, c.1885*

of Art since 1874, Chamberlain was an obvious choice for this commission and his plans were complete by summer 1883.[1] Although his partner William Martin took over the supervision of the work after Chamberlain's death in October 1883, the rose window was modelled to his original design by Samuel Barfield of Leicester.[2] The attention to detail and naturalistic floral subject matter exemplify the designer's belief in Ruskin's notion of 'truth to nature'; thus the lilies are accurately portrayed and sharply modelled. The panel was designed integrally with the building and typifies a characteristic of Chamberlain's work. Each square of the trellis is moulded with a section of lilies, so that as the trellis is built upward and outward, the lilies take form. The final piece was made and supplied by King & Co. of Stourbridge and erected by local builders William Sapcote and Co.[3]

1. *Post*, 29th November 1883; 2. *Post*, 12th September 1885; *Post*, 17th September 1887; 3. Hickman, 1970.

University of Central England School of Art, in the window arches on the side of the building facing Cornwall Street

Allegories of the Arts

Benjamin Creswick

1893
Red terracotta
Each 63cm high × 164cm wide
Status: I
Condition: good
Owned by: University of Central England

Made to decorate the first floor windows of

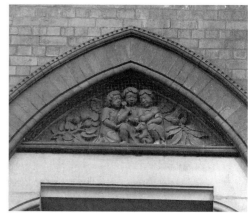

Creswick, *Allegories of the Arts* (detail)

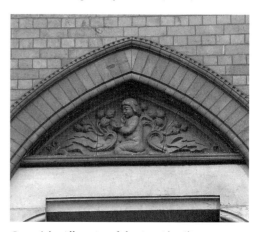

Creswick, *Allegories of the Arts* (detail)

the Cornwall Street extension of the School of Art, which was designed by the architect William Martin, the panels were completed ready for the formal opening on 9th September 1893. As modelling master at the school and also an enthusiast for the exten-

Melvina Road NECHELLS

sion, Creswick was an obvious candidate for the commission of this tympana sculpture. He was paid £150 for the panels, although he actually supplied a larger area of terracotta than was originally estimated, and he also promised to replace at no extra cost any terracotta which showed signs of decay within the first seven years.[1] Composed symmetrically, in the tradition of tympana, they consist largely of arrangements of Renaissance-styled putti amidst abundant floral surrounds, modelled almost in the round. They illustrate various arts: music, dance and drawing or book illustration can be seen, although several have now decayed beyond recognition. True to Ruskin's ideals, these panels emphasise the close relation between art and nature. Creswick's imaginative, stylised modelling differs from that on the original school building modelled and carved by Samuel Barfield, which is more closely identified with Ruskin's belief in sculptural decoration consisting of accurate imitation of nature.

1. Birmingham School of Art, *Committee minutes*, 12th September 1893, letter reproduced dated 25th August 1893.

Junction of Melvina Road and Saltley Road

Youth

Harry Seager

1959
Concrete sculpture on brick pedestal
213cm high
Status: not listed
Condition: good
Owned by: City of Birmingham

Commissioned by the Public Works Department in 1958, the sculpture was selected from several models put forward by the artist who was living in Smethwick at the time. Its cost of £370 was paid for from the Capital Account. When unveiled it was reported in the local press that the sculpture was to be 'but the first of a series of statues planned for the city's estates'.[1] Seager's piece represents youth in the form of an abstracted figure of a pony-tailed girl. Composed of large, simplified forms, it shows a debt to the modern movement in sculpture and particularly to the influence of Henry Moore's monumental, reclining nude figures.[2]

1. *Despatch,* 14th September 1960; 2. *Sculpture in a city,* Cannon Hill Trust, May 1968, p.6; Letter from the artist, 6th January 1986.

Seager, *Youth*

Metchley Park Road
EDGBASTON

Birmingham Women's Hospital, courtyard
Mother and Child
John Bridgeman

1972
Ciment fondu with copper-coloured patina
Statue: 170cm high × 60cm wide × 95cm
diameter; base: 67cm high
Plaque on pedestal reads: THIS STATUE HAS
BEEN PROVIDED / THROUGH THE
GENEROSITY OF / MRS L. ARTHUR SMITH /
GOVERNOR 1948–64 / MOTHER AND
CHILD / SCULPTOR J.A. BRIDGMAN
A.R.C.A. F.R.B.S.
Status: not listed
Condition: fair. Discoloured and covered
with guano
Owned by: Birmingham Maternity Hospital

Sited in a courtyard beneath the snack bar in
the main entrance area of the Women's
Hospital, this group was produced at the
sculptor's studio in Ufton and was
Bridgeman's third sculpture in Birmingham
to be based on the theme of motherhood.
Funded by a private donation, shortly after
the completion of the new maternity hospital
complex,[1] the work is a reddish-brown
colour and the cement-like material has been
left coarsely modelled. The seated figure is
treated naturalistically, having a contented
expression, and is raised on a bricked section
which forms the courtyard's garden.

1. *Mail*, 3rd October 1972.

Bridgeman, *Mother and Child*

Moseley Road BALSALL HEATH

*Swimming baths, corner of Edward Road
and Moseley Road*
Birmingham Coat of Arms
Hale & Son

1907
Plaster
100cm high × 150cm wide
Inscribed on scroll beneath: Forward
Status: II
Condition: good
Owned by: City of Birmingham

A well-preserved and highly coloured
Birmingham *Coat of Arms*, with the personi-
fications of Art and Industry in relaxed poses
leaning against the central shield.

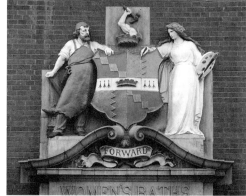

Hale & Son, *Birmingham Coat of Arms*

*Moseley and Balsall Heath Institute,
tympana of the six ground floor windows and
over the entrance*

Allegories of the Arts, with busts of Michelangelo and Shakespeare

Sculptor: Rowney

Designed by: William Hale

1879–83
Stone
Each: 50cm high × 100cm wide
Status: not listed
Condition: good
Owned by: Moseley Institute

Rowney, *Allegory of Music*

Rowney, *Allegory of Epic Poetry*

Designed by the local architect William Hale in 1879, although not completed until 1883,[1] the Institute is adorned with panels of figurative sculpture in the late Victorian Gothic style. They relate the function of the building to the artistic and social mores associated in the late 19th century with the Gothic style. The three craftsmen in the triangular pediment over the door, a spinner, blacksmith and metalworker, represent industries long associated with Birmingham. Closely flanked by busts of Michelangelo and Shakespeare,

representing the highest standards of artistic excellence, there is suggested a collaboration of Art and Industry that not only contributed to the commercial success of industries such as jewellery in Birmingham but also portray the idea that only through this commercial success could such an Institute be raised.

The six reliefs in the window tympana illustrate these kinds of activities available in the Institute. Representing Science, Literature, Art, Music, Poetry and Drama, they are intended to show these disciplines providing socially and morally beneficial

effects. The figures are depicted in medieval dress and settings which not only reflect the Gothic style of the building but also represent an expression of an artistic ideal. The Gothic style was seen as a means to express an idealised unity of the arts and crafts considered to have existed in the 14th century. Presenting these panels is an attempt to draw an image of the Institute and its activities as an equivalent to medieval guilds of craftsmen.

1. 'Provincial news', *The Builder*, vol.45, 3rd November 1883, pp.605–6.

Bloomsbury Public Library, above the windows

Allegories of Arts, Crafts and Leisure

Benjamin Creswick

1891–3
Buff terracotta
Small panels: 142cm high × 53cm wide; large panel: 276cm high × 90cm wide
Status: not listed
Condition: good
Owned by: Bloomsbury Library

The Library was designed by the architects Jethro Cossins and Peacock in 1890 and the foundation stone laid in 1891.[1] Creswick probably made the panels after the building was designed in 1890 and before its completion in 1893.[2] They run along the main façade of the library and illustrate various aspects of work, both industrial and rural, and leisure, including football, cricket, lacrosse and (more passively) reading. There are scenes of domesticity, showing childhood through to old age. The largest panel shows figures of Art, Craft and Industry presenting their wares to Birmingham, which is represented as a seated semi-nude, classically draped female, holding a mural crown in her lap and a laurel branch, the symbol of victory and achievement in the arts, in the crook of her arm. The figures are surrounded with fruit and flora, as well as armaments, which represent an industry of particular importance to Birmingham. Alongside the allegorical scene of the large panel, which is more in keeping with the style of the period, Creswick's illustration of contemporary figures and workaday realism is representative of his Ruskin-inspired attitude towards subject matter in public sculpture.

1. *BRBP*, 30th October 1890, no.17706; B. Little, *Birmingham Buildings*, Birmingham, 1971; 2. Beattie, 1983, pp.49, 241.

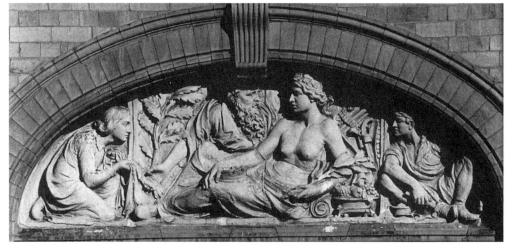

Creswick, *Allegories of Arts, Crafts and Leisure* (detail)

Public Baths, in the central arch

Birmingham Coat of Arms

Benjamin Creswick

1910
Buff terracotta
200cm high
Status: II
Condition: good
Owned by: City of Birmingham

The building was designed by Arthur Harrison[1] and was opened on 22nd June 1910, the third and last occasion on which Creswick worked for him. Creswick probably modelled the *Coat of Arms* earlier the same year. Placed in the terracotta central arch, its design follows that officially recognised in 1889 when Birmingham was designated a city. The two supporters are sharply detailed, portrayed with Creswick's familiar sinuous lines. At the base of Art, the female supporter, Creswick added a bust of Minerva, the goddess of the crafts and wisdom. He also added two shoots of bay laurel, symbolic of victory and referring here to the industrial and commercial success of Birmingham. They frame the shield and lead the eye up to the mural crown above.[2]

1. *BRBP,* 1907, No.19997; 2. V. Bird, 'Birmingham's neglected statuary', *Birmingham Weekly Post,* 19th February 1954.

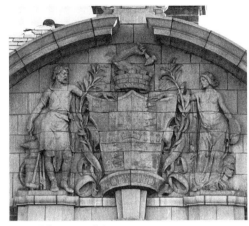

Creswick, *Coat of Arms*

Protheroe, *Bible and Hand*

Christadelphian Hall

Bible and Hand

Carved by J. Protheroe

Designed by W.E. Loxley

1968
Portland stone
152cm high × 139cm wide
Inscribed: 'Thy words were found... and thy word was unto / me the joy and rejoicing of my heart' Jer 15:16
Status: not listed
Condition: good
Owned by: Christadelphian Hall

Commissioned for the Christadelphian meeting rooms, built in 1968, th plaque was designed and the lettering carved by Loxley, a member of the North Birmingham Christadelphian Ecclesia. The main relief was carved by Mr. J. Protheroe, also an ornamental stonemason. The simplified elements of the panel depict an open book and hand and refer to the Christadelphian belief that the Bible is the inspired word of God which is to be referred to daily for guidance.[1]

1. Letter from R.F. Bownes for the North Birmingham Christadelphian Ecclesia, 28th March 1985.

Junction of New John Street and Great King Street

Monument to the Lucas Factory

Sculptor not known

1994
Slate: freestanding slab
300cm high × 60cm wide × 100cm deep
Inscribed in roundel: JOSEPH LUCAS & SON / 24 LITTLE KING ST. B'HAM / TOM BOWLING LAMP WORKS.
Inscribed around four faces: From small beginnings... LUCAS / INDUSTRIES / LIMITED / – ON THIS / SITE JOSEPH / LUCAS / ESTABLISHED / HIS / FIRST / WORKSHOP – / C.1872
Status: not listed
Condition: good
Owned by: City of Birmingham

A freestanding single slab of slate with a 120cm diameter circle of slate section set into the ground, within a block paving circle 300cm diameter, by the edge of a large roundabout. The Lucas factory was located to the north of this memorial on ground now closed for redevelopment. The texture varies across the stone from rough to smooth and the whole piece presents a very subdued memorial to what was a vibrant industrial area.

New Street Station, platform 6/7, west end

Iron Horse

Kevin Atherton

1987
Steel
180cm high × 240cm long × 1cm thick
Status: not listed
Condition: fair. Scratches and rust damage
Owned by: Railtrack Plc

One of twelve horses sculpted by Atherton and installed along the railway track from Birmingham to Wolverhampton. They were commissioned in a collaboration between West Midlands Arts, British Rail and four local authorities, at a total cost of £12,000.[1] Drawing on Eadweard Muybridge's photographs of horses in motion, each horse is different in relation to its position along the route, and this particular one is captured at a slow walk, heading off the end of the platform. The name is a pun on the 'Iron Horse' description of early trains, and the pieces are meant to keep the passengers' interest along a length of track which is not particularly attractive.[2] An article at the time of their installation said that 'they move and pass you by like triumphant vestiges of the industrial life they embody and which was once a vibrant part of this area'.[3] In this way they are precursors of the 'post-industrial monuments' installed in the city in the early 1990s, such as Gormley's *Iron:Man*. These sculptures won an Independent/Gulbenkian Foundation award for the arts in 1991, as recorded on a nearby plaque.

1. T. Grimley, 'On track for living art', *Post*, 13th

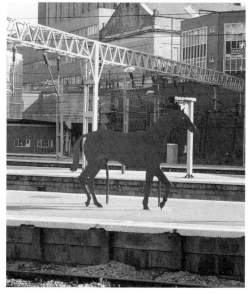

Atherton, *Iron Horse*

March 1987; 2. *Mail*, 21st August 1986; *Mail*, 13th November 1986; 3. T. Sidey, 'British Rail passengers looking out of their window are in for a big surprise', *Arts Review*, 24th April 1987, p.263.

The Royal Birmingham Society of Artists building, corner of New Street and Victoria Square, entrance portico

Two Name Plaques

William Bloye

1919
Bronze
150cm high × 69cm wide
Raised lettering on each: ROYAL / BIRMINGHAM / SOCIETY / OF / ARTISTS / FOUNDED 1814

Inscribed bottom right: W. Bloye 1919
Status: not listed
Condition: good
Owned by: Royal Birmingham Society of
Artists

This is the earliest known example of Bloye's
sculpture in Birmingham and the only one
made before he worked with Eric Gill. The
two plaques were commissioned for the new
building erected in 1913 which replaced
Rickman's original one of 1829.[1] Made
immediately after World War I, they were
not erected until 1919.[2] Although Bloye was
not a member of the RBSA until 1930, as
head of sculpture at the Birmingham School
of Art from 1919 he was an obvious candi-
date for the commission, as the School was
born out of the Society in the mid-19th
century, and there is a long history of close
contact between them. The plaques have a
Royal *Coat of Arms* at the top, with a collec-
tion of artist's materials grouped around a
palette at the bottom. Although the relief
carving is detailed and well modelled, with
lettering, prominently raised and enamelled
white, the modelling is uneven and inconsis-
tent which contrasts with his later work,
clearly showing the particular value and
influence upon Bloye of Gill as a letter
carver.

1. J. Hall and W. Midgley, *History of the Royal
Birmingham Society of Artists*, Birmingham, 1928;
2. Information given by the Secretary of the Royal
Birmingham Society of Artists, 1985.

Bloye, *Name Plaque*

*56 and 60 Newhall Street, third storey of
façade*

St. George and the Dragon (see illus-
tration overleaf)

William Neatby

1900
Buff terracotta
Four panels, each: 175cm high
Status: II*
Condition: good
Owned by: not known

All four panels show a standing figure
grasping the neck of a serpent whose body is
coiled around the figure's legs. One pair
being the mirror image of the other pair, the
panels are arranged alternately between bay
windows, in each case the serpent with its
back against a quoined terracotta pilaster.
They are the main features in an array of
terracotta decoration which includes a
dolphin's head above each doorway. The
style of modelling shows similarities to
Neatby's terracotta for the City Arcade
designed at about the same time and made by
Doulton's.[1] The imagery bears little relation
to either the purpose of the building or the
original clients, for whom Newton and
Cheatle designed the building in 1899–1900.[2]
However, it does reflect the moral symbolism
prevalent in the Arts and Crafts Movement
in this period and that notably associated
with Ruskin's St. George's Guild.

1. A. Crawford, *Tiles and terracotta in Birmingham*,
Victorian Society, 1975; 2. *BRBP*, 1900, nos. 15370
and 17719.

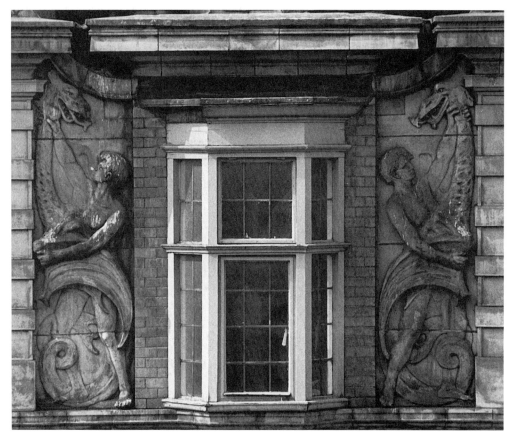

Neatby, *St. George and the Dragon* (see previous page)

Outside the Crown Courts

Wattilisk

Vincent Woropay

1988
Black Indian granite
430cm high × 70cm square
Status: not listed
Condition: good
Owned by: City of Birmingham

Unveiled on 16th March 1988,[1] this sculpture carved from black Indian granite has affinities with both Egyptian obelisks and the

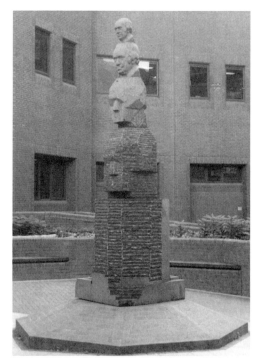

Woropay, *Wattilisk*

anthropomorphic structure of Native American totem poles. Its five surmounted portrait heads each at a different stage of abstraction are based on Sir Francis Chantrey's neo-Classical bust of the Birmingham scientist and inventor James Watt, which is now in the City Museum and Art Gallery.[2] The image and title of the work has obvious links to its surroundings (being next to Watt Street) and to the city's history. The successive reduction and increasing fine finish visible in the piled-up heads allude to the machines that Watt developed late in life for the making of larger or smaller copies of sculpture, each being the same proportion to the one above.

1. T. Grimley, 'Sculpture is chosen for new court', *Post*, 19th February 1987; M. Higgins, 'Lovers of sculpture are poles apart', *Post*, 17th March 1988; 2. Birmingham Museums and Art Gallery, *Public Art in Birmingham Information Sheets*, Birmingham, 1994.

Waste ground beside canal

Icarus

Juginder Lamba and Tony Phillips

1990
Wood and stone
200cm high × 300cm square
Status: not listed
Condition: poor. Stone figure covered with graffiti; wooden sections vandalised
Owned by: City of Birmingham

Situated on the canal side in the shadow of Winson Green prison, this piece was made as a collaborative project with local school-children, and combines a figure carved from stone with four columns carved from wood with other wooden poles acting as a sort of base. There is no allusion to the fate of Icarus in the work, which seems to fit more into the mould of an idol surrounded by totem poles. The work, especially the blandly smiling figure, is disfigured with graffiti and is now inaccessible behind high walls and locked gates in a run-down area of waste land.

Lamba and Phillips, *Icarus*

Selly Oak Hospital, front gardens of out-patients department

Compassion

Uli Nimptsch

1963
Bronze statue on concret pedestal
Sculpture: 170cm high × 200cm wide;
pedestal 100cm high
Inscribed on face of pedestal: WITH PROPER
GRACE / INFORMING A CORRECT COMPAS-
SION THAT PERFORMS ITS LOVE AND
MAKES IT LIVE; JAMES KIRKUP
Inscribed on right face of pedestal:
ULI NIMPTSCH A.R.A / SCULPTOR
Inscribed on rear of pedestal: COMPASSION /
THIS STATUE WAS COMMISSIONED / AND
PRESENTED TO SELLY OAK HOSPITAL / BY
THE / CHARLES HENRY FOYLE TRUST / ON
THE SUGGESTION OF / ONE OF THE
ORIGINAL TRUSTEES / THE LATE SIR
ALBERT BRADBEER / 1963.
Status: not listed
Condition: fair. Discolouration and cracking
of pedestal
Owned by: Selly Oak Hospital
Exhibited: Royal Academy, 1963

This comprises two life-size nude male
statues, one lying down and the other
kneeling over him, holding a bowl, a pose
suggesting the compassion of the title. The
idea of a sculpture for this location was
suggested by Locksley Hare, a senior partner
in the architectural practice of S.N. Cooke
and Partners, which was responsible for the
design of Selly Oak Hospital. He made the
suggestion to Sir Albert Bradbeer, one of the
original trustees of the Charles Henry Foyle
Trust, which financed the sculpture.[1]
Bradbeer originally asked Jacob Epstein to
make an arresting sculpture group, which
was to represent the human significance of
hospital work. Nimptsch was the artist who
was eventually commissioned by the trust
and he exhibited the work at the Royal
Academy in 1963.[2] The cost of the sculpture
was £5,350 and it was placed in its present
location later that year.[3] The original model is
now in the collection of the Birmingham
Museum and Art Gallery.

1. Information supplied by Mr. Simon Yates, Selly
Oak Hospital, 1985; 2. *Royal Academy exhibitors
1905–1970*, Wakefield, 1973; 3. *Mail*, 20th December
1963.

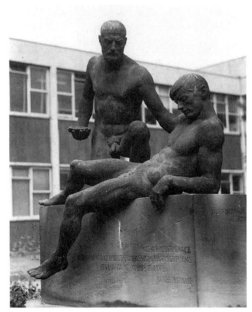

Nimptsch, *Compassion*

Our Lady of the Assumption church, south elevation

Assumption of the Virgin Mary

Peter Bohn

1957
Hollington stone
390cm high
Status: not listed
Condition: good
Owned by: Our Lady of the Assumption
church

The statue was commissioned by George
Bernard Cox and Bernard Vincent James, of
Harrison and Cox, architects of the 'New
Church, Maryvale for Rev. P.J. Lynch'.[1]
Replacing the previous church of Our Lady
of the Immaculate Conception (founded
1669), the building plans illustrate an outline
drawing of a large-scale Virgin and Child
group in the central niche. Bohn's statue is of
the Assumption of the Virgin Mary, in an
attitude of prayer and feet down-turned,
which is in keeping with the new name of the
church. The statue was in place at the conse-
cration of the church in November 1957.[2]
The figure's gigantic size and simplified,
stylised form provides a focal point on an
otherwise modern exterior.

1. *BRBP*, no.112319, drawing M.C.6, June 1954;
2. *Mail*, 12th October 1957; Information provided by
the artist, 1985.

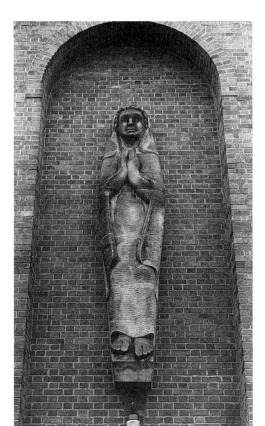

Bohn, *Assumption of the Virgin Mary*

Fox Hollies Inn, over the entrance

Fox and Hollybush

William Bloye

*c.*1927–8
Stone
114cm high
Status: not listed
Condition: good
Owned by: Fox and Hollybush Inn

The building was designed as new licensed premises in 1927 by the architects Wood, Kendrick and Reynolds for Mitchell and Butler's,[1] and was opened by 1929.[2] The architectural drawings show a 'stone' space allowed for the panel which suggests it was commissioned separately, possibly by the brewery and at about the same time as the building.[3] The composition of clear, deli-

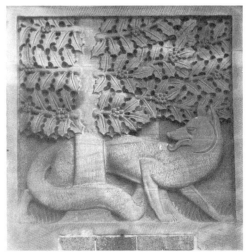

Bloye, *Fox and Hollybush*

cately outlined images placed on a plain background and subtly intermingled in an emphatically flattened space, shows a sophisticated and stylised handling typical of Bloye's more mature sculpture. However, the execution of this work may have been given to one of his assistants, as was the case with other pub signs. The fine linear work, as in the head of the fox, may indicate the hand of Gordon Herickx, whose panels decorate the Barber Institute, Edgbaston Park Road (q.v.).

1. *BRBP,* 1927, no.44424; 2. *Kelly's Birmingham directory,* 1929, p.1404; 3. A. Crawford and R. Thorne, *Birmingham pubs 1880–1939,* Birmingham, 1975, note 67.

Junction of Orphanage Road and Chester Road

Sir Josiah Mason

Francis Williamson

1885/1952
Bronze bust on stone pedestal
Bust: 90cm high
Pedestal inscribed: SIR / JOSIAH MASON /
1795–1881
Status: not listed
Condition: good
Owned by: City of Birmingham

This bust was cast by William Bloye in 1952 from Williamson's original full-size seated statue of Mason in marble, of 1885. Josiah Mason (1795–1881) was a wealthy local industrialist renowned for his philanthropy. He devoted much of his fortune to charity and founded the Mason Orphanage at Erdington (1860–8) and the Mason Science College, Edmund Street (1875–80), later incorporated into Birmingham University and demolished in 1965.

The statue has a complicated history. In 1869 the Council decided to commemorate the foundation of Mason Orphanage with a portrait statue of Mason.[1] The sculptor E.G. Papworth was originally given the commission but the scheme was not approved by Mason, who declined to sit, and the project was forgotten until his death in June 1881.[2] It was resumed by the Council on 3rd August 1881, although payment was not to be from the rates but from subscriptions which had already raised £775. In January 1884, the Sir Josiah Mason Memorial Committee, headed by Dr Heslop, informed the Public Works

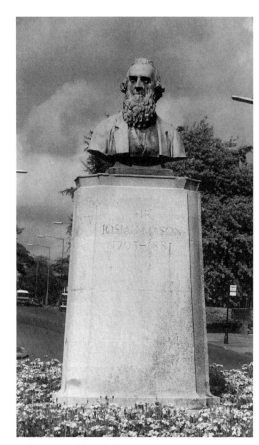

Williamson, *Sir Josiah Mason*

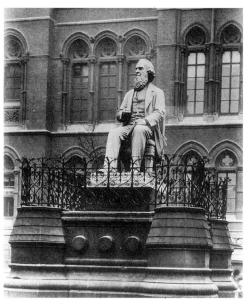

Williamson, *Sir Josiah Mason* c.1890

Department that Williamson was to be entrusted with the project and suggested that a vacant pedestal in Ratcliffe Place (now Chamberlain Square) opposite Mason College, would be the most appropriate setting for the finished work.[3] The statue, claimed to be an 'exceedingly faithful' likeness in face and figure, was unveiled in its prescribed place on 1st October 1885 by Sir John Lubbock MP.[4] It was of 'colossal proportion, [representing Mason] seated and in a characteristic attitude, holding in his right hand a pen with which he is about to sign the Trust Deed of the Mason College. The chair in which the figure is seated is Gothic treated in a sculpturesque manner. On the back are the arms of Mason College and underneath are scrolls representing the plans of the College.'[5]

On 6th October 1885, the statue was accepted by the Corporation and placed in the care of the Public Works Department.[6] It eventually fell into a poor state of repair and was removed in 1951, the bust being preserved.[7] The Birmingham Civic Society, in

conjunction with the Erdington Historical Society, suggested to the Public Works Department that the bust be cast in bronze and placed near the Mason Orphanage. This was approved and Bloye executed the work for £222 8s. 0d.,[8] which was placed in position in 1952 and the original statue then destroyed.[9]

1. J.T. Bunce, *History of the Corporation of Birmingham*, vol.II, Birmingham, 1885, p.565; 2. Harman, 1885; 3. Birmingham Public Works Department, *Committee minutes 1882–1884*, 29th January 1884, p.391; 4. *Post*, 2nd October 1885; 5. Birmingham Public Works Department, *Committee minutes 1884–1886*, extracts from the report of the Sir Josiah Mason Memorial committee, p.308; 6. C.A. Vince, *History of the Corporation of Birmingham*, vol.III, Birmingham, 1902, p.383; 7. *Birmingham Civic Society Annual Report 1951–1952*, Birmingham, p.5; 8. Bloye, *Ledger*, 24th June 1953; 9. *Birmingham Civic Society Annual Report 1951–1952*, Birmingham, p.4.

Gracechurch Shopping Centre

Coats of Arms

James Butler

1976
Two aluminium sheet reliefs, partially painted
220cm high × 200cm wide
Inscribed respectively: ROYAL TOWN OF SUTTON COLDFIELD;
and QVONIAM SVMVS IN VICEM MEMBRA
Status: not listed
Condition: good
Owned by: Gracechurch Shopping Centre

The coats of arms have a highly linear and schematic display of motifs and are cut from aluminium sheet, secured by bolts and outlined in paint. They were commissioned by the Harry Weedon Partnership, architects of the Gracechurch Shopping Centre, which was developed by the United Kingdom Temperance and General Provident Institution.[1] One of the sculptures depicts the arms of the Royal Town of Sutton Coldfield as awarded in 1935, and it commemorates the status of the town before its merger with Birmingham in 1974. A shield incorporates the arms of the town's greatest benefactor, John Harman, otherwise known as Bishop Vesey, and the Tudor Supporters, a greyhound and a dragon, commemorate the fact that Henry VIII granted the town a Royal Charter in 1528. The stag at the crest and grassy mound at the base symbolise the park given to the inhabitants at this time. The second sculpture depicts the *Coat of Arms*, granted in 1940, of the developers of the Shopping Centre, the United Kingdom

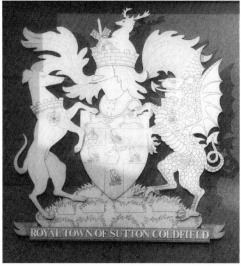

Butler, *Coat of Arms*

Temperance and General Provident Institution. It includes a sundial and fountain at the crest with two supporting lions resting on a spinning wheel and a globe as well as the Latin inscription meaning 'For we are members of one another'.[2]

1. Information provided by the artist, 9th December 1985; 2. G. Briggs (ed.), *Civic and corporate heraldry*, London, 1971, p.394.

Chess-Pieces

Alex Mann

1974
Cast iron, painted
Four sculptures, each: 366cm high
Status: not listed
Condition: good

Owned by: Sutton Coldfield District
Council

Commissioned by the architect Dennis
Paterson of the Harry Weedon Partnership,
the sculptures decorate the shopping centre
designed around five open courts.[1] The
theme was established in consultation with
residents who identified Sutton Coldfield
with the historic connection it had with the
crown and the church through Henry VIII
and Bishop Vesey as well as with one of the
top chess teams. The sculptures represent:
King and Queen, Royal Court; *Bishop*,
Bishop's Court; *King*, King's Court; *Castle*,
Castle Court. An additional sculpture was
also designed by Mann for the fifth court,
although the artist was not asked to execute
the full-scale model.[2] In these works Mann
has put the formal vocabulary of modern
abstract sculpture to a popular and orna-
mental use.

1. *Post*, 6th November 1974; Information provided by
the Gracechurch Centre Office, 27th October 1983;
2. Letter from the artist, 22nd April 1985.

Mann, *Chess-Piece*
(King)

Mann, *Chess-Piece*
(Queen)

Trafalgar House, west wall

Untitled

Bianca Rossoff

1960
Bronze
1060cm high
Status: not listed
Condition: good
Owned by: not known

Commissioned by Murrayfield Real Estates
Co. Ltd., the developers of the £350,000 shop
and office block known as Trafalgar House.[1]
The model of the abstract sculpture had been
designed by April 1960 before the building's
completion. In an article in the *Birmingham
Post*, the artist – referred to as 'Princess
Lowenstein' – said she had 'endeavoured to
emphasise the beautiful simplicity of the
design of the main elevations and the shape
of the "butterfly" canopy over the shop
fronting'.[2] The pointed chevron with fanning
arrangements of thin metal rods suggests the
appearance of a butterfly alighting on the
building, while the spiky, angular composi-
tion is also characteristic of British post-war
constructivist sculpture.

1. *Mail*, 21st August 1962; 2. *Post*, 29th April 1960.

Rossoff, *Untitled*

*Birmingham Central Reference Library, rear
exterior wall facing Congreve Passage*

Cader Idris, Wales

David Patten

1990
Coloured strips of steel
200cm high × 3000cm wide
Inscribed on accompanying plaque:
Descending a hill of eminence, I had a full view, under
a bright sun, of Cader Idris. If I was asked what
length would be a line drawn from the eye to the
summit? I should answer, 'To the best of my judge-
ment one mile.' I believe the space is more than five;
so fallacious is the vision when it takes in only one
object, and that elevated. William Hutton 1803.
Status: not listed
Condition: good
Owned by: City of Birmingham

This piece was a direct outcome of a show at
the Ikon Gallery in 1989, which was to mark
Birmingham's centenary. The choice of
subject matter came from the exhibition of a
William Ellis painting of Cader Idris at the
RBSA in 1889, which was included in the
Ikon show.[1] In Patten's piece, the low relief
of abstract coloured shapes of steel evokes
the landscape around Cader Idris in Wales,
with its peaks, valleys, lakes, greenery and
rock. Lightening up what would otherwise
be a dull façade of the library, Patten's shapes
conjure up a space without perspective,
particularly apt in relation to William
Hutton's quote which is mounted on a
plaque nearby.
 One of the city's first local historians,
Hutton (1723–1815) was a promoter of the
industrial landscape of Birmingham, which
contrasts with the landscape of north Wales,
a popular destination in the 19th century for
Birmingham tourists. Artists, too, often
sought inspiration not from their immediate
city environment but from the romantic
landscapes of Wales. Patten's piece similarly
derives inspiration from a source removed
from his immediate environment, a drawing
by the abstract expressionist Willem de
Kooning, *Woman* (1963), which forms the
basis for his deconstruction of the Cader
Idris landscape. Patten said of this piece, 'It
aims to provide an image, which, through its
colour and gestural form, creates a counter-
point to most city centre images'.[2] As with
many public art schemes in Birmingham, this
one has had its share of controversy, accused
by some of resembling graffiti.[3]

1. Letter and CV from the artist, 29th January 1996;
2. D. Vickeman, *Post*, 2nd February 1990; 3. *Express
and Star*, 2nd February 1990; *Mail*, 29th March 1990.

Patten, *Cader Idris*

Frontage of Queen's Chambers, above doorway

Queen Victoria Enthroned and Girl with Snake

Sculptor not known

Architects: Mansell and Mansell

c. late 1880s
Terracotta
Queen Victoria: 50cm square
Girl with Snake: 30cm diameter
Inscribed on doorway lintel, in gothic
lettering: QUEENS COLLEGE
Status: II*
Condition: good
Owned by: not known

This relief carving of Queen Victoria is placed in a round arched lunette below a pinnacle topped by a crown on a bible, and containing a roundel carving of a Girl with Snake. The Queen sits beneath a gothic style canopy and is depicted enthroned, holding the orb and sceptre. There is some fine terracotta decoration to the door frame, including a lion and a unicorn rampant on posts at either side, yet the carving of the Queen is not particularly crisp. Queen's College was granted a Royal Charter in 1843 and incorporated the Schools of Medicine and Surgery, but after its incorporation into the University of Birmingham became known as Queen's Chambers. The current decoration dates from its re-frontage which was carried out after 1880, possibly in 1904.[1] The Girl with Snake was the emblem of the College and a symbol of healing, whilst the bible on the pinnacle refers to the theological element of

Anon, *Queen Victoria Enthroned and Girl with Snake*

learning. The rest of the building frontage has a number of carvings of animal and vegetable forms in the ground floor window arches and overall this presents an interesting contrast to the modern and classical style buildings around it.

1. V. Skiff, *Victorian Birmingham*, 1983; Dent, p.567.

Junction of Park Circus and Waterlinks Boulevard

Face to Face

Ray Smith

1993
Steel, painted
600cm high × 400cm wide
Status: not listed
Condition: good, though obviously not
maintained
Owned by: City of Birmingham

Situated on a junction off a busy roundabout, *Face to Face* was commissioned by the City of Birmingham in conjunction with the Public Art Commissions Agency to act as one of the 'gateway' sculptures to the Heartlands area of the city (the others being *White Curl* and *Sleeping Iron Giant*). Two figures cut from flat steel are interlocked with another two figures at right angles, in a style which is reminiscent of the work of Jonathon Borofsky. One pair is active, frozen in a position of moving toward each other in a gesture of mutual attraction and friendship, a symbolic representation of fraternity and the rejuvenation of the area. This pair bisects the other more passive figures, whose relationship is more ambiguous.[1] The 'cut-out' treatment of the figures is emphasised by different paint colours on each figure, from grey through ochre to rust red, which give depth and interest to the shapes. Isolated by the road system, the work is beginning to look uncared-for, reflecting the difficulty in attempting to liven up the industrial areas beyond.

1. Press release and artist's statement, 1992, from the artist 20th January 1996.

Smith, *Face to Face*

Birmingham Nature Centre

Sign for Nature Centre

Sheila Carter and family

1990
Iron
480cm high × 360cm diameter
Status: not listed
Condition: good
Owned by: City of Birmingham

Designed by Sheila Carter and constructed by her husband Ron and their sons at Trapp Forge near Burnley. Crafted from wrought iron, the sign incorporates many plants, animals, birds and insects in its borders around vignettes which represent the months of the year. Each month is represented by specific breeds of plants and animals, appropriate to the season. For example, March is represented by mallard ducks, marsh

Carter family, *Sign for Nature Centre*

marigolds and daffodils, while August has thistles, goldfinches and fritillary butterflies.[1]

1. Letter and promotional material from the artist, 7th February 1996.

The Police Training Centre, forecourt

Sir Robert Peel

Peter Hollins

1855
Bronze statue on concrete plinth, covered with mosaic tiles
260cm high
Status: II
Condition: good
Owned by: City of Birmingham

As if addressing the House of Commons, Peel (1788–1850) is shown in a debating stance with one hand on his hip and the other holding a scrolled pamphlet, and with a book lying at his feet. He wears a gown over contemporary dress, whose voluminous folds suggest a classical precedent and bearing. This was one of many statues of Peel commissioned throughout England after his death. He was held in particular esteem by the people of Birmingham for his restoration of local control over the police force, after the Peoples' Charter of 1839. A subscription fund was inaugurated under the Peel Testimonial Committee[1] and the commission for a statue was given to Hollins, the most renowned local sculptor of the day. It was cast by Elkington and Masons of Newhall Street at a cost of £2,000, the first bronze statue cast in one piece in Birmingham. However, the subscription collected fell short

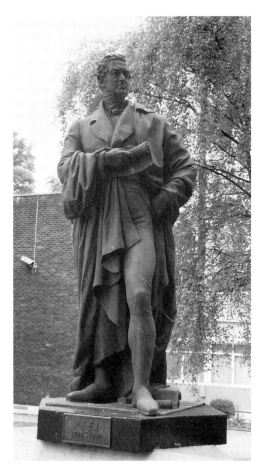

P. Hollins, *Sir Robert Peel*

of the cost by more than half, and because he was financially responsible, Hollins lost heavily, with the committee noting that the work was more a gift from the sculptor than from the city.[2]

The statue was unveiled on 27th August 1855, 'in the presence of at least 15,000 persons'[3] located at the junction of Ann Street and Congreve Street, and set on its original plinth of polished granite it reached a height of 6 metres. It was protected by railings also designed by Hollins, which represented 'large clusters of wheat ears to commemorate the repeal of the Corn Laws'[4] which Peel, as Prime Minister, achieved in 1849. In 1873 the statue was moved, without its railings, a short way to Council House Square (now Victoria Square), after the Council House was completed.[5] In 1926 the head was damaged by a lorry striking a gas lamp which fell across the statue. It was repaired and re-erected in Calthorpe Park in March 1927, but removed to its present site and set upon an incongruously new, white polyhedron in September 1963.[6]

1. *Illustrated London News*, 27th July 1850, p.75; 2. *Aris's Gazette*, 3rd September 1855, p.4; 3. *Illustrated London News*, 1st September 1855, p.259; 4. Dent, 1880, pp.558–9; 5. Harman, 1885; 6. *Post*, 26th November 1963; B. Pugh, *Solid citizens: statues in Birmingham*, Birmingham, 1982, pp.23–4.

Church of the Ascension, over west door

Christ Ascending

John Bridgeman

1973
Fibreglass with a gold-colour finish
215cm high
Status: not listed
Condition: good
Owned by: Church of the Ascension

Commissioned by the church architect Romilly B. Craze in collaboration with the Church Council, this figure of Christ was installed for the consecration on 14th July 1973.[1] It is fixed over the main entrance, gazing downwards, with arms open and feet slightly down-turned, so that a hovering effect is achieved, appropriate to the name of the church. This is the artist's only known work in fibreglass in Birmingham.

1. *Stirchley parish magazine*, 10th Anniversary Issue, July 1983, p.1; Information from the artist in conversation, 1985.

Plough and Harrow Road
LADYWOOD

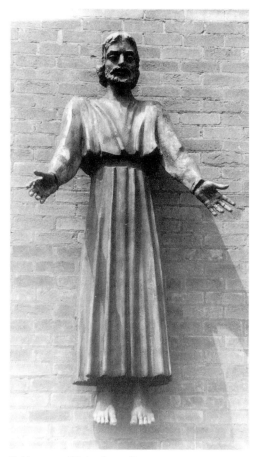

Bridgeman, *Christ Ascending*

St. George's Church of England School, on wall facing over playground

Untitled

Jeffrey Salter

1970
Ceramic
178cm high × 300cm wide
Status: not listed

Condition: good
Owned by: St. George's Church of England School

This abstract relief combines the form of a cross with a central disc, and is placed on a wall facing out across the playground. The work could reflect the school's religious affinity, whilst drawing upon patterns from nature or the local road network.

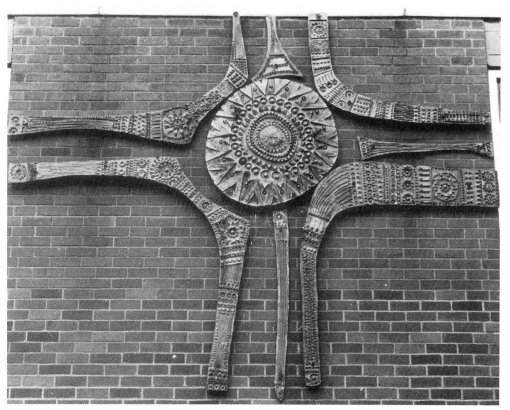

Salter, *Untitled*

*Cannon Hill Park, northern end near
Edgbaston Road*

South African War Memorial

Albert Toft

1905
Bronze sculpture on a red granite pedestal
Sculpture: 200cm high × 150cm wide ×
150cm deep; pedestal: 400cm high
Signed on work: Albert Toft Sculptor 1905
Inscribed on bronze panel on front of
pedestal: TO / THE GLORIOUS MEMORY /
OF THE / SONS OF BIRMINGHAM / WHO
FELL IN THE SOUTH AFRICAN WAR 1899–
1902 / AND TO PERPETUATE / THE
EXAMPLE OF ALL WHO / SERVED IN THE
WAR / THIS MEMORIAL IS ERECTED / BY
THEIR FELLOW CITIZENS
Status: not listed
Condition: fair. Surface discolouration on
sculpture, weathering of bronze rolls of
honour and some minor breakages on
stonework; some parts missing
Owned by: City of Birmingham

In March 1903 the *Birmingham Daily Mail*
launched an appeal fund for a memorial to
the five hundred and twenty-one soldiers
who died in the South African War.[1] This
eventually raised £2,000. In October, a sub-
committee was organised by Whitworth
Wallis to secure designs for the statue and by
July 1904 Toft had been chosen from the
fifteen sculptors invited to compete for the
commission.

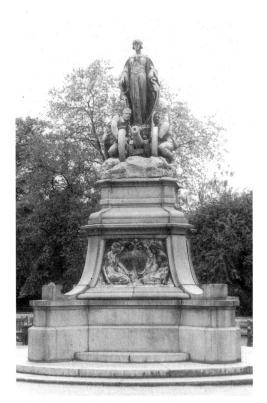

Toft, *South African War Memorial*

Toft's design was described as a combina-
tion of the real and the ideal. In the centre is a
gun carriage flanked on either side by a figure
of a soldier, realistically portrayed in a heroic
stance and bearing the attributes of war.
These were seen to personify Courage and
Endurance. On a half globe in the middle of
the carriage stands an idealised female figure,
described as a personification of Peace. With
her left arm she supports a shield bearing
both the City Arms and an incised image of
an olive branch (an attribute of Peace) and in
her extended right hand she originally held a
wreath to the honoured dead (now missing).
The statues were cast at Parlanti's foundry in
London, using the cire-perdue process which
enabled the reproduction of fine detailing as
can be seen, for example, in the decoration of
the gun carriage, the soldiers' attributes and
on the costume of Peace. On the front of the
pedestal a bronze bas-relief shows two clas-
sical female figures, considered to represent
Sympathy and Grief, holding wreaths and
supporting a shield bearing the inscription.
Bronze panels set into each of the remaining
three faces of the pedestal record the names
and the ranks of the dead.

Choosing a site for the memorial caused
problems. Two suggestions, that it be placed
in Old Square in the City or at the hospital
end of Corporation Street, were rejected and
in May 1904 the council accepted the offer
from Charles Hyde, Hon. Sec. of the
Birmingham Soldiers' Memorial Fund, to
place it in Cannon Hill Park.[2] It was unveiled
by Lieutenant-General Sir Ian Hamilton on
23rd June 1906, and described as 'the finest
yet erected in connection with the South
African war'.

1. *Mail*, 23rd June 1906, p.4; 2. C.A. Vince, *History of
the Corporation of Birmingham*, vol.IV, Birmingham,
1923, p.492.

Cannon Hill Park, on top of kiosk next to lake

Cannon Hill Park is one of Birmingham's largest parks, having been extended since it was given to the City of Birmingham in 1873 by Louisa Anne Ryland. The Midland Arts Centre is here, on the Queen's Ride, as well as the Nature Centre on the Pershore Road side of the park (see Pershore Road entry).

Ahoy

Paul Richardson and Caroline Webb

1993
Steel sheet and found objects
500cm high × 400cm wide × 400cm deep
Status: not listed
Condition: good, though rusted
Owned by: Midland Arts Centre

This piece was commissioned in 1993 by the Midland Arts Centre New Work Trust. It was devised as a collaboration between a jeweller, Caroline Webb and a sculptor, Paul Richardson, to be exhibited as the centre-piece for the Jewellery Focus exhibition at the MAC Centre. The artists worked together in conceiving the form and compo-sition of the piece, which is based on the theme of a spaceship. This evolved during the construction process, which Richardson describes as 'additive...mixing materials and collaging objects'.[1] Incorporated within the piece are the remnants of mechanised society, old bicycle wheels and car tyres and exhausts, springs and fan-blades, which are welded onto the exterior of the spherical steel sheet core. The whole was originally polished and lacquered, although it is now entirely rusted

Richardson and Webb, *Ahoy*

from prolonged exposure to the elements in its exposed location. Made at 3F Studios, Birmingham, the cost of the piece was £6,000, and funding came exclusively from the New Work Trust. It was erected at the start of the exhibition in late November 1993, when it was temporarily sited in the inner courtyard. When the exhibition ended in January 1994, it was moved to its present location.[2]

1. Letter from Paul Richardson, 20th February 1996;
2. Information given in telephone conversation with Dorothy Wilson from the Midland Arts Centre, 12th February 1996.

Raised mound on pedestrian area of roundabout

Swing

Kevin Atherton

1988
Steel
250cm high × 250cm long
Status: not listed
Condition: good
Owned by: City of Birmingham

Originally commissioned for the Glasgow Garden Festival of 1988,[1] this sculpture was

Atherton, *Swing*

purchased by Birmingham City Council for £5,000 and resited in 1990.[2] Though a static piece, the swing's movement is suggested by simultaneous successive 'snapshots' of its position, so that twenty swings are linked in the curve of flight. The principle of simultaneity in sculpture was explored in the 1910s by the Italian Futurist Boccioni, and Atherton's work uses this idea in a refreshing and colourful way. Unfortunately, the work's position is not conducive to easy viewing, either from the car or on foot.

1. G. Murray (ed.), *Art in the garden: installations*, Glasgow Garden Festival, Edinburgh, 1988, pp.28–9; 2. *Express and Star*, 22nd March 1990; *Post*, 23rd March 1990.

St. Chad's Cathedral

St. Chad's Cathedral was constructed between 1839 and 1841 and was the first Catholic Cathedral to be built in Britain since the Reformation. Commissioned by Bishop Walsh, Vicar Apostolic of the Central District and designed by Augustus Welby Northmore Pugin, architect and advocate of the Gothic Revival, it is a tall brick-built neo-Gothic building, in contrast to the Baroque Anglican Cathedral of St. Philip's. Works inside the cathedral include stained glass from the studios of John Hardman, also designed by A.W.N. Pugin, and *Stations of the Cross* designed by Albrecht Frans Lieven de Vriendt in 1875. There are several 15th-century German wood sculptures including the *Bishop's Throne* and clergy stalls, originally in the church of St. Maria in Capitolio, Cologne, and a statue of the *Blessed Virgin and Child* in the Lady Chapel which were donated by Pugin to give more authenticity

to the building. More recently, a fibreglass statue of *St. Joseph* designed by Michael Clark was erected in 1968 when the Cathedral underwent extensive renovation work.

St. Chad's Cathedral, over the doors and on either side of the west porch

Saints Augustine, Chad, Swithin, Wulstan, Thomas and Hugh, and Tympanum Relief of the Virgin and Child

A.W.N. Pugin

1839–41
Stone
The saints, each: 190cm high; the Virgin: 95cm high
Status: II
Condition: fair. Some disintegration of figures
Owned by: St. Chad's Cathedral

The six saints, all bishops renowned for their association with the early English Church, are from left to right: Augustine, Chad, Swithin, Wulstan, Thomas and Hugh. Each wears a bishop's mitre, carries a crozier and with the right hand makes the sign of the cross as a blessing. The differences between them largely concern details of dress in order to identify them. The Virgin and Child under a canopy is a traditional medieval design, and placed between a pair of incensing angels this motif was to appear in many Pugin decorations, such as on the south porch of St. Giles, Cheadle, Staffs.

A convert to Roman Catholicism, Pugin felt Gothic to be the 'true and Christian

A.W. N. Pugin, *Saints Augustine and Chad*

architecture'. St. Chad's was the first Catholic Cathedral to be built in England since the Reformation and also the first by Pugin. Despite the limited funds, Pugin was determined to uphold Catholic principles and, both ecclesiastically and aesthetically,

the sculpture on the west front was important, for without it the church would be deprived of a traditional and effective Christian symbolism. Pugin considered that 'a Christian church may and should be covered with sculpture of the most varied kind'[1] and although the style of carving is subdued and conventional, the portrayal of figures 'in correct costume' and arrayed in attitudes and positions suitable to the dignity of religion, suggested a correct if generalised Gothic spirit.

1. A.W.N. Pugin, statement to the press, in P. Stanton, *Pugin*, London, 1971, pp.59–60.

St. Chad's Cathedral, north aisle, east end

Tomb of Bishop Walsh

Edward W. Pugin

1850
Bath stone
500cm high × 240cm long
Status: II
Condition: good
Owned by: St. Chad's Cathedral

Made after designs by E.W. Pugin, the canopied tomb represents Bishop Walsh, Vicar Apostolic of the Central District and then London, and founder of St. Chad's Cathedral who died in 1849, recumbent in pontificals with crozier and mitre. Five shields below are carved with the arms of Bishop Walsh, the Cathedral, Oscott College, St. Edward the Confessor and Bishop Walsh again.[1] Flanked by two crocketed finials, the ogival arch, also decorated with crockets, is in the Decorated Gothic style. The dossal,

E. W. Pugin, *Tomb of Bishop Walsh*

carved in diaper pattern, shows on a quatrefoil Bishop Walsh offering up this Cathedral. The tomb was erected in 1850 by public subscription.[2] This is the only known example of a canopied tomb in Birmingham, though there are many medieval examples in chantry chapels and cathedrals elsewhere.

1. Dent, vol.1, 1880, pp.464–8; 2. Revd. Greaney, *A guide to St. Chad's Cathedral Church*, Birmingham, 1877.

University of Birmingham Dental Hospital, wall overlooking the Queensway

University Coat of Arms

William Bloye

c.1973
Fibreglass, painted
240cm high × 200cm wide
Status: not listed
Condition: good
Owned by: University of Birmingham Dental Hospital

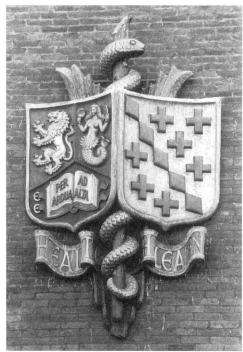

Bloye, *University Coat of Arms*

The Dental Hospital was designed by
Edward Allen of S.N. Cooke and Partners in
1965. This *Coat of Arms* was not contempo-
rary with the opening of the building and
was made around 1973, making it a very late
Bloye piece as he died in 1975. Bloye
produced various pieces for Cooke and
Partners. This piece consists of two heraldic
shields, the left-hand shield bearing a lion
and mermaid, underneath which there is an
open book with an inscription upon it. The
right-hand shield bears seven crosses and five
diamonds. In the middle, behind the shields a
pole rises, with a snake wrapped around it.
The ribbon below bears the inscription.

St. George's Road

BALSALL HEATH

*St. John the Evangelist church, St. George's
Road, on top of north tower*

St. John the Evangelist

Robert Bridgeman & Sons

c.1896
Stone
110cm high
Status: not listed
Condition: good
Owned by: St. John the Evangelist church

The original church was founded in 1896 and
the statue of St. John was then sited on the
central niche of the church, as is shown by a
photograph from 1930.[1] It was possibly
moved to its present location after World
War II. In the 1950s the church merged with
St. Martin's church and in the 1960s under-
went some alteration work, some of the
arches being removed. The figure of St. John
is shown wearing monk's robes and holding a
cup.

1. Photograph, 29th January 1930, in archive of the
church held by E.H. and H.E. Fletcher.

St. Martin's Lane CENTRAL CITY

St. Martin's church, Bull Ring

Although the lower part of this church's
tower dates from the 13th century, most of
the fabric was rebuilt 1873–5 in an early
14th-century manner by J.A. Chatwin, with
subsequent restoration by P.B. Chatwin in
1957 after World War II bombing. Within the
church are a number of medieval tombs with
finely carved figures depicting members of
the local gentry, and the interior has an
impressive hammerbeam roof and stained
glass, that in the south transept being by
E. Burne-Jones.

*St. Martin's church, north front, in niche
above door*

King Richard

Sculptor: Robert Bridgeman & Sons

Designed by: Julius Alfred Chatwin

1914
Stone
Statue: 200cm high; niche: 600cm high ×
180cm wide
Status: II
Condition: fair. Surface discolouration
Owned by: St. Martin's church

From 1873 to 1875, St. Martin's underwent
extensive renovation, which involved
rebuilding the whole church except for the
tower and spire. J.A. Chatwin was the archi-
tect responsible for the restoration work, and
the ornamented niche was set up on the
north front of the church at this time,[1] along
with an identical one on the west façade
which houses the statue of *St. Martin and a
Beggar*. The statue of *King Richard* was not

Bridgeman & Sons, *King Richard*

put in place immediately, as a photograph from 1875 of the church as rebuilt shows the niche, but the statue is not *in situ*.[2] It did not appear until January 1914, when a local newspaper reported that a statue of King Richard was to be placed above the door of St. Martin's to commemorate his visit to the city,[3] and later that month it was reported that the statue had been erected.[4]

1. *Birmingham Weekly Post*, 8th May 1898; 2. Dent, 1880, p.543; 3. *Mail*, 9th January 1914; 4. *Birmingham Weekly Post*, 31st January 1914.

St. Martin's church, west front, niche above door

St. Martin and a Beggar

Sculptor: Robert Bridgeman & Sons

Designed by: Julius Alfred Chatwin

1913
Stone
Statue, 200cm high; niche, 600cm high × 180cm wide
Status: II
Condition: fair. Surface discolouration
Owned by: St. Martin's church

St. Martin of Tours was born in Hungary in A.D. 315, the son of a soldier. An active missionary and miracle worker, his religious deeds included the founding of a religious commune at Lizage, Gaul, and he was the first holy man who was not martyred to be publicly venerated as a saint. This piece depicts one of his most famous acts of charity – as a young soldier he gave half his cloak to a naked beggar. This representation is an unconventional one, since it is actually a combination of this event and a similar one which happened later in his life, when as a bishop, he gave his tunic to a beggar.[1] The niche within which the statue is set is identical to that on the north façade, which contains the statue of *King Richard*. The statue itself was not installed until 1913, much later than the niche's construction in 1875.[2]

1. *Post*, 14th November 1955 and 19th November 1955; 2. *Mail*, 9th January 1914; *Birmingham Weekly Post*, 31st January 1914.

Bridgeman & Sons, *St. Martin and a Beggar*

St. Martin's church, south porch

Scenes from the Life of St. Martin

Sculptor: Robert Bridgeman & Sons

Designed by: Julius Alfred Chatwin

1873–5
Stone
Figure: 90cm high; large roundels: 60cm diameter; small roundels: 45cm diameter
Status: II
Condition: fair. Surface discolouration

Owned by: St. Martin's church

Chatwin designed these stone carvings for the south porch of the church depicting St. Martin at the apex of the arch, seated under a canopy and surrounded by six roundels showing scenes from his life. The two episodes of charity alluded to in the sculpture on the west front are clearly shown as separate events in the first and third roundels on the left and the composition as a whole is linked by stylised foliate decoration.

Bridgeman & Sons, *Scenes from the Life of St. Martin*

St. Martin's church, in the west transept

First World War Memorial

Designed by A.E. Lucas

1933
Stone with bronze relief
280cm high × 100cm wide
Inscribed: 1914 1918 / TO OUR / FALLEN / COMRADES / FIRST / SECOND / & THIRD / BIRMINGHAM / 14TH 15TH & 16TH / BATTALIONS / THE ROYAL WARWICKSHIRE REGIMENT
Status: not listed

Condition: good
Owned by: St. Martin's church

Similar in style to the Cenotaph in Whitehall, this was designed by a member of the 16th battalion and unveiled on 12th November 1933.[1] The column of white stone is surmounted by a shallow relief bronze antelope, and is guarded by three bronze columns carrying a silk cord in regimental colours and with a regimental cap badge.

1. *Post*, 13th November 1933.

St. Martin's church, over the high altar

Reredos

Executed by Farmer & Brindley

Designed by: Julius Alfred Chatwin

1876
Red sandstone and alabaster
Whole: 160cm high × 600cm wide; figures: 80cm high
Status: II
Condition: good
Owned by: St. Martin's church

Ranging across the entire width of the central chancel window, this impressive reredos was designed in 1874 by J.A. Chatwin.[1] Costing some £900, all raised by subscriptions to which the Warwickshire Freemasons contributed £300,[2] it was unveiled with Masonic ceremonies in November 1876, although two vacant arcade spaces were not filled until 1878. Consisting of forty-five figures, all carved in alabaster, from the north side the panels show: the entry into Jerusalem; Christ expelling the money

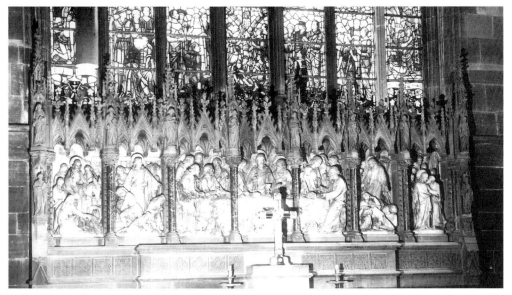

Farmer & Brindley, *Reredos*

lenders from the temple; the Last Supper, in the centre; the Agony in the garden; and the betrayal by Judas. The main structure is of red sandstone, enriched above with finials and crockets on pointed arched canopies in the Decorated Gothic style. A number of

figures of Apostles and of Moses and Aaron are also arranged in niches along the top and the sides.

1. 'The reredos in St. Martin's Church, Birmingham', *The Builder*, vol.36, 20th April 1878, p.417; 2. *Church leaflet*, St. Martin's Church, Bull Ring, undated.

St. Philip's Cathedral

Designed by Thomas Archer and built by 1715, St. Philip's is Birmingham's Anglican cathedral, and is set in a square that was originally its churchyard. Refaced in 1864–9 by J.A. Chatwin, this English Baroque church contains superb examples of stained glass by Edward Burne-Jones and William Morris, as well as a number of monuments from the 18th and 19th centuries by Peter Rouw the Younger, Hollins *père et fils* and Richard Westmacott.

St. Philip's Cathedral, over the four entrances

Four Baroque Window Surrounds

Sculptor: Peter Hollins

Designed by: Thomas Archer (*c*.1668–1743)

1709–15
Stone
300cm high
Status: I
Condition: fair. Some discolouration and deterioration of stonework
Owned by: St. Philip's Cathedral

Designed in 1709 and consecrated in 1715, St. Philip's was built under an Act of Parliament of 1708 for one of the few new parishes created during the 18th century. The first of three churches designed by Archer and the only one to have such elaborate window surrounds, it was also the first to be built by an architect who had travelled to Italy since Inigo Jones' St. Paul's, Covent Garden (1631–3). Pevsner called St. Philip's 'a most subtle example of the elusive English Baroque',[1] although the four window

P. Hollins, *Window Surround*

surrounds and other sculptural details show the influence of Borromini, who incorporated a similar swirling floral surround on the principal façade of the Palazzo di Propaganda, Rome.[2] However, Archer's motif also incorporates mythical or bestial imagery, giving it a more theatrical appearance. The original window surrounds were probably carved by Joseph Pedley, a mason from Warwick, who agreed in 1710 to produce all the 'moldings' for St. Philip's.[3] As, however, the exterior has since been entirely refaced, it seems likely that the sculptural details have also been replaced:

between 1864 and 1869 the architect J.A. Chatwin was responsible for a programme of renovations on the church, and the detailing was possibly executed by local sculptor Peter Hollins who began the refacing in memory of his father, William Hollins.[4] As far as can be determined from an engraving of the west doors in *Vitruvius Brittanicus*,[5] all four window surrounds are faithful copies of the originals.[6]

1. Pevsner, 1966, pp.106–9; P. Portoghesi, *Roma Barocca*, Cambridge, Massachusetts, 1970, illus. pp.159–63; 3. M. Whiffen, *Thomas Archer: architect to the English Baroque*, London, 1950; 4. K. Downes, *English Baroque architecture*, London, 1966, p.106; 5. *Vitruvius Brittanicus*, I, 1715, plates 10 and 11; 6. Hickman, 1970, pp.12–14.

St. Philip's Cathedral churchyard

Bishop Gore
See entry for Colmore Row

Memorial to Members of the Lines family
See entry for Temple Row West

Memorial to Thomas Unett
See entry for Temple Row

Burnaby Obelisk
See entry for Temple Row

Memorial to John Heap and William Badger
See entry for Temple Row

Angel Drinking Fountain
See entry for Temple Row

Formerly Sennely's Park, now in store

Remains of a Pyramid

Avterjeet Dhanjal and Frank Forster

1991
Portland stone, with bronze figure
250cm high × 1000cm wide × 1000cm long
Status: not listed
Condition: poor. Bronze figure stolen
Owned by: City of Birmingham

Dhanjal was artist in residence at Hillcrest School from 1988–9 and was subsequently asked to create a sculpture based on his work there. He combined elements of a broken stone pyramid with a bronze portrait of Eleanor McFarlane, one of the pupils at the school, who was portrayed in casual wear leaning against one of the stones. The artist's residency cost £6,000 and the sculpture cost £27,000.[1] The work was unveiled at a ceremony on 29th November 1991 but rapidly became the target for vandalism and graffiti. Unfortunately, the bronze figure was stolen outright between Christmas and February 1993 and the rest of the sculpture has been removed by the council.[2] There are tentative plans for a re-casting of the figure so that the work can be resited within the grounds of Hillcrest School.

1. Birmingham Museums and Art Gallery records, and information from T. Sidey, 1995; 2. J. Smith, *Mail*, 24th June 1993.

The Brookvale public house, over the main entrance

Putto with Grapes

William Bloye

1934
Stone, painted
145cm high
Inscribed: THE BROOKVALE 1934
Status: not listed
Condition: good
Owned by: The Brookvale pub

Bloye, *Putto with Grapes*

Designed in July 1933 by Hobbiss for Mitchell and Butler's,[1] Bloye was responsible for all the stone carving, including this cartouche and probably the interior decoration as well.[2] Painted brightly in gold, red and green, the baroque-styled surround provides a suitably bold frame for the name and date in raised lettering. Below is carved the head of a putto flanked by two bunches of grapes and grape leaves, one of Bloye's most popular motifs, especially for public houses. As the cartouche is carved in full relief, almost in the round, it expresses a sense of ripeness that is characteristic of Bacchus the god of wine, which is suitable for a pub sign. Placed centrally on a symmetrical façade, it provides a pleasing focus that contrasts with the red brick of the building, and picks up on two small bunches of grapes situated lower on the façade.

1. *BRBP*, 1933, no.58397; 2. Bloye, *Ledger*, 30th November 1934, p.20, invoice no.61.

Bull Ring Shopping Centre, exterior façades and St. Martin's House

Bull Forms

Trewin Copplestone

1963
Fibreglass, bronzed
200cm high × 400cm long
Status: not listed
Condition: good
Owned by: City of Birmingham

Commissioned by Laing's Architects' Department, contractors for the architects of the Bull Ring Shopping Centre, Sydney Greenwood and T.J. Hirst. The size and location of the bull forms were specified but the artist was responsible for surface texture, design, manufacture and instalment.[1] Four were made. Each sculpture was cast in one piece from a polystyrene mould onto a metal

Copplestone, *Bull Forms*

frame, and each weighs nine tonnes.[2] Illumination from behind provides a bold silhouette by night, whilst the overall geometric appearances of the bull forms are characteristic of the Pop Art Movement. As emblems they refer not only to the ancient market locality there, after which the shopping centre was named, but also were seen locally as 'showing to the world the symbol and determination of new Birmingham'. The sculpture on St. Martin's House was damaged by fire in 1983 and has been restored. Three of these have now been removed, their location unknown, the only one left is on the Bull Ring Centre. Copplestone produced a large painted mural for the inside of the shopping centre at the same time, which was removed to make way for advertising hoardings.[3]

1. Letter from the artist, 12th August 1985; 2. *Focus, incorporating Birmingham Christian News*, January 1964, p.8; 3. Letter from the artist, April 1996.

Bull Ring outdoor market, raised area

Admiral Horatio Nelson

Sir Richard Westmacott

1809
Bronze
170cm high × 150cm wide; pedestal: 370cm high × 210cm
Status: II*
Condition: fair. Bronze has minor cracks; pedestal cracked and discoloured due to bronze leaching
Owned by: City of Birmingham

Nelson, born in 1758, became an officer of the British Navy in 1777, only six years after

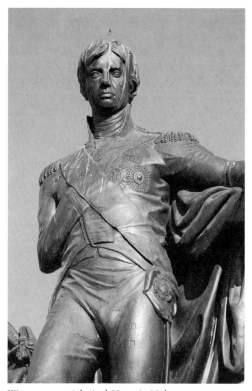

Westmacott, *Admiral Horatio Nelson*

first going to sea. He fought in the American Revolutionary War and soon earned popular acclaim as well as service honours at the battles of Cape St. Vincent in 1797 and the Nile in 1798. His scandalous private life with Lady Hamilton had little effect on his popularity, and he made a visit to Birmingham in 1802, diverting from Worcester to the acclamation of a large crowd.[1] He sailed against the fleets of Napoleon in 1803, meeting his end triumphantly at the Battle of Trafalgar on

21st September 1805. He was given a state funeral and burial in St. Paul's Cathedral.

Westmacott was paid £2,500 for Birmingham's memorial to Nelson, a sum raised within a few months, mainly in small donations from working-class subscribers. The general public interest in the memorial was also demonstrated in the weeks of debate at all levels to decide what form it should take.[2] Indeed, as well as being an example of the typically 19th-century concern with improving public taste, the work was a reflection of the increasing force of local aspirations. This helps to explain why the Birmingham monument is without the large scale, the classic grandeur or heroic plinth of those erected elsewhere, such as Flaxman's in St. Paul's or the Liverpool monument by M.C. Wyatt. The statue was unveiled on 25th September 1810 as part of the celebrations for the Golden Jubilee of George III. A handbill was issued by the sculptor describing the figure and the original pedestal with its low relief depiction of 'the town of Birmingham, murally crowned, in a dejected attitude [is] represented mourning her loss; she is accompanied by Groups of Genii, or children, in allusion to the rising race, who offer her consolation by bringing her the Trident and Rudder.'[3]

The figure and drum-shaped pedestal were surrounded by a railing expressed as pikes linked by a twisted cable, with, at each corner, an upturned cannon supporting a cluster of pikes and a ship's lantern. The under life-size figure of Nelson is shown in a realistic manner:[4] the pose is casual and he wears naval uniform displaying the empty sleeve of his missing arm, with no symbolic

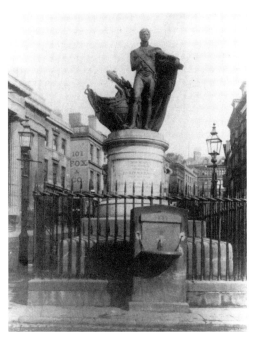

Westmacott, original state and situation of
Admiral Horatio Nelson, picture mid-1800s

allusions other than the pedestal group
described above. Less realistic is the out-of-
scale portrayal of his flagship, 'Victory',
against which he leans. This was the first
publicly-funded statue to be erected in
Birmingham and the first figurative memorial
to Nelson to be erected in Britain. It was
moved in 1961 during the development of the
Bull Ring area and then resited in its present
location, with a new plain pedestal and
without lamps. As a consequence, the partic-
ular association with the City of Birmingham
has been lost to today's viewer.[5]

1. *Gazette*, 6th September 1802; 2. *Gazette*, 11th
November 1805; 3. Quoted in J.A. Langford, *A
century of Birmingham life 1741–1841*, vol.2, 1868,
p.309; 4. A. Yarrington, 'Nelson the citizen hero:
State and public patronage of monumental sculpture
1805–18', *Art History*, vol.6, no.3, September 1983,
pp.315–29; 5. T. Grimley, *Post*, 3rd December 1991;
Birmingham Information Bureau, May 1977.

Bloye, *Lion Pediment*

*Supreme Works, top of the façade and over
the entrance*

Lion Pediment and Seated Craftsmen

William Bloye

*c.*1922–3
Stone
Top panel: 456cm wide (including lettering);
lower panel: 152cm wide
Lettering flanking the lions: SUPREME
WORKS
Status: not listed
Condition: good
Owned by: Supreme Works

The building was designed by Holland
Hobbiss in 1921 and an illustration of it
appeared in an article he wrote for the
Birmingham School of Art magazine *Effort*,
in April 1923.[1] Hobbiss drew attention to the
fact that the lions, which stand on their hind
legs facing each other, 'are symbolic of
strength and courage' inspired by 'those over
the famous gateway at Mycenae'.[2] As the
Supreme Works made jewellery and were
also gold- and silversmiths, these lions clearly
have a symbolic association for they are

Bloye, *Seated Craftsmen*

emblems of protection here just as they were over the main gateway of Mycenae, an important early centre of bronze-working and a wealthy and powerful royal citadel. Carved in low relief (nowhere does the depth of carving exceed 6cm) and decorated with sharp, angular details, Bloye's style of carving is fashionably archaic and frieze-like, emphasising 'the early Greek purity of line'. The lions' tails uncurl to join with the lettering, whose firm serpentine line and sharp serifs show that Bloye had already absorbed Gill's purist sense and well-crafted typographical design. These stylistic influences are also apparent in the frieze over the doorway where two craftsmen are depicted working at a table, carved in flat, linear relief.

1. H.W. Hobbiss, 'Applied decoration on buildings', *Effort*, April 1923, pp.3–5; 2. *BRBP*, 1921, no.33220.

Handsworth public library, over the entrance and over the adjacent window

Scenes from Birmingham's Industrial Past

Benjamin Creswick

1891
Stone
76cm high
Status: II
Condition: good
Owned by: Handsworth Library

Creswick was commissioned to carve these two narrative panels to decorate the two gables of the 1891 extension to the library, which was originally opened in 1880.[1] They commemorate the association of James Watt's and Matthew Boulton's steam engine with Handsworth, where their Soho foundry formed the cradle of the industrial revolution.[2] In the relief over the entrance, Watt is depicted showing his companion, Dr. Robinson, a model of his steam engine. Over

the window Watt and Boulton, surrounded by models and instruments, are said to be discussing the feasibility of applying rotary motion to the steam engine. The servant of the inn, seen in the latter relief, is said to be a Dick Cartwright, who overheard the two men and gave their secret away. When Watt subsequently attempted to patent it, someone else had beaten him to it. Carved with a surround of intricate, floral decoration, the realistic narrative of these two reliefs provided a suitable subject matter for Creswick. He was committed to presenting naturalistic and contemporary details in a style of 'workaday realism', reflecting the influence of Ruskin.[3]

1. *Handsworth Library Reports*, 1890, 1891; Handsworth Local Board Records, *The library extension works accounts*, 1891; 2. S. Smiles, *Lives of the Engineers*, London, 3 vols., 1968 edition; 3. V. Bird, 'Birmingham's neglected statuary', *Birmingham Weekly Post*, 13th August 1954.

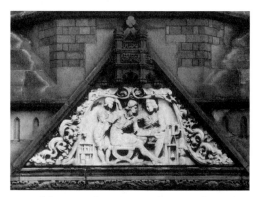

Creswick, *Scenes from Birmingham's Industrial Past*

Blue Coat School, over entrance to main building (originals inside)

Blue Coat Children

Edward Grubb

Originals 1770; replicas 1930
Painted stone
Each 120cm high

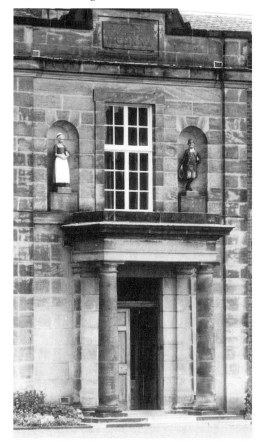

Bloye, replicas of *Blue Coat School Statues*

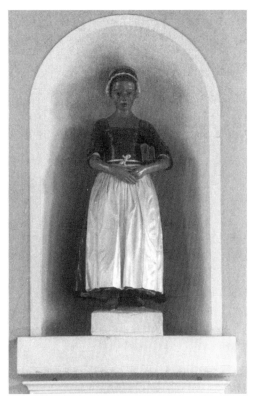

Grubb, *Blue Coat School Statue*

Inscribed, under the boy: Train up a child in the way he should go and when he is old he will not depart from it;
Under the girl: We cannot recompense you but ye shall be recompensed at the resurrection of the just
Status: not listed
Condition: both the originals and the replicas are in good condition
Owned by: Blue Coat School

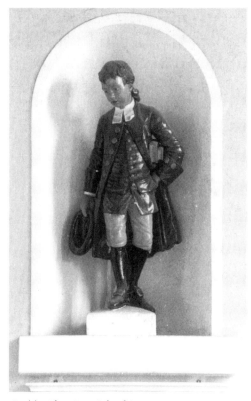

Grubb, *Blue Coat School Statue*

Originally over the entrance to the Blue Coat School, St. Philip's churchyard (now demolished), the two statues were commissioned in 1769[1] and completed the following year. They are of a boy and a girl, portrayed in the original school uniform of the Blue Coat School, although they were unpainted until 1881.[2] The Birmingham historian William Hutton wrote that they were executed 'with a degree of excellence that a Roman statuary

would not blush to own'.[3] When the school moved to its present site in Harborne in 1930, the statues were found to be in poor condition. William Bloye was commissioned to restore them and then take casts from them in artificial stone.[4] These replicas are now in two niches over the entrance to the central administration building, under which the two inscriptions have curiously been reversed, and the originals are in niches inside the main hall.

1. *Minutes of the Blue Coat School Board of Governors*, Birmingham, September 12th 1769; 2. *Mail*, 6th August 1881; 3. W. Hutton, *An history of Birmingham*, Birmingham, 2nd edition, 1783, p.213; 4. *Despatch*, 24th July 1931.

Queen's College chapel, tympanum over west entrance

Ordination

William Bloye

1947
Stone
140cm high × 150cm wide
Inscribed on cloak of central figure: ΟΨΞ ΥΜΕΙΣ ΜΕ / ΕΞΕΛΕΞΑΣΘΕ / ΑΛΛΕΓΩΕΞΕΛΕ / ΞΑΜΗΝ ΥΜΑΣ / ΚΑΙ ΕΘΗΚΑ ΥΜΑΣ / ΙΝΑ ΥΜΕΙΣ ΥΠΑΓΗΤΕ / ΚΑΙ ΚΑΡΠΟΝ ΦΕΡΗΤΕ
Inscribed on lintel of door below: ΔΙΑΚΟΝΟΣ ΚΑΙΝΗΣ ΔΙΑΘΗΚΗΣ
Status: not listed
Condition: good

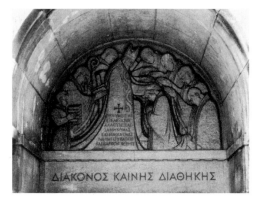

Bloye, *Ordination*

Owned by: Queen's College chapel

Compressed under a round arched portico, this shallow relief shows eight figures compacted around a central bishop, who is laying his hands on a new member of the priesthood. The inscriptions on the lintel and the work are both in classical Greek: the former roughly translates as 'This place promotes the New Testament', and the latter as 'You have not chosen me but I have chosen you to go and do good'. Designed by Hobbiss, the chapel was begun in 1939 but was damaged in the war and only dedicated in 1947.[1] Bloye's ledger shows entries for both years referring to this piece.[2]

1. *Post*, 16th April 1947; 2. Bloye, *Ledger*, 4th November 1939, p.86; 23rd July 1947, p.114.

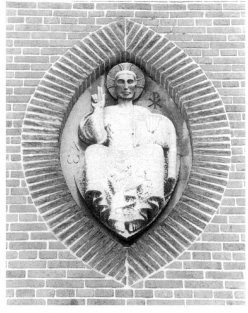

Bloye, *Christ*

Christ

William Bloye

1947
Stone
160cm high × 80cm wide
Status: not listed
Condition: fair. Weathering and discolouration
Owned by: Queen's College chapel

Set within a distinctively pointed oval niche, this shallow relief shows a seated Christ with his hand raised in blessing. The details are finely carved in Bloye's linear manner, though weathering has taken its toll.

Jewellery Business Centre

Gates to Jewellery Business Centre

Michael Johnson

1991
Stainless steel, brass and glass
610cm high × 300cm wide
Accompanying plaque reads: The Gates to the
Jewellery Business Centre are crafted of stainless
steel, cast brass and glass, symbolising silver, gold and
precious stones. The design represents base materials
growing into fine jewels. The Gates represent the
security of the Jewellery Business Centre but remain
permanently open to provide welcome.
Status: not listed
Condition: good
Owned by: Jewellery Business Centre

These gates were commissioned by the
Duchy of Cornwall as part of the restoration
programme for the Jewellery Business Centre
in 1991. Awarded first prize in the 1991
Birmingham Design Awards, the gates are
composed of tree-like organic forms of
twisting metal within an arched framework.
The solid glass and sinuous steel elements
present a very tactile experience and the
whole ethos of the gates is summed up well
by the plaque's inscription. The gates' design
is reflected in a hanger for the Centre's sign,
to the left above the entrance. This piece was
the centre of controversy in both local and
national press, though 'once people realised
that tourists were turning up to be guided to
the gates, the outrage at this piece of modern

design evaporated like snow in August at the
prospect of their money'.[1]

1. *Mail*, 1st April 1991; T. Grimley, *Mail*, 8th April
1991; T. Grimley, *Expanding Meanings in Public Art*,
debate at the Ikon Gallery, 8th June 1995.

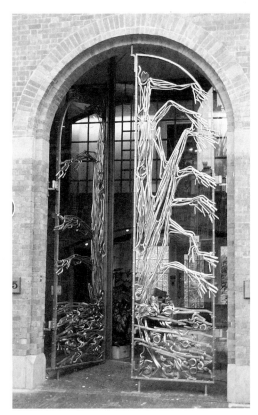

Johnson, *Gates to Jewellery Business Centre*

Fountain Court barristers' chambers

Fountain (Nude Girl) see illustration
overleaf

William Bloye

1964
Bronze sculpture on raised stone basin
Figure: 155cm high; base: 170cm high ×
150cm diameter
Inscribed: W. Bloye 1964
Status: not listed
Condition: good
Owned by: Fountain Court

This aquarian figure of a young girl, stooping
as if to pour water from the shell she holds, is
standing on a stone basin set above a pool
shaped in four cusps. This fountain decorates
the courtyard of the barristers' chambers
designed by Holland Hobbiss and Partners,
and cost £900. Bloye was also responsible for
the plaque commemorating the opening of
the chambers on 3rd October 1964 and the
four heraldic shields over the entrance.[1] The
plaster mould for this piece is in store at the
Birmingham Museum and Art Gallery.

1. Bloye, *Ledger*, 4th and 25th September 1964, p.172.

Police Station

Keystone Heads

William Bloye

*c.*1930–3
Stone
Each: 30cm high × 15cm wide
Status: not listed
Condition: good
Owned by: West Midlands Police

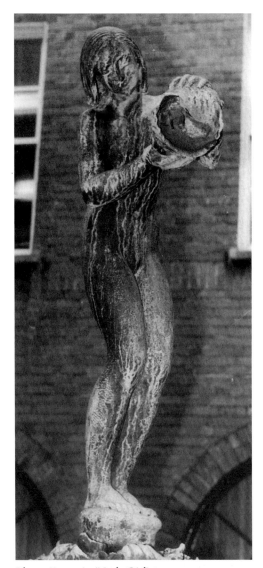

There are three heads over separate doorways into the police building (only one of which is in use). Each head is different, with two bearded men and one woman. These are carved in a bold neo-Egyptian style showing smooth facial features and blank almond-shaped eyes. They are framed by depressed arch hairlines which form an evenly undulating background and emphasise the smooth surfaces of the faces. Forming only part of Bloye's sculptural programme for the police station,[1] designed in 1930,[2] the heads show the interest of the period in ancient oriental and neo-primitive styles of sculpture.

1. Bloye, *Ledger*, 12th July 1933, p.6, invoice no.40;
2. *BRBP*, 1930, no.52232.

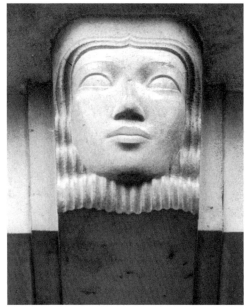

Midland Hotel, above the entrance

Caryatids

John Rollins

1903
Stone
Each 175cm high
Status: not listed
Condition: good
Owned by: Midland Hotel

These two caryatids are similar in style to those Rollins modelled in terracotta for the Birmingham General Hospital, Steelhouse Lane (see under Lost Works). They are hefty, life-size figures with rounded limbs and solid bodies. Their drapery is similarly modelled in heavy folds, consciously hanging on the bias. Rollins is attributed with this work because the Midland Hotel was rebuilt by William Henman, the architect of the General Hospital, seven years later and in a similar style.[1] The whole hotel complex has recently been redeveloped and the caryatids have been restored to a very clean condition.

1. 'Midland Hotel, Birmingham', *The Builder*, vol.85, 1903, p.254.

Bloye, *Fountain (Nude Girl)*: see p.121

Bloye, *Keystone Head*

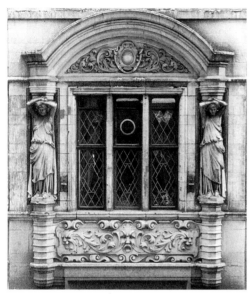

Rollins, *Caryatids*

St. Agatha's church, façade

Christ in Majesty and Scenes from the Life of St. Agatha

Sculptor: H.H. Martyn & Co, Cheltenham

Designed by: William Henry Bidlake

c. 1901–3
Stone
Tower sculpture: 675 cm high overall;
tympana, each: 235 cm wide
Status: I
Condition: fair. The tower sculptures are

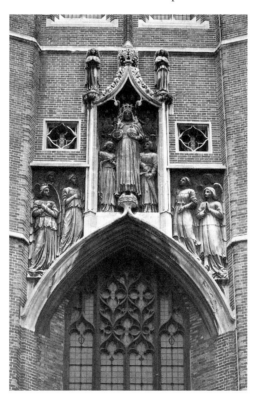

Martyn's, *Christ in Majesty*

dirty due to weathering
Owned by: St. Agatha's church

Designed by W.H. Bidlake, architect of St. Agatha's, which was built between 1899 and 1901, the sculptural details form an integral part of the architectural composition. The attribution is supported by architect's drawings of the tower and its sculpture in general outline which is in the church collection, and a drawing of the west front, which shows the sculpture represented as executed, which was exhibited at the Royal Academy in 1902 and illustrated in *The British Architect* in 1903[1] (this could, however, have been drawn after the completion of the church).

The details were carved by H.H. Martyn's of Cheltenham, who noted this collaboration in their brochure datable to 1905.[2] A close inspection of the sculpture in 1981 revealed that the panels were fixed to the wall with bronze pins or clamps,[3] so it is likely that the architect provided large drawings which were scaled-up to full size in the Sunningend Studios in Cheltenham. The cherub voussoirs, on the other hand, may have been carved *in situ*: there is an undated photograph showing a procession of surpliced clergymen in front of a new, clean St. Agatha's; both the portal voussoirs appear as plain blocks and the tympana are filled in with raw brick.[4] Another faded photograph, however, shows a stonemason at work on the north-west portal, perhaps putting the finishing touch to one of the cherub voussoirs, and was also illustrated in *The British Architect*.

The three relief panels on the central tower represent Christ in Majesty, surrounded by winged angels. The tympana

Martyn's, *Scene from the Life of St. Agatha*

Martyn's, *Scene from the Life of St. Agatha*

reliefs show two scenes from St. Agatha's life: on the left tympanum she is shown shackled, in reference to her imprisonment, her tortured body being healed by a vision of St. Peter and an angel. The right tympanum panel depicts the saint being burnt, a torture she endured rather than break her life-long vow of consecration to Christ. Other carved details on the church include four angel finials on the tower, the cherub voussoirs around the porches together with the inscriptions above in textura Gothic script: ENTER INTO HIS COURTS WITH PRAISE and ENTER INTO HIS GATES WITH THANKSGIVING. Interior details include corbel stones depicting the heads of St. Peter and St. Agatha, together with ceiling bosses and capitals.

1. *The British Architect*, vol.LIX, 23rd January 1903, pp.62–3; 2. H.H. Martyn, *brochure*, in the archives of their historian, J.H.M. Whitaker, 1985; 3. Letter from Sutton Webster, specialist on W.H. Bidlake, 25th November 1985; 4. 'The Church of St. Agatha, Sparkbrook, Birmingham', *The Builder*, vol.LXXXIV, 10th January 1903, p.40; J. Whitaker, *The Best*, 1985.

The Mermaid public house, corner of Warwick Road and Stratford Road

Mermaid

Alan Bridgwater (attributed)

*c.*1960
Stone, painted
110cm high × 200cm wide
Status: not listed
Condition: poor. Stonework split with details eroded. Paintwork badly peeled
Owned by: not known

Bridgwater, *Mermaid*

Attributed to Bridgwater by his widow, who holds all of his records,[1] the panel was designed in collaboration with the architect Holland Hobbiss for the brewery. William Bloye also carried out some sculptural decoration at The Mermaid,[2] though these are likely to have been smaller details. The pub has lain derelict since the early 1990s and the site has been sealed off since late 1996, with the result that the Mermaid panel is now in particularly poor condition.

1. Letter from the artist's widow, 22nd March 1986; 2. Bloye, *Ledger*, 2nd January 1948, p.117.

The Bear Inn public house, over entrance

Bear and Staff

William Bloye

*c.*1937
Stone, painted
140cm high
Status: not listed
Condition: good
Owned by: The Bear Inn

Designed by Hobbiss in November 1936,[1]

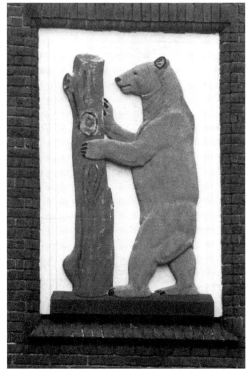

Bloye, *Bear and Staff*

the Bear public house was rebuilt in 1937 on its original site for Mitchell and Butler's. Bloye's low relief was completed by the end of the year.[2] It depicts a bear standing upright next to a ragged staff, a motif taken from the crest of the Earls of Warwick of the 15th century and, subsequently, a change in the arms of the Warwickshire County Council. This is a reminder that until the boundary changes of 1974, Birmingham was in Warwickshire. Although the panel has been painted a dull brown and beige, Bloye's careful modelling is still evident. Yet in spite of the contrast it makes with the plain background, the motif appears less emphatically emblematic than, for example, his sign for the Antelope public house nearby, which also derives from a heraldic badge. The flatness of the relief is increased by a projecting ledge below, on which both the bear and staff appear to be standing.

1. *BRBP*, November 1936, no.66711; 2. Bloye, *Ledger*, 6th January 1938, p.59, invoice no.374.

The Antelope public house, 512 Stratford Road, over entrance

The Antelope

Sculptor: Tom Wright

Designed by: William Bloye

*c.*1929
Stone, polychrome
180cm high × 100cm wide
Inscribed on lintel: THE ANTELOPE
Status: not listed
Condition: good
Owned by: The Antelope pub

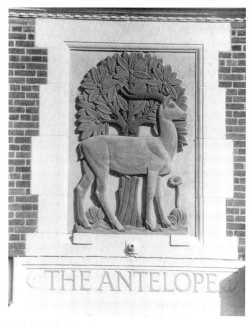

Wright, *The Antelope*

Boldly set into a white stone background against the brown brick façade of the pub, this is a fine piece of relief carving which distinguishes the building from its surroundings. Based on a heraldic emblem, the fawn-coloured antelope, carved in a linear manner, stands out against the light green of the tree behind.[1] Although the design is undoubtedly Bloye's, the carving has been attributed to one of his assistants, Tom Wright.[2] This pub was designed by Holland and Hobbiss,[3] whose name is discreetly inscribed above the entrance, and the overall building was enthusiastically greeted by the brewers: 'In years to come that sculptural doorway may well draw

as enthusiastic admirers as many a doorway at Oxford or Cambridge.'[4]

1. A. Crawford and R. Thorne, *Birmingham pubs 1890–1939*, Birmingham, 1975, p.25; 2. Hickman, 1970, p.591; 3. *BRBP*, 1926, no.41157; 4. Mitchell and Butler's, *Fifty years of brewing 1879–1929*, Birmingham, 1929.

Sparkhill Library and Building Control Office, formerly Yardley District Council Public Office, over the first floor windows

Allegory of Knowledge and Justice

Benjamin Creswick

*c.*1900
Stone
Four panels, each: 80cm high
Status: not listed
Condition: good
Owned by: Sparkhill Library

Each of the four panels shows a seated female figure in long robes, holding attributes that symbolise virtues associated with public office. On the library is Knowledge, holding a lamp, and Justice, blindfold, holding scales

and a sword. On the Building Control office is History, scribing on a tablet, and a figure who appears to hold a strap or thong. The style of the carving, in both the explicitly allegorical nature of the iconography and the sharply rendered and somewhat hectic details, suggests that Creswick was the sculptor responsible. The building was designed in 1898 by local architect Arthur Harrison,[1] for whom Creswick worked on several occasions, although it was not completed until 1902.[2] It was built by Yardley Parish Church, intended, it is said, to encourage the inhabitants of Sparkhill to remain in Worcestershire, although in 1911 the district was absorbed within the city of Birmingham.

1. 'Public offices and depot, Yardley', *The Builder*, 3rd December 1898, pp.508–9; 2. *Kelly's Directory of Birmingham*, London, 1902.

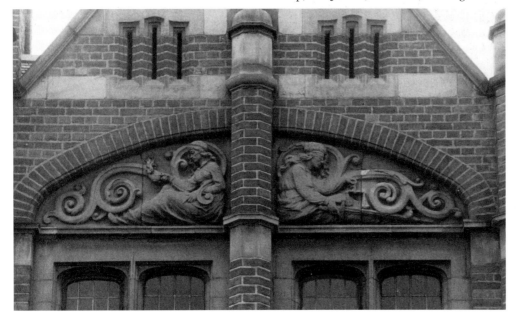

Creswick, *Allegory of Knowledge and Justice*

Electricity substation, first floor of façade

Cartouche

Gibbs & Canning

c.1902–3
Buff terracotta
150cm high
Status: not listed
Condition: good
Owned by: Midlands Electricity Board

There are five cartouches decorating the façade of this otherwise plain, red-brick building. It was designed in 1902 by Ewen Harper,[1] whose Methodist Central Hall was not yet finished. Gibbs and Canning supplied the cartouches, with their heavy scrolls. Although they appear suitable in the context of the austere façade of this building, they lack fine detailing.

1. *BRBP,* 1902, no.16843.

College of Food and Domestic Arts

Coat of Arms

Raymond Kings

c.1965–7
Ciment fondu, polychrome
275cm high
Inscribed: SERVICE BEFORE SELF
Status: not listed
Condition: good
Owned by: College of Food

Commissioned for the new College of Food and Domestic Arts, Kings was contracted by his agent Henry Joseph of Allied Artists, who was responsible for the architectural decorative details.[1] The *Coat of Arms* follows that granted to the college on 20th September 1962, although the cluster of fruit, signifying abundance, in the crest and the motto were not officially specified at that time.[2]

1. Letter from Henry B. Joseph, Allied Artists, 15th April 1985; Letter from John Kings, 13th November 1985; 2. G. Briggs, *Civic and corporate heraldry,* London. 1971, p.60.

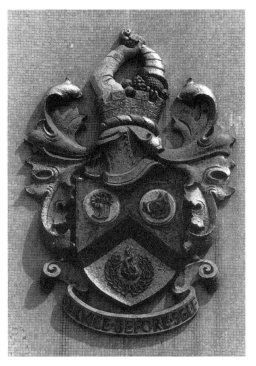

Above Gibbs & Canning, *Cartouche*

Kings, *Coat of Arms*

St. Philip's Square, south side

Memorial to Thomas Unett

Peter Hollins

*c.*1856
Pink marble obelisk and stone steps
200cm square × 530cm high
Signed bottom left of marble base on south
face: PETER HOLLINS
Inscribed in gilt Roman lettering on north
and south faces of obelisk: ALMA / INKER-
MANN / SEBASTAPOL.
Inscribed on south face of pedestal in gilt
gold lettering: THOMAS UNETT, C.B / LIEU-
TENANT-COLONEL OF THE 19TH FOOT. /
BORN IN BIRMINGHAM / ON THE 12TH OF
NOVEMBER 1800 / WAS MORTALLY
WOUNDED / AT THE SEIGE OF SEBASTAPOL
/ WHILE LEADING THE BRITISH COLUMN /
TO THE FINAL ASSAULT ON THE REDAN /
ON THE 8TH OF SEPTEMBER 1855 / HIS
FRIENDS AND FELLOW-TOWNSMEN / DEDI-
CATE THIS OBELISK / TO HIS MEMORY / AS
A RECORD OF THE NOBLE EXAMPLE / OF
ONE WHO CHOSE THE FOREMOST PLACE /
IN THE PATH OF DUTY / AND MET DEATH /
WITH THE CALM UNDAUNTED SPIRIT / OF
A CHRISTIAN SOLDIER.
Status: II
Condition: good but slightly dirty
Owned by: St. Philip's Cathedral

Unett's memorial consists of a finely polished
pink marble obelisk on a base of three stone
steps. The lettering is cleanly carved and the
whole is a noble and fitting monument to this
soldier about whom little is now known.
This is an unusual work by Hollins in that
there is no portrait or figure.

Memorial to F.G. Burnaby

Sculptor not known

Portland stone
360cm square at base × 1700cm height
The inscriptions are raised and in Roman
type. Inscribed on North Face: BURNABY.
Inscribed on East Face: KHIVA / 1875.
Inscribed on West Face: ABU KLEA / 1885.
Status: II
Condition: fair. The monument is generally
dirty, with guano encrustation and graffiti
particularly at the base. Carved details show
signs of deterioration through weathering
Owned by: St. Philip's Cathedral

The memorial obelisk for Frederick
G.Burnaby (1842–82) is positioned upon a
pedestal and double stepped base. As well as
the inscriptions indicating the dates of his
military campaigns, the south side of the
monument contains a three-quarter relief
portrait of Burnaby in uniform. Directly
above this portrait, at the base of the obelisk
above the cornice that divides the monument,
the stone is carved to portray military regalia,
including breast plate and helmet, serving as a
direct reference to Burnaby's military career.
The cornice that separates the pedestal from
the obelisk is decorated with acanthus leaves.
Burnaby was a well-known military figure
and local politician, who stood as a conserva-
tive candidate for Birmingham in 1884.[1] His
accounts of his travels, particularly *A Ride to
Khiva*, led to his meeting Queen Victoria.[2]
He was killed in action whilst on a mission to
rescue General Gordon.

1. Briggs, A. *History of Birmingham*, Vol.2, Oxford
University Press, 1953, p.177; 2. Pugh, p.30.

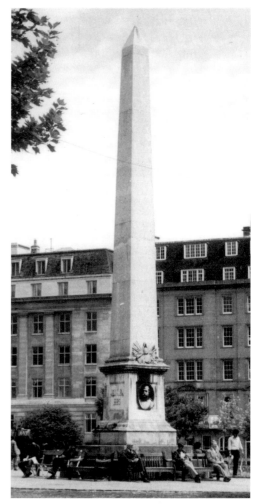

Anon, *Burnaby Memorial*

Memorial to John Heap and William Badger

Sculptor not known

*c.*1833
Anglesea marble
130cm square × 200cm high
Inscribed on south face in Roman lettering:
JOHN HEAP / WHO WAS KILLED BY
ACCIDENT / ON JANUARY 26TH 1833 AGED
38 YEARS / WHILE ASSISTING IN BUILDING
THE BIRMINGHAM TOWN HALL / ALSO
WILLIAM BADGER / WHO WAS KILLED BY
THE SAME ACCIDENT / AGED 26 YEARS
Status: II
Condition: fair. Weathered on all surfaces
with some splitting of the stone. Covered in
lichen at joints. Lettering smoothed and not
easily discernible
Owned by: St. Philip's Cathedral

This monument consists of a small section of
one of the fluted town hall columns,
surmounting a pedestal made of the same
white stone, upon which is the inscription.
Heap and Badger were working on the site
when a pulley block broke, dropping the
pillar onto them.[1]

1. *Birmingham Faces and Places*, vol.2, p.77.

*Attached to wall on the south eastern side of
St. Philip's Square*

Angel Drinking Fountain

Sculptor not known

Mid 1800s
Iron fountain on stone screen
300cm tall × 150cm wide × 50cm deep
Inscribed on book: WHOSOEVER /
DRINKETH OF / THIS WATER / SHALL /
THIRST AGAIN / BUT / WHOSOEVER /
DRINKETH OF THE / WATER THAT I SHALL
/ GIVE SHALL / NEVER THIRST
Status: II
Condition: good but dirty
Owned by: Birmingham City Council

This drinking fountain was originally sited
outside Christ Church (which faced onto
what is now Victoria Square), until its demo-
lition in 1899. This explains the religious
connection of the inscription, and the melan-
cholic-looking angel which overlooks the
bowl. Painted black, the ironwork consists of
the angel and book, and a scallop-shaped
bowl backing onto reeds, which is within a
wreath. This is all set into a stone screen
which is topped with a classical pediment.
Just in front is a small kneeling stone. A small
modern plaque records its restoration in 1988
by the City Council, Cathedral and Wragge
& Co., solicitors.

Great Western Arcade, above entrance

Allegories of Science and Art

William Ward

Ward, Allegories of Science and Art

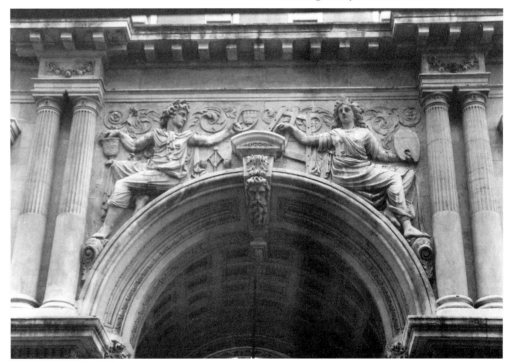

1875–6
Darley Dale and Bath stone
400cm high
Status: II
Condition: good
Owned by: not known

These imposing carvings are located at one end of this arcade built over a tunnel of the Great Western Railway by the architect W.H. Ward in 1875 and opened on 28th August 1876.[1] The first of several such arcades in Birmingham, it comprised ninety-four shops and offices under a glass roof.[2] The figures were intended, along with two others in the spandrels on the Colmore Row façade, to attract trade from the other main shopping area on Bull Street. The male figure, personifying Science, holds attributes including dividers and compasses. The female, personifying Art, holds an painter's palette and has an easel by her side. Both figures fit their architectural setting, seated around the arch, their outstretched hands echoing its shape. The arch is further decorated by stylised foliation in low relief, typical of the period yet reminiscent also of French 17th-century architectural decoration. They complement the Italian-French Renaissance architecture of the arcade, a style Ward employed elsewhere, notably for the Board of Guardians building on Newhall Street, 1883–4.

1. Dent, 1880, p.573; 2. 'The new arcade, Birmingham', *The Builder*, 2nd September 1876, p.862.

4, Temple Row West, Lloyds Bank, formerly the Birmingham Joint Stock Bank, banking hall entrance and window arches

Keystone Heads
Designed by Julius Alfred Chatwin

1862–4
Stone
Each 50cm high
Status: II
Condition: good
Owned by: Lloyds Bank

These five heads, each one different, are alternately male and female and take mythological figures such as Minerva and Neptune as their models. They embellish the ground floor rusticated arches of this Italian classical styled façade, with its Renaissance and Mannerist detailing. Chatwin's first bank, its general acclaim at the time led him to design similar palazzo-style buildings along most of the north side of Colmore Row and, in 1870, to become architect to Lloyds Bank. Whether in the Classical or Gothic style, Chatwin generally included such prominent sculpture in his buildings. The sculptor here is unknown: it may possibly have been Farmer and Brindley of London, or even the local sculptor, John Roddis, both of whom worked with Chatwin elsewhere.[1]

1. Pevsner, 1966.

West side of St. Philip's Square

Memorial to Members of the Lines Family

Late 1840s
Stone slab with iron struts and decorative relief
130cm wide × 80cm deep × 200cm tall
Inscribed on both sides of slab with painted lettering. Main lettering on west side reads:
THE MEMORY OF SAMUEL LINES / ARTIST / BORN AT ALLESLEY FEBY 7TH 1778.
Status: II
Condition: poor. Stone spalling; lettering almost completely deleted; ironwork rusted
Owned by: St. Philip's Cathedral

This tapering stone slab has a tubular iron strut up each corner and an overhanging pediment with an egyptianate winged symbol in the centre. The whole presents a very simple appearance, but is marred by the bad state of the stonework which makes the inscriptions impossible to read. Samuel Lines was a well-known local artist in the first half of the 19th century, setting up a school of drawing in 1807 which moved to Temple Row West, where he taught for 50 years until his death.[1]

1. Dent, vol.3, p.565.

Chatwin, *Keystone Heads*

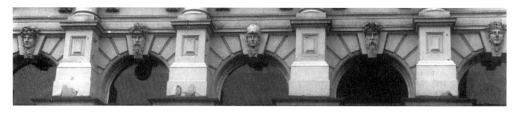

City Arcade, above the entrance

Heads, Beasts and Figures

William Neatby

1899–1901
Dark brown terracotta
50cm high
Status: not listed
Condition: good
Owned by: not known

Neatby, *Heads, Beasts and Figures*

Two heads, one of a man, the other a woman, are part of a larger decorative scheme, for at the top is a frieze of fantastic beasts and around the domes are terminal figures surmounting elaborate volutes. The heads are stylised, modelled as mythical warriors in the contemporary style influenced by French Symbolism, but still in the tradition of the Arts and Crafts Movement, such as that of George Frampton's sculpture. City Arcade was designed by the Birmingham architects Newton and Cheatle[1] for whom Neatby also decorated the King's Café, Colmore Row (now demolished). It originally consisted of three arms extending from Union Passage to the High Street, to New Street and Union Street, although only this last one remains.[2] Neatby designed all of the terracotta decoration[3] and these heads are only two in a series made by Doulton's for the entrances to all three arms. Neatby's design for the woman's head was illustrated in *The Studio* in 1903.[4]

1. *BRBP*, 1899, no.15138; 2. A. Crawford, *Tiles and terracotta in Birmingham*, Victorian Society, 1975; 3. 'Designer's jottings', *Artist*, vol.28, 1900, p.107; 4. A. Vallance, 'Mr. W.J. Neatby and his work', *The Studio*, vol.29, June 1903, pp.113–17.

The University of Birmingham's central cluster of buildings was designed by Aston Webb and Ingress Bell from 1900–9. An impressive campanile overlooks Chancellor's Court, with the Great Hall and library on opposite sides, whilst outside this space are more modern buildings containing academic and administrative departments. See entries under Edgbaston Park Road for other works on University property.

Barber Institute of Fine Arts, forecourt

Equestrian Statue of King George I

John van Nost the Elder

Unveiled in Dublin 1722; re-erected in Birmingham in 1937
Bronze, on a stone pedestal
Statue: 300cm high × 200cm long; pedestal: 200cm high × 300cm long
Status: II
Condition: good
Owned by: University of Birmingham

This memorial statue to George I was commissioned by a committee of the Dublin Parliament in 1717, and is probably by John van Nost the Elder, who had made at least five other equestrian statues of him. This work was unveiled on a pier of Essex (now Gratton) Bridge in Dublin on 1st August 1722 amidst great celebrations. However, monuments to British monarchs in Ireland became prime targets for republican sympathisers and this statue only survived because it had been placed temporarily in the back garden of Mansion House. The Corporation therefore found it expedient to sell it in 1937, rather than re-erect it.[1] The Trustees of the

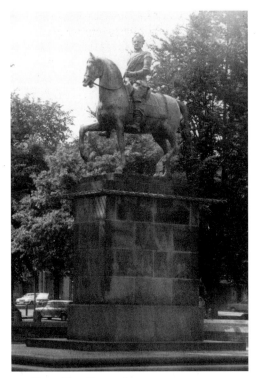

van Nost, *King George I*

sical motif suggestive of victory and a reminder of the classical tradition from which the statue derives.[3] Birmingham University Union's newspaper pointed out, however, that George I, a German by birth, had been quoted as saying 'I hate boets and bainters', and the article used this as an ironic comment on its current siting outside the Barber Institute.[4] The statue was subject to some conservation upon its arrival in 1937, and more recently, minor repairs were carried out in 1993.[5]

1. *Mail*, 2nd October 1937; 2. 'Dublin king (in bronze) for Birmingham', *Despatch*, 2nd October 1937; 3. K. Garlick, 'Birmingham's only "Horse"', *Post*, 8th July 1952; 4. *Guild News*, 22nd October 1953, p.5; 5. Birmingham Museums and Art Gallery, *Public art in Birmingham information sheet no.17*, Birmingham, 1994.

Barber Institute purchased the statue,[2] making it the oldest memorial work in Birmingham. It is a particularly fine piece.

Following a long tradition of the equestrian statue, of which the earliest surviving example is the bronze statue of Marcus Aurelius of the 2nd century A.D. in Rome, this subject provides sculptors with the challenge of unifying the horizontal figure of the horse with the vertical figure of the rider. In van Nost's work, the King wears contemporary dress but is given a laurel crown, a clas-

Barber Institute of Fine Arts, the entrance

Heraldic Shields

Gordon Herickx

*c.*1936–7
Stone, polychrome
160cm high
Status: II
Condition: good
Owned by: University of Birmingham

Devised as part of the exterior decoration of the new Barber Institute which was built in 1936–7 to the designs of Robert Atkinson. The coats of arms of the Barber family are on

Herickx, *Heraldic Shields*

the left and those of the University of Birmingham are on the right. Brightly painted, they were carved by Herickx in relief within a geometric surround, complementing the rectilinear design of the double storey entrance.[1]

1. *The Builder*, vol.79, 4th August 1934, p.196.

Barber Institute of Fine Arts, the façade
Symbols of the Arts
Gordon Herickx

*c.*1936–7
Stone
160cm high
Status: II
Condition: good
Owned by: University of Birmingham

The four recess stone slabs are carved with a lyre, symbolising Music; a laurel branch, symbolising Fine Arts; a palm leaf – reward

Herickx, *Emblem of Merit*

of Merit; and a torch – Civilisation. This scheme was devised by Thomas Bodkin, the first Director of the Barber Institute. As a former pupil and assistant of William Bloye, Herickx's carvings show an elegance and

refinement complementing the linear form of the façade, yet also boldly emblematic, in keeping with their symbolic purpose.[1]

1. *The Builder*, vol.79, 4th August 1934, p.196.

University of Birmingham, Great Hall, over the entrance
Beethoven, Virgil, Michelangelo, Plato, Shakespeare, Newton, Watt, Faraday and Darwin
Henry Pegram

Building designed by Aston Webb and Ingress Bell

1907
Darley Dale stone
Each: 180cm high
Status: II*
Condition: good
Owned by: University of Birmingham

Pegram, *Portrait Figures*

Representing Art, Philosophy, Science and Industry, these nine life-size statues were intended to 'bear relation to the function of the University at large'.[1] They are arranged in groups of three, each figure standing within a canopied niche and either carrying an attribute or poised to indicate each chosen discipline. Not included in the original sketch of the façade of 1902,[2] they are largely an unimaginative series, remarkable only in that they were carved *in situ*, as indicated by the lines of jointure of each figure, comprised of five blocks of stone, continued from the façade. W.S. Frith, Webb and Bell's usual sculptor, carried out all of the heraldic and other ornament here and Robert Anning Bell did the mosaic above.

1. A. Webb and E.I. Bell, 'The Birmingham University', *The Builder*, 3rd May 1902, p.448; 2. 'Birmingham University', *The Builder*, 13th July 1907, p.55.

Aston Webb building, to the left of the entrance hall

King Edward VII (1841–1910)

Edward Drury

1911–12
Blancho Paracci marble statue, on a pedestal of Sicilian marble
Figure: 215cm high
Inscribed on pedestal: HIS MAJESTY KING EDWARD VII / ACCOMPANIED BY QUEEN ALEXANDRA / OPENED THESE BUILDINGS JULY 7 1909 / AND CONCLUDED HIS

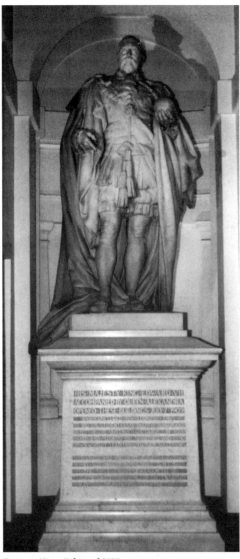

Drury, *King Edward VII*

ADDRESS THUS / 'TO YOU THE STUDENTS I SAY THAT THE HONOUR AND / DIGNITY OF THIS UNIVERSITY ARE LARGELY IN YOUR / HANDS AND I LOOK TO YOU TO INITIATE AND HAND / DOWN WORTHY TRADITIONS TO YOUR SUCCESSORS' / THIS STATUE WAS PRESENTED TO THE UNIVERSITY / BY ALDERMAN FRANCIS CORDER CLAYTON, / THE FIRST PRO-VICE CHANCELLOR, / TO COMMEMORATE THE OPENING OF THE UNIVERSITY / BY HIS MAJESTY, KING EDWARD VII
Status: not listed
Condition: fair. Details eroded and sceptre removed
Owned by: University of Birmingham

The King is portrayed wearing the full robes of the Order of the Garter and holding the royal orb and sceptre. Originally in bronze, both the sceptre and detailing on the orb have since disappeared. By 1910, Drury had already executed portraits of King Edward VII for the Mercers' Hall, the National Gallery, New South Wales and Warrington Town Hall. At the time he was also working on another large statue of the King for Aberdeen. Working from photographs and wax sketches, a quarter-size clay model was ready by November 1910,[1] and the final work was in progress in April 1911.[2] The finished piece was unveiled by Mrs. Joseph Chamberlain on 27th June 1912.[3]

1. *Despatch,* 7th November 1910; 2. *Post,* 1st April 1911; 3. *Post,* 27th June 1912.

University Square

Ancestor I

Dame Barbara Hepworth

1971
Bronze
280cm high
Status: not listed
Condition: good
Owned by: University of Birmingham

Originally designed in 1970 as part of a series of nine called *The Family of Man* first shown at the Marlborough Gallery, London, in April 1972,[1] this cast of *Ancestor I* is the second work loaned to Birmingham University by Barbara Hepworth.[2] It consists of four separate sections bolted together, two emphatically vertical alternating with two horizontal. Although apparently casually stacked, they are united by the overall smooth texture and patina of the bronze, and the suggestion by the top and bottom pierced sections of a standing figure. Hepworth's monolithic sculpture dates back to her earliest figures (for example, *Contemplative Figure*, 1928) but open, stacked forms like this did not appear until this series.

1. Barbara Hepworth, *The Family of Man*, Marlborough Art Gallery, exh.cat., April-May 1972; 2. *University of Birmingham Bulletin*, no.156, 19th June 1972.

Mechanical Engineering Department, below the window of the large lecture theatre

Engineering

William Bloye

1954
Stone
120cm high × 600cm wide
Inscribed around central motif: ELECTRICAL ENGINEERING MECHANICAL ENGINEERING; and at the base of the work: TO STRIVE TO SEEK TO FIND AND NOT TO YIELD
Status: not listed

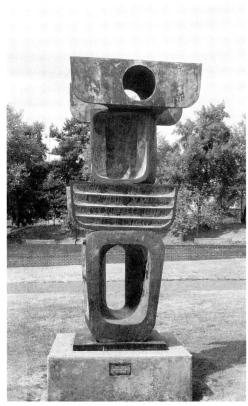

Hepworth, *Ancestor I*

Bloye, *Engineering*

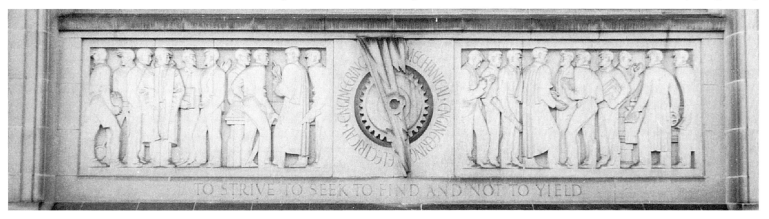

Condition: good
Owned by: University of Birmingham

Bloye's relief[1] was unveiled when the building, designed by the architects Peacock and Bewlay, with whom Bloye had worked previously, was opened on 2nd July 1954.[2] It consists of two figurative panels, one on either side of a motif comprising a bolt of lightning shot through a cogwheel, combining the emblems of the two departments. Each panel depicts nine male students and a tutor in contemporary dress. Only the head of the tutor exceeds the upper framing boundary, a device that suggests his commanding presence and one that derives from Egyptian art, which had influenced Bloye as early as 1932 in work for the Legal and General Assurance building. Both panels represent engineering generally. In the left one a student stands in front of a drawing board holding a T-square. In the right panel, a figure operates a lathe handle whilst someone else appears to be carrying out an instrument inspection. The figures are carved sharply, in profile and in a compressed space against a largely plain background.[3] This style is typical of Bloye, seen as far back as the *Hall of Memory* panels of the early 1920s. The lettering, which includes the final words of Tennyson's poem 'Ulysses', is incisively carved and thoughtfully spaced, adding sobriety to the emblematic quality of the relief.

1. Bloye, *Ledger*, 11th November 1953, p.139;
2. *Official Opening Ceremony*, pamphlet, 2nd July 1954, illustration facing p.5; *Mail*, 2nd July 1954;
3. 'University of Birmingham: Opening of new mechanical engineering buildings', *Engineering*, vol.178, 9th July 1954, p.59.

In front of the Mechanical Engineering Department

Wrestlers

Edward Bainbridge Copnall

c. 1950
Granite
65cm high
Status: not listed
Condition: good
Owned by: University of Birmingham
Exhibited: Royal Academy, 1950

The sculpture was purchased from ex-student subscriptions as a gift to the University of Birmingham in appreciation of F.K. Bannister on the occasion of his retirement in 1974.[1] As Professor of Thermodynamics, Professor Bannister (1909–75) had established the Postgraduate School of Thermodynamics and Related Studies in 1951; it was the first post-graduate school at the University and one of the first in the country.[2] The selection of a sculpture was made by a university colleague, John Patterson, who arranged to buy the work, still in the possession of Copnall's widow (the sculptor having died in 1973). He chose *Young Peace* (exhibited at the RA in 1947)[3] which represented Eve as a young girl in the Garden of Eden with a serpent at her feet. Purchased by the university, it was later rejected by Mrs. Bannister who thought it an unsuitable subject. Eventually, *Wrestlers* (exhibited at the RA in 1950)[3] was offered and accepted as a substitute sculpture for the University. This change was probably made because, while the former subject was seen to allude to temptation, the latter is a traditional

Copnall, *Wrestlers*

theme which equally alludes to thermodynamics, a science of interacting relations between heat and metal and to the professor's struggle to attain his position as a leader in his field of study. The solid rock-like characteristics of the carved granite are retained whilst movement of the struggling figures is

portrayed by a careful balance of abstracted and simplified forms. Its volume is juxtaposed by the somewhat uncomfortable looking short steel pole and brick plinth on which it is placed. It is illustrated in Copnall's book *A sculptor's manual*.[4]

1. Obituary, *The Times*, 3rd February 1975; 2. Letter from Professor John Patterson, 5th February 1986; 3. *Royal Academy exhibitors 1905–1970*, vol.II, Wokingham, 1977, p.80; 4. E.B. Copnall, *A sculptor's manual*, Oxford, 1971, p.31.

University of Birmingham, outside Staff House

Nude Girl with Hat

Bernard Sindall

1974
Bronze
160cm high
Status: not listed
Condition: good
Owned by: University of Birmingham
Model exhibited: Barber Institute, 1974

Nude, but for a hat on her head, this statue of a young girl was presented to the University by Sir Robert Aitken, who retired as Vice-Chancellor and Principal in 1968, and his wife, Lady Aitken, who unveiled it on 22nd October 1974.[1] Professor Hamish Miles, Director of the Barber Institute, selected Sindall for the work which, with a grant from the John Feeney Charitable Bequest and the Arts Council, cost £1,250.[2] The sculptor was given the freedom to choose his own subject. A small resin model of this statue was shown at the Barber Institute during the summer of 1974, alongside a similar yet large-scale figure titled *Seated Girl*.[3] The features of the statue are rounded, except for a pointed nose, upturned nipples of her pubescent breasts and the angular poise of her elbows. She stands casually, smiling, but in a vaguely classical pose, like Donatello's *David*.[4] An upright female nude in a hat is a well-established genre in post-Renaissance painting, starting with Cranach in the 16th century and continued by Rubens in the 17th century. The artist said that he made the work with the students in mind, hoping 'the statue will be an object of pleasure to people'.

1. *University of Birmingham Bulletin*, no.222, 28th October 1974; 2. *Sunday Mercury*, 20th October 1974; 3. 'At the Bar', *Country Life*, 27th June 1974; 4. 'London report', *Art International*, February/March, 1976, p.42.

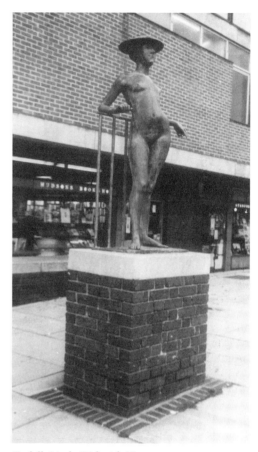

Sindall, *Nude Girl with Hat*

Electric supply station, over the entrance

Birmingham Coat of Arms

Benjamin Creswick

1906–7
Stone
180cm high
Status: not listed
Condition: good
Owned by: Midlands Electricity Board

This piece was commissioned for one of four stations supplying power for the city tram service. The building was designed in 1905 by the architect F.J. Osborne and built the following year, although it was not operational until early in 1907.[1] Set in a stone surround, in an almost square frame, the *Coat of Arms* constitutes the only decorative element on the building. Carved in hard, pale grey stone, its sharp details show stylistic similarities with other coats of arms by Creswick – notably the sinuous shapes of the contrapposto supporter and the leafy floral decoration. However, the piece is rather restricted by the subject matter, echoing the somewhat plain and squat elevation of the building.

1. V. Bird, 'Birmingham's neglected statuary', *Birmingham Weekly Post*, 19th February 1954.

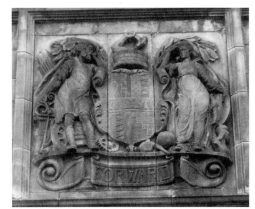

Creswick, *Coat of Arms*

Over the entrance to the Porter's lodge and the entrances to the blocks of flats

Temptation of St. Anthony and fifteen Keystone Heads

Oliver Barrett

*c.*1937–8
Portland stone
Temptation: 125cm high × 110cm wide;
heads: 8cm high × 60cm wide
Status: not listed
Condition: fair. Some discolouration due to weathering on most heads

The *Temptation of St. Anthony* shows four devils encircling and taunting the saint with his attribute, a pig, whilst the fifteen keystones represent devils related to the

Barrett, *Temptation of St. Anthony*

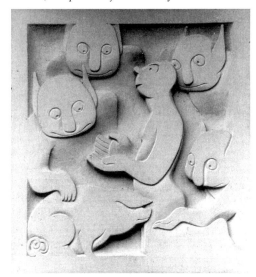

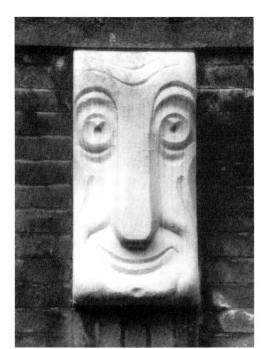

Barrett, *Keystone Head*

saint's tribulations. The flats were designed in 1937 by the architects Mitchell and Bridgewater of London with Gollins and Smeeton of Birmingham and built by

Provincial Flats Ltd. headed by James Harman, whose idea it was to have the sculptures on his buildings.[1] Given a free hand in the design, Barrett took several months to do the work, completing it early in 1938.[2] Carving each one *in situ*, he worked in secrecy, revealing them only when each one was finished. Stark and concentrated by the rectangular shape of the keystones, the faces protrude like primitive images, their mask-like resemblance suggesting the influence of African or Polynesian sculpture. Before World War I sculptors like Epstein (1880–1959) and Gaudier Brzeska (1891–1915) had discovered the expressive potential of primitive art, which continued to be an inspiration well into the 1930s, as in the work of the German artist Ernst Barlach (1870–1938), which may have influenced Barrett. Both the heads and the figures of the relief are deliberately contorted, looking more like cartoon images and providing a note of humour on the otherwise chaste brick façades.

1. *BRBP,* 1936 (finalised March 1937), no.66388;
2. *Mail,* 8th March 1938, p.10.

The Council House was designed by Yeoville Thomason in 1874–9 in an embellished classical style supposed to harmonise with the adjacent town hall. As well as the sculptural work, there is a mosaic by Salviati under the pediment which shows personifications of Science, Art, Liberty, Municipality, Law, Commerce and Industry.

The Council House, pediments

Britannia and Supporters; Manufacture; the Union of the Arts and Sciences; Literature; Commerce

Designed by Yeoville Thomason

Sculpted by Richard Lockwood Boulton & Sons

1874–9
Portland stone
Pediments: 800cm high at apex
Inscribed at bottom right of central pediment: R.L. Boulton

Boulton & Sons, *Britannia and Supporters*

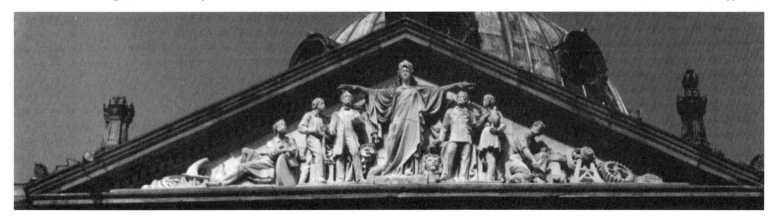

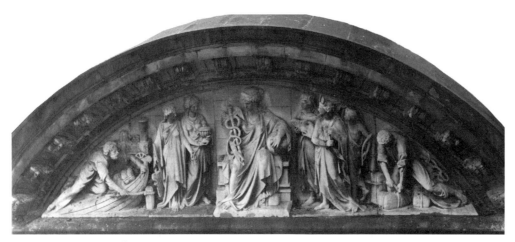

Boulton & Sons, *Manufacture*

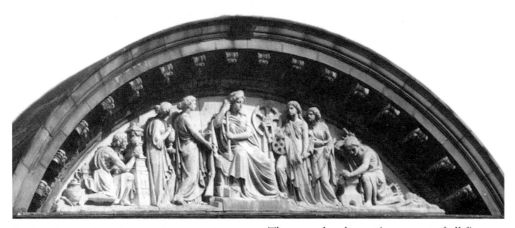

Boulton & Sons, *The Union of the Arts and Sciences*

Status: II*
Condition: good
Owned by: City of Birmingham

The central and most important of all five pediments decorating the exterior of the Council House is that of *Britannia and Supporters*. The other four, two on either side of the building, represent *Manufacture, the Union of the Arts and Sciences, Literature,* and *Commerce*.[1] The relation between

Britain and the Birmingham Manufacturers suggested in the central pediment is the clearest expression here of civic pride. Selected by the members of the Borough Council, most, if not all of whom were factory owners themselves, the subject of the sculpture reflected a corporate self-esteem and showed their awareness of contributing to the wealth and standing of the nation. The sculpture of the central pediment on the Council House can be seen as the crowning feature of a much larger decorative scheme which covers most of the main façade, and which was mostly executed by John Roddis (completed *c.* 1885).

All of this decoration, the floral and faunal motifs of the architrave, the recessed mosaic by Salviati, the coffered arch, floral spandrels and ornately carved corbelstones, heightens the impression made by each architectural component and by the building as a whole. These decorative patterns lead the eye to the figures at the top. Carved fully in the round, all seven statues of the central pediment are free-standing and project from their architectural confines, a characteristic of classical sculpture although, again typically, their overall shapes and stances do conform to the triangular shape of the pediment. Standing on a podium in the centre, the highest point, Britannia is the largest and most impressive statue of all. She dominates those on either side with her arms outstretched over their heads. Unlike all the figures of the four other pediments, Britannia is the only one in classical robes. The six flanking statues are in contemporary dress. Four are workmen in aprons with shirtsleeves rolled up, operating tools and displaying types of goods made in

Birmingham. As to the two immediately adjacent to Britannia, they are dressed in suits, for they represent the factory owners.

It can hardly be accidental that the grouping of figures seems to represent a kind of social hierarchy, for it is directly over the heads of the factory owners alone that Britannia holds laurel wreaths, symbolic of victory and classical honour given to champions and heads of state. The exact deployment of figures is left vague in the architect's original drawings of 1874, but it is likely that Boulton and Sons worked from a separate set of drawings. Although the composition comprises an iconography that has a particular pertinence to Birmingham, the sculptors would have been well aware of notable precedents in pediment sculpture. One of the more immediate is the main pediment of St. George's Hall, Liverpool, with sculpture designed by C.R. Cockerell and Alfred Stevens in 1849. Now known only from engravings, it consisted of Britannia in the centre amidst other classically robed figures, with labourers in contemporary dress placed in the background. Whereas the Liverpool figures were in classical dress, those on Birmingham's Council House exemplified the trend of the latter 19th century to portray figures in contemporary dress whilst drawing upon the timeless stability of Britannia in her classical dress. In spite of the similarity of style and the existence of Britannia in the Liverpool pediment, the central Council House pediment drew more closely upon an earlier French model, but in a way that was not universally acclaimed.

A satirical article in a local newspaper, *The Owl*, at the time of the completion of the

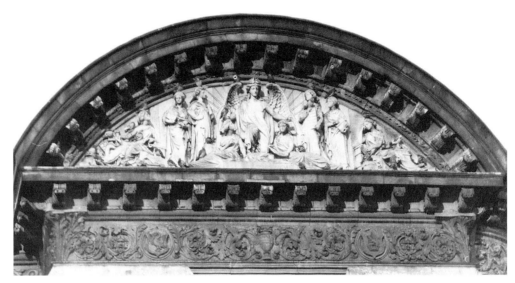

Boulton & Sons, *Literature*

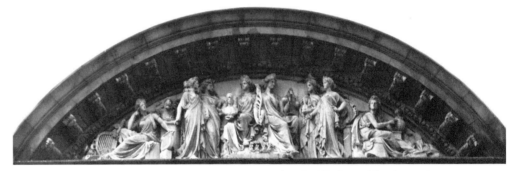

Boulton & Sons, *Commerce*

Council House in 1879, criticised the design for its timid imitation of the pediment on the Pantheon in Paris, sculpted by David d'Angers in the early 1790s, having 'cut away the best figures from the tympanum and galvanise[d] the residue into whatever contortions may best suit your fancy'.[2] The Pantheon pediment shows St. Geneviève, the patron Saint of Paris, posed similarly to Britannia with outstretched arms holding laurel wreaths over the heads of the kneeling figures of post-revolutionary patriots. *The*

Owl was also scathing about the lions above the main doorway, which were also produced by Boulton & Sons: 'Should you wish to make a special feature of your portico, take a walk in the Black Country. You will find there, upon the chimney of almost any collier's hut, a crock ornament representing a French poodle, made to do duty as a spill box. Follow this work of art studiously; but be especially careful to retain the same attitude, as the fore legs, being elongated in order to accommodate the length of a spill, would give the animal the outline of a giraffe if represented passant.' Roddis's decorations came off no more lightly, but the pediments and detailing are important elements in providing interest on this heavy building.

1. Harman, 1885, pp.258–9; *The Builder*, 2nd March 1878, p.214; 2. *The Owl*, vol.II, no.2, 7th August 1879.

The Council House, main staircase

Prince Albert

John Foley

1866
Carrara marble
Statue: 230cm high; pedestal 93cm high
Inscribed: J.H. FOLEY RA 1866
Status: not listed
Condition: good
Owned by: City of Birmingham

This statue showing Prince Albert (1819–61) dressed in the Order of the Garter robes was commissioned by a memorial committee formed in January 1862, three weeks after his death.[1] By June, a public subscription fund had raised the large sum of nearly £2,000, a testimony to his popularity in Birmingham and 'some half dozen of the leading sculptors' were invited to compete for the commission.[2] This was originally intended to be an outdoor memorial placed beneath a Gothic canopy, but as a suitable exterior site could not be found, the finished statue was placed 'temporarily' in the Corporation Art Gallery (a room in the Central Free Libraries, Ratcliff Square). Unveiled on 27th April 1868, it proved a popular exhibit and was considered partly responsible for a record number of visitors – 'the labouring classes especially'[3] – to the gallery that year.[4]

In 1878, when expanding collections forced the removal of a large part of the art collection to Aston Hall, the statue was replaced in the library area where it was joined in 1884 by a companion statue of *Queen Victoria* (1883). This had been commissioned from Foley in 1871 using the balance of the original subscription fund but was finished after his death by Thomas Woolner in 1874.[5] In 1883 the suggestion had been made to place the statues in the Council House, in recesses on either side of the Reception Room at the top of the Grand Staircase,[6] but this had been waived pending the proposed construction of a connecting gallery between the Council House and new Art Gallery (opened 1885). The statues were to stand at its entrance.[7] However, this scheme was not in fact undertaken until 1890, and in 1887, the year of the Queen's Jubilee and visit to Birmingham, it was decided that the statues should finally be given a permanent setting in the Council House.[8] Although the 1883 proposal was accepted, the detailed plans were not carried out and the statues

Foley, *Prince Albert*

were placed halfway up the staircase where they still stand today. This statue of Albert was one of two completed by Foley in 1866, the other being for Cambridge University (now at Madingley). He produced another one for Dublin in 1871 and also designed that of the *Albert Memorial*, London 1874 (finished after his death by Thomas Brock). The slight discolouration of the Birmingham statue was caused by fire in the Central Free Libraries in 1879.

1. Dent, 1880, pp.563–4; 2. 'The Albert Memorials', *The Builder*, vol.20, 21st June 1862, p.445; 3. *Birmingham Morning News*, 17th April 1871; 4. Borough of Birmingham Museums and School of Art Committee, *Annual Report*, 1888, p.61; 5. Harman, 1885, p.293; 6. Letter from J. Jaffray of the Statue Committee to Mayor Alderman White, in *Birmingham Council Proceedings 1882–1883*, 2nd October 1883, pp.648–9; 7. Free Libraries Committee's Report, *Birmingham Council Proceedings 1883–1884*, 22nd April 1884, p.303; 8. Estates Committee's Report, *Birmingham Council Proceedings 1886–1887*, 1st March 1887, p.257.

Queen Victoria

Thomas Woolner

1884
Marble
150cm high
Status: not listed
Condition: good
Owned by: City of Birmingham

Queen Victoria's long reign coincided with the increasing industrial prosperity and imperial expansion of Britain and she was greatly mourned upon her death on 22nd January 1901. The Albert Memorial Committee, using the remainder of the funds

Woolner, *Queen Victoria*

subscribed for the Prince Consort's memorial, commissioned J.H. Foley again to execute a companion figure of the Queen. However, when Foley died in 1874, the commission was given to Woolner, who finished the work.[1] Queen Victoria, although in her 64th year when the work was completed, is shown as a young woman in her twenties, wearing a simple off-the-shoulder gown and tiara, holding a long folded shawl over her crossed arms. None of the usual regal insignia is shown and no elaborate jewellery; in fact the work depicts instead the Victorian ideal of chaste feminine youth and beauty. In addition, by the position of the hands and the gently modelled facial features, the half-length female portraits of Leonardo da Vinci are brought to mind. The statue was exhibited in the central octagonal hall at the Royal Academy in 1883,[2] and although originally supposed to be sited in the Art Gallery, it now stands with Foley's *Prince Albert* on the stairs in the Council House.

1. Borough of Birmingham and School of Art Committee, *Annual Report*, 1886, p.52; 2. Graves, 1906.

John Skirrow Wright

William Bloye

1957
Bronze bust
42cm high
Signed on the right side at base of bust:
W. BLOYE 1956.
Inscribed on brass plaque on pedestal: JOHN SKIRROW WRIGHT / Born February 2nd 1822 / Died in this building / April 15th 1880 /

Bloye, *John Skirrow Wright*

Status: not listed
Condition: good
Owned by: City of Birmingham

Commissioned by the City Council in 1956 and costing £490,[1] the bust was modelled by Bloye from the original marble statue by F.J. Williamson (q.v.) which formerly stood in Chamberlain Square until 1951, when it was put into storage.[2] Bloye used the head of the original statue as a model for a likeness, but he worked his bust in clay on a smaller scale. Bloye's bust was unveiled on 13th September

1957 and Williamson's statue was then destroyed.

1. Bloye, *Ledger*, 12th September 1957, p.160;
2. Birmingham Information Bureau, May 1977, p.10.

Victoria Square

After the redevelopment of Centenary Square and its successful integration with a number of pieces of public art, the City Council embarked on an ambitious restructuring of the city centre from 1991 to 1993 which has included extensive pedestrianisation and a total redesign of Victoria Square. Once a nondescript area cut off from the Council House by a road, Victoria Square has been transformed into what the council sees as a civic space rivalling many European counterparts, dominated by the water feature by Dhruva Mistry which now draws the eye up from the level of New Street to the façade of City Hall. The plaza not only includes Mistry's work, but the slightly earlier *Iron:Man* by Gormley, and Brock's *Queen Victoria* of 1901. The process behind the creation of this new space was a long and often fraught one, and the project cost £3.2 million overall, funded by the European Regional Development Fund and the Henry Moore Foundation. The council originally commissioned Marta Pan, a French artist, to design a new layout for the square, and although her basic idea of a cascade of water with flanking flights of steps was accepted, she was not invited to take the scheme any further. The maquette for Pan's scheme is in store at the Birmingham Museum and Art Gallery. Mistry was eventually commissioned to finish the project, within the restraints

already laid down by the original plan. The whole scheme was 're-opened' by the Princess of Wales on 6th May 1993, though not without controversy as to whether the *Iron:Man* should be removed for the occasion!

Queen Victoria

Thomas Brock (original)

Copy by William Bloye

1901/1951
Bronze statue on a granite pedestal
Figure: 320cm high; pedestal: 400cm high
Pedestal inscribed: VICTORIA R.I. /
1837–1901
Status: not listed
Condition: good
Owned by: City of Birmingham

In 1897 Mr. W.H. Barber, a Birmingham solicitor and benefactor of the Barber Institute, offered to present the first outdoor statue of Queen Victoria to the city in memory of his father and to commemorate the Diamond Jubilee that year. Barber considered Brock the most suitable sculptor for the commission, as he had already executed three statues of the Queen at Worcester, Cape Town and Lucknow, as well as having modelled the Queen's image in the coinage of 1897. Barber insisted that the statue should be an enlarged replica of Brock's statue at Worcestershire Hall. The offer of the statue was accepted by the City on 27th July 1897[1] and the completed work unveiled on 10th January 1901, twelve days before the death of the Queen, in an open space in front of the Council House,

renamed Victoria Square.[2]

The original white marble statue stood on a 3.5 metre-high pedestal of dark Cornish granite, the diminutive figure of Queen Victoria made more monumental by Brock who unnaturalistically lengthened the state robes. The statue remained here, being flanked by the statues of *John Skirrow Wright* and *Joseph Priestley,* until 1913 when they were replaced by the statue of *King Edward VII.* In 1950 the Square was redesigned as part of the permanent works marking the Festival of Britain, 1951. *King Edward VII* was removed to Highgate Park and, as the marble original of *Queen Victoria* had weathered badly, the Council of the Civic Society provided a grant of £800 towards the cost of reproducing it in bronze.[3] Removed from the square on 13th March 1950, the statue was renovated by William Bloye before being cast in bronze by H.H. Martyn and Co., Cheltenham. It was returned to the site on 25th May 1951 and erected on a pedestal of light-coloured reconstructed Cornish granite on the centre island of the square, thus reversing the original colour contrast of sculpture and base. It was unveiled by Princess Elizabeth on 9th June 1951.

1. C.A. Vince, *History of the Corporation of Birmingham*, Birmingham, vol.III, 1902, p.384; 2. C.A. Vince, *op. cit.*, vol.IV, 1923, p.491; *Birmingham magazine of arts and industries*, no.3, vol.3, 1901, pp.73–7; 3. W. Haywood, *The work of the Birmingham Civic Society*, Birmingham, 1946, pp.137–40.

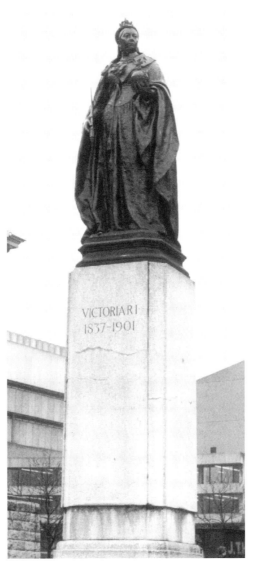

Bloye, *Queen Victoria*

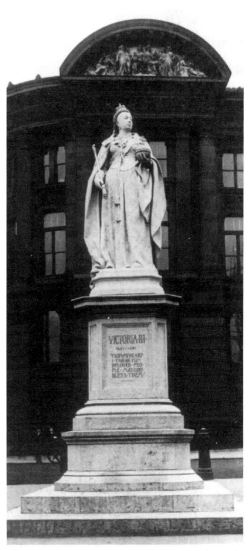

Bloye, *Queen Victoria, original state* (picture: early 1900s)

Iron:Man

Antony Gormley

Sculpture in place 1992, square officially
opened 1993

Iron
600cm high
Status: not listed
Condition: good
Owned by: City of Birmingham

Commissioned in 1991 by the TSB bank and
donated to the city as part of its policy for
encouraging public sculpture,[1] the *Iron:Man*
is a full-length figure weighing 6 tonnes, with
its feet buried under the paving slabs. Sited in
front of the TSB building, it is a torso with a
faceless head which the artist had named
Untitled 'until such a time as usage give it
one', though it subsequently came to be
known as the 'Iron Man', after which the
artist asked that it be named *Iron:Man*.[2]
Leaning 7.5 degrees backwards and 5 degrees
to its left, the statue is enigmatic and monu-
mental. As a sculptural theme, the torso was
introduced by Rodin at the end of the 19th
century, prompted by archaeological finds
that were accidentally eroded by time. But, as
a modern sculptural genre, it reflects the
alienation of the individual in modern indus-
trial society.[3] Yet the artist hoped the piece
would be invested with its own meaning by
the people of Birmingham as it became part
of the cityscape, and the TSB laid emphasis
on individuality and identity as an important
element in the design of public spaces.
Indeed, despite initial misgivings, the piece
has been hailed as one of the most successful
of the more recent additions to the city's

sculptural landscape. Sir Nicholas Goodison,
Chairman of TSB, wrote to Michael
Diamond, former Director of Birmingham
Museums and Art Gallery at the time, stating
'we have greatly enjoyed the controversy. We
remain convinced that in time people will
come to believe that it is indeed the best
thing in the square.'[4]

Manufactured by Firth Rixson Castings of
Wednesbury, subsequent accusations that the
sculpture was rusting were revealed as
groundless when Gormley confirmed that
the specific type of iron encourages oxidisa-
tion to protect the metal.[5] He said that 'it is
rooted in the traditions of labour of
Birmingham and the Black Country and is a
celebration of the power of that tradition'.[6]
Since the take-over of TSB by Lloyds Bank,
there have been calls for the sculpture to be
removed to Lloyds' headquarters in Bristol.
However, as the council owns the work, this
is not possible, let alone desirable. The
maquette for this piece is on display in the
offices of the Public Art Commissions
Agency in the Jewellery Quarter, and PACA
was funded in early 1995 to produce an inter-
pretative plaque and scale model of *Iron:Man*
for the visually impaired which will be sited
near the actual work.

1. *Made in Birmingham: TSB's new sculpture*, Press
Release TSB bank, 13th September 1991; T. Grimley,
'Vision of latest city sculpture', *Post*, 14th September
1991; *Antony Gormley completes TSB Sculpture*, Press
Release TSB bank, 23rd February 1993;
2. Correspondence between the Public Art
Commissions Agency and the artist, 1991,
PACA records; 3. T. Grimley, 'Monument to a proud
past', *Post*, 1st March 1993; 4. Correspondence in
PACA records, 1991; 5. A. Roberts, 'Brummies
struggle with metal fatigue', *The Times*, 20th April
1993; 6. PACA records.

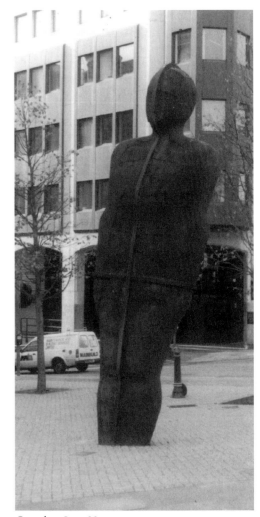

Gormley, *Iron:Man*

River, Youth, Guardians and Object (Variations)

Dhruva Mistry

1993
River: Bronze sculpture within Wattscliff lilac sandstone pool
Youth: Bronze sculpture within Wattscliff lilac sandstone pool
Guardians: Sandstone
Object (Variations): Sandstone
River: 280cm high × 250cm wide × 400cm long
Youth: 150cm high × 150cm diameter
Guardians, each: 300cm high × 250cm wide × 500cm long
Object (Variations), each: 200cm high × 50cm square
Carved round rim of the upper bowl by Bettina Furnée: AND THE POOL WAS FILLED WITH WATER OUT OF SUNLIGHT, AND THE LOTOS ROSE, QUIETLY, QUIETLY, THE SURFACE GLITTERED OUT OF HEART OF LIGHT, AND THEY WERE BEHIND US, REFLECTED IN THE POOL. THEN A CLOUD PASSED, AND THE POOL WAS EMPTY
Status: not listed
Condition: *River*: good; *Youth*: good; *Guardians*: fair. Some graffiti, cracking of stonework and mould development; *Object (Variations)*: good
Owned by: City of Birmingham

Dhruva Mistry's monumental plan for Victoria Square[1] consists of four distinct elements which link the upper level in front of the Council House with New Street below by a stepped water feature.[2] His solution to the spatial problem was to have a focal sculp-

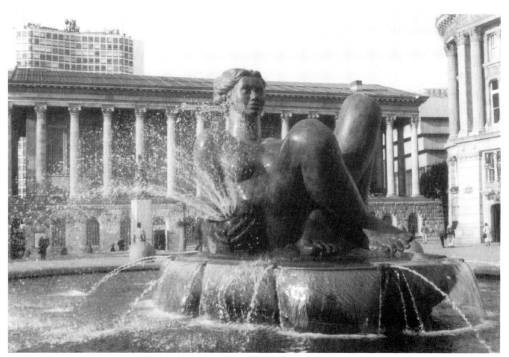

Mistry, *River*

tural fountain at the top level, *The River*, with flanking *Guardians* at the lower level. Water runs down to a lower pool where *Youth* is sited between the *Guardians*. In addition, two obelisks, the *Object (Variations)*, are sited on either side of the upper area.[3] Water was seen as an essential part of the scheme by the council, because of the existing civic pride associated with the modernisation of the water works in the 1800s (and commemorated by the *Chamberlain Memorial Fountain* in Chamberlain Square, q.v.). Equally, a multicultural approach to the centrepiece was desirable to reflect the city's diversity of ethnic groups. Finally, the works had to be of sufficient stature to hold their own against

the recently installed *Iron:Man*, by Antony Gormley, outside the TSB bank, and the resited monument to *Queen Victoria*. Mistry's scheme pulls together a number of disparate threads into a whole that, whilst not entirely coherent, manages to fulfil such an exacting brief without sacrificing too much integrity. Despite its different parts, the scheme must be seen as a whole, something that was brought to a head when the council initially refused to install the two obelisks on either side of the square, because it was felt that they were unnecessary. Mistry is quoted as saying that 'what pleases me is that the arsenal of vocabulary would end up creating a cohesive impact'.[1] The whole redevelopment was opened by the Princess of Wales in May 1993, as recorded by an inscription along the wall at the bottom of the westward

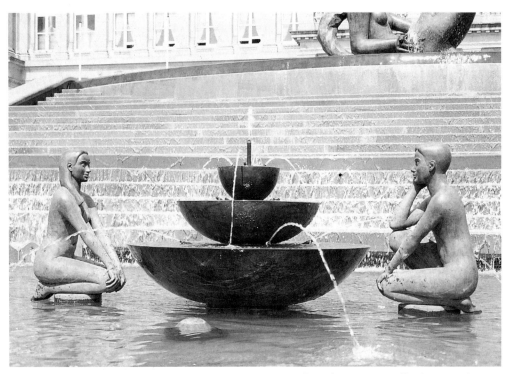

Mistry, *Youth*

flight of steps.

The main focal point of Mistry's scheme for Victoria Square is the monumental female figure of *The River*, situated beneath the façade of the Council House within a pool, and acting as a fountain which sends water cascading down to lower pools at the level of New Street. Rapidly nicknamed 'The Floozie in the Jacuzzi' by the local press, the nude's proportions are descended from those of Matisse's figures, whilst as a reclining nude she points to the precedents of Giorgione,

Botticelli and Picasso's *Vollard Suite*. The waters that spout from the ball that she holds flow down to the youthful figures below, so she acts as a giver of life in the way that the Indian River Ganges is revered as a goddess because of its fertility. This is in contrast to the European tradition of masculine representations of river gods, though sources signifying the life-giving effect of water are also often surmounted by female nudes, possibly associated with Diana/Natura. She stares out into the surrounding space, either challenging or inviting. In this way she follows in a long line of 'encapsulated' female

nudes in painting and sculpture, though the civic body has been criticised for this display of 'patriarchal domination' through the enclosure of a passive female form in such a traditional manner. The sandstone pool in which she reclines has six large salmon carved in bas-relief on its floor, and the quote from T.S. Eliott's *Burnt Norton* was carved on its rim by Bettina Furnée. This acts as a cryptic explanation of the whole water scheme: the pool is filled by the rays of water (sunlight) from *The River*'s orb; the lotus, being associated with the tranquillity of Buddha, sets a calmness over the entire scene; the figures of *Youth* are reflected in the water as emblems of its life-giving qualities; then once the cloud has passed, the cycle can begin again.

At the bottom of the water cascading from the monumental figure of *The River* is another pool containing the smaller and more intimate group of *Youth*. A boy and a girl are poised facing each other across three bowls of a gentle fountain. Sitting on a cube and cylinder respectively, with an egg and a cone in the water beside them, this contemplative pair receive the life-giving water from above, with the symbols, although non-specific in their attributes, acting as eternal constants within the mythological setting. For example, the egg acts as a further clue to the continuation of life as given by the waters. These figures also play a part in the 'explanation' of the whole scheme as given by the quote from T.S. Eliott's *Burnt Norton* around the rim of the upper pool.

Two *Guardians* flank the lower level of Mistry's scheme.[4] These are large, mythical beasts with animal bodies and human heads.

One, the more masculine figure, has a winged body with the forelegs of a lion and the rear legs of a bull, and the horns and ears of a bull on a human face; the other, female creature, has cloven hooves on the forelegs and claws on the rear, with a more human face. Their title is a play on regard/guard, as their never-sleeping presences both 'protect' the site and look out to the city beyond. Mistry had already created several similar creatures since 1985,[5] the most recent being a *Reguarding Guardian* at the National Museum of Wales, Cardiff 1990. The tradition of mythical beasts made up from parts of various animals is a long one, the most obvious precedent for Mistry's *Guardians* being the Sphinx, part lion, part human. It was a sphinx's riddles that Oedipus solved, sphinxes were used to guard Egyptian tombs (the most famous being the huge one at Giza) and they act as a perfect embodiment of enigma which sums up the sculptor's non-specific iconological programme. However, Mistry has quoted other beasts as well which have acted as precedents: the gate guardians of the Great Stupa at Sanchi in India (1st century A.D.), which include a pair of winged lions with similar postures to these creatures; and

Mistry, *Guardian*

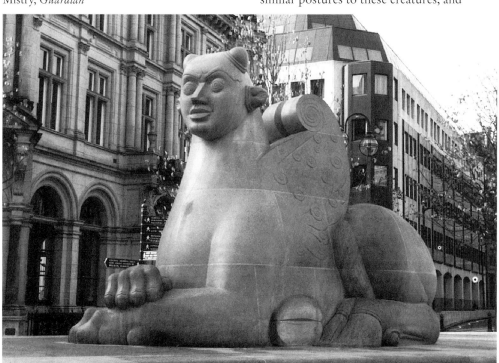

Mistry, *Object/Variation*

lamassu from the palace of Ashurnasirpal at Nimrod, combining the agility of a bird and the strength of a bull with human intelligence. Monumental lions which act as embodiment of national pride are also a feature of major civic spaces in Britain: in Trafalgar Square in London four huge lions by Landseer are combined with fountains and Nelson's monument to create a space which Birmingham's planners were obviously aware of[6] and Mistry has adapted this

theme to a more non-specific and timeless purpose.

In contrast to the frontal, horizontal nature of the overall scheme, the two sandstone pillars which act as lampstands at each corner of the upper area are statements of verticality acting as definitions of the boundaries of Mistry's vision for the square. The council initially refused to install these two obelisks because it was felt that they were unnecessary and did not relate to the other elements. However, without these anchor points it would be difficult to determine the scale of the scheme from the upper terrace, and after Mistry's insistence, they were duly erected. Both are abstract, although they can be seen as scale models of lighthouses, pagodas, Mexican pyramids, or even temples in their architectural details. Mistry refused to explain the reasoning behind their inclusion and the necessity for them to act as lampstands is unclear, particularly as the whole area is well lit at night.

1. *Mail*, 15th November 1991; *Mail*, 26th February 1992; W. Feever, 'Where bigger means better', *The Observer*, 25th October 1992, p.62; 2. Birmingham Museums and Art Gallery, *Public art in Birmingham information sheet 2*, Birmingham, 1994; 3. L. Green, 'Pleasing the heart: Dhruva Mistry in Birmingham', *Contemporary Art*, June 1993, pp.36–40; 4. T. Grimley, 'A square of sculpture, spaces and sphinxes', *Post*, 5th May 1993; 5. 'Guardian 2', *Arts Magazine*, vol.60, October 1985, p.139; 6. Two flanking lions are shown in a sketch of the proposed area in *Pedestrianisation in Birmingham*, leaflet, Birmingham, 1990.

Medical School, University of Birmingham, over the main entrance

Aesculapius bearing the University of Birmingham Coat of Arms

William Bloye

*c.*1938
Portland stone
165cm high × 350cm wide
Inscribed under shield: FACULTY OF MEDICINE
Status: not listed
Condition: good
Owned by: University of Birmingham

This panel was finished by March 1938 and when the Medical School was opened in June 1938 it was complete with its sculptured panel. The main feature is the traditionally bearded Roman God of Medicine, Aesculapius, with his attributes a staff and serpent, the emblem of medicine. In the centre is the University *Coat of Arms* and the inscription is the University's motto. This composition alludes to the interdependence of the University and the hospital, for the construction of the Medical School had been made a condition by the organisers of the Hospital Centre Scheme for the building of the hospital.[1] Bloye had already carved a number of motifs for the Students' Union building and was to do more for the University at a later date.[2] Rather complex and extensive, more so than his earlier relief carving of *Aesculapius* at the Central Birmingham Chest Clinic, this emblem is a well-balanced and lively composition. The overall rectilinear shape reflects the subtle patterns of brickwork in the façade that it adorns.

1. S. Barnes, *A short history of the Medical School*, University of Birmingham, 1957, p.17; 2. Bloye, *Ledger*, 23rd March 1938, p.61, invoice no.393; 28th March 1938, p.64, invoice no.912.

Bloye, *Aesculapius and University Coat of Arms*

Door archway and above, Midland Bank, on corner of Vyse Street and Warstone Lane

Personification of Banking, with relief Allegorical Figures

Sculptor unknown

Stone
Banking figure: 100cm high. Relief: 80cm high × 120cm wide
Status: not listed
Condition: good
Owned by: Midland Bank

Anon, *Allegorical Figures*

Anon, *Personification of Banking*

The architects of the original building on this site are unknown, though it is thought that it dates from 1892 as the London and City Bank. The doorway is all that remains of the original building, which has undergone considerable changes to the façade. The bearded figure symbolising the bank's function was sculpted in the round and placed in an elaborate niche beneath a domed canopy, directly above the main door to the bank. He carries a pot in his left hand and a wallet hangs from his belt. In the lunette above the door is a high relief carving of a classically draped female figure holding a shield with coat of arms, possibly of the original bank. To her left is a man with a hammer and anvil, and to her right is a glassblower, whilst an urban scene is sketched in the background. Sited in the centre of the Jewellery Quarter, this must have been a prime site for the bank, and the sculptural decoration will have drawn attention to the building's façade.

The Towers public house, high over the entrance

The Towers

William Bloye

1936
Stone, painted
130cm high
Status: not listed
Condition: good
Owned by: The Towers pub

A bold, simplified image of castellated towers carved in relief, this plaque decorates a public house designed by Holland Hobbiss[1] for Mitchell and Butler's in 1936, on the removal of the licence of the Station public house, Ladywood Road. Bloye was responsible for all of the stone carving on this brick building.[2]

1. *BRBP,* 11th January 1936, no.64881; 2. '"The Towers", Walsall Road, Perry Bar, Birmingham', *The Builder,* vol.CLIII, 15th October 1937, p.690.

Bloye, *The Towers*

Sparkhill Methodist church, tower

Pilgrim's Progress

Alan Bridgwater

1959
Sandstone
120cm high × 120cm wide
Status: not listed
Condition: good
Owned by: Sparkhill Methodist church

Bridgwater was commissioned by the architects of the new church, Messrs Bromilow, Smeeton and While.[1] The plaque on the tower depicts a scene from Bunyan's *Pilgrim's Progress* and shows Christian carrying the burden of sin on his back as he struggles up the Hill of Difficulty towards the Celestial City. Directly carved, a powerful effect is achieved by the simplified forms and the diagonal composition of the panel.

1. Information provided by the architects, telephone conversation, 1985.

Bridgwater, *Pilgrim's Progress*

Legal and General Assurance Building, 7–8 Waterloo Street, four panels on the top storey corners of the façade

Wisdom, Fortitude, Charity and Faith

William Bloye

*c.*1932
Portland stone
Four panels, each: 160cm high × 80cm wide
Status: not listed
Condition: good, though some discolouration
Owned by: not known

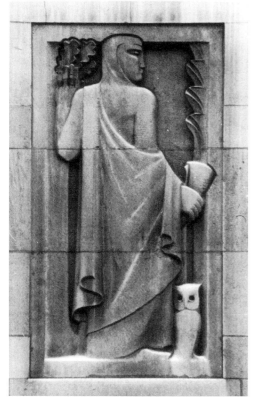

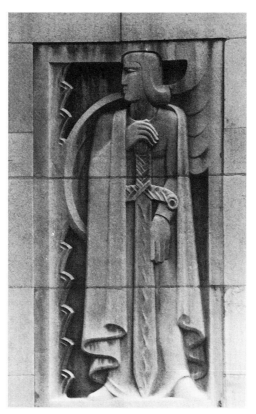

Bloye, *Fortitude*

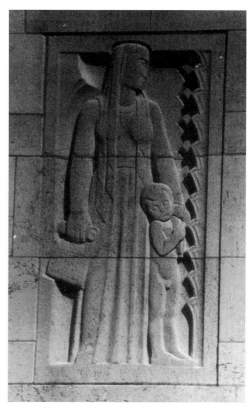

Bloye, *Charity*

The building was designed in 1931 in a severe classical style by the architect S.N. Cooke,[1] with whom Bloye had worked from the early 1920s, and probably on whose recommendation he received this commission. Bloye also advised on the design of the main entrance, with its travertine pilasters banded with black marble.[2] Begun early in 1932, the building

Bloye, *Wisdom*

was complete with its panels before September.[3] Carved in profile with simplified details and set in bold relief against plain shallow backgrounds all stylistically typical of the period, the figures cut sharply into the broad, flat frames. This device emphasises the compressed space of the relief and complements the sharp outline and arresting white façade of the building. It also underlines the emblematic purpose of the four Virtues, the

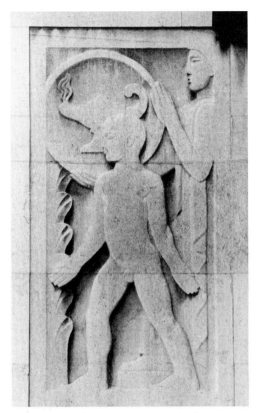

Bloye, *Faith*

personifications of those qualities intended to be seen as synonymous with insurance. *Wisdom* is shown with an owl and the tree of life, whilst holding papers; *Fortitude* holds a broad sword; *Charity* protects a child; and *Faith* is represented with a flame and hands in prayer.

1. *BRBP*, 1931, no.53541; 2. Hickman, 1970, p.61; 3. Bloye, *Ledger*, 14th April 1932, p.1; *Mail*, 8th September 1932, p.5.

New Oxford House, façade

Capitals and Pediment Sculpture

William Bloye

*c.*1935
Portland stone
Two heads, each: 85cm high; putto: 100cm high
Status: not listed
Condition: good
Owned by: not known

Bloye, *Capital*

Decorating the entrance to offices designed by S.N. Cooke in 1934 for the Midland Employees Mutual Assurance Company in a fashionable stripped rectilinear style,[1] the two heads form capitals facing each other. New Oxford House (as it is now known) was not built until 1935 and Bloye was responsible for all the sculptural decoration of the façade, including the two capitals carved as heads that face each other across the main threshold.[2] On this rectilinear façade they are refreshingly light, carved with such stylised features as their blank eyes, long attenuated noses and gently undulating hair which disappears into the surrounding stone. The style used is neo-Egyptian which contrasts with the classical putto standing in the neo-Baroque broken pediment over the first floor window. This figure holds a horn of plenty, signifying the notion of welfare, the purpose of the original occupants of the building. The faces' flat, simplified, linear features deliberately appear to emerge from the stone pilasters that are also cut in a recti-

Bloye, *Pediment Sculpture*

linear, almost Egyptian style popular at the time. Their simple, sharp look reflects the stark white, stripped classical façade of the building. Bloye was also responsible for the limited amount of carved decoration on Nevill House, immediately adjacent, also designed in 1934 by Cooke's partner, W. Norman Twist.[3]

1. *BRBP*, 1934, no.59946; 2. Bloye, *Ledger*, 2nd November 1935, p.31, invoice no.70; 3. *BRBP*, 1934, no.59946.

Church of the Sacred Heart and St. Margaret Mary, exterior wall

Sacred Heart

Gibbs & Canning

1934
White terracotta
200cm high
Status: not listed
Condition: good
Owned by: Sacred Heart and St. Margaret Mary church

This figure of Christ in a traditional pose – his right hand held up in a sign of peace, his left hand on his heart exposed on his chest – was the last major work modelled by John Evans,[1] chief modeller at Gibbs and Canning before his retirement. It was modelled to a design made by the architect of the church, George Cox of Harrison and Cox.[2] Made to decorate the new tower of this church built twelve years earlier,[3] the finely modelled figure stands out within its aedicule, the pale white terracotta contrasting with the dull red brick.

1. *Gazette*, 28th January 1935; 2. *Tamworth News and Four Shires Advertiser*, January 1935; 3. *Despatch*, 4th March 1935.

Gibbs & Canning, *Sacred Heart*

British Gas Social Club grounds, Hollyfields

Gas Department War Memorial (Britannia)

Figure modelled by Louis Weingartner

Designed by Walter Gilbert

1921
Bronze figure on a pedestal of Hopton marble
Statue: 140cm high; pedestal: 220cm high
Inscribed on front of pedestal: TO THE / GLORIOUS MEMORY / OF / THE MEN OF THE / BIRMINGHAM / GAS DEPARTMENT / WHO GAVE / THEIR LIVES IN / THE GREAT WAR / 1914–1919 AND 1939–1945 (Names of the fallen soldiers are listed under the names of the regional sections).
Also inscribed at the base: LET THOSE WHO COME AFTER SEE TO IT THAT THEIR NAMES BE NOT FORGOTTEN
Status: not listed
Condition: good
Owned by: British Gas

The cenotaph memorial is crowned by an allegorical figure representing Britannia, similar in form to Phidias' well-known design for Athena Parthenos *c.*447–439 B.C. Explaining his monument, Gilbert wrote: 'Cenotaph the word really means a monument which is erected over a place other than a tomb ... it is not necessarily without a figure, though you find it in countries where the representation of the figure was forbidden. By the introduction of the figure the memorial becomes much more appealing to our sense of beauty, since we are a western nation, and also to our imagination, since we

are impulsive and energetic rather than a contemplative race. The figure proposed is Britannia holding the (little Nike or) Victory, for the British troops, seamen and soldiers, brought victory to the Allied Armies, and in the other arm she carries the palms of victory and the rosary of remembrance.'[1] In the leaflet produced for the unveiling ceremony in 1921 it was further noted: 'The Britannia is designed in a slight and delicately modelled form, after the style of the Tanagra figures, which were the choice household possessions of the Greeks in their greatest period of appreciation of sculpture. The reason for the choice of this period of the Art by the artist (Mr Walter Gilbert) to commemorate those who have fallen and for the intimate expression of the love with which their names and remembrance are regarded by the employees of the Gas Department, will be apparent to all. For just as the Greek set up the artist's expression of the beauty in the place of honour and had it always before his eyes in his home, so the employees of the Gas Department have erected an emblem of the immortal beauty of the sacrificing love of their comrades for their country and their fellows and have placed it in the centre of their daily labours in order that the sacrifice may never be forgotten.'[2]

The memorial was originally suggested by the Gas Committee in July 1919.[3] Gilbert, who specialised in war memorials at this time, was recommended by Sir Whitworth Wallis FSA, Keeper of the Museum and Art Gallery and his model was approved on 19th April 1920. The cost of the memorial was £550, which was met over a period of eighteen months by staff of the Gas Department

Weingartner, *Gas Department War Memorial* (detail of figure)

who were contributing to a War Memorial Welfare Fund.[4] The bronze figure was cast by H.H. Martyn of Cheltenham and the base installed on 24th October 1921 together with the nominal role of the 1,239 men commemorated. The unveiling ceremony took place in the Great Hall of the Council House on 19th November 1921.[5] The memorial was subsequently moved to the main landing. As Gilbert worked in close collaboration with

the bronze-worker Louis Weingartner, it is likely that the figure was modelled by him.[6] Together they produced a similar design, which took Britannia as its main emblem, for a war memorial at Troon. After being removed from the Council House, the scrolls and newspapers encased within the memorial were conserved and re-gilded before being re-sealed in the work. The memorial was kept in store for some time, but is now relocated in Erdington on a new base.

1. *Birmingham Gas Department Magazine*, vol.IX, no.5, May 1920, p.72; 2. City of Birmingham Gas Department, *Unveiling of War Memorial*, leaflet, 19th November 1921; 3. *Birmingham Gas Department Magazine*, vol.VIII, no.7, July 1919, p.103; 4. *Birmingham Gas Department Magazine*, vol.X, no.11, November 1921, p.163; 5. *Birmingham Gas Department Magazine*, vol.X, no.12, December 1921, p.180; 6. W. Gilbert and L. Weingartner, *Sculpture in the garden*, publicity booklet, Birmingham, undated (*c.*1925).

University of Aston site, Aston Triangle, in front of Sacks of Potatoes public house

Tipping Triangles

Angela Conner

1994
Stainless steel
540cm high
Status: not listed
Condition: fair. Patination stained brown by running water. Works intermittently
Owned by: University of Aston

A competition to produce a work of public sculpture for the Aston University site was instigated in 1987, and Conner's designs were accepted. British Steel donated the materials and work got under way from about 1989. However, progress was hampered due to British Steel not being able to fulfil their promise of materials, due to internal restructuring.[1] They eventually made the generous donation, but numerous safety considerations, increases in costs due to extra elements being required and difficulties in finding parts which would work properly also played their part in the delay. According to the artist, the aim of the work is 'to provide beauty and tranquillity for the site whilst using the University's triangle symbol to provide cheerfulness and focus'.[2] The large triangular 'tippers' are filled with water trickling from the top of the structure and then disgorge their load after passing a certain point of equilibrium. As this happens in turn for each triangle, the effect is of constant motion. This work provides a counterpoint to William Pye's *Peace Sculpture* at the other side of the campus, which is also a fountain sculpture (see under Aston Triangle).

1. Letter and CV from the artist, February 1996; 2. *Aston University Press Release*, 1994.

Conner, *Tipping Triangles*

Wyndlay Lane
SUTTON COLDFIELD

Boldmere Swimming Baths, entrance hallway

Memorial to Members of Boldmere Swimming Club

Benjamin Creswick

1920
Bronze
80cm high
Signed: B. Creswick Sc 1920
Plaque inscribed: This statue which formerly stood in Sutton Park, was presented to the borough in 1921 by the Boldmere Swimming Club in memory of club members who fell in the 1914–1918 war.
Status: not listed
Condition: good
Owned by: Sutton Coldfield District Council

This statue of a man teaching a boy to swim is the only non-architectural free-standing sculpture made by Creswick in Birmingham. He probably obtained the commission because of his reputation as a sculptor, but he was also a resident of Sutton Coldfield. Helped by his two sons, the statue was modelled and cast in his back garden at 'Elmwood', Jockey Road, and was presented to the Swimming Club in 1921.[1] The present swimming baths were not opened until 1971.[2]

1. *Mail*, 24th February 1933; 2. *Sutton News*, 28th November 1980 (letter from F. Creswick-Outram).

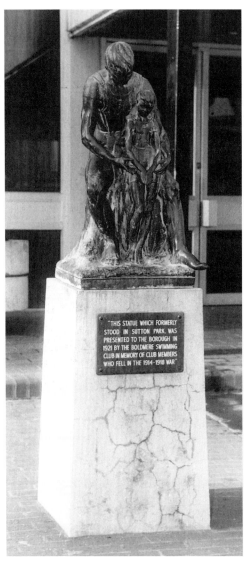

Creswick, *Boldmere S.C. Memorial*

Yardley Road YARDLEY

South Yardley Public Library, over entrance

Library Emblem

William Bloye

1938
Stone
60cm high × 200cm wide
Inscribed: NUTRI MENTUM SPIRITUS
Status: not listed
Condition: good
Owned by: South Yardley Library

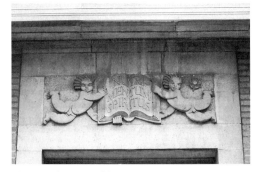

Bloye, *Library Emblem*

This frieze shows two flying putti, delightfully rounded with blank eyes and a shock of hair, holding an open book bearing the inscription roughly translated as 'nourish the spirits of the mind'. Their bold, simplified carving complements that of the primitive styled columns supporting the portico and continued above it as decorative features. Bloye completed the frieze for the library, designed by J.P. Osborne, by the end of 1938.[1]

1. Bloye, *Ledger*, 31st December 1938, p.72, invoice no.472.

Albert Street CENTRAL CITY

Formerly 83 Albert Street, Morton's shoe and boot manufacturer, over the corner entrance

Elves and the Shoemaker

Benjamin Creswick

*c.*1890
Terracotta
Approx: 60cm high × 100cm wide

This panel depicts a scene from Grimms' well-known fairy tale of *The Elves and the Shoemaker*, an appropriate subject for its location on this factory. In accordance with the fairy tale, two small elves sew and hammer shoes. They are framed as if on stage by two sinuous tree trunks and, underneath, by two shoots of sprouting foliage. Although the factory was erected in 1883,[1] there is no record of Creswick visiting Birmingham before he took up his post at the School of Art in 1889. There is a medievalising tendency and an emphasis upon surface pattern in the design that is similar to his panels for Handsworth library (1891). Considering the early date of the building, it is possible that this panel was his first public work in Birmingham.[2] The building was demolished in 1985 and the work was lost as a consequence.

1. *Kelly's directory for Birmingham*, London, 1883;
2. V. Bird, 'Birmingham's neglected statuary', *Birmingham Weekly Post*, 19th February 1954.

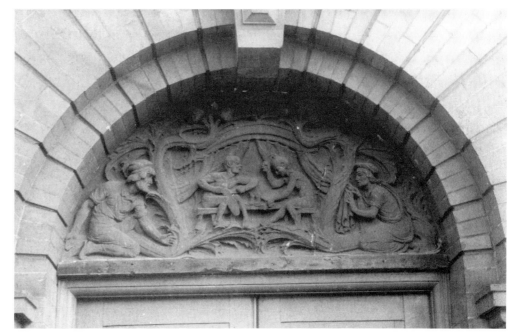

Creswick, *Elves and the Shoemaker*

Market Hall, Bull Ring

Fountain with Figures

Messenger & Sons

1851
Bronze
Statue: 150cm high; overall: 640cm high;
bowl of fountain: 460cm diameter

The Market Hall was opened 12th February
1835 and covered an area between Bell Street,
Philip Street, the Bull Ring and Worcester
Street. This bronze fountain was erected in
1851 in the centre of the hall, commissioned
by the Commissioners of the Street Acts.
Costing £900 overall, the basin of the foun-
tain was made of Yorkshire sandstone and
was 4.5 metres in diameter. This supported a
pedestal of magnesian limestone, on each side
of which were hung cast bronze arrange-
ments of the various wares which were sold
at the market – fish, game, vegetables and
flowers and fruit. This formed the base for
the bronze statue itself, which consisted of
four figures of children, each representative
of one of Birmingham's major industries,
gun-making, glass-blowing, bronzing and
engineering, which surrounded the column
of the fountain.[1] The bowl of the fountain
was in the form of a Greek tazza, and had
around its edge eight lions' heads from which
the water emitted. The apex of the fountain
was marked by a decorated urn which also
spouted water. 'Suspended from rings
attached to panels of the pedestal, and resting
upon the consoles, are four groups in bronze,
representing the various commodities sold in
the market. One of these is composed of fish,
another of game, a third of vegetables and a

fourth of flowers and fruit'.[2] The fountain
was inaugurated on the 24th December 1851
by John Cadbury, Chairman of the Market
Committee.[3] It appears to have been
removed from the Market Hall around 1880
with the intention of re-erecting it in
Highgate Park later that year,[4] but this did
not happen and the piece was destroyed in
1923.[5] The fountain was the subject of a
watercolour by Walter Langley in 1880
which is now in the collection of BMAG.

1. W.J. Harrison *et al.*,*Warwickshire Photographic
Survey*, photograph WK/B11/3503, *c.*1880 and
engraving WK/B11/3508, 1870; 2. *Gazette*, 29th
December 1851, p.3; 3. Dent, 1880, p.475; Harman,
1885, p.258; 4. *The Builder*, vol.39, 1880, p.125;
5. *Mail*, 13th November 1961.

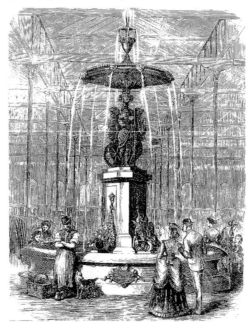

Messenger & Sons, *Fountain*

District Bank, 23–4 Bennett's Hill

Coat of Arms; Agriculture and Engineering

Sculptor: Peter Bohn

Designed by: F.R. Siddens

1961
Fibrous plaster
Two panels, each 150cm high × 488cm wide

This Coat of Arms and panel depicting the
progress of agriculture and engineering were
designed by F.R. Siddens, then chief designer
for the Birmingham Guild of Handicrafts
and modelled and cast by Peter Bohn and
C.H. Blamires of the Guild for the new
District Bank, Bennett's Hill. It was the wish
of the bank to produce a panel which recog-
nised the rise of Birmingham from being an
agricultural community to an industrial
power. The left panel depicted the march of
agriculture, from left to right: a horse and
wagon, a reaper with a scythe, a land-girl
driving a tractor, and a mechanical harvester
signalling the onset of modernity. The right-
hand panel illustrated the march of engi-
neering, from right to left: bronze-age man
making domestic utensils from primitive
materials, blacksmith forging farm imple-
ments, the introduction of female labour and
a scientist representing the 'coming of the
atomic age and automated industry'.[1] These
two panels converged in the centre in a sun
motif, which supported the coat of arms of
the District Bank on its rays.

1. 'New bank on its old site', *Post*, 22nd November
1961.

Fortress House, Broad Street

Vulcan

William Bloye

1937
Stone
Dimensions not known

Notes exist that refer to a figure of Vulcan on a Holland and Hobbiss designed building, Fortress House, which was dismantled in the mid-1980s.[1] No further details are known.

1. UCEPSP records.

Formerly Victoria Square, then Chamberlain Square, then scrapped

John Skirrow Wright

Francis Williamson

1883
Marble
280cm high
Inscribed on bronze plaque: John Skirrow Wright, born February 2, 1822, died April 13, 1880. In memory of the simplicity, kindliness, and integrity of his life and of his unselfish, continuing, and patriotic devotion as a public man, this monument is erected by the united gifts of all classes in the town he loved and for which he laboured.

Wright (1822–80) came to Birmingham in 1838 where he was employed as a junior clerk at the button manufacturers Smith and Kemp. He rapidly ascended in the company, finally becoming a partner in 1850. He was an ardent Nonconformist and taught in the Baptist Schools at Zion Chapel, Newhall Street, and in 1848 he was one of the founders of the People's Chapels in Great King Street, Hockley. He became the first chairman of Birmingham Liberal Association and was elected MP for Nottingham in 1880.[1] However, he never took his seat as he died suddenly in Birmingham Council House on the 15th April of that year. Shortly after his death a memorial committee was formed and it was resolved to open subscriptions for the purpose of erecting a statue to his memory. Williamson's statue was unveiled in front of the Council House by John Bright MP on 15th June 1883.[2]

The *Birmingham Daily Mail's* report on the unveiling ceremony shows how such

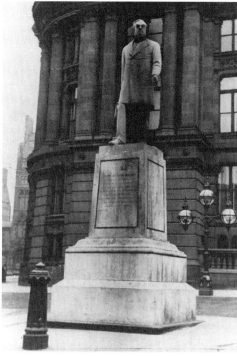

Williamson, *John Skirrow Wright*

statues were viewed at the time: 'The pose of the figure is admirable: Mr Wright stands in a bold, erect attitude, as was his wont when addressing an audience, and with his left arm slightly extended and his right resting on a pedestal. The sculptor Mr Williamson, who is fortunate in having such a strong individuality to work on, has been particularly happy in catching the facial expression.'[3] The statue was moved into Chamberlain Square in 1913 to make way for that of Toft's *Edward VII* and then to a storage depot in 1951. A bronze copy of the bust was made in 1956 by

William Bloye, and was unveiled in a niche in the Council House on 13th September 1957 (see under Victoria Square). The statue was then destroyed.

1. E. Edwards, *John Skirrow Wright MP – A memorial tribute*, Birmingham, 1880; 2. Harman, 1885, p.294; 3. *Mail*, 15th June 1883.

Corner of Church Street and Colmore Row, top of manufactory

Horses

Sir Edward Thomason

These four horse statues used to stand on top of the manufactory on Colmore Row.[1]

1. R.K. Dent, *The making of Birmingham*, Birmingham, 1894, pp.341–3.

Corner of Colmore Row and Newhall Street, formerly Scottish Provident Institution

Allegorical Figures

John Roddis

These figures representing the virtues used to decorate the Scottish Provident Institution on Colmore Row.[1]

1. UCEPSP records.

Good Companions public house, above the entrance

Dancing Putti

William Bloye

c.1939
Stone
80cm high

Within a baroque-styled pediment, two naked putti, arm in arm, dance together in a bacchanalian celebration, holding above their heads a large bunch of grapes, some of which have dropped to their feet. This group formed part of the decoration of this new public house designed for Mitchell and Butler's in 1938 by S.N. Cooke.[1] Bloye completed the carving by May 1939,[2] produced in a bold, expressive style typical of his decoration of public houses. The pub no longer exists.

1. *BRBP*, 1938, no.71366; 2. Bloye, *Ledger*, 9th May 1939, p.79.

Mask of Pan

William Bloye

c.1939
Stone
70cm high × 210cm wide

A laughing mask of Pan in the centre of this relief is accompanied on either side by two musicians, each with long flowing hair. Framing the mask are hops and grapes carved in bold relief with a background of vine leaves. With a combination of deep carving and fine lines cut into the surface, this panel

expressed a sensual pleasure typical of Bloye's sculpture yet rather missing from the architecture of this 1930s public house.

Bloye, *Pan*

Weller, *Cyclad*

Edgbaston Park Road
EDGBASTON

University of Birmingham, Winterbourne House, 58 Edgbaston Park Road, forecourt

Cyclad

Antony Weller

1972
Resin aluminium
200cm high

Originally exhibited, along with another piece entitled *Family*, in the gardens of Winterbourne House, the Department of Extramural studies, in an exhibition called Free Painters and Sculptors held in the autumn of 1972. It was then loaned long-term by the artist. The work is based upon the artist's admiration of the elongated necks of Cycladic, pre-Greek statues, but reinterpreted in an 'even more simple way'.[1] The sculpture was in need of repair in the early 1980s and is now no longer *in situ*. Its fate is unknown.

1. Letter from the artist, 22nd February 1984.

Hagley Road
EDGBASTON

Liberty's night club, car park

Liberty

Ian Horner

c. 1979–80
Fibreglass
560cm high

Horner, *Liberty*

Commissioned for £7,000 by the night-club owner and restaurateur, Andreas Gregoriou, as a roof-top emblem for the original Liberty's night-club in Halesowen. Based on Auguste Bartholdi's *Statue of Liberty or Liberty Enlightening the World*, New York harbour, 1875–84, it took Horner three months to complete. Eventually denied planning permission, the statue was moved to the new Liberty's branch in Hagley Road, Edgbaston. Gregoriou planned 'to build a tower and put the statue in it but then the club was sold'.[1] Although Whitbread purchased the club in 1984, the statue was still owned by Mr. Gregoriou. The statue is no longer *in situ*, and its fate is unknown.

1. 'Taking liberties', *Post*, 20th August 1985.

Handsworth Park, sunken garden

Child with a Lamb

John Walker

1936
Bronze with varied green patina on pedestal of Whitbed Portland stone
Figure: 88cm high; pedestal: 178cm high

Commissioned as a result of a sculpture competition organised by Birmingham College of Arts and Crafts in 1932, it was funded by Richard Wheatley, a Handsworth patron of the arts and ex-student of the College. The brief was for a decorative feature suitable for a park and the competition was open to past and present students.[1] Walker, a student between 1925 and at least 1936, won the first prize of £30 for his model in February 1933[2] and was awarded a further £250 to carry out his design in bronze.

The figure was cast and patinated by the bronze statue founder A.B. Burton of Surrey by September 1936,[3] and the plinth designed with assistance by December. Gratefully accepted by the City on 9th November 1936, it was erected in Handsworth Park and officially unveiled by the Lord Mayor on 15th January 1937. The local press recorded that Wheatley 'had been struck by the fact that all the pieces of sculpture in public places seemed either to be memorials to great citizens or to record some great event. None seemed created out of an artistic appreciation. He hoped that by seeing things of beauty, people would be encouraged to spare a little money from the modern ways of recreation for things of art which would beautify their homes.'[4] The simplified and

stylised forms and compact design show the influence of Walker's teacher at the School of Art, William Bloye. Wheatley financed two other art competitions at the College of Art and Crafts, including a mural decoration at Dulwich Road Senior Boys School in 1936. After his death in 1938, he bequeathed £8,000 to the City towards the Birmingham Civic Centre scheme: (see the entry for Bloye's *Boulton, Watt and Murdock*, Broad Street). The sculpture is no longer present and its whereabouts and fate are unknown.

1. Birmingham School of Art, *Minutes*, 1932–3, 15th February 1933, no.4637; 2. *Richard Wheatley Bequest*, file no.169, letter of 2nd February 1933; 3. Ibid., letter of 28th September 1936; 4. 'Art gift to city unveiled in Handsworth Park', *Gazette*, 16th January 1937.

Walker, *Child with a Lamb*

Highgate Park, Highgate Road, Sparkbrook

King Edward VII

Albert Toft

1913
Carrara marble figure and bronze supporters
on a stone pedestal
Statue, approx: 200cm high
Inscribed on right side of pedestal: ALBERT
TOFT Sc 1913
Status: II

In 1910 the *Birmingham Mail* stated that it
was willing to become the medium for a
memorial fund to Edward VII (1841–1910),[1]
and a booklet was published stating the aims
of the fund.[2] These were the provision of a
statue of the late King and the building of a
new Children's Hospital. There was a
dramatic response to the fund and the
opening list of donations, published on June
8th 1910,[3] amounted to over £5,000 – already
enough to cover the cost of the statue. Toft
was given the commission for the work, but
initially met with some problems in selecting
a suitable piece of marble from the Carrara
quarry, due to the size of the piece required.[4]
However, work was well under way through
1912 and the finished statue was unveiled by
the Duchess of Argyle on 23rd April 1913 in
Victoria Square, beside that of *Queen
Victoria*, with the statues of *Joseph Priestley*
and *John Skirrow Wright* having been moved
to Chamberlain Square.[5]

The statue represented the King as at his
Coronation in 1901, wearing the uniform of a
Field-Marshal under the Coronation robe
and carrying the sceptre, signifying authority,
(subsequently broken) and orb, signifying
world empire. In addition to his figure, there
were three pieces cast in bronze mounted on
the pedestal: a man with his arm protectively
around a boy represented 'Education
fostering progress'; the corresponding female
figure represented 'Peace' and had further
small groups representing 'Sympathy' and
'Understanding' on the tops of each chair
arm; and on the face of the pedestal was St.
George and the Dragon, with an elaborate
crown above. The bronze figures weathered
much better than the marble statue, but the
figure of St. George first lost his lance, then
all three bronze groups were stolen in 1985–6
and have not been recovered. The pairing of
the statues of *King Edward VII* and *Queen
Victoria* was not a successful one. As early as
1914 *The Builder* criticised them as ill-
matched designs,[6] and when the square was
remodelled in 1951, the King's statue was
removed to Highgate Park. It is now no
longer present and its fate is unknown.

1. *Mail*, 10th May 1910; 2. *Birmingham memorial to
King Edward VII, objects of the fund*, Birmingham,
1910; 3. *Mail*, 8th June 1910; 4. 'Birmingham King
Edward memorial', *The Architect*, vol.87, 17th May
1912, pp.326–8; 5. C.A. Vince, *History of the
Corporation of Birmingham*, vol.IV, Birmingham,
1923, p.492; 6. 'Art beneath the rule of commerce',
The Builder, vol.106, 1st May 1914, p.517.

Toft, *King Edward VII*

The Golden Eagle public house, Hill Street, frieze in the cocktail bar

Golden Eagle

William Bloye

1936
Metal sheet, painted
95cm high

Bloye designed both the Eagle sign and the frieze in the cocktail bar of this public house which was rebuilt by the architect F.J. Osborne in 1935 for the Holt brewery[1] and opened in October 1936.[2] The only known example of Bloye working with sheet metal, this 'good, Germanic golden eagle'[3] was composed of irregular, flat, angular sections pressed into shape from a single sheet. He produced an image more abstract and emblematic than much of his sculpture in stone or wood. Seen against a metallic blue background, outlined with clouds, the eagle undoubtedly complemented the polished black granite and glazed faience cladding of this fashionably 1930s-style public house,

Bloye, *Golden Eagle*

unique in Birmingham, but sadly demolished in 1989.

1. *BRBP,* 1935, no.62641; 2. *Post,* 23rd October 1936, p.3; 3. Hickman, 1970, pp.63–4.

Bacchanalia

William Bloye

1936
Plaster, sgraffiti
Frieze: 33cm high; roundel: 260cm diameter
Inscribed on the ceiling: with beaded bubbles winking at the brim; and on the wall: Fugit irreparabile Tempus

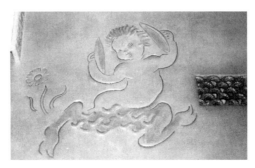

Bloye, *Bacchanalia* (detail)

This frieze, around all of the room's walls, evoked the lively atmosphere of the cocktail bar of the 1930s.[1] Several figures could be seen that formed part of Bloye's repertoire, including satyrs and nude figures whose joyful, pagan subject matter follows the

Bloye, *Bacchanalia* (detail)

tradition of Antonio Pollaiuolo's frieze of nude dancers in the Villa Gallina, at Arcetri outside Florence (1464–71).[2] A more sober cameo of Father Time with the quotation closely following Virgil's 'Fugit irrepabile Tempus' (Time flies away and cannot be restored),[3] contrasts with the ceiling roundel of Bacchus, god of Wine, who is encircled by an appropriate line from Keats.[4] The cursive drawing, with a slight relief to the plaster work, carefully modelled, was reminiscent of Gill's line drawing. The building was closed in 1983 and demolished in 1989.

1. *BRBP,* 1935, no.62641; Birmingham City Architects Department, *List of notable buildings in Birmingham,* Birmingham, 1977; 2. L.D. Ettlinger, *Antonio and Piero Pollaiuolo,* Oxford, 1978, pp.3, 5–6; 3. Virgil, *Georgics,* BK iii, 1, 284; 4. J. Keats, *Ode to a Nightingale,* verse 2, in J. Stillinger (ed.), *John Keats Complete Poems,* London, 1982.

Longboat public house (now the Flapper and Firkin), side wall

Canal Boat

Walenty Pytel

1969
Welded metal
238cm high

Commissioned by Allied Artists as part of the decorative details for Ansell's new canal-side public house, which was designed in 1969. Fixed to the wall, Pytel's emblem combined sheet metal, chain and wire to produce a stylised image of a longboat in sharp perspective. This work has now been removed and the pub renamed as the 'Flapper and Firkin'.

Ansell's Architects Department Building plan, *job no. AB140, drawing 16/R*; Letter from Henry Joseph, 1985.

Pytel, *Canal Boat*

Kings, *Squirrel and Acorns*

The Squirrel public house (now The Nineteenth Hole), corner of Ladywood Middleway and Morville Street, Ladywood

Squirrel and Acorns

Raymond Kings

1961
Ciment fondu, painted
105cm high

Commissioned for the new public house which was designed for Ansell's Brewery by the local architects Kelly and Surman, in 1961.[1] A compact design with curved outline, the sign was comparable to Kings' other work of this period, particularly *George and the Dragon*. The simplified, bold modelling shows the influence of his earlier master, William Bloye. This sculpture is no longer in place, as the pub has changed its name to 'The Nineteenth Hole'.

1. Letter from Ansell's Architects Department, 12th March 1985.

Near the Lucas Factory

Aeolus

William Pye

1975
Metal tubes
Dimensions unknown

Presented to the city on 4th August 1975, *Aeolus* was sponsored mainly by Lucas Industries, with a contribution from the Arts Council of Great Britain. The original cost was £5,000, but this rose another £3,500 as a reinforced base had to be installed. Originally located on a landscaped site near the Lucas Factory, *Aeolus* was beset with technical problems, as was Pye's later *Peace Sculpture* (Aston University, q.v.). Comprising two hanging curtains of weighted metal tubes which banged together in the wind, the sculpture caused uncontrollably noisy disturbances and work was carried out to make it silent. The National Exhibition Centre, Yorkshire Sculpture Park and Aston University were amongst those who were offered the piece, but it was deemed too expensive to resite, and had to be put into storage by the Public Works Department in August 1978. It is believed that it has subsequently been scrapped since the Yorkshire Sculpture Park applied to take the piece, but were unable to locate it.[1]

1. Letter from the artist, 19th February 1996.

The Pallasades, formerly New Street Shopping Centre, east wall, above New Street Station

Pedestrian Circulation

John Merilion

1970
Glass reinforced plastic, polychrome
300cm high × 970cm wide

Merilion, *Pedestrian Circulation*

Designed by Merilion and executed with Raymond Nicholls, the five-unit panel finished in brightly-coloured resin was situated above the main escalators and stairways to the station. According to the artist, 'its imagery is concerned with pedestrian circulation, giving some indication of directions and movements in the area. The diagonal sections and the British Rail symbol point to the station. The colouring is intended to be strong enough to exist successfully with the colourful background of the shop units.'[1] The work was removed in the early 1990s as part of the refurbishment of the Pallasades shopping centre.

1. Information provided by the artist, handout, Autumn 1970.

Untitled

John Merilion

1970
Metal filled glass reinforced plastic panel
300cm high × 1300cm long

Designed by Merilion and executed in collaboration with Raymond Nicholls, this panel comprised fourteen units and decorated the west court of the shopping centre as an integral part of the architectural scheme. The abstract design with metallic finish incorporates a continuous cog and wheel motif and was intended to show the general theme of Birmingham's industrial activities. This mural has been removed as part of the refurbishment of the Pallasades shopping centre.

Information provided by the artist, handout, Autumn 1970.

Merilion, *Untitled*

Cannon Hill Park, outside Foyle House

Untitled

Birmingham College of Art

*c.*1964
Tubular and sheet welded metal, on stone
wall and natural rock base
620cm high

Produced for the Midlands Arts Centre for
Young People in Cannon Hill Park, this
piece was made as part of an International
Work Camp held there in 1964. The sculp-
ture was intended to be a water feature deco-
rating a small lake sited next to the Hexagon
building in the grounds of the park, and both
sculpture and lake were carried out by young
people from over thirty countries.[1] It was
designed by students from Birmingham
College of Art and made by apprentices from
Tube Investments Ltd. The tripod construc-
tion was originally located on an island in the
centre of the lake and had water rising up and
cascading down over the angled and laddered
slats and framework. The pool was later filled
in by the Parks Committee for the purposes
of another festival and the sculpture was
moved, but is no longer in the park. Its fate is
unknown.

1. Letter from Alicia Randle, co-founder of Midlands
Arts Centre for Young People, 17th February 1986.

Birmingham College of Art, *Untitled*

*Midlands Arts Centre, Cannon Hill Park,
store*

Family Group

Charles I'Anson

1967
Welded and bronze-coated steel, steel-blue
patina
457cm high × 396cm wide

I'Anson, *Family Group*

This piece, commissioned by William and
John Kenrick and the Charles Henry Foyle
Trust, was unveiled on the 1st September
1967 at the Arts Centre. Intended to 'convey
the spirit of the centre', the sculpture was
made using the artist's direct welding tech-
nique and took three months to complete.[1] It
was originally positioned on the gable end
above the entrance to Foyle House but was
later removed when the main entrance was
extended.[2] It was expected to be resited, but
this has not happened.

1. *Mail*, 1st September 1967; 2. Letter from Mrs H.
I'Anson, the artist's wife, 11th July 1985.

Smallbrook Queensway
CENTRAL CITY

Bull Ring pedestrian area, formerly known as Manzoni Gardens

King Kong

Nicholas Monro

1972
Reinforced coloured fibreglass
550cm high

This sculpture was commissioned in 1972 by the Peter Stuyvesant Foundation for the City Sculpture project organised in collaboration with the Arts Council of Great Britain.[1] Although it has long been absent from Birmingham, the massive fibreglass King Kong lives on in the memory of its citizens, as is evidenced by the amount of letters referring to it in connection with more recent commissions.[2] The City Sculpture project aimed to give sculptors the opportunity to make works in relation to the sites on which they were to be shown and to give the public sufficient time to come to a reasoned evaluation of these sculptures in their environment. At the end of the sponsored six months, however, the city council did not wish to retain Monro's piece and it was sold to a used-car dealership as an eye-catching hoarding. It was later removed and ended up in Ingleston market, Edinburgh, from where it was eventually taken and destroyed. The Arnolfini Gallery in Bristol has a maquette for *King Kong*.[3] Birmingham's other work commissioned for this project was Robert

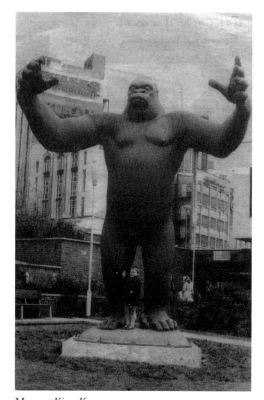

Monro, *King Kong*

Carruthers' *Gate Construction*, at Bell Barn Lane (q.v.).

1. Arts Council of Great Britain, *City sculpture*, London, 1972; 2. T. Grimley, *Post*, 29th July 1991; 3. Illustrated in D. Petherbridge, *Art for architecture*, London, 1987, p.17.

Steelhouse Lane CENTRAL CITY

General Hospital, central entrance porch in quadrangle and at side entrance

Caryatids

John Rollins

1896–7
Terracotta
Approx 200cm high

This group of three figures was situated on the outer pier of the triangular porch at the central entrance of the administrative block to the General Hospital on Steelhouse Lane.[1] The figures held the lamp of life over their heads, aided by 'Philanthropy', and beneath their feet they trampled the serpent of Death. This group represented the art of medicine and the science of surgery, and a further three figures were situated on a second triangular porch at the entrance to the outpatients' department, representing Light, Air and Purity – the three elements essential to Health. They have since been demolished and the whole hospital site is now being redeveloped.

1. *RIBA Journal*, 1897, p.338.

Suffolk Queensway
(formerly Easy Row) CENTRAL CITY

Victoria Square CENTRAL CITY

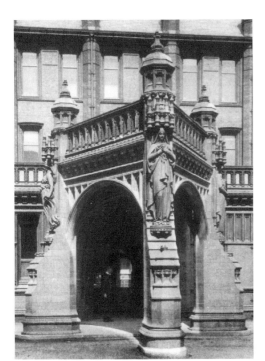

Rollins, *Caryatids*

Woodman public house, niche above front door

Woodman and Dog

Sculptor unknown

300cm high

This figure of a woodman with his dog used to be situated on the second storey of the Woodman public house, which was destroyed when the area was cleared for the Queensway system.

1. K. Turner, *Central Birmingham, 1920-1970*, Strand, 1995, p.64; 2. V. Bird, 'Birmingham's neglected statuary', *Birmingham Weekly Post*, 19th February 1954.

Pediment above main entrance to Town Hall

Britannia with Mermaid and Sea Horses

J.P. Walker

1938
Material not known: possibly plaster and or wood
Approx 180cm high × 300cm wide

Birmingham celebrated the centenary of its Corporation in 1938, and this temporary pedimental decoration was added to the Town Hall as part of the festivities. Although Birmingham has no maritime connections, Britannia 'ruling the waves' may have been a suitable subject for a period of uncertainty in Britain, also reflected in the subject of Raymond Kings' *George and the Dragon* which was put up at the same time. Depicted in a stylised, modernistic manner, the pedimental group made an interesting contrast to the classical style of the Town Hall.

Walker, *Britannia with Mermaid and Sea Horses*

Outside Council House, atop a tall column

St. George and the Dragon

Alan Bridgwater

1938
Plaster, gilded
Column approx 900cm high
Sculpture approx 100cm high × 100cm wide

This sculpture was made in 1938 for celebrations surrounding the centenary of the City of Birmingham's Corporation. St. George was seen in traditional pose, pinning the dragon with a lance. It can be surmised that it stood for the year and was subsequently destroyed.

Bull's Head public house, over the entrance

Vase of Fruit

Designed by William Bloye

*c.*1935
Stone, painted
140cm high

This white, fluted vase bearing grapes, apples, pears and hops set amidst green vine leaves, was completed by June 1935.[1] Although not shown in the original architectural drawings, it was the central feature dominating the façade of this public house rebuilt by Ansell's

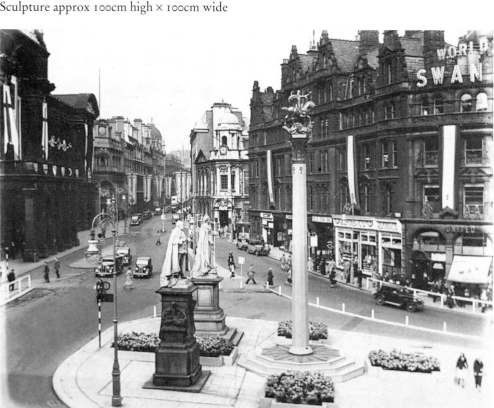

View of Victoria Square showing column with Bridgewater's *St. George and the Dragon*

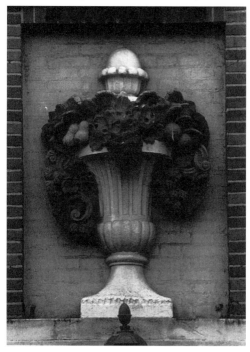

Bloye, *Vase of Fruit*

Brewery in 1934 to designs by the architect J.P. Osborne.[2] It was intended to carve a bull's head here, but there is a delightful story explaining that the stonecarver responsible was drunk when he carved it, and the result was so poor that it had to be rescued by changing it to this vase and fruit.[3] The public house upon which this was carved no longer exists.

1. Bloye, *Ledger*, 7th February 1935, p.22, invoice no.126; 2. *BRBP*, 13th July 1934, no.60875; 3. Information provided by Douglas Hickman, 13th November 1985.

Cross Guns Inn, exterior wall

Cross Guns

Walenty Pytel

*c.*1970s
Welded metal, painted black
175cm high × 220cm wide

This unusually large emblem decorating the main façade of Mitchell and Butler's public house was commissioned through Pytel's agent, Henry Joseph of Allied Artists.[1] A graphic arrangement of a panoply of weapons, the design is comparable to *Canal Boat*, but is presented in low relief rather than using a three-dimensional effect. The work is no longer in place on the pub's exterior and there is an obvious blank space where it used to be.

1. Letter from Henry Joseph, 1985.

Pytel, *Cross Guns*

Elliot, Son and Boyton, Waterloo Street, in store. Formerly over the entrance to the Gazette Building, Corporation Street

Satan

Countess Feodora Gleichen

*c.*1894
Bronze figure on marble throne
90cm high
Exhibited: Royal Academy, 1894

Identified locally for many years as Mercury, the Greek messenger of the Gods, this allegorical figure was first exhibited under the artist's title of *Satan* at the Royal Academy in 1894.[1] Satan is represented as a winged and armoured knight, enthroned, with arms crossed over an upright sword. Attracting critical attention, it was considered in 1901 as 'a fanciful and weird design ... the work reveals undoubted skill and invention, although it is somewhat overloaded'.[2] The association with Mercury may have been due to a similarity of the two characters' attributes: the two facing snakes on Satan's throne being like those forming Mercury's caduceus. Another reason for the mistaken identity was probably connected with the sculpture's location on the Gazette Building which, between 1904 and 1929, served as the publishing offices of the *Birmingham Gazette* and associated newspapers, including the *Sunday Mercury*.[3] It remained over the main entrance until February 1981, when it was stolen.[4] Quickly recovered, it was put in store at Elliot, Son and Boyton, agents of Wingates Investments Ltd., owners of the building at that time. The sculpture had weathered badly and lost various details,

including the helmet plume and sword blade; the snakes, once entwined around the chair arms, had been broken off.

1. Graves, 1905, p.248; 2. M. Spielmann, *British sculpture and sculptors of today*, London, 1901, p.18; 3. *Birmingham Gazette and associated Birmingham newspapers, progress 1741–1929*, Birmingham, 1929, pp.25–7; 4. 'Ladder gang grab work-of-art statue', *Sunday Mercury*, 8th February 1981.

Gleichen, *Satan*

Small Heath Park. Original marble statue formerly in Chamberlain Square

George Dawson

Francis Williamson

Original: 1885; Bust recast 1951
Bronze bust
180cm high

George Dawson (1821–76) was a preacher, lecturer and politician who first came to

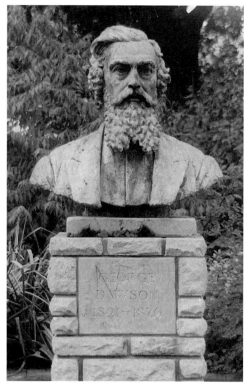

Williamson, *George Dawson*

Birmingham in 1844 to preach at Mount Zion Baptist Chapel. His sermons proved immediately popular but some doctrinal conflict led to his resignation after one year. However, his followers and friends united to build a chapel for him which was opened as the Church of the Saviour in 1847. Outside of chapel he lectured on a wide variety of topics, particularly English literature, and many of these lectures were printed. He was a founder of the Shakespeare Memorial Library and an advocate of free public libraries. After Dawson's death, the sculptor Thomas Woolner was commissioned to produce a statue of the preacher, which was duly unveiled in 1881. However, there was a great deal of dissatisfaction with the likeness[1] and the Memorial Committee selected Williamson to produce a second statue of Dawson after seeing the bust of Dawson which he had just completed for the Church of the Saviour. Williamson produced three models, from which the Committee produced the preferred design, and a marble statue to this model was erected in place of that by Woolner and unveiled on 24th February 1885. The new statue was warmly greeted, though some anxiety continued to be expressed concerning the canopy with which it had to contend. The differences between the versions of the two sculptors seem hardly noteworthy, though Williamson's does appear to have enlivened the dress and given the figure more elegance and animation than that by Woolner. In 1951 the Williamson statue and the canopy were scrapped, though this bronze copy of the statue's bust was first made by William Bloye and placed on a pedestal beside the gatehouse to Small Heath

Park.[2] The 0.5 tonne bust, worth £1,000 to scrap metal dealers, was stolen in 1991, and has not subsequently been recovered.[3]

1. 'The George Dawson memorial', *The Dart*, Birmingham, 14th October 1881; 2. W. Ainsworth, 'In search of George Dawson', *The Birmingham Historian*, no.5, Autumn/Winter 1989; 3. *Mail*, 5th June 1991.

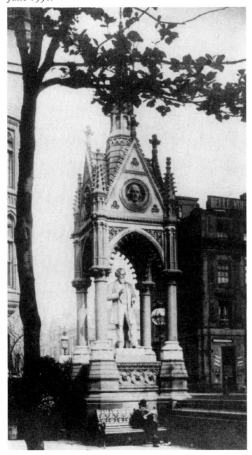

Williamson, *George Dawson*

George IV

Sir Edward Thomason

1823
Bronze
180cm high

This was the first life-size bronze statue to be cast in Birmingham,[1] and cost over £1,500 to produce. Thomason never found a customer for the piece, and it was eventually sold in 1880 for £150, which was its scrap value.[2] It was considered to be a very good likeness of the King. The statue disappeared and was probably melted down by its buyer. Other reports suggest it may have been sent to Westminster Hall, London, in 1844, where the *Literary Gazette* dismissed it as 'Brummagem and contemptible'.[3]

1. R.K. Dent, *The making of Birmingham*, Birmingham, 1894, pp.341–2; 2. Harman, 1885; 3. *Literary Gazette*, 1844, p.466.

Playgrounds at Hawkesley Farm Moat Estate, Turves Green, Kent's Moat Estate, Bangham Pit, Millpool Hall Estate

Playsculptures

John Bridgeman

c.1959
Concrete, finished in metallic paint
From: 55cm high

These works were commissioned by the City Architect, A.G. Sheppard Fidler on the recommendation of Mary Mitchell, the City Landscape Architect, for the playgrounds she had designed on the new housing estates on the outskirts of the city.[1] Bridgeman's functional play sculptures were semi-abstract in their design, often based on the theme of bird and flight, while the larger works were less representational and were reminiscent of Henry Moore's environmental sculptures.[2] Made in the artist's studio the works were built up on an armature and cast in concrete, while the smaller ones were cast in solid moulds and then finished in metallic paint. Received favourably in the national as well as local press, the *Swan* at Kent's Moat Estate was considered 'one of the most appealing' along with the toddlers' playsculpture *Fledgling* on the same site.[3]

1. Letter from Mary Mitchell, 22nd April 1985; 2. 'Playgrounds in Birmingham', *Architect and Building News*, vol.218, 14th December 1960, pp.767–8; 3. 'Concrete Play Sculpture', *Royal Society of British Sculptors, Annual Report 1962–63*.

Unrealised Works

Broad Street CENTRAL WEST

Spirit of Birmingham

William Bloye

Bronze figure, on top of a stone column
Figure: 300cm high; column 4200cm high

Although a statue on a column personifying the Spirit of Birmingham was thought to have been included in a model of the Civic Centre as early as 1934,[1] it was as part of the celebrations to mark the coronation of King George VI in 1937 that Bloye was first commissioned by the Civic Society[2] to make a giant nude figure of a young smith, similar in character to *Industry*, the Supporter on the City Coat of Arms.[3] The concept of a monumental figure standing on a high Doric column has associations with late 18th- and early 19th-century interests in the erection of similar colossal monuments to celebrate naval victories. The nude figure here is also reminiscent of the *genius* figures of the Baroque, though it was conceived in a neo classical style. In 1938, under a project for the beautification of the city to celebrate the centenary of the granting of the Charter of Incorporation, a permanent statue was envisaged for the Civic Centre on the site of what is now Centenary Square, and the Civic Society granted £1,500 to the Corporation for this purpose.[4] Postponed until 1948 due to the war, Bloye then produced a model 76cm high, and then a quarter-size model in clay, approved by the General Purposes Committee. It was forecast that the full-size model would be ready by July 1951, and the bronze cast a year later, but the total estimated cost for the 140ft column and statue had reached £43,520 and so the proposal, initially postponed for a year, was never completed.[5]

1. Anon, 'Birmingham Civic Centre scheme', *Architect and Building News*, vol.168, 3rd October 1941, pp.9–11; 2. Birmingham Civic Society, *Report of the Birmingham Civic Society, 1937–1938*, Birmingham, 1938, pp.19–20; 3. H.J. Black, *History of the Corporation of Birmingham*, vol. VI, Birmingham, 1957, pp.573–6, 621; 4. W. Haywood, *The work of the Birmingham Civic Society*, Birmingham, 1946, p.61; 5. Birmingham Civic Society, *Report of the Birmingham Civic Society 1948–1949*, Birmingham, 1949, p.6.

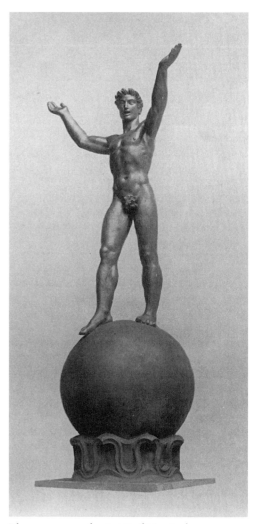

Bloye, maquette for *Spirit of Birmingham*

Glossary

TYPES AND COMPONENTS

acroterion (plural: acroteria): an ornamental block on the apex and at the lower angles of a *pediment*, bearing a statue or a carved finial.

aedicule: a statue *niche* framed by *columns* or *pilasters* and crowned with an *entablature* and *pediment*; also a window or door framed in the same manner.

arcade: a range of arches carried on piers or columns, either free-standing or attached to a wall (i.e., a 'blind arcade').

arch: a curved structure, which may be a *monument* itself, e.g., a Triumphal Arch, or an architectural or decorative element within a monumental structure.

architrave: the main beam above a range of *columns*; the lowest member of an *entablature*. Also the *moulding* around a door or window.

atlantes: male version of a *caryatid* figure.

attic course/attic storey: the course or storey immediately above the *entablature*, less high than the lower storeys.

base: the lowest visible course of masonry in a wall; the lowest section of a *column* or *pier*, between the *shaft* and *pedestal*; the lowest integral part of a *sculpture* (sometimes mounted on a pedestal). Loosely, the lowest portion of any structure.

bas-relief: see *relief*.

boss: architectural term. A roof boss is a block of wood or keystone which masks the junction of vaulting ribs in exposed roof spaces.

bust: see *sculpture*.

canopy: a roof-like projection over a *monument*, *sculpture*, *cross*, etc.

capital: the transition between a *column* and the ceiling or arch above it. It can either be free-standing or attached to the wall.

cartouche: an ornamental *panel* with edges simulating a scroll of cut parchment, usually framing an *inscription* or shield.

caryatid: support, replacing *column*, in the form of a female figure.

cenotaph: a *monument* which commemorates a person or persons whose bodies are elsewhere; a form of World War I memorial popularised by Sir Edwin Lutyens' precedent at Whitehall, London.

clock tower: usually a square tower having a clock at the top with a face on each exterior wall having a commemorative function and/or sculptural elements.

colonnade: a range of *columns* supporting an *entablature*.

column: upright structural member with a *shaft*, topped by a *capital* and usually rising from a *base*. Whatever the shape of the capital or base, the shaft is usually round or octagonal in plan. In *classical* usage the columns generally conform to several main types, or Orders: Corinthian, Doric, Ionic and Tuscan (see *order* p.180).

console: a decorative bracket with a compound curved outline, resembling a figure 'S' and usually taller than its projection.

cornice: (i) the overhanging *moulding* which crowns a *façade*; (ii) the uppermost division of an *entablature*; the uppermost division of a *pedestal*. The sloping mouldings of a *pediment* are called **raking cornices**.

crocket: architectural term. An ornamental architectural feature, usually in the shape of a bud or curled leaf, projecting at regular intervals from the inclined side of pinnacles, spires, canopies or gables.

cross: structure with intersecting horizontal and vertical members. May be a monumental form in its own right or a decorative or architectural element.

crucifix: type of *cross* with figure of Christ.

dado/die: on a *pedestal*, the middle division above the *plinth* and below the *cornice*.

entablature: in *classical* architecture, the superstructure carried by the *columns*, divided horizontally into the *architrave*, *frieze* and *cornice*.

façade: front or face of a building or *monument*.

finial: architectural term. An ornament which completes a vertical projection such as a spire or gable.

foundation stone: a stone situated near the base of a building or monument, bearing an *inscription* recording the dedicatory ceremony.

founder's mark: sign or stamp on a *sculpture* denoting the firm or individual responsible for casting.

fountain: a structure with jets, spouts and basins of water for drinking or ornamental purposes. Component parts may include sculptural decoration or *inscription*.

frieze: in *classical* architecture such as Greek temples, the frieze was the middle division of the *entablature*, between *cornice* and *architrave*, which was often used for *relief* sculpture. Modern usage extends the concept of a frieze to any long, narrow sculptural relief incorporated into an architectural work, excluding medallions and roundels in their own right.

grotesque/gargoyle: figure or beast often acting as a waterspout.

inscribed stone: boulders, monoliths, sarsens,

slabs, etc.

inscription: written dedication or information.

keystone: the wedge-shaped stone at the summit of an *arch*, or a similar element crowning a window or doorway.

lamp: street light with decorative elements or commemorative function.

Latin cross: free-standing Victorian or Edwardian Gothic spire, usually with niche statues, after the 13th-century Eleanor Crosses, put up by Edward I.

lettering: characters which comprise the *inscription*. The following types are commonly found. **Applied**: metal letters stuck or nailed. **Incised**: letters carved into stone or etched in metal. **Relief**: low relief letters. **Upraised**: high relief letters.

lintel: architectural term. Horizontal beam or slab spanning a door or window, supporting the wall above.

maquette (Fr. 'model'): in *sculpture*, a small three-dimensional preliminary sketch, usually roughly finished.

medallion: in architecture, a circular frame (i.e., shaped like a medallion or large medal) within which relief sculpture may be situated.

milestone: waymark, breadstone, Coal-Tax post, etc.

modello (It. 'model'): a small-scale, usually highly finished, sculptor's (or painter's) model, generally made to show to the intended patron.

monument: a structure with architectural and/or sculptural elements, intended to commemorate a person, event, or action. The term is used interchangeably with *memorial*.

mosaic: design comprised of small, usually coloured, pieces of glass, tile or marble.

mural: large-scale decoration on or attached to a wall.

niche: a recess in a wall used as a setting for a *statue*, *bust* or ornament.

obelisk: tapering upright *pillar* with rectangular or square section, ending pyramidally, usually *free-standing*.

ogee arch: architectural term. A type of archway consisting of two 'S' shaped curves meeting at their apex. Introduced in the late 13th or early 14th century, this arch was commonly used in the late Middle Ages.

panel: rectangular plane which either takes the form of a board or plaque or a carved or moulded section or part of a *pedestal* or *screen*.

pedestal: the base supporting a *sculpture* or *column*, consisting of a *plinth*, a *dado* (or *die*) and a *cornice*.

pediment: in *classical* architecture, a low-pitched gable, framed by the uppermost member of the *entablature*, the *cornice*, and by two raking cornices. Originally triangular, pediments may also be segmental. Also, a pediment may be open at the apex (i.e., an open-topped or broken-apex pediment) or open in the middle of the horizontal cornice (an open-bed or broken-bed pediment). The ornamental surface framed by the pediment and sometimes decorated with sculpture is called the *tympanum*.

pier: solid masonry support, distinct from a column.

pilaster: a shallow *pier* projecting only slightly from a wall.

pillar: a free-standing vertical support which, unlike a *column*, need not be circular in section.

plaque: a plate, usually of metal, fixed to a wall or pedestal, including *relief* and/or an *inscription*.

plinth: (i) the lowest horizontal division of a *pedestal*; (ii) a low plain base (also called a socle); (iii) the projecting base of a wall.

podium: circular platform.

putto (plural: putti): decorative child figure,

derived from *classical* art, often signifying mankind in a state of innocence and lost innocence.

ready-made: a form of *sculpture* in which a manufactured object is given the status of a work of art by removal from its original utilitarian context and placed into a new non-functional context. Pioneered by Marcel Duchamp in 1913, it became an accepted genre of sculpture in Dada and *Surrealist* art. (For example: City Engineer's Department, *Beam Engine*, Dartmouth Circus.)

relief: sculpture in which the forms stand out or recess from a supportive surface (which need not necessarily be of the same material). The depth of the relief is often characterised as 'high' or 'low', or *haute-* or *bas-* depending on how far the forms stand off the surface.

reredos: architectural term for Christian churches. A carved or decorated *screen* above and behind the altar. Also known as an altarpiece or a retable.

roundel: circular or oval frame within which a *relief* sculpture may be situated.

screen: wall or other dividing element, often semi-circular, placed behind a *statue* or *monument*.

sculpture: three-dimensional work of art which may be either representational or abstract, *relief* or *free-standing*. Among the many different types are: (i) bust – strictly, a representation of the head and shoulders (i.e., not merely the head alone); (ii) effigy – representation of a person, the term usually implying that of one who is shown deceased; (iii) equestrian – representation of a horse and rider; (iv) kinetic – a sculpture which incorporates actual movement, whether mechanical or random; (v) relief – see separate entry; (vi) statue – representation of a person in the round, usually life-size or larger; (vii) statuette – a small-scale statue,

very much less than life size; (viii) torso – representation of the human trunk without head or limbs.

seat: bench with a commemorative function or sculptural elements.

shaft: main section of a column, between the *capital* and the *base*.

statue, statuette: see *sculpture*.

stela: stone slab standing upright, which may be carved, inscribed or support panels.

steps: often included in architectural elements of a *monument* or *sculpture*. For example, a stepped base.

string-course: a continuous horizontal band projecting from or recessed into a *façade*.

tablet: stone panel, often inscribed.

tympanum: section over a door or window which is often enclosed by a pediment. It has no structural function and so is usually filled with decoration or *relief* sculpture.

urn: vase with lid originally made to receive ashes of the dead, but in sculpture, usually decorative.

volute: architectural term. A curvilinear ornament on *capitals*.

voussoir: architectural term. Wedge-shaped stones used in *arch* construction.

war memorial: structure which commemorates those who served or died in particular wars.

DECORATIVE AND DESCRIPTIVE TERMS

acanthus: long leaf usually curled over at the lip. It is the standard form of foliage in classical decoration, on a Corinthian *capital*, for example, and often takes the form of a *frieze* especially on war memorials.

allegory (literally: 'another way'): a literary or artistic genre which gives a narrative description of a subject in the guise of another. It uses personifications, usually female, as the embodiments of abstract concepts; and representatives such as mythological, biblical, legendary or historical figures renowned for such qualities. An allegory also often makes use of metaphor. (For example: Queen Victoria as Justice, Victoria Law Courts, Corporation Street.)

attribute: a symbolic object by which an allegorical or sacred personage is conventionally identifiable.

avant-garde: a term deriving from military terminology which has been used since the middle of the 19th century to describe artists and their work which was radical and experimental in comparison to academic theories and practices.

Baroque: an art historical term which has two principal meanings. (1) A period of style in art history between the late 16th century and the early 18th century. (2) A non-technical descriptive term meaning 'florid' or 'overwrought'. The emphasis of Baroque design is on balance through the harmony of parts in subordination to the whole, achieved through contrasts of mass, light and details.

bust: sculptural type. Representation of the head and upper portion of the body.

caduceus: attribute of Hermes and Mercury, messenger of the Gods. A staff, culminating in a pair of intertwined snakes, surmounted by two wings. As an emblem on its own, in post-Renaissance secular *iconography* it is a symbol of peace, justice, art or commerce.

classical: refers to the style deriving from Greek or Roman art, sculpture and architecture, particularly of the 5th century B.C. Any work described as 'classical' takes ancient models as examples of greatness.

conversation piece: a class of composition, especially common to 18th-century English painting, in which portraits of individuals are grouped together in a life-like manner and usually engaged in discussion.

cusp: points formed at the meeting of foils in a tracery.

Doric order: see *order* (p.180).

fasces: composed of an axe in the middle of a bundle of rods, the fasces were carried in procession by lictors in front of the chief magistrates as a symbol of their power over the lives and liberties of the people of ancient Rome. As an emblem, it symbolises order, republican sentiments, the common good and concordance. Fasces were adopted by the Fascists as their badge.

festoon: depiction of a garland suspended between two points.

fluting: shallow concave grooves running vertically on the shaft of a *column* or other surface.

foil: leaf-shaped lobe created by *cusp*.

foliate: decorated with leaf designs or *foils*.

free-standing: sculptural type. Free-standing sculptures are not attached to any kind of support, except for a *base* or *plinth*.

Futurism: an *avant-garde* art movement, founded in 1909 by Marinetti in Milan, Futurism in art and sculpture glorified speed, modernity and violence. The most important of the Futurist sculptors was Umberto Boccioni, whose *Unique forms of Continuity in Motion* can be seen in the Tate Gallery, London.

genre: originating from the French, in art historical terminology genre denotes a 'kind' or 'type' of visual art. A second meaning of the term applies to scenes of everyday life or activities depicting socially less privileged classes.

Gothic: a term used to denote the style of medieval art and architecture that predominated in Europe *c.*1200–*c.*1450. In architecture it is characterised by the pointed arch and an overall structure based on a system of ribbed cross vaulting supported by clustered columns and flying buttresses, giving a general lightness to the building. In

sculpture the figure is generally treated with naturalistic detail, but is often given an exaggerated elegance through elongation and the use of an 'S' curve. Although the style had an almost uninterrupted history in northern countries, especially in England, it had a major revival in the architecture of the 19th century.

iconography: the visual conventions by which traditional themes are depicted in art under changing historical and cultural conditions. The term is also used for that method of art history which traces those transformations, often in relation to their literary sources.

in situ (literally: 'in place'): a term used to denote the original location of a work of art for which it was first intended.

Ionic order: see *order*.

moulding: contour given to projecting feature.

neo-Classical: artistic style and aesthetic movement which spread across Europe in the second half of the 18th century, which drew on the renewed interest in antique examples of art, sculpture and particularly architecture. Using knowledge derived from Hellenistic and Roman copies of Greek originals, neo-Classical architecture included deliberate imitation of antique precursors.

order: in *classical* architecture, an arrangement of *columns* and *entablature* conforming to a certain set of rules. The Greek orders are (i) **Doric**, characterised by stout columns without *bases*, simple cushion-shaped *capitals*, an entablature with a plain *architrave*, and a *frieze* divided into *triglyphs* and *metopes*; (ii) **Ionic**, characterised by slender columns on bases, capitals decorated with volutes, and an entablature whose architrave is divided horizontally into fasciae and whose frieze is continuous; and (iii) **Corinthian**, characterised by even slenderer columns, and a bell-shaped capital decorated with *acanthus* leaves. The Romans added

Tuscan, similar to the Greek Doric, but with a plain frieze; and **Composite**, an enriched form of Corinthian with large volutes as well as acanthus leaves in the capital. They also had their own **Roman Doric**, in which the columns have bases.

personification: the visual embodiment (often in the form of a classically-robed female figure) of an abstract idea (e.g. Britannia).

Romanesque: a style of medieval art which prevailed in Europe c.1050–c.1200; in England it is also known as Norman. In architecture it was characterised by round headed *arches*, heavy continuous wall surfaces and a wealth of simple decorative geometric patterns. In sculpture and painting the figure was simply-drawn with drapery and hair treated as a decorative element.

rustication: masonry cut in blocks, often rough-hewn, separated from each other by deep joints. A rusticated *column* has alternate rough and smooth blocks comprising the shaft.

sgraffiti: decorative design incised whilst the plater is still wet.

swag: representation of a drape of a curtain.

Symbolism: loosely organised movement of painters and sculptors from c.1885 who were connected with sentiments expressed through French symbolist poetry. Moréas stated that art should 'clothe the idea in a sensuous form', resolving conflict between the material and the spiritual world.

tracery: ornamental form characteristic of *Gothic* architecture, notably in windows.

trophy: sculptured group of arms or armour commonly found on military *monuments* and *war memorials*.

Virtues and Vices: personifications of abstract concepts used in Christian *iconography* intended to instruct about both religious and secular moral conduct. Originating from the

Late-Antique allegorical poem by Prudentius Psychomachia, describing the battle between Good and Evil, it was developed into an elaborate allegorical scheme in medieval times. The Seven Cardinal Virtues are divided between the three Theological Virtues, Faith, Hope and Charity, and the Natural Virtues of Justice, Prudence, Temperance and Fortitude. These have often been modified to include other Virtues such as Chastity.

MATERIALS, PROCESSES AND CONDITION

accretion: the accumulation of extraneous materials on the surface of a sculpture, for example, salt, dirt, pollutants or *guano*.

alabaster: a sulphurate of lime, a sort of gypsum. A very soft material for sculpture famed for its smoothness of polish and ability to take paint directly onto its surface.

aluminium: a modern, lightweight white metal obtained from bauxite.

artificial stone: a substance, usually cement or reconstituted stones, moulded and then fired rather than carved.

bronze: alloy of copper and tin, with traces of metals which affect the surface patination as the sculptural work weathers. A very responsive, strong and enduring substance, it is easily handled and has become one of the most common materials for sculpture.

cast: the reproduction of an object obtained when a material in a liquid state is poured into a mould and hardened. Recast: made from moulds taken from the original cast or from replicas.

ciment fondu: a cement-like material which is easily moulded and can be coloured.

cire perdue (Fr. 'lost wax'): metal-casting technique used in sculpture, in which a thin layer of wax carrying all the fine modelling and details is laid over a fire-proof clay core

and then invested within a rigid-fixed, fire-proof outer casing. The wax is then melted and drained away ('lost') through vents, and replaced with molten metal. The resulting cast is an extremely faithful replication of the wax original.

Coade stone: artificial stone made in Lambeth from *c.*1769 to *c.*1820 and used in a wide variety of sculpture because of its resistance to frost.

concrete: a composition of stone chippings, sand, gravel, pebbles, etc., mixed with cement as a binding agent. Although concrete has great compressive strength it has no tensile strength and thus, when used for any *free-standing* sculpture, must be reinforced with an armature of high-tensile *steel* rods.

corrosion: gradual deterioration of a material through chemical reaction with acids, salts or other agents. It is accelerated by the presence of moisture.

crazing: pattern of cracks on surface or coating.

delamination/spalling: the splitting away of the surface layers of stone or brick parallel to the surface.

erosion: the wearing away of material by the action of other material.

graffiti: unauthorised lettering, drawing, or scribbling applied to or scratched or carved into the surface of a *monument* or *sculpture*.

granite: an extremely hard crystalline igneous rock consisting of feldspar, mica and quartz. It has a characteristically speckled appearance and may be left either in its rough state or given a high polish. It occurs in a wide variety of colours including black, pink and grey-green.

guano: bird excrement.

iron: a naturally occurring metal, silver-white in its pure state, but more likely to be mixed with carbon and thus appearing dark grey. Very prone to rust (taking on a characteristic reddish-brown colour), it is usually coated with several layers of paint when used for outdoor *sculptures* and *monuments*. As a sculptural material it may be either (i) cast – run into a mould in a molten state and allowed to cool and harden; or (ii) wrought – heated, made malleable, and hammered or worked into shape before being welded to other pieces.

limestone: a sedimentary rock consisting wholly or chiefly of calcium carbonate formed by fossilised shell fragments and other skeletal remains. Most limestone is left with a matt finish, although certain of the harder types can take a polish after cutting and are commonly referred to as *marble*. Limestone most commonly occurs in white, grey or tan.

lost wax: (see *cire perdue*).

marble: in the strictest sense, *limestone* that has been recrystallised under the influence of heat, pressure, and aqueous solutions; in the broadest sense, any stone (particularly limestone that has not undergone such a metamorphosis) that can take a polish. Although true marble occurs in a variety of colours, white has traditionally been most prized by sculptors, the most famous quarries being at **Carrara** in Italy, and at Paros (**Parian** marble) in the Aegean. **Pentelic** marble from Mount Pentelikos in Greece is characterised by its golden tone, caused by the presence of *iron* and mica.

patina: surface colouration of metal caused by chemical changes which may either occur naturally, due to exposure for example, or by processes employed at a foundry.

pits/pitting: holes and other imperfections in a metal surface due to casting process or corrosion.

plaster: material comprised of lime, sand, and water, with hair as a strengthener. Easily malleable when wet, it hardens when dry. It may be carved or poured into moulds to make casts.

polychromy: the practice of finishing a sculpture, etc., in several colours.

sandstone: a sedimentary rock composed principally of particles of quartz, sometimes with small quantities of mica and feldspar, bound together in a cementing bed of silica, calcite, dolomite, oxide of iron, or clay. The nature of the bed determines the hardness of the stone, silica being the hardest.

steel: an alloy of *iron* and carbon, the chief advantages over iron being greater hardness and elasticity.

terracotta (Italian: 'baked earth'): clay baked to an enduring hardness, which may come in a variety of colours dependent on the amount of iron oxide in the material. Can be modelled or cast in a number of ways and enamels or glazes can be applied. Terracotta was used extensively in Birmingham by Victorian architects because its easy handling made it ideal for decorative purposes. (For example: Victoria Law Courts, Corporation Street.)

PROPER NAMES

Allied Artists: a company started in the late 1930s by Henry Joseph to aid architects in their selection of artists and sculptors for decorative work on new buildings. Based in Birmingham, Allied Artists has been responsible for many works on pubs and churches, but more recently has changed its emphasis to the mass production of stained glass.

Arts and Crafts Movement: British social and artistic movement of the second half of the 19th century. Widespread dissatisfaction with the quality of manufactured goods after the 1851 Great Exhibition led to the likes of Pugin, Ruskin and Morris advocating a return to guild-like practices and an

emphasis on crafts skills. The movement advocated truth to materials in design and architecture and looked largely to medieval art for its models. Morris made a successful business out of decorating the homes of the rich with designs created on these principles.

Birmingham Museums and Art Gallery (BMAG): coming under the control of Birmingham City Council's Leisure Services division, BMAG is responsible for a number of sites including Aston Hall, the Science Museum and the Museum and Art Gallery at Chamberlain Square. It is here that works of sculpture listed as being 'in store' are kept, along with details of the artists and their works. There is also an archive of information on recent commissioning in the city. Members of the public are allowed access to records or stored works, upon application to the Gallery. BMAG, Chamberlain Square, Birmingham, B3. Tel: 0121-235 2834.

Public Art Commissions Agency (PACA): a private, charitable company which was created to facilitate the 'per cent for art' scheme based around the redevelopment of Centenary Square in Birmingham in the early 1990s, for which it holds a great many slides and models. It has been responsible for commissioning many of the recent public art works in Birmingham and has now completed a number of national projects, including the Channel Fish scheme (designed by Jean-Luc Vilmouth) in the Waterloo International Rail Terminal. Its aims also include the promotion of training for public art and its integration into architectural and environmental designs. PACA's director is Vivien Lovell. Public Art Commissions Agency, Studio 6, Victoria Works, Vittoria Street, Birmingham B1 3PE. Tel: 0121-212 4454.

Royal Academy of Arts (RA): founded in 1768 and moving several times before being finally located in Burlington House, London, the Royal Academy (often abbreviated to RA) aims to raise the status of artists through a system of training and exhibitions of works. Annual exhibitions have provided the chance for Academicians and other artists and sculptors to show their latest works, which would often lead to further commissions. Many of the sculptors who have works in Birmingham regularly showed models or casts of these pieces at the RA.

West Midlands Arts: the regional board of the Arts Council of Great Britain for the West Midlands, which provides funding for creative events including performance, exhibitions and conferences. Has been responsible for aiding the commissioning of some public art works in Birmingham. Chief Executive: Michael Elliott. WMA, 82 Granville Street, Birmingham B1 2LH. Tel: 0121-631 3121.

Biographies of Sculptors and Architects

Kevin Atherton (b.1950)
Born 25th November 1950 in the Isle of Man and educated at the Isle of Man College of Art 1968–9, he studied fine art at Leeds Polytechnic 1969–72. Came to prominence with commissions integrating work with 'lived in' spaces, for example his *Platform Piece* for British Rail, consisting of three life-size figures on Brixton station, London 1986. Works also include: *A Body of Work*, Langdon Park School, Poplar, London 1983; *Upon Reflection*, bronze, Elthorne Park, London 1985; *A different ball game*, Kings Hill, West Malling, Kent 1994; *A private view*, Taff Viaduct, Cardiff Bay 1995. Currently working at the Chelsea College of Art and Design on issues around Virtual Reality.

1. Strachan, 1984, p.254; 2. *Kevin Atherton, a body of work*, Serpentine Gallery, London, 1989; 3. Letter from the artist, 26th February 1996.

Number of works in Catalogue: 2

Oliver O'Connor Barrett (b.1908)
Born in 1908 in Eltham, London. In 1927 he attended Fircroft College in Birmingham and three years later, without formal art training, began direct carving in wood. He exhibited for the first and only time at the Royal Academy in 1933 and in the following year had his first one-person show, at the Cooling Galleries, London. This was subsequently transferred to the Ruskin Galleries in Birmingham where it was described as 'the most important of its kind in the city since the appearance of Epstein's Genesis'. He lived in Edgbaston from about 1936 until 1940 when he moved to America, where he taught art at several colleges. He had four exhibitions of his sculpture, paintings and drawings in New York in 1944, 1946, 1953 and 1962, and in the latter year became head of sculpture at the Norton School of Art, Palm Beach, Florida. There is another work by Barrett, *Darkness* (wood carving), in store at the Birmingham Museum and Art Gallery, acquired 1934.

1. 'Notes of the month', *Apollo*, vol.XIX, no.113, May 1934, p.281; 2. *Sunday Mercury*, 14th May 1944, p.5; 3. *RAE*, vol.I, Wakefield, 1973, p.89.

Number of works in Catalogue: 1

Harry Bates (1850/1–1899)
Born at Stevenage, Hertfordshire. Between 1869 and 1882 he was apprenticed and worked as a carver for the well-known firm of architectural carvers, Farmer and Brindley. He went to SLTAS in 1879 and studied at the RA Schools 1881–3, during which time he won a travelling studentship. This enabled him to work in Paris 1883–5, when he was in contact with Dalou (who had taught him at SLTAS), and Rodin. He was responsible for architectural carving for various buildings including the Institute of Chartered Accountants, City of London; and Holy Trinity church, Sloane Street, Chelsea. Sculptures include: *Homer*, RA 1886 (relief panel); *Pandora*, RA 1890; *Mors Janua Vitae*, RA 1890; *Lord Roberts Memorial*, Calcutta, 1896 (copy at Kelvingrove Park, Glasgow); *Queen Victoria Memorial*, Dundee, 1899. AWG 1886; ARA 1892.

1. S. Beattie, *The new sculpture*, New Haven and London, 1983, p.240; 2. W. Armstrong, 'Mr. Harry Bates', *Portfolio*, 1888, pp.170–4; 3. E.J. Winter Johnson, 'Mr. Harry Bates ARA', *Artist*, December 1897, pp.579–88; 4. Obituary, *Magazine of Art*, 1899, p.240.

Number of works in Catalogue: 1

Gilbert Bayes (1872–1953)
Born 4th April 1872 in London, died 10th July 1953 in London. He studied at the City and Guilds Technical College, Finsbury before entering the RA Schools in 1896 where he was taught by George Frampton and Harry Bates. After winning the gold medal and travelling studentship in 1899, he spent three months studying in Italy and nine months in Paris. Inspired by medieval legend and romance, his early style was a blend of French Symbolism and English Arts and Crafts. He also carved hieroglyphic figures in a neo-Assyrian style in many reliefs such as *King Assurnasirpal*, Sydney 1903–6. His early work consists largely of equestrian knight statuettes, for example: *Sirens of the Ford*, 1899 (version at Preston); *Knight Errant*, St. Cross College, Oxford 1900, and decorative panels such as *Jason Ploughing the Acre of Mars*, RA 1900, mostly cast in bronze. He also made many reliefs in terracotta, stone and various metals, decorating pedestals (*Sigurd,* RA 1910) and buildings (*The Aldeburgh Memorial,* RA 1917) as well as fountains and memorial sculpture. Larger statues include an over life-size marble figure of the *Maharaja of Bickaneer*, RA 1914. An enthusiast of polychromy, between 1929 and 1939 he designed and modelled stone-ware for Boultons, including an ornamental clock for Selfridges and the frieze on the façade of Doulton's headquarters on the Albert Embankment. Exhibitions: regularly at the RA until 1952; Salon des Artistes Français 1922–30.

1. W.S. Sparrow, 'A young English sculptor: Gilbert Bayes', *The Studio*, vol.25, March 1902, pp.102–8; 2. C. Marriott, 'The recent works of Gilbert Bayes', *The Studio*, vol.72, December 1917, pp.100–13; 3. J. Cooper, *Nineteenth century romantic bronzes*, London, 1975, p.94; 4. Beattie, 1983, pp.36, 240–1;

5. L. Irvine, 'The architectural sculpture of Gilbert Bayes', *Journal of the Decorative Art Society*, no.4, 1980, pp.5–11.

Number of works in Catalogue: 1

William James Bloye (1890–1975)
Born in Cornwall in 1890, he died on 6th June 1975 in Arezzo, Italy. He studied at Birmingham School of Art 1904–9, receiving the William Kenrick Scholarship for 1905–6 and from 1914 until the outbreak of World War I he studied sculpture at the Royal Academy. In 1917 he became a part-time teacher of modelling at Vittoria Street and City Road Schools – two branch schools of the Birmingham School of Art. In 1919 he was appointed as the new full-time teacher of modelling at the Central School at Margaret Street, providing that he be allowed time and facilities to continue his own training which had been interrupted by the war. He spent two four-week periods as a pupil of Eric Gill at Ditchling in Sussex in 1921 and 1922, paid for by the School. Here he trained in stone-carving and letter-cutting, both areas in which the School was seen to be deficient by a Board of Education Report of 1921. This acquaintance with Gill proved to be a significant influence on Bloye's work. By about 1925 Bloye had a thriving studio in Golden Hillock Road, Small Heath, where he was engaged on many public commissions, particularly for architectural carving, and was himself employing no less than seven assistants, all of whom had trained under him at the School of Art. In 1925 Bloye became a member of Birmingham's Civic Society and from this period established himself as the city's unofficial civic sculptor receiving virtually all commissions of an official nature, including work for libraries, hospitals, clinics and the University. He retired from the School of Art in 1956 and moved to Solihull, continuing to execute commissions, mainly fountains and portrait busts, up until his death. ARBS 1934; FRBS 1938.

1. Information given in phone call by Edward Allen, Senior Partner of S.N. Cooke, architects, April 1985; 2. *Post*, 15th June 1938; 3. *Post*, 21st March 1952; 4. *Post*, 29th May 1967; 5. Royal Academy of Arts, *Students Registers 1890–1922*, p.30; 6. *Birmingham Post year book and who's who 1967–68*, Birmingham, 1968, p.789.

Number of works in Catalogue: 51

Peter Bohn (b.1930)
Born in Coventry 19th October 1930, he moved to Sutton Coldfield and attended Vittoria Street Art School, Birmingham 1941–4 and Birmingham School of Art 1944–56 on a part-time basis while working in William Bloye's studio. Carving in stone, wood and slate, since 1956 he worked as a freelance except between 1959 and 1971 when he joined the Birmingham Guild. In 1972 he moved to Malvern. Works include religious figures, coats of arms and architectural restoration mainly in Birmingham and the Midlands such as: *Mother and Child*, St. Mary's school, Wednesbury 1956; coat of arms, Smethwick Swimming Baths; coat of arms, Birmingham University Graduates hall of residence; *Crucifix*, Our Lady and St. Hubert church, Warley; *Stations of the Cross*, Loyola Hall, Liverpool; statue of *Thomas Maxfield*, Newcastle under Lyme; and restoration at St. Philip's church, Birmingham and various Oxford colleges. He also modelled the Lloyds Bank horse in various sizes.

1. Letter from the artist, 16th April 1985 and 30th January 1996; 2. 'New bank on its old site', *Post*, 22nd November 1961; 3. 'Ex-guardsman sculptor', *Mail*, 31st August 1956.

Number of works in Catalogue: 3

Richard Lockwood Boulton & Sons, Cheltenham (1850s–c.1970)
Richard Lockwood was born in 1835 (possibly in Birmingham) and died in Bournemouth, 23rd January 1905. He trained with the architect E.W. Godwin in the west of England and studied the works of John Ruskin. He carved for other neo-Gothic architects such as Sir Giles Gilbert Scott and A.W.N. Pugin. In the 1850s the business of R.L. Boulton and Sons was founded by the brothers of Richard Boulton under the title Boulton & Swales and was based at Westminster Bridge Road, London, with branches in Birmingham and Worcester. The brothers died after twenty years and this prompted R.L. Boulton to amalgamate the firm in one place at Cheltenham (c.1876), with his four sons as managers – L.D., R.W., G.D. and F.C. Boulton. It gave Cheltenham a reputation as a centre for ecclesiastical art and church furnishings in marble, stone and wood. R.L. Boulton retired in 1893, handing over the business to his sons. In February 1908, R.L. Boulton & Sons was appointed Ecclesiastical Church Furnishers to HM King Edward VII. The firm ceased trading c.1970. Exhibited at the RA in 1859. The firm won a medal at the Great Exhibition 1851, and at Paris International Exhibitions.

1. *Cheltenham Examiner*, 25th January 1905; 2. R.L. Boulton, *Catalogue*, c.1910; 3. Graves, vol.I, London, 1905, p.250.

Number of works in Catalogue: 1

John Bridgeman (b.1916)
Born 2nd February 1916 in Felixstowe, Suffolk, he studied painting at Colchester School of Art 1936–9 under Barry Hart and Edward Moss and then at the Royal College of Art 1947–9 under Frank Dobson. Bridgeman worked as a letter carver on war memorials and for the Design Research Unit organised by Misha Black in 1951, becoming a tutor of sculpture at Bromley, Kent and Willesden, London 1951. He became Head of Sculpture at Carlisle

College of Art 1951–6 and then succeeded William Bloye as Head of Sculpture at Birmingham School of Art 1956–81, moving to work in Leamington Spa. Producing figures and groups in bronze, ciment fondu and stone, his commissions include: a bust of *Professor McClaren*, on the occasion of his retirement, for the University of Birmingham Medical School; Wall Panels, Swan Hotel, Yardley, now lost; *Madonna*, Coventry Cathedral 1970; *Mother and Child*, All Saints church, West Bromwich 1981; *Family Group* and *Crucifix*, St. Bartholomew's church, Eastham Community Centre, London 1983; *Boat Children Memorial*, London Embankment 1984–5; and *Fountain Sculpture*, South Staffordshire Waterworks, Walsall 1985. Exhibited at the Festival of Britain 1951 and at the RA from 1957; Birmingham City Museum and Art Gallery; Compendium Gallery, Moseley, Birmingham; Stratford-on-Avon; Lincoln; Boston and Leamington Spa with the '79 Group'. ARCA 1947; RBS 1957; FRBS 1960.

1. *Birmingham Post year book and who's who 1961–2*, Birmingham, 1962, p.730; 2. A. Everitt, 'A modern midland sculptor in praise of tradition', *Post*, 16th May 1970; 3. *Post*, 16th November 1968, p.9; 4. Letters from artist, 1984 and 2nd March 1996.

Number of works in Catalogue: 5

Robert Bridgeman & Sons of Lichfield

Founded in 1879 by Robert Bridgeman, the practice of Bridgeman and Sons of Lichfield specialise in ecclesiastical and architectural masonry, carving and restoration work. They produce pieces in wood, stone, alabaster and metal both to their own designs and those of architects, with whom they have a long history of collaboration. Other work in Birmingham includes pieces in St. Philip's Cathedral and St. Chad's Cathedral, and they have work in most cathedrals in England as well as colleges, halls, churches and mansions. The firm is still in operation.

1. Robert Bridgeman and Sons, *Heritage of Beauty*, publicity leaflet, undated.

Number of works in Catalogue: 4

Alan Bridgwater (1903–62)

Born in Sparkbrook, Birmingham, 17th June 1903, he died there in January 1962. He won a scholarship to study sculpture at Birmingham School of Art where he attended full-time from 1923–33. Granted several bursaries, he later taught evening classes and worked in William Bloye's studio during the vacations. One of his test pieces was purchased by the Victoria and Albert Museum: this memorial tablet (1928) is now in the Tate Gallery collection of British sculpture. Bridgwater applied for the Prix de Rome in 1930, for which he was highly commended and received a letter from Eric Gill commending his entry. In 1934 he set up as a sculptor in Harborne, Birmingham, taking a partner and practising as Bridgwater and Upton 1937–45. In 1948 he was appointed part-time teacher of sculpture at Dudley School of Art and was promoted to full lectureship at Birmingham School of Art in 1952. He moved to studios in Edgbaston in 1951. Bridgwater has works in private and public collections including academic works such as *Torso*, 1932 (in Birmingham Museums and Art Gallery); *Fawn*, 1936 (in Dudley Art Gallery); maquette for *Unknown Political Prisoner*, 1952 (in artist's widow's collection); *The Thinker*, 1958, for which he received an honorable mention in the Paris Salon, 1959. His portraits include: *W. Benslyn FRIBA*, 1948, bequeathed to BMAG; *Lindsay Bullivant FRIBA*, 1948; *Abraham Lincoln*, 1960. Much of his sculpture was done in collaboration with architects such as George Drysdale, Bromilow, Smeeton and While, Holland Hobbiss and J.B. Surman, for whom he produced panels and statues mainly for churches and schools. Works include: figure and panel, St. Hubert's church, Rowley Regis 1935; figures, Dudley police station 1939–40; coat of arms and stone lettering panels, *Kings Norton War Memorial*, 1947; five figures, Wawkesley Farm church, Longbridge Lane 1956; Dudley College of Education, Hall of Residence 1956; keystones, St. Boniface church, Quinton 1958. Exhibited at RA from 1937–62, RSA from 1950s, Royal Glasgow Fine Arts 1958; RWA 1950; RBSA, Dudley, Rugby and other Midland galleries. He also exhibited portraits and landscapes in oils. ARBSA 1935; ARBS 1948; RBS 1949; Council Member of RBS.

1. 'Birmingham student's sculpture', *Mail*, 29th January 1932; 2. *Birmingham Post year book and who's who*, Birmingham, 1960–61, p.731; 3. *WWA*, 12th edition, Eastbourne, 1964, pp.74–5; 4. *RAE*, vol.I, Wakefield, 1973, p.193; 5. J. Mackay, *Dictionary of western sculptors in bronze*, Woodbridge, Suffolk, 1977, p.51; 6. Letter from the artist's widow, Mrs. B. Bridgwater, 22nd March 1986.

Number of works in Catalogue: 2

Thomas Brock (1847–1922)

Born in Worcester in 1847 and died in London 1922. He studied at the Government School of Design in Worcester and at the Royal Academy, from 1867, winning a gold medal in 1869. Brock made numerous portrait busts, funerary monuments and public statues and achieved a reputation as an establishment sculptor after his master J.H. Foley died in 1874. He was influenced by the young sculptors, Alfred Stevens, Alfred Gilbert, Alfred Drury and Onslow Ford and his works were always highly competent and in a grand style. Commissions include: *Sir Bartle Frere*, Victoria Embankment Gardens 1888; *Rt. Rev. Henry Philpott, DD, Bishop of Worcester*, Worcester Cathedral 1896; *tomb of Sir Frederick Leighton*, St. Paul's

Cathedral 1900; *Queen Victoria Memorial,* Buckingham Palace, in collaboration with Aston Webb, 1901–9. Exhibited at the RA 1868 onwards. ARA 1883; RA 1891; First President of RBS 1905; Hon DCL Oxford 1909; KCB 1911.

1. M.H. Spielmann, *British sculpture and sculptors of today*, London, 1901, pp.26–33; 2. E. and M. Darby, 'The national memorial to Victoria', *Country Life*, 16th November 1978; 3. Beattie, 1983, pp.134 and 241.

Number of works in Catalogue: 1

Kenneth George Budd (1925–95)
Mural designer born in London, 16th October 1925, died 21st January 1995. Studied at Beckenham School of Art 1941–4 and the Royal College of Art 1947–50. Several works are located in Birmingham, where he was commissioned by the Public Works Department to decorate the following inner ring road developments: *Horsefair in 1908*, mural, Holloway Circus 1967; *J.F. Kennedy Memorial,* mural, 1968; *History of Snow Hill,* mural, St. Chad's Circus 1968. Other works include interchange and ring road mosaic and concrete murals, Newport, Gwent; mosaic coat of arms, Tower Foyer, Guy's Hospital, London; *Local Life 1890–1910,* Abertillery, Gwent; various mosaics for Newport Borough Council and Gwent County Council 1990–3. He also carried out several joint commissions with his son, Oliver Budd, who has continued his practice since his death in 1995. ARCA 1950.

1.*WWA,* 26th edition, Havant, 1994; 2. Letter from the artist's son, Oliver Budd, 20th February 1996.

Number of works in Catalogue: 1

Esmund Burton
Burton, a stone and wood carver who lived in London, produced decorative and architectural sculpture from the 1920s. Works include:

architectural decoration at Trinity College of Music, London 1926; garden vases, Melchet Court, Hampshire 1926; *Memorial to Lord Gerald Wellesley,* headstone, 1926; panels in Music Room, for Harry Lauder, at Wernfawr, Harlech, Wales; courtyard fountain, illustrated in W. Aumonier's *Modern Architectural Sculpture.* Burton was elected as a carver to the Art Workers' Guild in 1919 and was a member and Past-President of the Master Carver's Association.

1. 'A craftsman's portfolio', *Architectural Review*, vol.LX, no.361, December 1926, pp.258–9; 2. W. Aumonier, (ed.), *Modern architectural sculpture*, New York, 1930, pp.124, 131, 142; 3. Letter from Mr. P. Bentham, Honourable Secretary of the Master Carver's Association, 18th March 1985.

Number of works in Catalogue: 1

James Walter Butler (b.1931)
Born in Deptford, 25th July 1931, he studied at Maidstone School of Art 1948–50, St. Martin's School of Art 1950–2 and the Royal College of Art. He worked as an architectural carver 1950–3 and 1955–60 and became a tutor of sculpture and drawing at the City and Guilds of London Art School 1960–75. Major commissions include: *Water Feature with Reclining Nude,* Hatfield 1970; portrait statue of President Kenyatta, Nairobi 1973; *Monument to the Freedom Fighters of Zambia,* Lusaka 1974; *The Burton Cooper,* Burton-on-Trent, 1977; *Richard III,* Leicester, 1980; *Dolphin fountain,* Dolphin Square, London; *The Leicester Seamstress,* bronze, Hotel Street, Leicester. Exhibited regularly at the RA from 1958. ARA 1963; RA 1972; RWA 1980; FRBS 1981.

1. Strachan, 1984, p.252; 2. *WWA,* 25th edition, Havant, 1992.

Number of works in Catalogue: 1

Robert Carruthers (b.1925)
Born in 1925, he studied at Cheltenham College of Art and the Royal College of Art where he was awarded the major travelling scholarship 1953–4. He taught at the RCA, winning the French scholarship in 1958, and at Swindon College of Art. Public works include: *The Tower to Ledoux,* c.1970. Exhibited at AIA Gallery, London, 1966; Museum of Modern Art, Oxford, 1970 and in subsequent group exhibitions in England. He possibly exhibited at the RA in 1951 and 1955.

1. *RAE,* vol.I, Wakefield, 1973, p.274; 2. *City sculpture*, Arts Council of Great Britain, London, 1972.

Number of works in Catalogue: 1

Sheila Carter (b.1928) **and family**
Born in Bolton, Lancashire, 28th March 1928, Sheila Carter studied art at Bolton Art School before winning a scholarship to the Royal College of Art where she studied 1949–51. She graduated as a textile designer before going into industry, producing designs for woven textiles and later on doing some teaching work. She married Ron Carter, a blacksmith, and they gradually developed their own business, the Trapp Forge in Burnley. She now produces all the designs for the forge's ironwork. Commissions include: *Beacon for Europe,* London 1993; railing and lighting scheme, Victoria Square, Birmingham; Gates, Manhattan Brewing Company, New York; Chapel for the Loyal Regiment, Preston parish church 1995 and extensive iron-work in Manchester, Cambridge, Blackpool, Glasgow and Edinburgh. Private commissions include: firegrate for HM the Queen, Home Farm, Sandringham; lanterns, chandeliers and other metalwork for the Crown Prince Khalid, Saudi Arabia. The forge is presently producing gates and panels for the Honorable Artillery

Company, City Road, London.

1. Telephone conversation with the artist, 8th February 1996; 2. Letter and promotional material from the artist, 8th February 1996.

Number of works in Catalogue: 1

John Henry Chamberlain (1831–1883)

Born in Leicester, 16th June 1831, he died in Birmingham, 22nd October 1883. The son of Revd. Joseph Chamberlain, he was articled to Henry Goddard of Leicester and finished his training in London. An ardent disciple of Ruskin, he visited Venice before settling in Birmingham in 1856. In 1864 he joined the architect William Martin who had often worked for the Corporation in a previous partnership. Martin and Chamberlain designed many of the best civic buildings in Birmingham, including the old Reference Library, Ratcliffe Place (1879) and the Midland Institute, Paradise Street (1855–7), both destroyed; thirty Board Schools in Birmingham; pumping stations for the Water Works Department and also churches and private houses. Although Chamberlain was not related to Joseph Chamberlain, the councillor and Mayor of Birmingham 1870–4, he was acquainted with leading public figures in the city. He was appointed member of the Midland Institute Council in 1867 (Hon. Sec. 1868–83); Chairman of the School of Art Board 1874–83; committee member of the old library in Union Street; a founding member and honorary secretary of the Shakespeare Memorial Library and original member of the Shakespeare Club. Appointed Professor of Architecture at both the School of Art and Queen's College, where he became Vice-President in 1879, and was also chosen by Ruskin as a trustee of the St. George's Guild. Elected member of the Society of Artists, 1861.

1. L. Stephen, and S. Lee (eds.), *Dictionary of national biography*, vol.10, London, 1887, pp.2–3; 2. Pevsner, 1966, pp.118–19; 3. Hickman, 1970.

Number of works in Catalogue: 2

Sir Francis Legatt Chantrey (1781–1841)

Born in Norton, near Sheffield, 7th April 1781, he died in London, 25th November 1841. Apprenticed in Sheffield to Mr. Ramsey, a carver and gilder, he was taught to draw by the engraver Raphael Smith. Chantrey's early career was spent as a portrait painter and wood carver in Sheffield and London. In about 1805 he turned to clay modelling and received his first commission, the *Rev. J. Wilkinson Memorial* for Sheffield parish church. Chantrey went to Paris in 1814 and Rome in 1819, where he visited the studios of Thorwaldsen and Canova. Most well-known for his portrait statues and memorials, Chantrey had a large studio and foundry where he produced his bronze statues, including those of *Sir Thomas Munro*, 1838 and the *Duke of Wellington*, 1840. His bust of *Horne Took*, which was exhibited at the RA in 1911, brought him recognition. Other major works include the *Children of Rev. W. Robinson*, Lichfield Cathedral 1812; statue of *Lady Frederica Stanhope*, Chevening church 1823. Exhibited at the RA 1804–42. He left part of his fortune to the RA to found what is known as the Chantrey Bequest. ARA 1815; RA 1818; Knighted 1835; FRS; FSA.

1. Gunnis, 1964, pp.91–6; 2. Graves, vol.II, 1905; 3. E.G. Underwood, *A short history of English sculpture*, London, 1933; 4. E.B. Chancellor, *The lives of the British sculptors*, London, 1911; 5. M. Whinney, *English sculpture 1720–1830*, Victoria and Albert Museum, London, 1971.

Number of works in Catalogue: 1

Julius Alfred Chatwin (1830–1907)

Born at Great Charles Street, Birmingham in 1830, the son of a button manufacturer, he was educated locally and at London University before working from 1846 as an architect for Branson and Gwyther of Birmingham, then the largest building contractors in the country, designing architectural decoration for them. Articled in 1851 to Sir Charles Barry, the most successful British architect of his day, he returned to Birmingham and opened an office on Bennett's Hill in 1855 before visiting Italy in 1857. Chatwin was the most prolific church builder and restorer in Birmingham. He built, enlarged or altered almost all of the city's parish churches, and except for alterations he made to St. Philip's (now Birmingham Cathedral) in 1864–9 and 1883, all of his decorations were in the Gothic style. In every case he designed all of the interior fittings and decorative carvings, most of which were carried out by Robert Bridgeman and Company of Lichfield. Chatwin also designed domestic and commercial architecture including, from 1866, most of the north side of Colmore Row in an Italian Mannerist style. From the first bank he designed on Temple Row West in 1864, he became the architect for Lloyds Bank for over thirty years. He was also architect to his old school, King Edward VI, from 1866. Philip B. Chatwin, his son, became his partner in 1897, seeing through most of his father's last works. Made FRIBA 1863; elected to the RBS 1866; its President 1864; Vice-President RSA; Fellow of the Royal Antiquary Society of Scotland.

1. P.B. Chatwin, *The life story of J.A. Chatwin 1830–1907*, Oxford, 1952.

Number of works in Catalogue: 2

Michael Clark (1918–90)

Born in Cheltenham, 19th December 1918, died 24th January 1990. Son and pupil of Philip Lindsey Clark. He studied art at the Chelsea School of Art 1935–7 and sculpture at Kennington City and Guilds School 1947–50. Largely producing religious works, he is represented in over a hundred churches, schools

and public buildings in Britain. Sculptor in stone, wood, bronze and glass fibre, his major works include: relief of *Christ, St. Edward and St. Peter*, awarded the RBS 'Best work of the year' medal; *Glorious Assumption*, carving in wood, The Friars, Aylesbury, awarded the Otto Beit medal 1960; *Risen Christ*, Church of Our Lady, St. John's Wood, London. Exhibitions; RA 1949 onwards. Otto Beit Medal for Sculpture, 1960; 1978; Silver Medal, 1967. ARBS 1949; FRBS 1960; President RBS 1971–6.

1. Royal Society of British Sculptors, *Annual Report and Supplement*, 1960, p.8, illus. p.22; 2.*WWA*, 20th edition, Wokingham, 1982, p.83; 3. Letter from the artist, 4th February 1985.

Number of works in Catalogue: 1

Coade and Sealy, Lambeth (active 1769–1820)
Coade and Sealy manufactured artificial stone for architectural use including keystones, capitals, and medallions, as well as busts, statues and monuments. Coade stone was hardwearing, relatively inexpensive and allowed for particularly fine detailing as the cast moulds were sometimes hand-finished before baking. Originally run by Mrs. Eleanor Coade (1708–96) and her nephew John Sealy (1749–1813), the business was taken over on Mrs. Coade's death by her daughter, also Eleanor Coade (1732–1821). Her cousin, William Croggan, succeeded Sealy and eventually gained complete control of the company. Several leading English modellers and designers were employed by the firm, including John Bacon the Elder (1740–99) as chief sculptor, as well as John Rossi, Flaxman, James George Bubb and Thomas Banks. Works include: gate piers, Strawberry Hill, for Horace Walpole 1772; *Monument to Sir Henry Hillman*, formerly at St. James's, Hampstead Road, London *c*.1800; a massive tympanum, west pediment, Greenwich Palace 1810–13.

1. Gunnis, London, 1964, pp.105–9; 2. A. Kelly, *Mrs. Coade's Stone*, 1990.

Number of works in Catalogue: 1

Angela Conner
Born in London, a self-taught artist, she served as an apprentice to Barbara Hepworth and is a sculptor and painter in stone, bronze, water, light and wind. She has done many portrait sculptures, including *General de Gaulle*, *Camilla Parker-Bowles* and *Dame Elizabeth Frink*. Other commissions include: a large 'tipper' for the King of Saudi Arabia 1975; and a mobile water sculpture for outside the Heinz Hall, Pittsburgh USA 1981; 10-foot-tall water sculpture for the public gardens of the Count and Countess Oeynhausen, Bad Driburg, Germany; *Yalta Memorial*, Thurloe Square, London 1986. Solo shows include: Lincoln Centre, New York; Browse and Darby, Cork Street, London 1986 and Istanbul Biennale; and she has had work exhibited at the RA, V&A, Carnegie Museum of Modern Art, BMAG and others worldwide. Her works are in the collections of the Arts Council of Great Britain, House of Commons, Eton College and the National Portrait Gallery, among others. FRBS.

1. C. Courtney, 'Sculpture by Angela Conner', *Architect (RIBA)*, vol.93, October 1986, p.13; 2. *WWA*, 26th edition, Havant, 1994, p.99; 3. Letter from the artist, 23rd February 1996.

Number of works in Catalogue: 1

Edward Bainbridge Copnall (1903–73)
Born in Cape Town, South Africa, 29th August 1903, he died in Kent, 18th October 1973. He moved to England as a child and studied painting at Goldsmith's College of Art and at the RA Schools until 1924. Turning to sculpture in 1929, he produced mainly architectural and figurative work in stone and wood. He was head of the Sir John Cass College 1945–53.

Main commissions include: *Figure*, RIBA headquarters, London 1931–4; *Progression*, Marks & Spencer, Edgware Road, London 1959; *Swan Man*, ICI Building, Putney Bridge, London; *Thomas à Becket*, St. Paul's Cathedral churchyard 1973. Author of *A Sculptor's Manual*, Oxford, 1971. Exhibited at RA 1925–70; Paris Salons; Royal Scottish Academy and leading English galleries. He was represented in the British Sculpture of the Twentieth Century exhibition, Whitechapel Art Gallery, 1980–1. MBE 1946; President RBS 1961–6.

1. *RAE*, vol.I, Wakefield, 1973, p.80; 2. J. Johnson, and A. Greutzner, *Dictionary of British artists 1880–1940*, Woodbridge, Suffolk, 1976, p.121; 3. Strachan, 1983, p.254; 4. S. Nairne, and N. Serota, *British sculpture in the twentieth century*, London, 1981, p.250; 5. B. Read, and P. Skipwith, *Sculpture in Britain between the wars*, London, 1988, pp.48–9.

Number of works in Catalogue: 1

Sioban Coppinger (b.1955)
Born in Canada, Coppinger left Bath Academy in 1977 with a BA in Fine Art. Works include a portrait bust of *Professor J.B. Kimmonth*, St. Thomas's Hospital, London, 1981; and *Ewe and Man on a Park Bench*, Rufford Country Park, 1983.

1. Strachan, 1983, p.254.

Number of works in Catalogue: 1

Trewin Copplestone (b.1921)
Born in Dartmouth in December 1921, he studied art at Nottingham College of Arts and Crafts and Goldsmith's College of Art. He became a tutor of mural painting at Hammersmith College of Art and a visiting lecturer in Art History. He also worked as a consultant art advisor, subsequently becoming Editorial Director and later Director of Publishing for the Hamlyn Group. He now

owns and manages his own publishing company. He has broadcast various programmes for television including 'Art for All' for London Weekend Television, and he has written and edited art books such as *Architecture, an introduction for children*, London, 1969 and history of art books for W.H. Smith & Son. Exhibitions include: New Burlington Gallery, London 1952 (with the London Group) and RBA Gallery, Pall Mall, London 1956. Solo shows include: Matthiesen's, London 1957. Other work includes: theatre sets and costumes for the Mermaid Theatre and Margate Stage Theatre; his decorative work includes a mural at Carlisle Civic Centre, 1965 and paintings, murals and mosaics for apartments and offices in London and Birmingham.

1. Letter from the artist, 12th August 1985; 2. 'Trewin Copplestone: portrait of the artist', *Art News and Review annual year book*, 13th April 1957; 3. CV from the artist, 7th April 1996.

Number of works in Catalogue: 2

Benjamin Creswick (1853–1946)

Born 29th January 1853 in Sheffield, he died in Sutton Coldfield in February 1946. Originally apprenticed as a knife grinder, he began modelling in clay and was largely self-taught, though he was influenced by John Ruskin, under whose supervision he worked at Coniston and Oxford, and who gave him support both artistically and financially. During this time he made the first ever portrait of Ruskin from life and, sponsored by him, Creswick opened a studio in London by 1884. Ruskin introduced Creswick to A.H. Mackmurdo, and was associated with Mackmurdo's Century Guild, founded in 1882. Although not actually a member, Creswick produced plaster figures for fireplaces shown at the Century Guild's display at the Inventions Exhibition, London 1885. Working largely as

an architectural decorator, like many Arts and Crafts artists Creswick was proficient in a variety of media, working in metal, wood, plaster and terracotta as well as printing. He worked for a period in Liverpool and Manchester before coming to the Birmingham School of Art as Master of Modelling and Modelled Design 1889–1918. From as early as 1890 the number of students attending his classes increased, testifying to his skill and enthusiasm, and Walter Crane remarked that the quality of modelling at the school had noticeably improved. After his retirement he continued to work, making sculpture for private commissions. Major works include friezes for Cutler's Hall, City of London 1887–8; a frieze for Henry Heath's showroom, Oxford Street, London (destroyed); a huge figure of *Humanity* for the Positivist church, London and *Memorial to the Men of Huddersfield*, Greenhead Park, Huddersfield 1904–5. Exhibited at the Sheffield Society of Artists 1877–1909; Walker Art Gallery, Liverpool 1886; Royal Academy 1888 onwards; Birmingham Arts and Crafts Guild and Birmingham Society of Art Spring Exhibition 1895; and the Royal Birmingham Society of Arts 1914.

1. Birmingham Museum and School of Art Committee, *Annual report*, 1890, pp.8–9; 2. *Birmingham magazine of arts and industries*, vol.III, 1901–3, pp.171–5; 3. F. Brangwyn, Obituary, *Post*, 13th February 1946; 4. Beattie, 1983; 5. S. Evans, *Arthur Heygate Mackmurdo, 1851–1942 and the Century Guild of Artists* (unpublished thesis), University of Manchester, School of Architecture and Town Planning, 1986.

Number of works in Catalogue: 11

Hubert Dalwood (1924–1976)

Born in Bristol in 1924, he died in London, 2nd November 1976. Apprentice designer at Bristol Aeroplane Company 1939–45, he studied at

Bath Academy of Art under Kenneth Armitage 1946–9. He won an Italian Government scholarship to study in Italy, 1951 and took up a teaching post at Newport School of Art, Monmouth 1951–70. After his first show of sculpture at Gimpel Fils gallery, London in 1954, he was offered the Gregory Fellowship in sculpture at Leeds University 1955–8. Taught at Leeds College of Art, Royal College of Art, London and Maidstone College of Art 1954–64. In 1964 he was appointed Visiting Professor at the University of Illinois, Urbana, USA. He was Head of Sculpture at Hornsey College of Fine Art 1966–73; he won the Churchill Fellowship in 1972, travelling to Japan and the Far East; and was made Head of Sculpture at the Central School, London 1974–6. Works include: *Abstract*, Liverpool University 1959; *Screen*, University of Manchester; *Echelon with Concrete Pillars*, Wolverhampton Polytechnic 1972; *Untitled*, outside the Business Statistics Office, Tredegar Park, Newport, Gwent 1978. His sculpture is in the collections of the Tate Gallery; Victoria and Albert Museum; MOMA, New York; Guggenheim Museum, New York; Albright-Knox Museum, Buffalo, USA. Member of RBS 1963. Exhibited at Gimpel Fils gallery, London 1954–70; Venice Biennale 1962; British Sculpture in the 60s, Tate Gallery 1966; the Toronto International Sculpture Symposium 1967; British Sculpture, RA 1972; retrospective at the Haywood Gallery, toured in 1979.

1. *Hubert Dalwood, sculptures and reliefs*, Arts Council of Great Britain, London, exh.cat., 1979; 2. *Hubert Dalwood*, Gimpel Fils, London, exh.cat., 1970.

Number of works in Catalogue: 1

Miles Davies (b.1959)

Born 2nd April 1959 in Leigh, Lancashire, Davies was educated at Leamington Spa School of Art and studied Fine Art at Brighton

Polytechnic 1978–81. Public commissions outside Birmingham include pieces for sculpture trails in the Forest of Dean, 1988 and *Open Door*, Ashton Court, Bristol 1989; Millfield Sculpture Commission, Millfield School 1991 and High Street roundabout, Bilston, Wolverhampton. Solo exhibitions include: Artiste Sculpture Garden, Bath 1990; Arnolfini, Bristol 1990; Yorkshire Sculpture Park, Wakefield 1991. Recent group exhibitions include: Eisfabrik, Hannover; New Meanings for City Sites, Birmingham Museums and Art Gallery, Birmingham 1991; Road Works II, Bilston Art Gallery, Bilston 1994. He has works in public and private collections in England, France and Germany including, from 1995, the Peterborough Sculpture Trust.

1. Letter and CV from the artist, 7th February 1996; 2. M. Garlake, 'Round-up', *Art Monthly*, October 1989, p.21; R. Hopper, *Miles Davies sculpture catalogue*, 1991.

Number of works in Catalogue: 2

Fiore De Henriques (b.1921?)
Very few biographical details are known about this half-Italian and half-Spanish sculptor. She exhibited bronze portrait heads at the RA in 1950 and 1955 and took part in the Festival of Britain touring exhibition, Skill of the British People, 1951. She exhibited at the Hanover Gallery, London 1957. Probably moving to America in the late 1950s, her work was shown at the Hutton Gallery, New York 1959. She was described in the Birmingham local press as 'an unconventional cheroot-smoking Italian who lived in America'. Works include portrait busts of *Princess Margaret*, *Adlai Stevenson*, *John Kennedy*, *Lord Olivier*, *Lady Egremont* and *Augustus John*, many of which were exhibited in a garden in Cheyne Walk, London in 1975, her first exhibition in London for 25 years.

1. *Art News*, vol.58, no.50, March 1959, p.60; 2. *RAE*,

London, vol.II, 1973, p.145; 3. N. Banks-Smith, 'Fiore de Henriquez', *Guardian*, 24th July 1978, p.8; 4. T. Mullaly, 'Magical setting for portrait sculpture', *Daily Telegraph*, 25th September 1975.

Number of works in Catalogue: 1

Avterjeet Dhanjal (b.1939)
Born in Dalla, in the Punjab region of India, Dhanjal studied sculpture at Chandigarh Art School and now lives and works in Ironbridge, Shropshire. He organised the First International Sculpture Symposium in India, where he has many works sited outdoors. He has worked on a number of regional and international projects which take as their starting points environmental or community concerns. Works include: *Grown in the Field*, Warwick University Arts Centre 1978; *Untitled*, Bodicote House, Cherwell District Council, Oxon. 1981; *Along the Trail*, slate and rope, National Garden Festival, Stoke-on-Trent 1986.

1. *BMAG records*; 2. Welsh Sculpture Trust, *Sculpture in a country park*, Margam, Wales, 1983, pp.84–7; 3. Strachan, 1984, p.267.

Number of works in Catalogue: 1

Francis William Doyle-Jones (1873–1938)
Born in West Hartlepool, 11th November 1873, he died in London, 10th May 1938. Pupil of Edouard Lanteri (1848–1917), who succeeded Jules Dalou as master of sculpture at the National Art Training School (now the Royal College of Art). Doyle-Jones, who had studios in Chelsea, specialised in war memorials and portrait sculpture. His South African War Memorials include those for Middlesborough 1904; West Hartlepool 1905; Llanelly 1905; Gateshead 1905 and Penrith 1906. He designed and sculpted at least four World War I memorials, including *Gravesend War Memorial*, in the form of a figure of Victory. Models of two memorial statuettes were exhibited at the Royal Academy in 1921.

Portrait busts and medallions include: *Captain Webb Memorial*, Dover 1910; *Robert Burns*, bust, Galashiels 1914; *T.P. O'Conner*, Fleet Street 1934; *Edgar Wallace*, Ludgate Circus 1934. Exhibited at the RA 1903–36 as well as the International Society, the Royal Hibernian Society, the Glasgow Institute and the Walker Art Gallery.

1. 'Captain Webb Memorial at Dover', *Building News*, vol.98, no.2893, 17th June 1910, p.825; 2. *RAE*, vol.IV, Wakefield, 1979, p.153; 3. J. Johnson, and A. Greutzner, *Dictionary of British artists 1880–1940*, Woodbridge, Suffolk, 1976, p.154.

Number of works in Catalogue: 1

Edward Alfred Briscoe Drury (1856–1944)
Born in London, 1856 and died there in 1944. He studied at Oxford School of Art and the National Art Training School. An outstanding student, he was awarded the gold medal for his sculpture in 1879, 1880 and 1881, and then became assistant to Dalou in Paris 1881–5. On his return to London, he worked as an assistant to Boehm. Taught briefly at Wimbledon School of Art 1892–3. Public commissions include figures of *Morning* and *Evening* for City Square, Leeds 1898; *Peace, Truth and Justice* for the War Office, Whitehall, London 1904–5; architectural sculpture for the Victoria and Albert Museum 1908; statue of *Joshua Reynolds*, Burlington House (Royal Academy) courtyard, London 1932. He produced numerous portrait busts, statuettes and memorials, including *Queen Victoria*, Bradford 1902. Exhibited at the RA 1885–1945. Awarded a gold medal at the Paris International Exhibition 1900; ARA 1900; RA 1913; Associate of Royal Belgian Academy 1923; RBS silver medal 1932.

1. A.L. Baldry, 'A notable sculptor: Alfred Drury, ARA', *The Studio*, vol.37, February 1906, pp.3–18; 2. M.H. Spielmann, *British sculpture and sculptors today*, London, 1901, pp.109–15; 3. Beattie, 1983,

p.242; 4. E.G. Underwood, *A short history of English sculpture*, London, 1933.

Number of works in Catalogue: 1

John Evans
Chief modeller for Gibbs and Canning, John Evans was born in Liverpool and worked with his father, Samuel Evans who had his own practice in Liverpool. He later started to work intermittently for Gibbs and Canning whose works were near Glascote colliery, Tamworth, where he was eventually appointed modeller and head of the model and mould plaster department. Other works included modelling for the Technical Institute, coat of arms for the electricity power station, Birmingham and an Indian figure for a bootmakers in Northampton.

1. *Tamworth News and Four Shires Advertiser*, January 1935.

Number of works in Catalogue: 4 (listed under Gibbs & Canning)

Farmer & Brindley (active mid 1850s–1929)
A firm of architectural stone carvers who carved under contract. They had premises on Westminster Bridge Road, Lambeth, an area of London long associated with suppliers of architectural sculpture. William Brindley was the executant under the direction of William Farmer who also handled the contracts. Sir George Gilbert Scott, their most notable and prolific patron, said of Brindley that he was 'the best carver I have met with and the one who best understands my views'. They produced the model of the Albert Memorial for Scott and later all of the ornamental work for it; the capitals, etc., on Scott's Government Offices, Whitehall; and ornamental carving for the series of his major ecclesiastical restorations at Exeter, Gloucester, Lichfield (the choir and Lady chapel statues) and figures for the reredos at

Worcester. In 1863–9 they made the statues of *Science* and *Art* for the Holborn Viaduct, London. Under the surviving partner, Brindley, the firm served almost every English architect of repute until World War I. Other work by them includes the historical sculpture on Alfred Waterhouse's Manchester Town Hall (1868–77); the carved stone pedestal of Thornycroft's *Monument to General Gordon*, 1885–8; all the subsidiary sculpture on Belcher and Pite's Institute of Chartered Accountants Hall, City of London (1888–93); and the reredos of St. Paul's Cathedral. A large number of their carvers attended the South London Technical Arts School, notably C.J. Allen and H. Bates. The firm amalgamated with another in 1929, when all of their records were destroyed.

1. B. Read, *Victorian sculpture*, New Haven and London, 1982; 2. Beattie, 1983.

Number of works in Catalogue: 1

John Flaxman (1755–1826)
Born in York in 1755, he died in London, 7th December 1826. Son of a caster and model maker who worked for the leading sculptors of the mid-18th century. By 1767 Flaxman began to exhibit plaster models of classical figures at the Society of Artists and in 1769 entered the RA Schools where he befriended William Blake. Working with his father for Matthew Boulton in Birmingham and the Wedgwood factory, he designed cameos and made wax models of classical friezes and portrait medallions, which helped develop his linear style. Visiting Rome in 1787 he remained there for seven years making monuments and producing his first book of illustrations. On return to England in 1794 he built up a good practice specialising chiefly in monuments and portrait busts. Considered one of the foremost Romantic-Classicists in England his works include: statue of *Sir Joshua Reynolds*, St. Paul's Cathedral 1813; busts of

Josiah Wedgwood, Stoke-on-Trent parish church 1803 and *Pasquale di Paoli*, Westminster Abbey 1807; *Monument to Lady Fitzharris*, Christchurch Priory, Hampshire 1817. He exhibited at the Royal Academy 1770–1827. Became Professor of Sculpture at the RA in 1810 and a member of the Painting and Sculpture Academy in Rome in 1816. ARA 1797; RA 1800.

1. A. Graves, *The Royal Academy of Arts 1769–1904*, vol.III, London, 1905, pp.123–5; 2. Gunnis, 1964, pp.147–9; 3. D. Irwin, *John Flaxman 1755–1826*, London, 1979; 4. E.G. Underwood, *A short history of English sculpture*, London, 1933; 5. E.B. Chancellor, *The lives of the British sculptors*, London, 1911; 6. M. Whinney, *English sculpture 1720–1830*, Victoria and Albert Museum, London, 1971; 7. D. Bindman, (ed.), *John Flaxman*, London, exh.cat., 1979.

Number of works in Catalogue: 1

John Henry Foley (1818–1874)
Born in Dublin, 24th May 1818, he died in London, 27th August 1874. After studying at the Royal Dublin Society's School 1831–4, he entered the RA Schools in 1835, later winning the silver medal. In the front rank of British sculptors he produced statues, busts and monuments in England, Ireland and India. Works include: *Equestrian Statue of Viscount Hardinge*, Calcutta 1859; *Prince Albert and group of Asia* on the *Albert Memorial*, 1864–72; *Prince Consort*, Fitzwilliam Museum, Cambridge 1876. Exhibited at the RA 1839–61. ARA 1849; RA 1858; Member of Royal Hibernian Society 1861; Member of Belgian Academy of Arts 1863; and British Institution 1840–54.

1. W. Cosmo, *The works of J.H. Foley*, London, 1875; 2. J. Mackay, *Dictionary of western sculptors in bronze*, Woodbridge, Suffolk, 1977, p.137; 3. B. Read, *Victorian sculpture*, New Haven and London, 1982; 4. E.G. Underwood, *A short history of English sculpture*, London, 1933.

Number of works in Catalogue: 1

Dame Elizabeth Frink (1930–93)
Born in Thurlow, Suffolk, 14th November 1930, she died in Woolland, Dorset, 18th April 1993. Studied at Guildford School of Art 1947–9 and Chelsea School of Art 1949–53 under Bernard Meadows and Willi Soukop, making her first visit to France in 1951. She received public recognition after her first exhibition at the Beaux Art Gallery in 1952 and for her prize-winning entry for the *Monument to the Unknown Political Prisoner* competition in 1953. Taught at Chelsea School of Art 1953–61, at St. Martin's School of Art 1954–62 and the Royal College of Art 1965–7. Much of her early work was based on memories of growing up during World War II, as she translated the aggressive forms of war machines and missiles into anthropomorphic human and animal forms. Using a fast technique of modelling in plaster from which direct casts in bronze are made, her work is based on a series of themes, predominantly massive male figures and heads as well as animals and birds. Main public works include: *Wild Boar*, Harlow New Town 1957; *Eagle*, lectern, Coventry Cathedral 1962; *Risen Christ*, Our Lady of the Wayside, Solihull 1964; *Horse and Rider*, Dover Street, London 1974; *Running Man*, Barbican 1982; *Christ*, Liverpool Anglican Cathedral 1993. Her work is represented in the major art galleries in Great Britain as well as in the USA, Australia and South Africa. Exhibiting since 1952, her first solo exhibitions include St. George's Gallery, London 1955 and Waddington Galleries, London from 1959. During the 1970s she made works for Amnesty International protesting human rights violations. A major retrospective of her work was held in 1985 at the Royal Academy, where she exhibited regularly since 1954. CBE 1969; ARA 1972; RA 1977; DBE 1982.

1. E. Frink, *Catalogue raisonné*, Salisbury, 1984; 2. Obituary, *The Independent*, 19th April 1993; 3. E. Frink, and E. Lucie-Smith, *Frink: A portrait*, London, 1994; 4. E. Roberts, 'Frink again', *Women's Art Magazine*, no.62, January/February 1995, pp.22–3; 6. E. Lucie-Smith, 'Dame Elizabeth Frink 1930–1993: an appreciation', *Art Review*, London, vol.45, June 1993, pp.58–9; 7. M. Wykes-Joyce, 'Elizabeth Frink', *Art and Artists*, no.221, February 1985, pp.17–19; 9. E. Frink, *The art of Elizabeth Frink*, London, 1972; 10. *Elizabeth Frink: sculpture and drawings 1950–1990*, National Museum of Women in the Arts, Washington DC, exh.cat., 1990; 11. E. Lucie-Smith, *Elizabeth Frink: sculpture since 1984 and drawings*, London, 1994; 13. *Elizabeth Frink: sculpture and drawings 1952–1984*, Royal Academy of Arts, London, exh.cat., 1985.

Number of works in Catalogue: 1

W.S. Frith (1850–1924)
Studied at Lambeth School of Art in the late 1860s, and also at the RA Schools from 1872. In 1879, he and John Sparkes effected the transfer of the Lambeth modelling classes to SLTAS and the following year, he succeeded Jules Dalou as modelling master. His public work included a substantial amount of carving for architects and he carried out pieces for many buildings by the architect Aston Webb, for example: lectern, St. Mary, Burford, Shropshire, c.1890; terracotta figures, Clare Lawn, Sheen, c.1893 (destroyed); stone carving and fountain, Christ's Hospital School, Horsham, Sussex, 1902–3. He collaborated with F.W. Pomeroy and Doulton artists on the *Victoria fountain* (1888, now on Glasgow Green) making the group representing Canada and the figure of Victoria, 1886–7. AWG 1886; founder member RBS.

1. S. Beattie, *The new sculpture*, New Haven and London, 1983, p.244.

Number of works in Catalogue: 1

Gibbs & Canning, Tamworth (active c.1840–1940)
One of the four principal producers of terracotta in England, alongside Edwards of Ruabon, Burmantofts of Leeds and Doultons of Lambeth, Gibbs & Canning existed before 1851 and were described in 1861 as makers of sewerage pipes. However, in 1873–81 they supplied the buff and grey terracotta for the Natural History Museum, Kensington, designed by Alfred Waterhouse and considered the first building of repute and standing to use terracotta to any significant degree. Cheaper than stone and able to take fine, sharp detailing, terracotta quickly became the most popular decorative facing material and remained so into the 20th century. As terracotta clay is only found next to deposits of coal, Gibbs & Canning remained at their site near to Glascote colliery outside Tamworth, but in the 1890s, the heyday of terracotta, they also established a pottery in Deptford, London. Their work can be seen on buildings throughout Britain: largely in London, such as on G.H. Townsend's Bishopsgate Institute (1894) and Frank Matcham's Victoria Palace Theatre (c.1910); in Liverpool on Alfred Waterhouse's Victoria building, Liverpool University (1887–92); but mostly in Birmingham and the Midlands. They worked with several local architects, notably Sandy and Norris, Harrison and Cox, and Horace Bradley, decorating theatres, cinemas, offices and church buildings. As terracotta declined in popularity Gibbs & Canning had to lay off staff from 1932 onwards. In March 1940 they closed the terracotta department, and finally closed down completely in the late 1950s.

1. A. Crawford, *Tiles and terracotta in Birmingham*, Victorian Society, Birmingham Group, 1975; 2. Unpublished notes and original documents, Tamworth Museum collection.

Number of works in Catalogue: 5

Walter Gilbert (1872–1945)
Born in Rugby, 1872 he died in Worcester, 23rd December 1945. Second cousin to the sculptor

Sir Alfred Gilbert, RA. After a university education he attended Birmingham School of Art 1898–9 as a part-time student. In 1900 he became Master of the Art Department at Bromsgrove School of Science and Art. A great entrepreneur, he also acted as agent to several craftworkers, selling their products under the name of the Bromsgrove Guild of Decorative Arts which had its first major success at the Paris Exhibition of 1900, where it won nine awards. Around 1904 the flourishing business was converted into a limited company and employed several continental craftsmen. A major commission from this period was the ornamental brasswork for the Great Gates at Buckingham Palace for Sir Aston Webb (1904). Gilbert later withdrew from the Guild and set up in partnership with the gifted Swiss modeller and brassworker from the Guild, Louis Weingartner, their main commission being the sculptural details for the *Great Reredos* at Liverpool Cathedral in 1909–10. They had a studio in Weaman Street, Birmingham from 1923–32 and, while Gilbert also worked freelance in local industries, together they produced garden sculptures as well as numerous war memorials including that for the Birmingham Conservative Club (now in the Birmingham Club, Ethel Street), and others at Crewe, Troon and Eccleston Park, Liverpool. Gilbert had a broad art-historical knowledge and wrote articles including 'Romance in Metalwork', and 'The essentials of craftsmanship in metalwork'. A bronze bust of Walter Gilbert by his son, Donald Gilbert, was exhibited at the RA in 1931 and there is a memorial to him and Louis Weingartner, also by Donald Gilbert, at Hanbury church, Worcester.

1. Birmingham School of Art, *Student registers, 1898–1899*; 2. *Kelly's directory of Warwickshire*, London, 1900, p.41; 3. W. Gilbert, and L. Weingartner, *Sculpture in the garden*, publicity booklet, Birmingham, undated (*c*.1925); 4. W. Gilbert, 'The essentials of craftsmanship in metalwork', *Architectural Review*, vol.59, April 1926, pp.127–47; 5. Loppylugs and B.J. Morrison, *Characters and craftsmen*, Bromsgrove, 1976; 6. *RAE*, vol.III, Wakefield, 1973, p.150; 7. R. Pancheri, 'The rise and demise of the Bromsgrove Guild', *Bygone Bromsgrove*, Stratford-upon-Avon, 1981; 8. W. Gilbert, 'Romance in metalwork', *RIBA Journal*, 3rd series, vol.XIII, no.6, 1906.

Number of works in Catalogue: 1

The Countess Feodora Gleichen (1861–1922)
Born in London, 20th December 1861, she died there 22nd February 1922. Taught first by her sculptor father, Admiral Prince Victor of Hohenlohe-Langenburg and at the Slade School under Alphonse Legros, she then completed her studies in Rome. Producing mainly portraits, allegorical figures and decorative objects, she was one of the few successful women sculptors at this time. Commissions include: life-size statue of *Queen Victoria*, Jubilee Hospital, Montreal; bust of *Queen Victoria*, Cheltenham Ladies' College; statue of *Peace*, 1899; bust of *Emma Calvé*, 1896, at Osborne; *Diana Fountain*, in bronze and coloured marbles, presented to Hyde Park by Lady Walter Palmer in 1906. Exhibited: RA from 1892–1922; Paris Exhibition, 1900; New Gallery 1894; New Dudley Gallery, 1907. Awarded prize for Bas Relief Competition organised by the Royal Academy, 1906.

1. M.H. Spielmann, *British sculptors of today*, London, 1901, pp.18–19; 2. 'London exhibitions', *Art Journal*, 1907, p.43; 3. *The Studio*, vol.36, 1906, p.86; 4. B. Read, *Victorian sculpture*, New Haven and London, 1982, p.355.

Number of works in Catalogue: 1

Antony Gormley (b.1950)
Born in London, he studied archaeology and anthropology, then art history at Cambridge, before spending three years in India. He then studied sculpture at the Chelsea School of Art and at Goldsmith's College of Art. He has worked with a wide range of media including bread, clay, rock, copper, wood, steel and lead, the latter being one of his preferred materials due to its ambiguous connotations of death and environmental hazards. From his travels in India he gained an interest in Eastern culture and tradition, particularly through the works of the aesthetic philosopher Coomaraswamy, and it was through this source that he began to explore the relationship between art and life. Gormley says of his work that it is 'about the relationship between space and imagination'. He began to gain his reputation in the 1980s particularly through his works which are based on direct casting of his own or other peoples' bodies, and had his first solo exhibition at the Whitechapel Gallery in 1981. Throughout the 1980s he was connected with the New British Sculpture Movement. He exhibited at the Venice Biennale 1986 and Documenta 8, Kassel 1987, and he won the prestigious Turner Prize in 1994. Works include: *Untitled* (Peace Sculpture), stone and iron, Maygrove Peace Park 1984; *Learning to See*, lead, fibreglass and plaster male figure, Roche Court Sculpture Garden, Salisbury 1992; *Field for the British Isles*, shown at the Ikon Gallery in 1995; *Angel of the North*, Gateshead, 1997; and many other international commissions.

1. M. Roustayi, 'An interview with Antony Gormley', *Arts Magazine*, vol.62, September 1987, pp.21–5; 2. *Antony Gormley, five works*, Arts Council of Great Britain, Ikon Gallery, London, exh.cat., 1987; 3. A. Gormley, *Antony Gormley*, New York, 1984; 4. M. Newman, 'New sculpture in Britain', *Art in America*, vol.70, September 1982, p.177; 5. M. Archer, 'Antony Gormley', *Studio International*, vol.196, 1984, p.44; 6. M. Beller, 'Heavy metal', *Artweek*, vol.23, 3rd December 1992, p.23; 7. J. Hutchinson, *Antony Gormley*, London, 1995.

Number of works in Catalogue: 1

Lee Grandjean (b.1949)
Educated at Winchester School of Art 1968–71, and was a Research Fellow there from 1980–1. His work has been described as encapsulating 'essentially non-physical concerns', and pieces such as *From the City* (1988) sum up this 'striving after a formal equivalent for a sensation, a belief or urgent desire'. Has work in collections of the Arts Council, the Department of the Environment and Leicestershire Education Committee, among others. Exhibitions include: Figures in the Garden, Yorkshire Sculpture Park 1984; Before it hits the floor, Institute of Contemporary Arts, London 1983; Blond Fine Art, London 1983; Stoke National Garden Festival 1986; The Cutting Edge, Manchester 1989; solo show, Beaux Arts Gallery, Bath 1990; Christchurch Mansion, Ipswich 1990. Has been commissioned by the Royal Bank of Scotland, 1986; Peterborough Development Corporation, 1987–8; and St. Mary's church, Peterborough, 1990–1, among others.

1. *Public Art Commissions Agency records*; 2. D. Lee, 'The human touch', *Arts Review*, vol.40, 12th and 26th August 1988, p.585; 3. R. Rushton, *Arts Review*, vol.42, 13th July 1990, p.390; 4. R. Ayers, 'Before it hits the floor', *Artscribe*, no.39, February 1983, p.48.

Number of works in Catalogue: 1

Tawny Gray (b.1965)
Born in Zimbabwe, 23rd May 1965, she moved to the UK in 1984. Gray works on a consultancy basis in graphic design and has also had a number of artistic and sculptural commissions. These include: fountain in the shape of a male torso, London 1985; *Flying man*, in steel and fibreglass, 1992; six sculptures based on the logo of The Big Peg (jewellery company), mixed metals 1992; gate, steel, Canalot Production Studios, London 1992; mural on the theme of Dürer's rhinoceros carried by seven old women, Custard Factory,

Digbeth, Birmingham 1993.

1. Letter from the artist, 8th February 1994.

Number of works in Catalogue: 1

Suzi Gregory (b.1967)
Received an MA in fine art from the Chelsea School of Art and won the first prize in the Henry Butcher Prize 1989. Her commissions include three works for various sections of Sir Terence Conran's businesses, one at the Heal's Building on Tottenham Court Road and another at Butler's Wharf, all in London.

1. *Public Art Commissions Agency records*.

Number of works in Catalogue: 1

Edward Grubb of Birmingham (1740–1816)
Probably born in Towcester in 1740, he moved to Stratford-on-Avon with his two brothers, one of whom, Samuel, was a stonemason. Edward Grubb worked as a stonemason and statuary, but later turned to portrait painting. He and Samuel then moved to Birmingham before 1769, although Edward returned to Stratford where he died in 1816. He signed a monument to the Earl of Carhampton at Kingsbury (d.1788); monuments to William Ash in 1789 and the Revd. Richard Riland in 1790, both in Holy Trinity church, Sutton Coldfield, to Peter Judd at Stratford-on-Avon in 1796, and another to Edward Taylor at Steeple Aston, Oxon., in 1797.

1. S. Redgrave, *Dictionary of artists of the English school*, London, 1878, p.189; 2. R. Gunnis, *Dictionary of British sculptors 1660–1851*, London, 1964, pp.181–2.

Number of works in Catalogue: 1

Ron Haselden (b.1944)
Born in Gravesend, Kent he attended the Gravesend School of Art 1961–3 and the Edinburgh College of Art 1963–6 where he

studied sculpture. His work consists mainly of light installations, both for gallery spaces and large-scale al fresco pieces. He has also worked extensively in collaboration for educational projects and with the mentally handicapped. Since 1971 he has taught sculpture at the University of Reading, Fine Art Department, and he lectures at many other colleges both in Britain and abroad. Other commissions include: *Neon Sculpture*, Royal Centre, Nottingham, with J. Sullivan (award-winning piece); *Magnetism affects our social behaviour*, George Green Memorial Museum, Nottingham 1985; *If music be the food of love, play on*, Chipping Norton School, Oxfordshire 1989. Solo exhibitions and installations include: Third Eye Gallery, Glasgow 1977; *Paper*, Ikon Gallery, Birmingham 1980; Camerawork Gallery, London 1985 and 1987; *Belvedere*, TSWA 3-D Project, Bellever Forest, Dartmoor 1987; *Patience: Son et lumière performance*, Whitechapel Art Gallery, Pomeroy Purdy Gallery and Architectural Association, London 1988; *Fête*, Feeringbury Manor, Essex 1989. This latter piece was the title piece for a solo exhibition, Fête and other works, Serpentine Gallery, London 1990. Other shows include: Grey Matter, Six Sculptors, Ikon Gallery, Birmingham 1988; Whitechapel Open, Whitechapel Art Gallery, London 1988 and 1989; Tree of Life, Cornerhouse Gallery, Manchester (touring) 1989.

1. *Ron Haselden, Fête and other works*, Serpentine Gallery, London, exh.cat., 1990.

Number of works in Catalogue: 1

Barbara Hepworth (1903–75)
Born in Wakefield, 10th January 1903, died in a fire at her studio in St. Ives, 1975. The daughter of a Yorkshire county surveyor, Hepworth attended Leeds School of Art 1920–1, where she met fellow student Henry Moore, and the

Royal Academy 1921–4. Worked in Rome with John Skeaping 1924–6, whom she married in 1925 but divorced in 1931. Influenced by Brancusi, Arp, Gabo and Moore, her early sculptures of figures and animals were abandoned in favour of abstract work in the 1930s. From 1931 she worked with Ben Nicholson (whom she married in 1933) under whose influence she made severe, geometrical pieces. They exhibited together at the Lefèvre gallery, working in groups such as Unit One (1933–4) and Abstraction-Creation (1933–5). In 1939 they moved to St. Ives, Cornwall, where she developed a lyrical style closer to Moore's. In the 1950s she gained an international reputation with anthropomorphic works like *Figures in a Landscape*. In the 1960s she was commissioned to make a 20-foot high *Winged Figure*, London 1962; and *Single Form*, United Nations Building, New York 1962–3. Exhibited at the Beaux Arts Gallery, Bath 1928; retrospectives include Wakefield Art Gallery, 1951; Whitechapel Art Gallery, London 1954, 1962; Tate Gallery, London 1968; Yorkshire Sculpture Park, 1980; Tate Gallery, Liverpool 1994. Awarded CBE 1958; OBE 1965.

1. S. Nairne, and N. Serota (eds.), *British sculpture in the twentieth century*, Whitechapel Art Gallery, London, 1981, p.254; 2. P. Curtis, and A.G. Wilkinson, *Barbara Hepworth: a retrospective*, Tate Gallery, Liverpool, exh.cat., 1994; 3. B. Hepworth, *Barbara Hepworth, a pictorial autobiography*, revised edition, Tate Gallery, London, 1985; 4. *Barbara Hepworth: carvings*, Marlborough Fine Art, London, 1982; 5. *Barbara Hepworth: carvings and bronzes*, Marlborough Gallery, New York, exh.cat., 1979.

Number of works in Catalogue: 2

Gordon Herickx (1900–53)

Born in 1900, he trained at the Birmingham School of Art under William Bloye. From 1945 until his death in July 1953, he was Sculptor Master at the Walsall School of Art. He assisted Bloye, for example, to carve the capitals in the church of St. Francis of Assisi, Bournville. In July 1953 he held his only one person show at the Kensington Gallery, London, where he exhibited 13 pieces, all carved in either Horton or Hoptonwood Stone. He died on the night following the opening of this show. In October 1953, the Birmingham City Museum and Art Gallery held a memorial exhibition, showing twenty works which represented nearly all of his output. His sculpture consists largely of the early floral subjects made between 1932 and 1936, and figure and head studies, notably the three *Dreamer* pieces and his last complete works, *Adam and Eve*, both of 1951. Herickx worked slowly, destroying pieces that he considered to be untrue. His forms are largely biomorphic, simplified in the style of Eric Gill, whose work he admired.

1. A. Garrett, 'The sculpture of Gordon Herickx', *The Studio*, vol.CXLVII, no.730, January 1954, pp.18–19; 2. R. Melville, 'Exhibitions', *Architectural Review*, vol.114, October 1953, pp.261–2.

Number of works in Catalogue: 2

Peter Hollins (1800–1886)

Born 1st May 1800 in Great Hampton Street, Birmingham, he died in the same house, 16th August 1886. He was the eldest son of William Hollins, in whose studios he trained until he went to London c.1822, where he worked under Francis Chantrey. Having come to some notice after showing his two group sculptures in 1830 at the Royal Academy, *The Murder of the Innocents* (also shown at the Great Exhibition of 1851) and *Cupid and Psyche*, and winning the Robert Lawley prize at the RBSA for his *Conrad and Medora* in 1831, he visited Italy in 1835 or 1836. Throughout his life he collaborated with his father's studios. He had assisted his father in the restoration of St. Mary's church, Handsworth, and with ornamental sculpture at Alton Towers, Staffs., both in the early 1820s. He also designed memorial sculpture, of which he produced many pieces throughout the Midlands, even whilst living in London. Considered the leading local sculptor for most of his life, Hollins was a well-known social figure in Birmingham, with acquaintances in local commerce, industry, the arts and on the town council, from which he obtained most of his public commissions. He closely followed the style of Chantrey, showing both classical and romantic qualities: dramatic poses sculpted sensitively with keen features. Always competently handled, his sculpture can be seen at its best in the monuments to *Lady Bradford*, Weston, Staffs., 1842 and *Mrs Thompson*, Malvern Priory 1838. He exhibited regularly at the RA 1822–71 and at the RBSA, of which he was Vice-President until 1879. He retired in 1874 due to rheumatism.

1. Obituary, *Birmingham Daily Post*, 18th August 1886; 2. Gunnis, 1964, pp.205–6; 3. N. Penny, *Church monuments in romantic England*, London, 1977, pp.89–92.

Number of works in Catalogue: 5

William Hollins (1763–1843)

Born at Shifnal, Shropshire, 18th March 1763, he died in Birmingham, 12th January 1843 and is buried in St. Paul's churchyard. A self-taught artist, largely through studying Vitruvius, he practised mainly as an architect and architectural sculptor. He designed the Old Library in Union Street (1799); new public offices and prison, Moor Street (1805–7); and the Retreat Almshouses, Warner Street, Bordesley (1831). It is also suggested that he was responsible for the design of the Gun Barrel Proof House in 1813. With his son, Peter, he carried out the Gothic restoration of St. Mary, Handsworth parish church in 1820, preparing the chapel for Chantrey's statue of James Watt; and planning garden buildings and carving stone for Lord Shrewsbury's house at Alton Towers. Hollins also designed the Royal

Mint at St. Petersburg, but refused an offer to go as architect to Catherine the Great. As a sculptor, he signed several monuments in churches throughout the Midlands between 1808 and 1823, including those to: *John Wainwright*, Dudley 1810; *Alexander Forrester*, All Saints, Leicester 1817; *James Goddington*, 1821 and *Benjamin Spencer*, 1823, both at Aston, Birmingham. Those to *Thomas Cooper*, 1818 and *Edmund Outram*, 1821 in Birmingham Cathedral are also by him. After several years study, devising a code of systematic rules for the formation of letters, he produced a work entitled *The British Standard of the Capital Letters contained in the Roman Alphabet*. After his death the family stonemasonry business was continued by Peter Hollins. Exhibited RBSA 1827–40; RA 1821–5.

1. L. Stephen, and S. Lee (eds.), *Dictionary of national biography*, vol.27, London, 1891, p.174; 2. Graves, vol.IV, London, 1906, p.134; 3. Gunnis, 1964, p.205; 4. F.W. Greenacre, *William Hollins and the Gun Barrel Proof House 1813*, Victorian Society, West Midlands Group, 25th May 1968.

Number of works in Catalogue: 3

Ian Horner (active 1970s–)
Ian Horner Studios of Harborne, specialists in fibrous plaster mouldings, produce busts and plaques, cornices, columns and arches as well as exhibition displays and night-club scenarios. The firm is still in operation.

1. Letter from the artist, 30th March 1985.

Number of works in Catalogue: 1

R.C. Hussey (1802–1887)
Trained as an architect, he became Thomas Rickman's partner in 1835 and together they built or made alterations to five churches, one asylum and two houses, one of which was Castle Bromwich Hall. Rickman retired in 1838, leaving the practice entirely to Hussey.

1. H. Colvin, *Biographical dictionary of British architects 1600–1840*, London, 1978, pp.689–93.

Number of works in Catalogue: 1

Charles I'Anson (1924–83)
Born 28th October 1924 in Birmingham, died 20th March 1983, Ilkley, West Yorkshire. Educated at Handsworth Grammar School and then at Stafford Training College 1946–9, he was largely self-taught as a sculptor and first produced portrait heads and busts in a traditional style. In the late 1950s and early 60s he developed a welding technique which he termed 'Direct Sculpture', by which metal was shaped directly, rather than cast from a mould. During this period he worked with Lyn Chadwick. He also gave many lectures, particularly on children's art, at various colleges including Birmingham and Aston Universities and the Birmingham School of Art. Head of the Art Department, King Charles I School, Kidderminster from 1963–6, he lectured at Bishop Lonsdale College of Education, Derby 1966–8 and then at Trinity and All Saints Colleges, Leeds until 1981. He received many commissions from schools, colleges, churches and other public buildings and his sculpture is represented in numerous public and private collections. His later work was based on a free and imaginative interpretation of animal and plant forms. Other work includes: *Winged Symbol*, Birmingham Museums and Art Gallery (early 1960s), in store; *Pierced Hand*, Bristol University Students' Union Chapel, 1964; *Dancing Fairies*, Windmill Hill Primary School, Stourport-on-Severn 1965; *Fighting Cocks*, Royal Artillery Gamecock Barracks, Nuneaton 1967; *Convoluted Forms*, Wakefield City Art Gallery, 1970; *Crucifix*, Trinity and All Saints' Colleges, chapel, Horsforth 1971; *Awen*, Cardiff Civic Centre 1975; *Rampant Lion and Ermine*, Minard Castle, Inveraray, Argyll 1980. Exhibitions include: RWEA 1955–67; Paris Salon 1961; London Group, 1962; Monte Carlo 1966; Midlands Art Centre, Birmingham 1967; Tulip Festival, Birmingham 1976. FRSA 1956; RBS 1966; FRBS 1967, council member 1970–4.

1. *Mail*, 1st September 1967; 2. G.M. Waters, *Dictionary of British artists working 1900–1950*, Eastbourne, 1975, p.176; 3. *International who's who in art and antiques*, 2nd edition, Cambridge, 1976, p.180; 4. WWA, Norwich, 1984, pp.237–8; 5. Letter from Mrs H. I'Anson, the artist's widow, 11th July 1985.

Number of works in Catalogue: 1

Jonah Jones (1919–c.1980)
Born in Durham in 1919, he trained as a sculptor and letter-carver with Eric Gill and later taught for a brief period as Director of the National College of Art and Design in Dublin. In the 1950s his work was often figurative and simplified 'in order to express a clear idea of its form and stress the solidity of the material'. Later sculptures demonstrated a concern with architecturally derived shapes and the investigation of contrast and balance in their arrangement. His public commissions in Wales include: *The Princess*, Aberffraw, Anglesey 1968; *Mercy and Justice*, Law Courts, Mold; *A Oes Heddwch*, a peace sculpture at Emrys ap Iwan School, Abergale. Carved busts include: *Sir Clough Williams Ellis*; *Bertrand Russell*; *Sir O.M. Edwards*; *Sir Huw Wheldon*. Major inscriptions in slate include: *Dylan Thomas* and *David Lloyd George* in Westminster Abbey. Author of *A Tree May Fall*, 1980 and *The Lakes of North Wales*, 1983.

1. Welsh Sculpture Trust, *Sculpture in a country park*, Margam, Wales, exh.cat., 1983, pp.48–51.

Number of works in Catalogue: 1

Albert Bruce Joy (1842–1924)
Born in Ireland in 1842, he died in Surrey, 25th May 1924. Studied at the National Art Training School, and at the RA Schools from 1863 and in

Rome. He then worked in J.H. Foley's studio and on his master's death in 1874 unofficially inherited the commission for the statue of *Robert James Graves*, 1877 at the Royal College of Physicians, Dublin. Producing a full range of conventional sculpture, his main works include: statues of *Gladstone*, Bow Road, London 1882; *Lord Frederick Cavendish*, Barrow-in-Furness 1885; bust of *Thomas Erskine May, 1st Baron Farnborough*, 1890; *Memorial to Archbishop Benson*, Rugby School chapel 1899. He exhibited at the RA from 1866; RSBA. He never sought or received the English Honour of Royal Academician.

1. M.H. Spielmann, *British sculpture and sculptors of today*, London, 1901, p.34; 2. B. Read, *Victorian sculpture*, New Haven and London, 1982, pp.75, 351; 3. J. Mackay, *Dictionary of British artists 1880–1940*, 1976, p.82.

Number of works in Catalogue: 1

Raymond Forbes Kings (1924–81)

Born in Birmingham, 17th September 1924, he died in Bromsgrove, 5th November 1981. Studied at Moseley School of Arts and Crafts until 1940 when he became apprenticed to William Bloye until 1942. After a period of war service, he moved to Castle Bromwich and continued to work with Bloye until 1960, collaborating on many architectural sculpture projects in Birmingham, London, Dublin and Baghdad. Kings started his own practice in Gravelly Hill, Erdington in 1960, beginning a period of greater creativity when his work became quite widely known. He taught part-time at Birmingham School of Art until 1967 when he moved to bigger studios in Bromsgrove. In 1979 he moved to Fernhill Heath, Worcestershire and here he designed and produced figurines and smaller pieces of sculpture and also developed his interest in architecture and local history. Kings' freelance work from 1960 includes one of his most ambitious pieces, a 20-foot figure of Christ at St. Martin's church, Sutton Road, Walsall 1960; stone carvings at St. Agnes of Monte Pulciano church, Walsall; Our Lady of the Angel church, Aldridge; St. Peter's church, Bromsgrove; coat of arms, St. Winifred's R.C. primary school, Castle Bromwich 1961–2; coat of arms, Marsh Hill Technical School. Inn signs include those at The Acorn, Coventry Road, Elmdon and The Arden Oak, Elmdon, *c.*1966. Other work includes *Lions and Tablets*, Synagogue, Pershore Road; stone restoration at the Guild Hall, Worcester 1978–80 and the Cardinal's throne and coat of arms, Westminster Cathedral, London. Exhibited at the 18th International Galerie Exhibition, New York 1974. Member of the Guild of Catholic Artists, 1962; ARBS 1963.

1. *Mail*, 29th November 1960; 2. Letter from the artist's son, John Kings, 13th November 1985.

Number of works in Catalogue: 4

Juginder Lamba

Born in Nairobi, Kenya, currently living in Shropshire. After an education in philosophy and education 1966–78, Lamba received a Henry Moore Fellowship in Sculpture at John Moore's University in 1995. His work concentrates on breaking down cultural boundaries, using motifs derived from tribal and oceanic art, and he aims to 'make work accessible to a consciousness which is independent of the purely historical aspects of our lives'. Solo shows include: Icarus, Wolverhampton Museum and Art Gallery 1993; retrospective, Bond Gallery, Birmingham 1993; From the Wood, Bluecoat Gallery, Liverpool 1995. Public commissions include: sculpture in Telford shopping centre, 1991; sculpture/installation, Bluecoat Gallery, Liverpool 1992; relief carving, Angel Centre, Worcester 1993.

1. Axis Visual Arts Information Service record, February 1996.

Number of works in Catalogue: 1

Tom Lomax (b.1945)

Born 12th May 1945 in Warrington, Lomax was first apprenticed as an engineer in 1961 then worked in engineering until 1970. He trained in fine art at Central School of Art from 1971–4, then at the Slade School of Art 1974–6, during which time he was studio assistant to William Pye. His work shows an interest in early Greek, Egyptian and African art and sculpture, combined with baroque influences as well as 20th-century primitivism. He is a visiting lecturer at several colleges, and has been a part-time lecturer at the Slade School of Art since 1982. He has worked both solo and collaboratively on public commissions: Urban Learning Foundation, with Paul Hyett Architects 1991–2; Cardiff Bay Development, with Tess Jaray 1992–3; Leeds Hospital Trust, with Tess Jaray 1993; Ceremonial Mace for University College, London 1993; Wakefield District Council, with Tess Jaray 1994. Solo exhibitions include: Slade School Gallery, 1993; Angela Flowers, London 1994; Coopers Lybrand, Atrium Gallery, 1994. Group Exhibitions include: Kettle's Yard, Cambridge 1987; St. George's Crypt 1988; Pomeroy Purdie Gallery, 1988; New Images for City Sites, Birmingham Museums and Art Gallery 1991; Tokyo International Art Fair 1993; International Art Fair, Andrew Lloyd Gallery, London 1993; Daniel Arnaud Contemporary Arts, London 1995; Hamerson plc, London 1995.

1. *Public Art Commissions Agency records*; 2. Letter and CV from the artist, 21st January 1996; 3. T. Lomax, 'Artists account', in 'Building study: Urban Learning Foundation, Tower Hamlets, London', *Architect's Journal*, 21st April 1993, p.44.

Number of works in Catalogue: 1

W.E. Loxley (1911–73)
Born in Birmingham, 28th March 1911, he died in Bournemouth, 1st December 1973. Studied at Moseley Road School of Art 1924–9, registering for a modelling course in the sculpture department in 1926–7. He then became an ornamental stonemason, taking over his father's firm and traded under the name of Ernest Loxley at his studios in Bristol Road South until 1955, after which time he worked for Mr. Protheroe, a Handsworth stonemason. Loxley moved to Bournemouth in 1971.

1. Birmingham School of Art, *Student Registers*; 2. Information provided in conversation, the artist's widow, 24th February 1986.

Number of works in Catalogue: 1

Samuel Ferris Lynn (1834–1876)
Born at Fethard, Co. Tipperary, Ireland, 29th October 1834, he died in Belfast, 5th April 1876. Studied at the Royal Academy from 1856, gaining a Gold Medal in 1859. Worked as an ornamental sculptor in Dublin and Manchester, also working for his brother the architect W.H. Lynn, carving decorations for banks. Exhibited idealised figures from 1856 such as *Grief*, 1858 and *Psyche*, 1859, until 1868 when he turned to portraiture. Patronised entirely by the nobility and gentry of north Ireland, his portraits include memorial busts of *J. Clarke*, Belfast 1868; *Alexander Mitchell*, Belfast 1869; *Rev. P. Shuldham Henry*, Queen's College, Belfast 1869; *John Thompson, High Sheriff of Co. Antrim*, 1871; *Lord Cairns, Attorney General*, 1872; and a marble bust of *John Lytte, Mayor of Belfast*, 1874. He executed a marble statue of *Lord Farnham*, Cavan 1872; and a bronze one of *The Marquis of Downshire*, Hillborough, Co. Down 1873. He entered Foley's studio in London, assisting in the modelling of the statue of the Prince Consort 1868–74 for the *Albert Memorial*, Kensington Gardens, having already made a statue of Prince Albert for the *Albert Memorial Clock*, Belfast 1865.

1. Graves, vol.IV, London, 1906, p.120; 2. W.G. Strickland, *Dictionary of Irish artists*, vol.II, Dublin and London, 1913, pp.33–5; 3. U. Thieme and F. Becker, *Allgemeines Lexikon der bildenen Künstler*, vol.XXIII, Leipzig, 1938, p.494.

Number of works in Catalogue: 2

John Maine (b.1942)
Born in Bristol in 1942, he studied at the West of England College of Art, then the Royal College of Art 1964–7, winning the Walter Neurath prize in 1966 and a Fellowship to Gloucester College of Art 1967–9. Working first in galvanised steel and wood, and from the mid-1970s in stone, he has explored volumetric relationships and interlocking geometric shapes in his sculptures, which are often located in an outdoor environment. Works include: *Six Markers on the Foreshore*, Portsmouth 1974; *Monolith II*, Sun Life Assurance building, Bristol 1980; *Outpost*, 1980; *Pyramid*, Nene Park, Peterborough 1981; *Hagi Project*, Hagi city, Japan 1981; *Arch Stones*, British High Commission, Canberra, Australia 1982–4. Maine has taught at Kingston Polytechnic and has exhibited in England, Australia and Japan. One-man show at the Serpentine Gallery, 1972; Southill Park, Bracknell 1973–4; Battersea Park Silver Jubilee Exhibition, London 1977; the first solo show at the Yorkshire Sculpture Park, 1978; the Welsh Sculpture Trust's outdoor exhibition at Margam, 1983.

1. Welsh Sculpture Trust, *Sculpture in a country park*, Wales, 1983, pp.100–1; 2. Strachan, 1984, pp.265–6; 3. J. Hall, 'Landscape art – public art or public convenience', *Apollo*, no.129, March 1989, pp.157–61.

Number of works in Catalogue: 1

Alex Mann (b.1923)
Born in Ayr, Scotland, 26th February 1923, he studied at Polochsiels Academy, Glasgow and Sidcup School of Art, Kent 1938–40. In 1956 Mann moved to Stratford-on-Avon, forming 'Alexander Fine Arts' in 1960. This was amalgamated with the Compendium Galleries, Moseley, Birmingham, which he directed until the mid-1970s. Primarily a painter, particularly of 'Visual-Sound' music, he has also produced public sculptures and murals for various commercial and industrial organisations in the West Midlands and elsewhere in the country. His works aim to express the identity of the location and include: ceramic mural, West Bromwich swimming pool, c.1970; water sculpture in glass and stainless steel, Stourbridge 1973. Mann's paintings have been regularly exhibited since 1947, for example in London (RA from 1975), Birmingham, Frankfurt and Aberdeen and are in public and private collections in Great Britain, Germany, Holland, France, USA, Australia and Japan.

1. WWA, 20th edition, Wokingham, 1982; 2. Letters from the artist, 22nd April 1985 and 12th August 1985.

Number of works in Catalogue: 2

Raymond Mason (b.1922)
Born in Birmingham, he attended the Birmingham School of Arts and Crafts from 1937. He won a scholarship to study painting at the Royal College of Art, but only studied there for one term. In 1943, he went to the Slade School of Art, which had been moved to Oxford, and it was during this period that he began to practise sculpture, on the advice of a lecturer, and also perhaps inspired by the sculpture in the Ashmolean Museum, Oxford, where he worked nights. Since 1946 he has lived and worked in Paris, where he has counted amongst his friends Giacometti, Balthus and Bacon. In 1960, he opened the Galerie Janine

Hao. His work consists mainly of high and low reliefs, large-scale sculptures, drawings and paintings. The latter includes a series of watercolours depicting Birmingham, made on a return visit in 1958 (in various private collections). His work is realist and figurative, mainly concerning human disaster or tragedy, often of a highly emotionally charged nature, such as *A Tragedy in the North: Winter, Rain and Tears*, Galerie Claude Bernard, Paris 1975–7 and *L'Agression au 48 de la rue Monsieur-le-Prince, le 23 juin 1975*. Mason's large sculptures exhibit a similar density of forms and sculptural compactness to the smaller reliefs, and are often a combination of relief and free-standing figures in street environments. Mason has an international reputation with monumental sculptural groups in Montreal (1985), the Tuileries, Paris (1986), Georgetown, Washington DC (1988) and Madison Avenue, New York. Exhibitions include: Serpentine Gallery, London and Museum of Modern Art, Oxford 1982; Galeries Contemporaines, Pompidou Centre, Paris and Musée Cantini, Marseilles 1985–6; Birmingham Museums and Art Gallery, Manchester City Art Gallery and Edinburgh City Art Centre, 1989 (touring exhibition); Marlborough Fine Art, London 1991; Marlborough Galleries, New York 1994, 1995. He has written extensively on art historical themes and on his own works, many of which are reprinted in the BMAG exhibition catalogue, 1989.

1. M. Brenson, 'Urban drama in high relief', *Art in America*, July/August 1979, pp.102–9; 2. R. Taplin, 'Raymond Mason at Marlborough', *Art in America*, vol.83, July 1995, p.87; 3. M. Edwards, *Raymond Mason*, London, 1994; 4. *Raymond Mason: Coloured sculptures, bronzes and drawings 1952–1982*, Arts Council of Great Britain, London, exh.cat., 1982; 5. J. Farrington, and E. Silber (eds.), *Raymond Mason: sculptures and drawings*, Birmingham Museums and Art Gallery, Birmingham, exh.cat., 1989; 6. H. Lessore, 'Raymond Mason', in *A partial testament: essays on some moderns in the great tradition*, The Tate Gallery, London, c.1986.

Number of works in Catalogue: 1

John McKenna
Lives in Worcester, where he has his own studio. He has carried out a number of public works for the West Midlands transport consortium, Centro, including *Glassblower*, Stourbridge town railway station (collaboration with Steve Field), 1995; and work at Canley railway station, Coventry, 1995. ARBS.

1. Information given in conversation with Mark Wiles, Principal Planner, Centro, 13th June 1996.

Number of works in Catalogue: 1

John Merilion (b.1930)
Born in Leicester, 22nd September 1930, he studied ceramics and textiles at Leicester College of Art 1948–53 and became a tutor at Birmingham School of Art in 1955. Based in Birmingham, he formed the John Merilion Design Group between 1969 and 1980, collaborating with Raymond Nicholls from 1969 to 1978. His freelance commissions comprise mainly decorative architectural reliefs and murals in man-made and modern materials and include: mural, Ceylon Tea Centre, Haymarket, London 1967; mural, Corah Ltd., Leicester 1968; mural, Ornithology Building, Tring, Herts. 1972. Other non-sculptural works in Birmingham include: murals and coats of arms, Birmingham Registry Office, Broad Street, 1962; mural, The Swan Hotel, Yardley (now lost); mural, Lloyds Bank (Overseas Department), Colmore Row 1968.

1. Letter from the artist, 20th June 1985.

Number of works in Catalogue: 2

Dhruva Mistry (b.1957)
Born in Kanjari, India, Mistry was trained at Baroda University before becoming a British Council Scholar at the Royal College of Art in London 1981–3. From 1984–5 he was sculptor in residence at Kettle's Yard Gallery, Cambridge and a Fellow of Churchill College Cambridge. His work has been praised for its sensitivity to the values of diverse cultures, whilst assimilating ideas from his Indian background into modern contexts, and it is this aspect of his work which has led to him being described as 'thoroughly postmodern', incorporating references as diverse as Picasso's minotaurmachy, Egyptian sculpture and Romanesque architecture. He is often compared to Anish Kapoor, another artist who integrates Indian culture into Western art forms, but Mistry is more rooted in the figurative tradition. He is known for his integrity to his overall conceptions. He was made a Royal Academician in 1991, the youngest since Turner. Works include: *Sitting Bull*, concrete, Liverpool Garden Festival 1984; *Reguarding Guardians 1 and 2* at the Hayward Annual, 1985; *City of Stoke on Trent: Her Head*, Stoke 1987; *Dialectical Image Series*, 1990.

1. S. Wagstaff, 'The bird that cuts the airy way', in *Dhruva Mistry: sculptures and drawings*, Kettle's Yard, Cambridge, exh.cat., 1985; 2. *Birmingham Museums and Art Gallery records*; 3. D. Cohen, 'Out of India: Hindu spirituality in recent British sculpture', *Sculpture*, vol.13, January/February 1994, pp.20–7; 4. 'Man and beast', *Studio International*, vol.198, December 1985, pp.40–1; 5. N. Dimitrijevic, 'Hayward Annual', *Flash Art (international edition)*, no.123, Summer 1985, p.58; 6. W. Feaver, 'Dhruva Mistry', *Art News*, vol.87, January 1988 and vol.90, February 1991.

Number of works in Catalogue: 4

William Mitchell (b.1925)
Born in London, 30th April 1925, he studied art at Southern College of Art, Portsmouth and at the Royal College of Art where he won a fourth

year scholarship (The Abbey Award) which enabled him to study at the British School in Rome. He established the William Mitchell Design Consultants group and produced sculptures in plastics, concrete, wood, marble and brick. Mitchell has been a member of the Design Advisory Board, Hammersmith College of Art and Trent Polytechnic; member of Formwork Advisory Committee and the Concrete Society. He has many pieces throughout the country, including: Liverpool Metropolitan Cathedral entrance; Three Tuns public house, Coventry 1966. Exhibitions include a joint show held at the Engineering and Building Centre, Broad Street Birmingham 1967, where he showed three over-life-size figures, *The Magi*, which were made from Thermalite load-bearing aerated concrete building blocks, produced by Thermalite Ltd., Lea Marston.

1. 'Painter's search for peace', *Post*, 11th May 1967.

Number of works in Catalogue: 1

Nicholas Monro (b.1936)
Monro studied at Chelsea School of Art 1958–61, and taught at Swindon School of Art 1963–8. He later returned to teach at the Chelsea School of Art. Solo exhibitions include: Robert Fraser Gallery, London 1968; Amsterdam 1969; Galerie Thealen, Essen, Germany, 1969; Waddington Galleries, London 1971. He has had work in group exhibitions in the UK, France, Germany and Italy.

1. *City Sculpture*, Arts Council of Great Britain, London, 1972.

Number of works in Catalogue: 1

Alexander Munro (1825/7–1871)
Born 1825 (or 1827, according to student registers at the Archive of the Royal Academy) in Inverness, he died 1st January 1871, Cannes,

France. Chiefly remembered as a portrait sculptor, Munro was brought up on the Duke of Sutherland's property in Scotland where his father worked as a stonemason. In 1847 he entered the RA Schools and in 1848 began working for Charles Barry on the stonecarvings for the new Houses of Parliament. After 1849, portrait sculpture became his main occupation and he produced many statues, busts, medallions and occasional group sculpture. His major statue commissions include: *Francesca da Rimini*, 1852 for W.E. Gladstone; *The Gladstone Children*, 1856; *James Watt, Hippocrates, Newton, and Galileo* for the Oxford Museum, 1863. In the collections of Birmingham Museum and Art Gallery there is a statue of *Paulo and Francesca*, 1851 and an original plaster model for *A Sleeping Child*. Exhibitions include: RA 1849–70; British Institution 1850–63; the Great Exhibition 1851.

1. S. Redgrave, *Dictionary of artists of the English school*, London, 1878; 2. Gunnis, 1964, pp.267–8.

Number of works in Catalogue: 1

William James Neatby (1860–1910)
Born in Barnsley in 1860, at the age of fifteen he was articled to and later employed by a Bradford architect for six years. Then for two years he practised as an architect on his own account in Whitby and elsewhere in Yorkshire. When aged twenty-three he went to work for Burmantofts Potteries in Leeds, designing, painting and making tiles for interior decoration. Six years later he joined Doulton's of Lambeth, in charge of their architectural department, again designing and making ceramics. He made great use of both terracotta and Carrara Ware and introduced new processes such as polychrome stoneware and Parian Ware. In 1900 or 1901 he set up a partnership with E.H. Evans manufacturing

furniture, metalwork and stained glass, but he continued to design for Doulton. Neatby was a proficient designer in several media: ceramics, glass, metalwork and enamels, gesso and plaster ceilings and also a little woodcarving. Works include tile decoration for the School of Art, Manchester (1897); the Royal Arcade, Norwich (1899); Orchard House, Westminster (1900); the City wholesale market, Leicester (1900, now demolished); and the Everards Building, Broad Street, Bristol (1901). Two large-scale works still exist: the interior of the Winter Gardens, Blackpool (1896); and Harrods Meat Hall, Brompton Road, Kensington (1902). The Frascati Restaurant in the Masonic Hall, Oxford Street, London (1902), with its glass ceiling and three large mural frescoes has been demolished, as has the interior of the Redfern Gallery, London and the Gaiety Theatre London (1903). In Birmingham, Neatby did the interior of the King's Café with stained glass, metalwork, mural tiles (by Doulton) and a panel figure of a king over the fireplace, made in enamels and gold, and medallions for the Theatre Royal. Both buildings, by Newton and Cheatle, are now demolished. Primarily an artist, Neatby was a painter of miniatures, an Associate of the Royal Miniature Society in 1906 and full member in 1907. Exhibited at the RA 1906, 1909; Arts and Crafts Exhibition, Grafton Galleries, London 1906.

1. A. Vallance, 'Mr. W.J. Neatby and his work', *The Studio*, vol.29, 1903, pp.113–17; 2. J. Barnard, 'Victorian on the tiles', *Architect and Building News*, September 1971, pp.46–51; 3. *RAE*, vol.V, Wakefield, 1981; 4. J. Johnson, and A. Greutzner, *Dictionary of British artists 1880–1940*, Woodbridge, Suffolk, 1976; 5. P. Atterbury, and L. Irvine, *The Doulton story*, London, 1979, pp.73–97; 6. 'Some new decorative work', *The Builder*, 16th March 1901, p.256.

Number of works in Catalogue: 2

Uli Nimptsch (1897–1977)
Born in Charlottenburg, Berlin, 22nd May

1897, he studied at the School of Applied Art, Berlin 1915–17 and at the Berlin Academy 1919–26 under Professors Gerstel and Lederer. He was in Rome at various times between 1931 and 1938, going to Paris for a year, and then settling in Great Britain. He had his first one-person show at the Redfern Gallery, London 1942, and retrospective shows at Temple Newsam in 1944 and Liverpool in 1957. Other work includes a statue of *Lloyd George* for the lobby of the House of Commons 1961–3; *Olympia*, c.1953–6 and *Seated Girl*, 1958 at the Tate Gallery. RBA 1948, ARA 1958, RA 1967 and Senior RA 1972. Master of the RA Sculpture School 1966–9. Exhibited at the RA from 1957.

1. *Uli Nimptsch RA, sculptor*, Royal Academy, London, exh.cat., 1973; 2. *RAE*, vol.V, Wakefield, 1981; 3. S. Nairne, and N. Serota, (eds.), *British sculpture in the twentieth century*, Whitechapel Art Gallery, London, 1981, p.259.

Number of works in Catalogue: 1

Ondré Nowakowski (b.1954)

Born 11th February 1954 in Pontypridd, South Wales, Nowakowski studied fine art at Staffordshire Polytechnic 1980–3 and did his Masters in fine art at Manchester Polytechnic 1983–4. He works from his studios in Sandbach, Cheshire. He produced large wooden figures in states of motion for the National Garden Festival, Stoke-on-Trent 1986, and his commissions include one for Butterley Brick Plc, Derbyshire 1987; *A Man Can't Fly*, Stoke-on-Trent City Council 1987; *Sun Dial*, Richard Wilson Art Centre, Gwynedd 1990; works in progress, Royal Oldham Hospital 1996.

1. Letter from the artist, 29th January 1996; 2. *Ondré Nowakowski: recent works*, Manchester Metropolitan University and Stoke-on-Trent City Museum and Gallery, 1995.

Number of works in Catalogue: 1

Robert Pancheri (1916–96)

Born in Bromsgrove on 22nd June 1916, died in Bromsgrove, 18th February 1996. He studied part-time at Birmingham School of Art 1934–9 under Alan Bridgwater and William Bloye, whose work he was particularly influenced by. At this time he was also working with his father, Celestino Pancheri, a wood carver in the Bromsgrove Guild. After war service, he resumed his sculptural practice, producing largely architectural sculpture for churches and public buildings in the Midlands. These include: *Figures*, Hammersly Road School, Kidderminster 1939; *St. Peter*, St. Peter's church, Handsworth 1956 (now closed); the Lady Chapel, St. Augustine's church, Edgbaston 1963; *St. Oswald and St. Anthony*, Winwick church 1971; *St. Anne and St. Ursula*, Malvern Priory church 1974; organ screen with sculptured gables, Bromsgrove parish church 1975; *Madonna and Child*, St. Luke's church, Rednall 1976; *John Plessington*, Franciscan Friary, Chester 1979; Memorial tablet to *Bishop Charles-Edwards*, Worcester Cathedral 1984. His restoration work includes twenty-seven ionic capitals of the Feeney Art Gallery extension, Birmingham and the wood carving on the Feathers Hotel, Ludlow, for which he received the Civic Trust Award 1970. ARBS, Diploma of the Royal Association of British Sculptors 1976.

1. Letters from the artist, 27th August 1985 and 24th January 1996; 2. Letter from the artist's son, March 1996.

Number of works in Catalogue: 3

David Patten (b.1954)

Born in Wolverhampton, Patten studied fine art at Birmingham Polytechnic (now University of Central England) 1972–5 and painting at the Royal College of Art 1975–8. He is mainly involved in collaborative projects with architects and engineers developing public spaces. He teaches art at North Warwickshire College of Technology and Art, Nuneaton. His commissions include one for Bradwell Hospital, 1988; *Monument to Attwood*, Halesowen 1990; Sheffield Hallam University, various collaborations with Jane Kelly, 1992–3; Amphitheatre, University Square, Sheffield, with Jane Kelly, 1994; Coventry Canal Corridor Public Art Strategy, with Maurice Maguire, 1994–5. Recent exhibitions include: Cader Idris and the City of a Thousand Trades, Ikon Gallery, Birmingham 1989; Approaches to Public Art, Ikon Gallery (touring exhibition) 1990; New Meanings for City Sites, Birmingham Museums and Art Gallery, 1991; Graves Art Gallery, Sheffield, with Jane Kelly, 1992–3; Design on Sheffield, Mappin Art Gallery, Sheffield 1994; International Design Workshop, Cardiff 1994. He has been involved with public art schemes in Sheffield and Cardiff. He is a member of the Public Art Fund, New York and the Public Art Forum, UK.

1. *Public Art Commissions Agency records*; 2. Birmingham Museums and Art Gallery, *Public art in Birmingham information sheet*, no.20, Birmingham, 1994; 3. Letter and CV from the artist, 29th January 1996.

Number of works in Catalogue: 2

Henry Alfred Pegram (1862–1937)

Born in London, 27th July 1862, where he died 25th March 1937. Studied at West London School of Art, taking book prizes in 1881 and 1883, and attended the Royal Academy 1881–7, where he won prizes in 1882, 1884 and 1886. Assistant to Hamo Thornycroft 1887–91. Created some decorative and ideal work, such as *Ignis Fatuus* (RA 1889) in the symbolist style but largely made figurative, portrait and memorial work: busts of *Rt. Hon. Edward Fry*, 1893; *Rt. Hon. Cecil Rhodes*, 1903; *Sir Robert*

Hart, Shanghai 1914. His architectural work includes *Industry and Britannia* reliefs, Imperial Institute, London 1892; bronze candelabra, St. Paul's Cathedral 1898; relief for Lloyd's Registry of Shipping, London 1901; decorative panels for St. Paul's School for Girls, Hammersmith 1909; and a frieze for the United Universities Club, Suffolk Street *c.*1906. He exhibited at the RA 1884–1936. ARA 1904; RA 1922; bronze medal at the Paris International Exhibition, 1889; silver in 1900; gold medal at Dresden, 1897.

1. Graves, vol.VI, London, 1906, pp.97–8; 2. *RAE*, vol.V, Wakefield, 1981, pp.294–6; 3. Beattie, 1983, p.248; 4. A.S. Gray, *Edwardian architecture, a biographical dictionary*, London, 1985.

Number of works in Catalogue: 1

Richard Perry (b.1960)
Educated at Leeds Polytechnic, he has works in the public collections of a number of county councils. Works include: *Quartet*, life-size bronze figures, the Old Market Square, Nottingham 1990–1; *Thomas Boulsover*, bronze figure, Tudor Square, Sheffield.

Number of works in Catalogue: 1

A. John Poole (b.1926)
Born in Birmingham, he went to Birmingham School of Art and then studied Industrial Design at Birmingham School of Art 1938–9. For two years during the war he worked in William Bloye's studio, where he learnt the art of letter-carving in the tradition of Eric Gill. He later completed his National Design Diploma at Birmingham School of Art 1949–51 and went on to teach sculpture part-time at Mid-Warwickshire College of Art and Walsall School of Art 1952–61. Poole set up his own studio in 1949 and moved to Bishampton, Worcs. in 1961. Mainly an architectural sculptor and letter-carver, Poole has also worked in

stone, wood, concrete and metal. Commissions include: *Commemorative Stone*, Tree Lovers League, Lee Bank, Birmingham 1960; *Figure*, Cannock Central Library 1959; *Abstract*, East Walk, Basildon, Essex 1960; figures of *St. Catherine* and *St. Mary*, Solihull School chapel 1961; *Life and Times of Liverpool*, relief, St. John's Precinct, Liverpool 1965; gates and doors, Park Tower Hotel, Knightsbridge, London 1973; high altar and ambo, St. Helen's Cathedral, Brentwood, Essex, for which he received the Otto Beit Award in 1974; *Sir Basil Spence* and *John Hutton* memorials, Coventry Cathedral 1978; *Field Marshal Wavel* and *Field Marshal Auchinleck* memorials, Wellington Chambers, St. Paul's Cathedral, London 1979; *Madonna and Child*, All Saints church, Gogowan, Shropshire 1982. Poole's architectural restoration work includes: Council house annexe, Edmund Street, Birmingham 1958; entrance front, Aston Hall, Birmingham 1972. Exhibitions include group shows at the Pershore Millennium 1972 and West Midlands Arts Exhibition, Lichfield Cathedral 1975. ARBS 1958; FRBS 1969. Chairman of the Society of Church Craftsmen; Member of the Arts League of Great Britain.

1. *Artists, craftsmen, photographers in the West Midlands*, West Midlands Arts, Stoke-on-Trent, 1977; 2. Letter from the artist, 13th April 1984.

Number of works in Catalogue: 3

Augustus Welby Northmore Pugin
(1812–1852)
Gothic Revival architect who was also the designer of many decorative elements in architecture, furniture, stained glass, church vestments, etc., and was a controversial and influential writer on architectural and religious matters. Pugin converted to Catholicism at an early age, and began independent practice as an

architect in 1836. For him, architecture became entwined with the re-awakening of feeling for the Roman Catholic church in England. He published many books, the most famous of which are the two early polemical discourses: *Contrasts ... Shewing the Present Decay of Taste* (1836) and *The True Principles of Pointed or Christian Architecture* (1841). His books expanded his theories that Gothic architecture could be built with modern materials and methods whilst being both beautiful and Christian. In 1836 he collaborated with Charles Barry in the preparation for the competition design for the new Houses of Parliament and then assisted with many aspects of its detailed ornamentation and interior design until his early death at the age of forty. His many churches include: St. Mary's, Derby 1837–9; St. Giles', Cheadle, Staffs. 1840–6; and St. Augustine's, Ramsgate 1845–7. He designed the Convent of the Sisters of Mercy in Handsworth, Birmingham 1840.

1. *Macmillan encyclopedia of architecture*, vol.3, London, 1982, pp.484–97; 2. P. Atterbury, and C. Wainwright (eds.), *Pugin: A gothic passion*, Victoria and Albert Museum, New Haven and London, exh.cat., 1994; 3. J. Harries, *Pugin: An illustrated life of Augustus Welby Northmore Pugin 1812–1852*, Aylesbury, 1973.

Number of works in Catalogue: 1

Edward Welby Pugin (1834–1875)
The son of A.W.N. Pugin, he began independent practice at eighteen on the death of his father, and had more than 100 churches listed at his death.

Number of works in Catalogue: 1

William Pye (b.1938)
Born in London, 16th July 1938, he studied at Wimbledon School of Art 1958–61 where he was taught by Freda Skinner, and at the RCA 1961–5. Taught at the Central School of Art and

Design 1965–70 and Goldsmith's College of Art 1970–7, becoming a visiting professor at California State University 1975–6. His major works are primarily explorations in the qualities of water, and he has worked extensively in collaboration with architects. In 1990, he formed the William Pye Partnership which is both a sculptural and an architectural practice. Making abstract metal sculptures which are often kinetic and have highly reflective surfaces, he has said that 'sculpture isn't naturally seductive but the addition of water gives it a sort of mesmeric quality to which people respond sympathetically'. His commissions include: *Balla Frois*, Glasgow Garden Festival 1988 (award winner); *Slipstream and Jetstream*, passenger terminals, Gatwick Airport 1988 (award winner); *Water Wall* on the British Pavilion designed by Nicholas Grimshaw and Partnership, Seville Expo 1992; Suspended water sculpture, British Embassy, Muskat, Oman 1994; *Confluence*, water sculpture, Hertford town centre 1994; *Cascade*, Market Square, Derby 1995; *Water Pyramid,* Le Colisée, Paris 1995. He also has public works in the USA and Japan. Work in progress (1995) includes: light features for Lambeth Palace, London and West India Quay feature for the London Docklands Development Corporation. Pye's films include: *Reflections*, 1971 and *Scrap to Sculpture*, 1975. Awarded the 'Structure 66' prize, Welsh Arts Council 1966; Royal UENO Award, Japan 1989. Exhibited throughout Great Britain including the Redfern Gallery, 1966 and subsequently; Ikon Gallery, Birmingham 1975; British sculpture in the twentieth century, Whitechapel Art Gallery 1981; Welsh Sculpture Trust Inaugural Exhibition, Margam Park, Port Talbot 1983. FRBS 1992; FRIBA 1993.

1. D. Farr, 'The patronage and support of sculptors' in *British sculpture in the twentieth century*, Whitechapel Art Gallery, London, exh.cat., pp.34–7 and 260; 2. Strachan, 1984, p.270; 3. CV provided by the artist for the WMCC Peace Sculpture Commission, 1984; 4. D. Redhead, 'Waterworks', *Crafts*, July/August 1989, pp.24–9; 5. 'Zen and the art of water', *Crafts*, London, no.105, July/August 1990, p.12; 6. C. Amery, 'Water: an art form to be tapped', *Financial Times*, 18th September 1995; 7. J. Watt, 'Making waves', *Perspectives*, February/March 1996, p.71; 8. Letter from the artist, 19th February 1996.

Number of works in Catalogue: 2

Walenty Pytel (b.1941)
Born in Sarny, Poland, 10th February 1941, he came to England aged five and studied graphic design at Hereford College of Art 1956–61. Working first as an illustrator for a book publisher in London, he also made paper models for window displays. He moved to Hereford in 1962 and opened two commercial art studios there, eventually turning to sculpture in 1965, first making models in metal and subsequently teaching himself welding. Pytel had studios in Woolhope from 1965–7 and then established the Bridge End Gallery and workshops at Letton, Herefordshire in 1979. He has works in private collections in Britain, Europe, United States, Australia and Canada. His commercial commissions in Birmingham were obtained through his agent, Henry Joseph of Allied Artists, Birmingham. Pytel's welded metal sculptures consist mainly of birds, animals and heraldic beasts and include: Scott Arms inn sign, Great Barr, Birmingham; mural, Chelmsley Wood shopping development. Main commissions include: *Silver Jubilee Monument*, Parliament Square, London, 1977; *The Fosser*, JCB Excavator Factory, Uttoxeter, Staffs. 1979; *Woodpecker*, H.P. Bulmer, Hereford and commissions for companies including Chanel, Paris and Cadbury's, Dublin. Exhibitions include: RSPB Centenary Exhibition, Walsall Museum and Art Gallery 1989; Alte Wasserturm, Essen, Germany 1989; Society of Wildlife Artists, Mall Galleries, London 1988 (award winner), 1989–93. He has also had recent exhibitions in the Middle East. His first main exhibition in the Midlands was held at the Midland Bank, New Street, Birmingham 1978. Membership: ARBS.

1. 'Banking on sculpure in soft steel', *Post*, 13th February 1978; 2. *The man who brings steel to life*, publicity leaflet provided by the artist, Hereford, 1983; 3. *The Bridge End Gallery leaflet*, undated; 4. Information provided by the artist, 6th March 1986; 5. Letter sent by artist, February 1996.

Number of works in Catalogue: 3

Paul Richardson (b.1967)
Born 3rd July 1967 in Barking, Essex, he studied Graphic Design 1983–5 and a Foundation course 1985–6 at Loughton College of Further Education before taking a degree in fine art at Birmingham Polytechnic 1986–9. He lived and worked in Birmingham until September 1995, during which time he was a member of the Rhubarb Studios at the Custard Factory, Digbeth, amongst others. He now lives in Suffolk and works in a studio in Brewery Yard, Ipswich. Public artworks include: *Busker* (archway feature) and *Canaletto murals*, Windmill Estate, Smethwick 1993; *Gun Powder Plot*, Snibston Discovery Park, Leicestershire 1994; *Divers*, Whitstable Leisure Pool, Whitstable 1995. Solo exhibitions include Alchemy, Bond Gallery, Birmingham 1993. Other exhibitions include: 3F Studios Show, Art College, Leamington Spa 1993; Food is Art, with Ivan Smith, Café des Artistes, Custard Factory, Birmingham 1993; Undercurrents, Network Touring Exhibition 1994–5. He has works in several private collections.

1. Letter and CV from the artist, 20th February 1996.

Number of works in Catalogue: 2

John Roddis (1839/40–1887)
A prominent sculptor with premises on Aston Road where he died in August 1887. Roddis did much carving for churches, such as the reredos of Wretham Road church (demolished); most of the carving for St. Augustine's, Edgbaston (c.1870); and also St. Catherine's of Sienna (1875, now demolished); the carvings for Goulbarn Cathedral, South Australia; and, incomplete at his death, a commission for Christchurch Cathedral, New Zealand. He also completed all of the exterior carving of Birmingham Museums and Art Gallery, except for the pediment (c.1885). He was responsible for many monuments including the *Earl of Derby's tomb*, Knowsley 1872, and the *Augustine Memorial* erected by Lord Granville on the Isle of Thanet. A foremost Liberal, he was on the Aston Local Board; the Aston School Board; was a founder member of the Midland Arts Club – its president in 1885; and a member of the Municipal School of Art Committee. He worked in a partnership known as Roddis and Nourse from 1870 until his death, and the firm continued until 1900.

1. Obituary, *Post*, 5th August 1887; 2. 'Building intelligence', *Building News*, vol.29, 1st October 1875, pp.378–9.

Number of works in Catalogue: 1

John Wenlock Rollins (1862–1940)
Born in 1862, he died in Chelsea, 6th June 1940. Attended the Birmingham School of Art, the South London Technical School under W.S. Frith (winning prizes in a National Art competition in 1885 and 1886), then the Royal Academy 1886–90. His first major architectural work was a marble mantlepiece for Hewell Grange, Worcs., 1890. After visiting Italy in 1891, he assisted Stirling Lee on panels for St. George's Hall, Liverpool 1892; produced decorative carving on Croydon Municipal Buildings for Charles Henman 1894–5; made a bronze fountain for the Horniman Museum and contributed figures for the principal façade of the Victoria and Albert Museum c.1905. His chief works are the colossal statue of *Queen Victoria* at the Royal Victoria Hospital, Belfast; and the *Boer War Memorial*, Eton College Chapel. He exhibited at the Royal Academy 1897–1913, showing many busts including those of *Colonel V. Milward*, 1891; *Bertram Priestman,* 1893; the *Duchess of Bresagli*, 1900; and several idealised works such as *Memories*, 1887; *Nydia*, 1901; and a statuette of a sea maiden, 1902.

1. Graves, vol.III, London, 1905, p.354; 2. Beattie, 1983, p.249.

Number of works in Catalogue: 1

Hans Schwarz (b.1922)
Born in Vienna he came to Birmingham in June 1939 and worked as a labourer for a year at the Cadbury factory, Bournville, before being interned. He attended Birmingham School of Art 1941–3, then worked in a commercial art studio 1943–5, also teaching part-time. He taught at various art schools until 1966. From 1945 he turned freelance designer but gave up graphic design in 1964 to paint and sculpt full-time. He has exhibited widely since 1940 in Birmingham and London, exhibiting solo from 1955. Commissions for both public and private bodies include: a large bronze figure, Wallsend-on-Tyne shopping precinct 1965; a large relief stainless steel fountain, for BR headquarters, Cardiff 1968; fibreglass relief, Greenwich library, Kidbrook estate 1973. In 1981 he won the £5,000 watercolour of the year Hunting prize. His work is in the collections of the National Portrait Gallery; the National Maritime Museum; Glasgow Art Gallery; Newport Art Gallery and Bridgwater Museum; and he has exhibited at the RA from 1975. Since 1966 he has written several books on art for Studio Vista and Pitman's, and has written articles for the *Artist*. He is a member of the New English Art Club; RWS; an Honorary Life Member of Hampstead Artists Council; RSBA. He has lived in London since 1953.

1. Biography from the artist, 1985; 2. Letter from the artist, February 1996; 3. *WWA*, 26th edition, Havant, 1994, p.423.

Number of works in Catalogue: 1

Harry Seager (b.1931)
Born in Birmingham, 9th May 1931, he trained at Birmingham School of Art from 1951–3. He has taught at Stourbridge College of Technology and Art as a part-time senior lecturer in fine art. Seager's early work was figurative and dominated by the influence of Henry Moore, but between 1964 and 1976 he became interested in Constructivism and Minimalism, working mainly in sheet glass. After a period of four years, when he stopped sculpting to concentrate on his drawing, he started to work in the figurative direction again. Commissions include: *Dream-Boat*, St. James's Street, London 1969, as well as work for the Leicester Education Authority; City Architect's Department, Birmingham; Beaufort Construction, London; and Bertelli Esportanzioni, Massa, Italy. He is currently producing a cast concrete sculpture for the Bellevue Primary School, Wordsley, West Midlands as part of a sculpture trail. He is represented in the collections of Dudley Art Gallery; CAS, London; City of Leeds Art Gallery; Victoria and Albert Museum, London and in private collections in Canada, USA, Holland, Italy and the UK. Exhibited since 1965, including five times at the Gimpel Fils Gallery, London between 1965 and 1981; group shows include: Exhibition of British Sculpture, Coventry Cathedral, 1968; Birmingham

Museums and Art Gallery, 1969; 10th Biennale of Sculpture, Middleheim Park, Belgium 1969; New Dimensions '71, Camden Art Centre, London 1971; International Directions in Glass Art, Australia (touring) 1982–3; Glass Fantastic, Birmingham Museums and Art Gallery, 1987; Sculptures, Reliefs and Drawings, Gimpel Fils, London 1989; Museum of Steel Sculpture, Ironbridge 1991.

1. Strachan, 1984, p.272; 2. Letter from the artist, 6th January 1986; 3. *WWA*, 26th edition, Havant, 1994, p.425; 4. R. Walker, 'Benjamin and Seager', *Arts Review*, December 1976, p.692.

Number of works in Catalogue: 2

Bernard Sindall (b.1924)

Born 24th November 1924, Sindall's early art training was interrupted by the war, during which he served in the Royal Navy corvettes. He won the Prix de Rome whilst at Brighton College of Art between 1946 and 1950 and then spent two years at the British School in Rome and travelling in Europe. Since the mid-1950s he has lived on the Kent-Sussex border, teaching at Canterbury and Maidstone. Two recent commissions are *Abundance and Seduction*, a roundel of the garden of Eden, gilded in gold leaf, Rotterdam Plaza 1992; and nine *Greek Muses*, in fibreglass and gilded with gold leaf, Barbican Centre, London 1993. He has also worked as a stonemason and a trawlerman. A mainly figurative sculptor, Sindall has exhibited at the RA; in Rome, 1951; Rye, 1974; Barber Institute of Fine Art, 1974; Bedford House Gallery, London 1976.

1. 'At the Bar', *Country Life*, 27th June 1974; 2. *University of Birmingham Bulletin*, no.222, 28th October 1974; 3. 'London report', *Art International*, February/March, 1976, p.42; 4. *WWA*, 21st edition, Havant, 1984, p.404; 5. *Arts Review*, July 1992, p.272; 6. *The Independent*, 6th October 1993.

Number of works in Catalogue: 1

Ray Smith (b.1949)

Born 8th March 1949, Ray Smith studied at Cambridge University 1968–71. As well as producing free-standing steel sculptures, he has done a substantial amount of painted, mosaic and ceramic tile mural work for public and private commissions. He is also a book designer and illustrator, and has designed and edited practical painting and drawing books for Dorling Kindersley as well as children's books for Jonathan Cape. He has lectured at various colleges including the Chelsea School of Art and the University of Plymouth. Solo exhibitions include: Ikon Gallery, Birmingham 1980; Institute of Contemporary Arts, London 1980; John Hansard Gallery, Southampton 1982; Spacex Gallery, Exeter 1987; South Hill Park Arts Centre, Bracknell 1988; The Winchester Gallery, Winchester 1990. Recent group exhibitions include: Contemporary Art Society Art Market, Royal Festival Hall, London 1994; Aspex Gallery, Portsmouth 1994; Knowle Gardens, Sidmouth Festival 1995. In 1993 he won the Royal Society of Arts 'Art for Architecture' Award. He was consultant and co-author for a public arts strategy document for the city of Liverpool in 1994 and he is the artist member of the Art Working Group for the National Curriculum. He is represented in various public collections in England, Wales and Germany.

1. R. Smith, *Open country: A survey of the work of Ray Smith 1972–1980*, Llandudno, 1980; 2. Letter and CV from artist, 20th January 1996.

Number of works in Catalogue: 1

Thomas Stirling Lee (1857–1916)

Born in London, he was apprenticed to J. Birnie Philip, who was at the time working on the Albert Memorial. Lee studied at the Royal Academy 1876–80, winning a gold medal in 1877 and a travelling scholarship in 1879. He went first to Paris, studying at the École des Beaux Arts 1880–1, and then to Rome for further tuition 1881–3. Back in England he assisted Alfred Gilbert with his experiments in the lost-wax casting process. He produced portraiture, ideal work and architectural sculpture. Other works include: *Bust of Alderman Edward Samuelson*, Walker Art Gallery, Liverpool. In 1887 he became a member of the Art-Workers' Guild, becoming a Master in 1898. Founder member of RBS.

1. J. Johnson, and A. Greutzner, *Dictionary of British artists 1880–1940*, Woodbridge, Suffolk, 1976; 2. Obituary, *The Studio*, August 1916; 3. Beattie, 1983; 4. G.M. Waters, *Dictionary of British artists working 1900–1950*, Eastbourne, 1975.

Number of works in Catalogue: 1

John Thomas (1813–1862)

Born at Chalford, Gloucs., 1813 and died in London, 9th April 1862. Apprenticed to a stonemason after being left an orphan at thirteen, he later went to Birmingham where a brother was practising as an architect. Having made a Gothic monument, Sir Charles Barry engaged him to execute the ornamental stone and wood work on Birmingham Grammar School, which took Thomas three years to complete. He executed forty-one pieces of sculpture at the British Institute and worked all over the country on a wide range of commissions. His output was colossal, for he also worked as an architect. He exhibited at the RA 1842–61, at the British Institution in 1850 and at the Great Exhibition in 1851. His best known work is for the Houses of Parliament and elsewhere in London; he also sculpted the lions on the Britannia bridge, Menai Straits. There is a bronze group of *Boadicea and her Daughters* and a bust of *Prince Albert* in Birmingham Museums and Art Gallery. His last work was a colossal statue of *Shakespeare* erected at the International Exhibition of 1862.

The main collection of his work is preserved at the Fine Arts Academy, Bristol.

1. Gunnis, 1964; 2. Graves, vol.IV, London, 1906; 3. 'John Thomas', *Art Journal*, 1849, p.340; 4. Obituary, *Art Journal*, 1862, p.144; 5. *Illustrated London News*, 14th June 1862; 6. Virtue, J.S. (ed.), *The Art Journal illustrated catalogue of the International Exhibition 1862*, London, 1863.

Number of works in Catalogue: 2

Robert Thomas (b.1926)

Born 1st August 1926 in Rhondda, Glamorgan. He studied art at Cardiff College of Art 1947–9 then the Royal College of Art 1949–52. He won the Otto Beit Medal from the RBS in 1963 and is a Past-President of the Society of Portrait Sculptors 1972–7. His public works include those in Broadway Shopping Centre, Coalville, Leics. 1963; *Teenager*, St. Anne's Girl's School, Hanwell, West London 1966; Blackburn, Lancs. 1974; *Family Group*, Ealing, London 1984; statue of the *Right Honorable Aneurin Bevan, M.P.*, Cardiff 1987; *Captain Cat*, Swansea Maritime Quarter 1990; commemorative statue of a miner's family, Rhondda, Glamorgan 1993. His portraits include *HRH Princess Diana*, 1989; *Viscount Tonypandy; Gwyn Thomas; Sir Geraint Evans; Dame Gwyneth Jones*. Thomas is currently working on a statue of *Isambard Kingdom Brunel* for Neyland, Milford House, Pembrokeshire.

1. *WWA*, 26th edition, Havant, 1994, pp.472–3; 2. Letter from the artist, 14th February 1996.

Number of works in Catalogue: 1

Sir Edward Thomason (1769–1849)

Thomason was a well-known Birmingham manufacturer and inventor, best known for his coins, jewellery, medals, gilt and painted buttons, and gold, silver and bronze tokens. He also produced facsimiles of the Warwick vase, which took seven years to complete. Other works include a bronze bust of the Duke of Wellington, which was presented to the Cavalry of England, Canterbury Cavalry Barracks by his widow. The first Birmingham industrialist to be knighted, he wrote his *Memoirs* in 1845.

1. E. Thomason, *Memoirs*, London, 1845.

Number of works in Catalogue: 2

Albert Toft (1862–1949)

Born 3rd June 1862 in Birmingham, died 18th December 1949 in Worthing. The son of Charles Toft, designer and modeller for pottery, he studied at Birmingham, and then at Hanley and Newcastle under Lyme Schools of Art. During this time he was also apprenticed to Wedgwoods as a modeller. In 1879 he won a National Scholarship to the National Art Training Schools (now the Royal College of Art), London, where he studied for two years under Lanteri. He had his own studio in London producing portraits, for example *George Wallis*, 1890 (in Victoria and Albert Museum) and specialising in genre figures, groups and ideal figures. His first great success was with a figure of *Lilith*, 1889 (in Birmingham Museums and Art Gallery). Other major works include: bronze statuette of *Mother and Child*, Preston 1889; *Fate-led*, 1862 (in Walker Art Gallery, Liverpool); *Spring*, 1897 (in BMAG); *The Spirit of Contemplation*, 1901 (in Laing Art Gallery, Newcastle upon Tyne); *The Metal Pourer*, Cardiff 1913; *The Bather*, 1915, Chantrey Bequest, Tate Gallery. He was also a sculptor of monuments including: *Queen Victoria*, Nottingham 1905; *Welsh National Memorial*, Cathays Park, Cardiff 1909; and throughout his career he continued to produce portrait busts including those of *Sir George Frampton RA*, 1915; *Sir Henry Irving RA*, 1919; and *Sir Alfred Gilbert MVo RA*, 1935. Exhibitions: RA 1885–1947. FRBS 1923.

1. M.H. Spielmann, *British sculpture and sculptors of today*, London, 1901, p.121; 2. A. Toft, *Modelling and sculpture: A full account of the various methods and processes employed in these arts*, London, 1924; 3. *WWA*, 2nd edition, 1929, London, p.458; 4. J. Mackay, *Dictionary of western sculptors in bronze*, Woodbridge, Suffolk, 1977, p.273.

Number of works in Catalogue: 3

Roderick Tye (b.1958)

Born in Coventry, Tye studied fine art and art history at Leeds Polytechnic 1979–81 before going to the Slade School of Art 1982–4. He was given a scholarship to the British School in Rome, gaining the Gulbenkian Rome Scholar in Sculpture 1984–5. Artists who have had particular influence on his development include Bernini, Giacometti, Lucino Fabro, Carl Plachman, John Davies and Pontormo. Tye produced a series of Baroque-influenced works based on his experience of Rome, which were shown in an Ikon Gallery exhibition in 1986. He has been lecturer at the Royal College of Art and Goldsmith's College of Art, London, and currently lectures in sculpture at the Slade School of Art. Solo exhibitions include: La bestia diventa fontana, Ikon Gallery, Birmingham 1986; Anna Bornholt Gallery, London 1989; Long and Ryle Gallery, London 1991; Gilmour Gallery, London 1995. Other major exhibitions have included those in Rome and Florence; Sculpture '93, Chelsea Harbour, London 1993; Whitechapel Open, London 1988, 1989 and 1994. Public commissions include: National Garden Festival, Stoke-on-Trent 1986; 9–13 Carthusian Street, London EC1 (Public Art Development Trust) 1987; National Art Collections Fund, 1991. There is a free-standing bronze in the collection of the Birmingham Museum and Art Gallery, *L'Angelo della Morte*, purchased 1990.

1. *Public Art Commissions Agency records*; 2. Letter and CV from the artist, 19th January 1996; 3. *Roderick Tye, La bestia diventa fontana: recent sculpture and drawings*, Ikon Gallery, Birmingham, exh.cat., 1986;

4. T. Sidey, review of Ikon Gallery exhibition, *Arts Review*, vol.38, 25th April 1986, p.225.

Number of works in Catalogue: 1

John Van Nost the elder (d.1729)

An inhabitant of Mechlin, Belgium, he came to England where he was said to have studied under Grinling Gibbons. He was employed as foreman to the sculptor Arnold Quellin until his master's death in 1686, whereupon he married Quellin's widow. Working from a yard in the Haymarket, London, Van Nost had a good reputation, making lead garden figures and vases for the gardens of many houses including Chatsworth (*c*.1698), Stourhead, Wilts., Boreham, Essex, Rousham, Oxon., and Seaton Delaval in Northumberland. He made statues, vases and chimney pieces for Thomas Coke's houses at Melbourne and at St. James's, London; the statues on the pediment of Buckingham House; and from 1700 he made designs and a model for fountains, figures, vases, panels and pedestals for the exterior of Hampton Court, and two marble tables and chimney pieces for the interior. In 1703–10 he made lead statues for Castle Howard; in 1705–16, two vases and eight heads for the Duke of Kent's house at Wrest Park, Bedfordshire; and in 1723 he made a statue of *Sir Robert Geffrye* for the Ironmongers' Company in Shoreditch. Other statues include *William III and Mary*, for the Royal Exchange, London *c*.1700; *Queen Mary*, University College, Oxford 1720; and *George I*, Grosvenor Square, London 1726. He made several important monuments, notably one for the Duke of Queensberry at Durisdeer, Dumfries 1711, with life-size figures of the Duke and Duchess under a great baldacchino supported by four twisting Corinthian columns, all in white marble. Van Nost died on 26th April 1729, his business being carried on by a nephew of the same name.

1. K. Garlick, 'Birmingham's only "horse"', *Post*, 8th July 1952; 2. Gunnis, 1964, pp.279–82.

Number of works in Catalogue: 1

John P. Walker (1912–?)

Born in 1912 he registered at Birmingham School of Art aged 12 years and 9 months in September 1925 and studied there until at least 1936. No attendance registers exist for the 1936–8 sessions and his name is not listed in subsequent years. According to a fellow student, Walker died young.

1. Birmingham School of Art, *Student Registers*, 1925–38; 2. Information provided by Robert Pancheri, 12th March 1986.

Number of works in Catalogue: 1

William Henry Ward (1844–1917)

Born at Allanton, Lanarkshire in 1844, he died at his home, Stafford House in Handsworth, in 1917. He was articled to the architect James Cranston of Oxford who designed two Gothic churches in Birmingham. Ward came to Birmingham in 1865, building up a large practice, designing hotels, restaurants and, in 1889, the Dudley Road Infirmary and the City Sanatorium. He worked as far away as Mexico City where he designed a public market. His restoration jobs included work at Maxstoke and Warwick castles. A keen exponent of historical styles he wrote a book, *Architecture of the Renaissance in France*, first published in 1911.

1. B. Little, *Birmingham buildings*, Newton Abbot, 1971, p.126.

Number of works in Catalogue: 1

Antony Weller (b.1927)

Born in London, 4th May 1927, he attended Wimbledon School of Art and the Royal Academy under Maurice Lambert. He makes sculpture in fibreglass, marble and bronze. His work is in permanent collections in the USA,

UK, South Africa, Japan and in private collections. An instructor at Camden Institute, he lives in London. Exhibited at the Royal Academy from 1956.

1. *WWA*, 26th edition, Havant, 1994, p.504; 2. *RAE*, vol.VI, Wakefield, 1982, p.251.

Number of works in Catalogue: 1

Sir Richard Westmacott (1775–1856)

Westmacott's father was a sculptor and he was sent to study under Canova in Rome in 1793, winning a gold medal in 1795. Returning to Britain in 1797, he started studying at the Royal Academy, where he exhibited 69 works until his death. One of the most prolific and well-known sculptors of his day, he was said to be earning £16,000 a year at the height of his success. He made many statues for Westminster Abbey (for example, *Pitt*, 1807–13) and St. Paul's Cathedral (for example, *Collingwood*, 1813–17), as well as major examples elsewhere: for example, *Achilles*, Hyde Park 1822; *Fighting and Dying Gladiators*, Woburn Abbey 1820. He was made Professor of Sculpture at the Royal Academy in 1827 on the death of John Flaxman, and knighted in 1837.

1. E. Benezit, *Dictionnaire des peintres, sculpteurs, dessinateurs et gravures*, Paris, 1976, vol.10, p.707; 2. M. Whinney, *Sculpture in Britain 1530–1830*, London, 1988, pp.384–97; 3. J. Mackay, *Dictionary of western sculptors in bronze*, Woodbridge, Suffolk, 1977; 4. E.G. Underwood, *A short history of English sculpture*, London, 1933; 5. M. Busco, *Sir Richard Westmacott*, 1994.

Number of works in Catalogue: 1

Thomas White (*c*.1674–1748)

Born in Worcester in 1674, he died there in 1748. He went to London as a boy and was apprenticed to a statuary in Piccadilly. In 1709 he was admitted a Freeman of Worcester, where he made a statue of Queen Anne, now in the centre of the façade of the Guildhall. Three

years later, he worked on a statue of Charles I, receiving £10. Between 1721 and 1724 he worked on the Guildhall, being responsible for most of the decorative carving including a great trophy of arms in the pediment signed and dated 1722. He is also attributed with a figure of Britannia on a house in Worcester as well as other figures there. In 1726–31 he built the brick church of St. Mary and St. Margaret, Castle Bromwich, in a traditional early Georgian style, but encasing the old timber building within it. As a statuary his most important monument is that to *Admiral Skynner*, Ledbury, Herefordshire, 1725, with its life-size busts. Other works signed by him include memorials to *Adam Cave*, Evesham 1698; *Sir John Turton*, Alrewas, Staffs. 1707; *Bishop Thomas*, 1710 and *Henrietta Wrottesley*, 1720, both in Worcester Cathedral; *Sir John Bridgeman*, 1719, and *Roger Mathews*, 1746 both at Llanbodwell, Shropshire; *George Peyton*, Tewkesbury Abbey, 1742; and *John Brydges*, Bosbury, Hereford 1742. He also had a yard in Shrewsbury because the monuments in Llanbodwell are signed 'of Salop'. He is said to have died a bachelor, leaving his wealth to Worcester Infirmary.

1. Gunnis, 1964, pp.430–1.

Number of works in Catalogue: 1

Bruce Williams (b.1962)

Born 21st March 1962 in Münster, Germany, his family moved to England in 1965. He studied art at Winchester School of Art and did his degree at Gwent College of Higher Education. He now lives and works in Brighton where he has had many exhibitions and installations, often on the subject of HIV and Aids. *Kiss Wall*, Brighton (1992) first used the technique of computer-modifying photographic halftones, with glass rods through bronze to show the resulting detail. Other public works include a

piece at Leicester Infirmary, 1995; and the Grafton Centre, Cambridge, 1995. Many of his works are temporary installations, for example, *Objects of Desire*, 1990 and *Everybody's World Aids Day*, 1991, both at Piccadilly Circus and in collaboration with Artonic. He was artist in residence at the Aspex Gallery, Portsmouth, 1994–6, and he had a solo exhibition there in May–June 1996. He has also set up a local community TV station in Somerstown, Portsmouth and an internet project for Art Aids Link, 1994, in collaboration with Video Virus. He has published in Art in Public, (ed. Jones, 1992).

1. Information provided by the artist in conversation, 9th May 1996; 2. Birmingham Museums and Art Gallery, Public Art in Birmingham, Information sheet, no.26, 1996.

Number of works in Catalogue: 1

Francis John Williamson (1833–1920)

Born 17th July 1833 in Hampstead, he died 12th March 1920 in Esher, Surrey. He studied at the Royal Academy where he was a pupil of John Bell and the apprentice of John H. Foley, whom he assisted for twenty years. He became private sculptor to Queen Victoria and reputedly modelled almost all the members of the Royal Family at his studios in Esher. Primarily a portrait sculptor, he also produced a considerable number of public statues and memorials and some ideal works. Sculptures include: *Queen Victoria*, Royal College of Physicians, London, with replicas in Australia, Rangoon and Ireland; *Memorial to Dean Milman*, St. Paul's Cathedral, London; statuettes of *Prince Alice of Albany; The infant Prince Edward of York; Lord Tennyson*, 1894. Ideal works include: *Hetty and Dinah*, purchased by Queen Victoria; and *Hypatia*. Williamson was noted for his skilled treatment of draperies and materials.

1. M.H. Spielmann, *British sculpture and sculptors of today*, 1901, pp.18–19; 2. Graves, vol.VIII, London, 1906; 3. U. Thieme and F. Becker, *Allgemeines Lexikon der bildenen Künstler*, vol.XVI, Leipzig, 1947, p.28.

Number of works in Catalogue: 5

Francis Derwent Wood (1871–1926)

Born in Keswick, but taken abroad as a young child, he began studying art in Karlsruhe, Germany. He returned to England in 1889, where he briefly worked as a modeller in his uncle's potteries of Maw and Co., and also for the Coalbrookdale Iron Company. He gained a National Scholarship at the National Art Training School, taking a course of modelling under Edouard Lanteri. Between 1890 and 1893 he assisted Alphonse Legros at the Slade School and entered the RA Schools, in 1894 also becoming an assistant to Thomas Brock. In 1895 he won a gold medal and in 1897, having also won an award at the Paris salon, and took the post of modelling master at Glasgow Art School. In 1901 he settled in London. Between 1918 and 1923 he was Professor of Sculpture at the RCA and was a founder member of the RBS in 1905. Works by him include four statues for the Kelvingrove Art Gallery, Glasgow in 1889, a series of figures for Glasgow Central station, a statue of *Queen Victoria* for India, and *Sir Titus Salt* for Saltaire, and many others. His portrait busts include: *Queen Victoria* and *Queen Alexandra* for the Calvary Club, Piccadilly; *Baron Overton* and *Margaret Somerville* in the Christian Institute, Glasgow; and the architect *George Harrison Townsend*, 1904. His allegorical figures include: the statues *St. George* and *Cupid and Psyche*, and his architectural sculpture includes the mural monument *Love and Life, Sacred and Profane*; and the figuring for the Mercantile Chambers, Glasgow 1897–8. His work is in the collections of the Tate, Birmingham Museums and Art

Gallery, Manchester and Fitzwilliam art galleries, and also in Australia.

1. W.K. West, 'The work of F. Derwent Wood', *The Studio*, January 1905, vol.33, pp.297–306; 2. Beattie, 1983.

Number of works in Catalogue: 1

Thomas Woolner (1825–1892)

Born at Hadleigh, Suffolk. He showed early signs of proficiency in modelling, and studied with Behnes from age twelve. He became a student at the Royal Academy aged seventeen. Later, he became a member of the Pre-Raphaelite Brotherhood and wrote a poem which was published in the first issue of *The Germ,* the journal of the Pre-Raphaelites. He did not have much success with commissions in England, and emigrated to Australia in 1852 to become a gold digger, but he did continue his sculpture practice, and sent a piece back to England entitled *Love*, which enhanced his reputation. He returned to England in 1857, and from 1860 onwards began to execute a large number of public monumental statues, portrait busts and ideal works, the latter being the most successful of his œuvre. He was elected Professor of Sculpture at the RA (dates unknown). His portrait busts include *Arthur Hugh Clough, Richard Cobden , Gladstone, Charles Kingsley, Tennyson, Charles Dickens.* Statues include *Bacon*, Oxford; *Macauley,*

Cambridge; *John Stuart Mill,* Thames Embankment; and *Captain Cook,* Sydney Harbour, Australia.

1. E.G. Underwood, *A short history of English sculpture*, London, 1933, pp.104–5.

Number of works in Catalogue: 3

Vincent Woropay (b.1951)

Educated at the Slade School of Art from 1977–9, he then won a scholarship to study at the British School in Rome 1979–81. He is a visiting lecturer at a number of institutions and his work is to be found in various international collections. He has a large-scale work, *Hand with Mithras* at Stoke-on-Trent railway station, and also has a piece in Bristol. Exhibitions include: Fabian Carlsson Gallery, London 1989.

1. R. Martin, review of Fabian Carlsson Gallery exhibition, *Flash Art (international edition)*, no.145, March/April 1989, pp.122–3; 2. M. Lothian, 'Distant thunder', *Arts Review*, vol.40, 9th September 1988, p.626; 3. Public Art Commissions Agency, *Art at the International Convention Centre*, Birmingham, 1995.

Number of works in Catalogue: 2

Tom Wright

No biographical details are available, although it is known that he worked as a carver in Bloye's workshop.

Number of works in Catalogue: 1

Tadeuz Zielinski (b.1907)

Born at Trzeninia, near Cracow, Poland in 1907, he studied at the School of Art and Interior Architecture at Cracow between 1925 and 1932. In 1941 he became a prisoner of war in Kozielsk, Russia, where he executed a relief in limewood of *Holy Mother Victorious*, later called *Our Lady of Kozielsk*. Zielinski arrived in Britain in 1949. His main works include: six figures in stone at the Military Chapel, Tiberias, Palestine 1944–6; reconstruction of the third and fourth stations of the cross, Jerusalem 1946–9; altar relief in synthetic bronze, statue of *Christ* in aluminium and *Stations of the Cross,* St. Andrew's church, Hammersmith; *Justice,* mural relief in synthetic bronze, magistrate's court, Camberwell; *Symbol of Norwich,* synthetic bronze relief, London Street, Norwich; *Our Lady of Kozielsk,* ceramic, Basilica, Nazareth, Israel. Exhibitions include: International exhibition, Sacre Art Vatican Roma; Lambeth Palace, Festival of Britain 1951; Colour and Rhythm: paintings and sculptures by Polish artists in Great Britain, New Vision Centre, London 1964. He has also exhibited in Ontario, Canada and Munich, 1960.

1. Information provided by the artist, 1985; 2. *Colour and rhythm: paintings and sculptures by Polish artists in Great Britain*, 9th November – 28th November 1964, London, exh.cat., 1964.

Number of works in Catalogue: 1

Bibliography

Books and articles

Ainsworth, W., 'In search of George Dawson', *The Birmingham Historian*, no.5, Autumn/Winter, 1989.

'The Albert Memorials', *The Builder*, vol.20, 21st June 1862, p.445.

Antony Gormley completes TSB Sculpture, Press Release TSB bank, 23rd February 1993.

Antony Gormley: five works, Arts Council of Great Britain, London, exh.cat., 1987.

Archer, Prof., 'On the progress of our art industries, works in metal: Spurrier's art-metal works', *Art Journal*, vol.XIX, 1875, pp.135–6.

'Art beneath the rule of commerce', *The Builder*, vol.106, 1st May 1914, pp.517–19.

Artists, craftsmen, photographers in the West Midlands, West Midlands Arts, Stoke-on-Trent, 1977.

Aston Hall, Birmingham Museums and Art Gallery, Birmingham, 1981.

Aston University press release, 1994.

Atterbury, P. and Wainwright, C. (eds.), *Pugin: A gothic passion*, V&A Museum, New Haven and London, exh.cat., 1994.

Atterbury, P. and Irvine, L. *The Doulton Story*, London, 1979.

Attwater, D., *The Penguin dictionary of saints*, Harmondsworth, 1965.

Aumonier, W. (ed.), *Modern architectural sculpture*, New York, 1930.

Ayers, R., 'Before it hits the floor', *Artscribe*, no.39, February 1983, p.48.

Baldry, A.L., 'A notable sculptor: Alfred Drury, A.R.A.', *The Studio*, vol.37, February 1906, pp.3–18.

Banks-Smith, N., 'Fiore de Henriquez', *Guardian*, 24th July 1978, p.8.

Barbara Hepworth, The family of man, Marlborough Art Gallery, London, exh.cat. April–May 1972.

Barbara Hepworth: retrospective exhibition 1927–1954, Whitechapel Art Gallery, London, exh.cat., 1954.

Barnard, J., 'Victorian on the tiles', *Architect and Building News*, September 1971, pp.46–51.

Barnes, S., *A short history of the medical school*, University of Birmingham, Birmingham, 1957.

Beach, J., 'Accessing information on public sculpture in Birmingham: an interactive catalogue', *Computers in the History of Art*, vol.5, part 2, 1995, pp.37–49.

Beach, J. and Noszlopy, G.T., 'Public art and planning in Birmingham', *Planning History*, vol.18, no.1, 1996, pp.21–7.

Beattie, S., *The new sculpture*, London, 1983.

Bindman, D. (ed.), *John Flaxman*, London, exh.cat., 1979.

Birmingham Advisory Art Committee, *Annual report*, 1936–43.

Birmingham City Architects Department, *List of notable buildings in Birmingham*, Birmingham, 1977.

'Birmingham Civic Centre scheme', *Architect and Building News*, vol.168, 3rd October 1941, pp.9–11.

'Birmingham Council House extension', *Architectural Review*, vol.32, July 1912, pp.37–47.

Birmingham faces and places: An illustrated local magazine, vols.I–VI, 1888–94.

Birmingham Gas Department magazine, 1919–20.

Birmingham Gazette and associated Birmingham newspapers, progress 1741–1929, Birmingham, 1929.

Birmingham Information Bureau, *Statues, public memorials and sculpture in the City of Birmingham*, May 1977.

'Birmingham King Edward Memorial', *The Architect*, vol.87, January–June 1912, pp.326–8.

Birmingham memorial to King Edward VII, objects of the fund, Birmingham, 1910.

Birmingham Museums and Art Gallery, *Public art in Birmingham, information sheet*, nos.2–20, Birmingham, 1994.

Birmingham Museum and School of Art Committee, *Annual report*, 1890.

Birmingham Post year book and who's who, Birmingham, 1950–1996.

Birmingham School of Art, File 294, *The new College of Art*, August 1964 – June 1965.

Birmingham School of Art, *Student registers, 1898–1938*.

'Birmingham University', *The Builder*, 13th July 1907, p.55.

Black, H.J., *A history of the Corporation of Birmingham*, vol.VI, Birmingham, 1957.

Bloye, W.H., *Sales Ledger 1932–68*.

Boulton, R.L., *Catalogue*, c.1910.

(Boulton, Britannia and Supporters, Council House) *The Owl*, vol.II, no.2, 7th August 1879.

Bournville: The factory in a garden, publicity leaflet, n.d.

Brenson, M., 'Urban drama in high relief', *Art in America*, July/August 1979, pp.102–9.

Bridge End Gallery leaflet, n.d.

Bridgeman, R. and Sons, *Heritage of beauty*, publicity leaflet, n.d.

(Robert Bridgeman, Allegorical Figures) *The Builder's Journal and*

Architectural Engineer, 2nd October 1907, pp.166–7.

(Robert Bridgeman, Caryatids) *RIBA Journal*, 1897, p.338.

(Robert Bridgeman, Court Oak) *The Studio*, vol.9, October 1896, p.53.

Brindleyplace press release, 10th August 1995.

Briggs, A., *History of Birmingham*, vol.II, London, 1953.

Briggs, A., *The power of steam*, London, 1982.

Briggs, G. (ed.), *Civic and corporate heraldry*, London, 1971.

Broadgate House, *Broad Street*, Birmingham, 1964.

(Thomas Brock, Queen Victoria) *Birmingham magazine of arts and industries*, no.3, vol.3, 1901, pp.73–7.

Budden, L.B., 'The Birmingham Hall of Memory', *Architectural Review*, vol.59, February 1926, pp.50–5.

'Building intelligence', *Building News*, vol.29, 1st October 1875, pp.378–9.

Bunce, J.T., *History of the Corporation of Birmingham*, vol.II, Birmingham, 1883.

Cannon Hill Trust, *Sculpture in a city*, Birmingham, May 1968.

'Captain Webb memorial at Dover', *Building News*, vol.98, no.2893, 17th June 1910, p.825.

(Robert Carruthers, Gate Construction), *Studio International*, vol.184, July/August 1972, p.17.

Chancellor, E.B., *The lives of the British sculptors*, London, 1911.

Chantrey Ledger, Royal Academy of Arts, London.

(Julius Alfred Chatwin, Ghiberti and Cellini), *Art Journal*, vol.XIX, 1875, pp.135–6.

Chronicles, chapter 1, verse 22; chapter 2, verses 2–6.

Church leaflet, St. Martin's Church, Bull Ring, n.d.

'The Church of St. Agatha', *The British Architect*, vol.LIX, 23rd January 1903, pp.62–3.

'The Church of St. Agatha, Sparkbrook, Birmingham', *The Builder*, vol. LXXXIV, 10th January 1903, p.40.

City of Birmingham Education Committee, *The Inauguration of the Building for the Colleges of Technology, Commerce and Art, Gosta Green by Her Majesty Queen Elizabeth II Accompanied by His Royal Highness the Duke of Edinburgh, 3rd November 1955*, Birmingham, 1955.

City Sculpture, Arts Council of Great Britain, London, 1972.

Cohen, D., 'Out of India: Hindu spirituality in recent British sculpture', *Sculpture*, Washington DC, vol.13, January/February 1994, pp.20–7.

Colour and Rhythm: paintings and sculptures by Polish artists in Great Britain, 9th November – 28th November 1964, London, exh.cat., 1964.

Colvin, H., *A biographical dictionary of British architects 1600–1840*, London, 1978.

(Cooke and Twist, Hall of Memory), *Architectural Review*, July 1912, vol. 87, pp.37–47.

Cooper, J., *Nineteenth-century romantic bronzes*, London, 1975.

Copnall, E.B., *A sculptor's manual*, Oxford, 1971.

Copnall, Edward Bainbridge, obituary of *The Times*, 3rd February 1975.

'Trewin Copplestone: portrait of the artist', *Art News and Review annual year book*, 13th April 1957.

(Trewin Copplestone, Bull Forms), *Focus*, Birmingham Christian news series, January 1964, p.8.

Cosmo, W., *The works of J.H. Foley*, London, 1875.

Courtney, C., 'Sculpture by Angela Conner', *Architect* (RIBA), vol.93, October 1986, p.13.

Cox, P., *Sculpture in a City*, Cannon Hill Trust, Birmingham, 1968.

'A craftsman's portfolio', *Architectural Review*, vol.LX, no.361, December 1926, pp.258–9.

Crawford, A., *Tiles and terracotta in Birmingham*, Victorian Society, Birmingham, 1975.

Crawford, A. and Thorne, R., *Birmingham pubs 1880–1939*, Birmingham, 1975.

(Benjamin Creswick), *Birmingham Magazine of Arts and Industries*, 1901–3, vol.III, pp.171–5.

Curtis, P. and Wilkinson, A.G., *Barbara Hepworth: a retrospective*, Tate Gallery, Liverpool, exh.cat., 1994.

Darby, E. and M., 'The national memorial to Victoria', *Country Life*, 16th November 1978.

Darke, J., *The monument guide to England and Wales: a national portrait in bronze and stone*, London and Sydney, 1991.

(Fiore de Henriques), *Art News*, vol.58, no.50, March 1959, p.60.

Dent, R.K., *Old and new Birmingham*, Birmingham, 1880.

Dent, R.K., *The making of Birmingham*, Birmingham, 1894.

Department of the Environment, *List of buildings of special architectural or historic interest*, London, 1982.

'Designer's jottings', *Artist*, vol.28, 1900, p.107.

Dickinson, H.W., *James Watt, craftsman and engineer*, Cambridge, 1936.

Dickinson, H.W., *Matthew Boulton*, Cambridge, 1937.

Dictionary of national biography, vols.6–40, London, 1886–94.

Dimitrijevic, N., 'Haywood Annual', *Flash Art (international edition)*, no.123, Summer 1985, p.58.

Downes, K., *English Baroque architecture*, London, 1966.

Doyle-Jones, F.W., *Francis William Doyle-Jones, Correspondence – Sculptor of Memorial in King Edward Square*, 1922.

Durman, M. and Harrison, M., *Bournville 1895–1914: The model village and its cottages*, Birmingham, 1996.

Edwards, E., *John Skirrow Wright MP – A memorial tribute*, Birmingham, 1880.

Edwards, M., *Raymond Mason*, London, 1994.

Edwards, T., *Birmingham treasure chest*, Birmingham, 1955.

Ettlinger, L.D., *Antonio and Piero Pollaiuolo*, Oxford, 1978.

Evans, S., *Arthur Heygate Mackmurdo, 1851–1942 and the Century Guild of Artists* (unpublished thesis) University of Manchester, School of Architecture and Town Planning, 1986.

Farr, D., 'The patronage and support of sculptors' in *British sculpture in the twentieth century*, Whitechapel Art Gallery, London, exh.cat., 1981.

Farrington, J. and Silber, E. (eds), *Raymond Mason: Sculptures and drawings*, BMAG, exh.cat., Birmingham, 1989.

Frink, E., *The art of Elizabeth Frink*, London, 1972.

Frink, E., *Catalogue Raisonné*, Salisbury, 1984.

Frink, E. and Lucie-Smith, E., *Frink: A portrait*, London, 1994.

Elizabeth Frink: sculpture and drawings 1950–1990, National Museum of Women in the Arts, Washington D.C., exh.cat., 1990.

Elizabeth Frink: sculpture and drawings 1952–1984, Royal Academy of Arts, London, exh.cat., 1985.

Gardiner, A.G., *Life of George Cadbury*, London, 1923.

Garlake, M., 'Round-up', *Art Monthly*, October 1989, p.21.

Garrett, A., 'The sculpture of Gordon Herickx', *The Studio*, vol.CXLVII, No.730, January 1954, pp.18–19.

'The George Dawson memorial', *The Dart*, Birmingham, 14th October 1881.

Gibbs and Canning, *List of terracotta façades*, issued by Tamworth Castle Museum, n.d.

Gilbert, W., 'The essentials of craftsmanship in metalwork', *Architectural Review*, vol.59, April 1926, pp.127–47.

Gilbert, W., 'Romance in metalwork', *RIBA Journal*, third series, vol.XIII, 1906, no.6.

Gilbert, W. and Weingartner, L., *Sculpture in the garden*, publicity booklet, Birmingham, undated (c.1925).

Gill, C., *History of Birmingham*, vol.I, London, 1952.

(Feodora Gleichen), 'London exhibitions', *Art Journal*, 1907, p.43.

(Feodora Gleichen), *The Studio*, vol.36, 1906, p.86.

Gormley, A., *Antony Gormley*, New York, 1984.

(Lee Grandjean, Untitled), *Arts Review*, 12th and 26th August 1988.

Graves, A., *Royal Academy exhibitors, 1769–1904*, vols.I–VIII, London, 1905–6.

Gray, A.S., *Edwardian architecture, a biographical dictionary*, London, 1985.

Greaney, Revd., *A guide to St. Chad's Cathedral Church*, Birmingham, 1877.

Green, L., 'Pleasing the heart: Dhruva Mistry in Birmingham', *Contemporary Art*, June 1993, pp.36–40.

Greenacre, F.W., *William Hollins and the Gun Barrel Proof House 1813*, Victorian Society, West Midlands Group, 25th May 1968.

Griffiths, J.C., *The third man: the life and times of William Murdock, 1754–1839, The inventor of gas lighting*, London, 1992.

Gunnis, R., *Dictionary of British sculptors 1660–1851*, London, 1964.

Hall, J., *Hall's dictionary of subjects and symbols in art*, London, 1974.

Hall, J., 'Landscape art – public art or public convenience', *Apollo*, London, no.129, March 1989, pp.157–61.

Hall, J. and Midgley, W., *History of the Royal Birmingham Society of Artists*, Birmingham, 1928.

Hardman, J. Studios, *The Studios in the Park*, publicity sheet, n.d.

Harman, T., *Showell's dictionary of Birmingham*, Birmingham, 1885.

Harries, J., *Pugin: An illustrated life of Augustus Welby Northmore Pugin 1812–1852*, Aylesbury, 1973.

Harrison, W.J. et al., *The Warwickshire Photographic Survey*, 1890–1955.

Harvey, W. A., *The model village and its cottages*, London, 1906.

Hayward, W., *The work of the Birmingham Civic Society*, Birmingham, 1946.

(Gordon Herickx, Heraldic Shields), *The Builder*, vol.79, 4th August 1939, p.196.

Hesiod, *Theogony*.

Hickman, D., *Birmingham*, London, 1970.

Hickman, D., *Joseph Chamberlain Memorial*, Birmingham Museums and Art Gallery, 1980.

Hill, J. and Kent, R.K., 'The memorials of Old Square', *Notices of the Priory of St. Thomas in Birmingham*, 1897.

Hobbiss, H.W., 'Applied decoration on buildings', *Effort*, April or June 1923, pp.3–5.

Hodgetts, M., *St. Chad's Cathedral, Birmingham*, Birmingham, 1987.

Horace, *Epistles*.

Hubert Dalwood, Gimpel Fils, London, exh. cat., 1970.

Hubert Dalwood, sculptures and reliefs, Arts Council of Great Britain, London, 1979.

Hyman, T., 'Raymond Mason at the Serpentine', *Artscribe*, no.39, London, February 1983, pp.47–8.

International who's who, London, 1981.

International who's who in art and antiques, 2nd edition, Cambridge, 1976.

Irvine, L., 'The architectural sculpture of Gilbert Bayes', *Journal of the*

Decorative Art Society, no.4, 1980, pp.5–11.

Italian text: Ms.338, Assisi Library, dated 1225. Translated by Fahy, Omnibus, pp.130–1, reproduced in A. Fortuni, *Francis of Assisi*, New York, 1981, pp.567–8.

John, chapter 8, verse 12.

Johnson, J. and Greutzner, A., *Dictionary of British artists 1880–1940*, Woodbridge, Suffolk, 1976.

Jones, J.T., *History of the Corporation of Birmingham*, vol.V, part.1, Birmingham, 1940.

Kelly, A., *Mrs. Coade's Stone*, 1990.

Kelly's directory of Birmingham, London, 1883–1929.

Kelly's directory of Warwickshire, London, 1900.

Kevin Atherton, A body of work, Serpentine Gallery, London, 1989.

Kings, Chapter 1, verses 5–9.

Langford, J.A., *A century of Birmingham life 1741–1841*, Birmingham, 1868.

Lee, D., 'The human touch', *Arts Review*, vol.40, 12th and 26th August 1988, p.585.

Lessore, H., 'Raymond Mason', in *A partial testament: essays on some moderns in the great tradition*, The Tate Gallery, London, c.1986.

Little, B., *Birmingham Buildings*, Birmingham, 1971.

Lomax, T., 'Artists account', in 'Building study: Urban Learning Foundation, Tower Hamlets, London', *Architect's Journal*, 21st April 1993, p.44.

'London report', *Art International*, February/March, 1976.

Loppylugs and Morrison, B.J., *Characters and craftsmen*, Bromsgrove, 1976.

Lucie-Smith, E., 'Dame Elizabeth Frink 1930–1993: An appreciation', *Art Review*, vol.45, June 1993, pp.58–9.

Lucie-Smith, E., *Elizabeth Frink: sculpture since 1984 and drawings*, London, 1994.

Mackay, J., *Dictionary of western sculptors in bronze*, Woodbridge, Suffolk, 1977.

Macmillan encyclopedia of architecture, vol.3, London, 1982.

Made in Birmingham: TSB's New Sculpture, TSB bank press release, 13th September 1991.

'Man and beast', *Studio International*, vol.198, December 1985, pp.40–1.

Marriott, C., 'The recent works of Gilbert Bayes', *The Studio*, vol.72, December 1917.

Martin, R., Review of Fabian Carlsson Gallery exhibition, 1989, *Flash Art (international edition)*, no.145, March/April 1989, pp.122–3.

Martyn, H.H., *Brochure,* in the archives of their historian, J.H.M. Whitaker.

Melville, R., 'Exhibitions', *Architectural Review,* vol.114, October 1953, pp.261–2.

'Midland Hotel, Birmingham', *The Builder*, vol.85, 1903, p.254.

(Mistry, Guardian 2), *Arts Magazine*, vol.60, October 1985, p.139.

Mitchell and Butler's, *Fifty years of brewing 1879–1929*, Birmingham, 1929.

(Nicholas Monro, King Kong), *Arts Review*, vol.39, 31st July 1987, p.526.

'Monumental', *The Builder,* vol.24, 7th April 1866, p.255.

Moss, D.J., *Thomas Attwood: The biography of a radical,* Montreal and London, 1990.

Murray, G. (ed.), *Art in the garden: installations*, Glasgow Garden Festival, Edinburgh, 1988.

Nairne, S. and Serota, N. (eds.), *British sculpture in the Twentieth Century*, Whitechapel Art Gallery, exh.cat., London, 1981.

(Neatby, Heads, beasts and figures), *The Studio*, vol.29, 1903, p.116.

Neil Kinnock to meet mystery commuter, Centro press release, 5th February 1996.

'The new arcade, Birmingham', *The Builder,* 2nd September 1876, p.862.

'The new Masonic Temple, Broad Street, Birmingham', *Architectural Review*, vol.62, 1927, pp.178–81.

New Masonic temple for the Masonic province of Warwickshire, Birmingham, 1926.

Newman, M., 'New sculpture in Britain', *Art in America*, vol.70, September 1982, p.177.

'Notes of the month', *Apollo*, vol.XIX, no. 113, May 1934, p.281.

Official Opening Ceremony, University of Birmingham, Medical School, leaflet, 2nd July 1954.

Official Opening Programme, Digbeth Institute, Birmingham, 16th January 1908.

Ondré Nowakowski: Recent works, Manchester Metropolitan University and Stoke-on-Trent City Museum and Gallery, exh.cat., 1995.

Opening Leaflet, Holy Trinity R.C. Church, 1934.

Opening Leaflet, St. John Fisher R.C. Church, March 1964.

Pancheri, R., 'The rise and demise of the Bromsgrove Guild', *Bygone Bromsgrove*, Stratford-upon-Avon, 1981.

Pedestrianisation in Birmingham, leaflet, Birmingham, 1990.

Penny, N., *Church monuments in romantic England*, London, 1977.

Percy, H.M., *New materials in sculpture*, London, 1962.

Petherbridge, D., *Art for architecture*, London, 1987.

Pevsner, N., *Warwickshire*, Buildings of England series, London, 1966.

Pevsner, N. and Metcalf, P., *The cathedrals of England: Midland, Eastern and Northern England*, London, 1985.

'Playgrounds in Birmingham', *Architect and Building News*, vol.218, 14th

December 1960, pp.767–8.

(Poole, St. Francis' Canticle to the Sun), *Focus*, incorporating Birmingham Christian News, February 1965, p.6.

Portoghesi, P., *Roma Barocca*, Cambridge, Massachusetts, 1970.

Proposed central mission for south Birmingham in connection with Carr's Lane Chapel, Birmingham, 1906.

'Provincial news', *The Builder*, vol.45, 3rd November 1883, pp.605–6.

Public Art Commissions Agency, *Sculpture commission announcement: public questionnaire findings*, n.d.

Public Art Commissions Agency, *Art at the International Convention Centre*, Birmingham, 1995.

'Public offices and depot, Yardley', *The Builder*, 3rd December 1898, pp.508–9.

Pugh, B., *Solid citizens: statues in Birmingham*, Birmingham, 1982.

Pye, W., *Peace sculpture for the Ackers, Small Heath, Birmingham*, WMCC press release, n.d.

Pytel, W., *The man who brings steel to life*, publicity leaflet, Hereford, 1983.

Raymond Mason: Coloured sculptures, bronzes and drawings 1952–1982, Arts Council of Great Britain, London, exh.cat., 1982.

Read, B., *Victorian sculpture*, New Haven and London, 1982.

Read, B. and Skipwith, P., *Sculpture in Britain between the wars*, London, 1988.

Redgrave, S., *Dictionary of artists of the English school*, London, 1878.

Redhead, D., 'Waterworks', *Crafts*, July/August 1989, pp.24–9.

'The reredos in St. Martin's Church, Birmingham', *The Builder*, vol.36, 20th April 1878, p.417.

Rhodes, D., *Brum trail 3*, Birmingham, 1975.

Roberts, E., 'Frink again', *Women's Art Magazine*, no.62, January/February 1995, pp.22–3.

Robinson, E. and Musson, A.E., *James Watt and the steam revolution: a documentary history*, London, 1969.

Roderick Tye, La bestia diventa fontana: recent sculpture and drawings, Ikon Gallery, Birmingham, exh.cat., 1986.

Roddis, J., *The Dart*, April 23rd 1881, p.11.

Ron Haselden, Fête and other works, Serpentine Gallery, London, exh.cat., 1990.

Rosenberg, E. and Cork, R., *Architects choice*, London, 1992.

Roustayi, M., 'An interview with Antony Gormley', *Arts Magazine*, vol.62, September 1987, pp.21–5.

Royal Academy exhibitors 1905–1970, vols.I–VI, Wakefield and London, 1973–82.

Royal Academy of Arts, *Student Registers, 1853–1890*.

Royal Academy of Arts, *Student Registers, 1890–1922*.

Royal Society of British Sculptors, *Annual Report and Supplement*, 1960.

Royal Society of British Sculptors, *Annual Report*, 1962–3.

Rushton, R., *Arts Review*, vol.42, 13th July 1990, p.390.

St. Mary's Harborne, booklet, c.1978.

'Sculpture', *Arts Review*, vol.38, 23rd May 1986, p.268.

'Sculpture: new law courts, Birmingham', *The Builder*, vol. 57, 21st December 1889, p.442.

Sidey, T., Review of Ikon Gallery exhibition, *Arts Review*, vol.38, 25th April 1986, p.225.

Sidey, T., 'British Rail passengers looking out of their window are in for a big surprise', *Arts Review*, 24th April 1987, p.263.

Skiff, V., *Victorian Birmingham*, London, 1983.

Smiles, S., *Lives of the Engineers*, three vols., London, 1968 edition.

Smith, R., *Open country: A survey of the work of Ray Smith 1972–1980*, Llandudno, 1980.

'Some new decorative work', *The Builder*, 16th March 1901, p.256.

Sparrow, W.S., 'A young English sculptor: Gilbert Bayes', *The Studio*, vol.25, March 1902, pp.102–8.

Spielmann, M.H., *British sculpture and sculptors of today*, London, 1901.

Stanton, P., *Pugin*, London, 1971.

Stillinger, J. (ed.), *John Keats complete poems*, London, 1982.

Stirling Lee, Thomas, obituary of, *The Studio*, August 1916.

Strachan, W.J., *Open air sculpture in Britain, a comprehensive guide*, London, 1984.

Strickland, W.G., *Dictionary of Irish artists*, vol.II, Dublin and London, 1913.

'The Sturge memorial at Birmingham', *The Builder*, vol.20, 21st June 1862, p.445.

Taplin, R., 'Raymond Mason at Marlborough', *Art in America*, vol.83, July 1995, p.87.

Tate Gallery, *Modern British painting, drawing and sculpture*, Tate Gallery catalogue, vol.I, London, 1964.

(Terpsichore fountain), *Bournville Works Magazine*, vol.XXXI, no.8, August 1933, pp.232–8.

Thieme, U. and Becker, F., *Allgemeines Lexikon der bildenen Künstler*, vols.4–32, Leipzig, 1910–38.

'John Thomas', *Art Journal*, 1849, p.340.

Thomas, John, obituary of, *Art Journal*, 1862, p.144.

Tilson, B., 'Art for the people', *RIBA Journal*, vol.98, November 1991, pp.40–4.

'"The Towers", Walsall Road, Perry Bar, Birmingham', *The Builder*, vol.CLIII, 15th October 1937, p.690.

Turner, K., *Central Birmingham 1870–1920*, Bath, 1994.

Turner, K., *Central Birmingham 1920–1970*, Stroud, 1995.

Uli Nimptsch RA: Sculptor, Royal Academy, London, exh.cat., 1973.

Underwood, E.G., *A Short History of English Sculpture*, London, 1933.

'University of Birmingham: opening of new mechanical engineering buildings', *Engineering*, vol.178, 9th July 1954, p.59.

'Untitled: sculpture at the Ackers', *Art and Artists*, no.218, November 1984, p.4.

'Unveiling of the statue of Bishop Gore', *Birmingham Diocesan Magazine*, vol.IX, no.4, April 1914, pp.139–43.

Vallance, A., 'Mr W.J. Neatby and his work', *The Studio*, vol.29, June 1903, pp.113–17.

'The Victoria Courts, Birmingham', *Building News*, vol.61, 24th July 1891, pp.128–9.

Vince, C.A., *History of the Corporation of Birmingham,* vols.III–IV, Birmingham, 1902–23.

Virgil, *Georgics*, bk.iii.

Virtue, J.S. (ed.), *The Art Journal illustrated catalogue of the International Exhibition 1862*, London, 1863.

Vitruvius Brittanicus, London, 1715.

Wagstaff, S., 'The bird that cuts the airy way', in *Dhruva Mistry: sculptures and drawings*, Kettle's Yard, Cambridge, exh.cat., 1985.

Walker, R., 'Benjamin and Seager', *Arts Review*, December 1976, p.692.

Wallis, W., 'Sculpture', in British Association, *Handbook of Birmingham*, 1886.

Warner, P., *Auchinleck, The lonely soldier*, London, 1981.

Waters, G.M., *Dictionary of British artists working 1900–1950*, Eastbourne, 1975.

'The Watt memorial, Birmingham', *The Builder*, vol.24, 1st September 1866, p.655.

Webb, A., and Bell, E.I., 'The Birmingham University', *The Builder*, 3rd May 1902, p.448.

Welsh Sculpture Trust, *Sculpture in a country park*, Margam, Wales, exh.cat., 1983.

West Midlands County Council, *Sculpture commission, The Ackers, Small Heath*, Brief 9153G/AH/ICAP.

Whiffen, M., *Thomas Archer: architect to the English Baroque*, London, 1950.

While, G.H., 'Design of the Church', *Contact*, no.21, December 1957, p.3.

Whinney, M., *Sculpture in Britain 1530–1836*, Harmondsworth, 1964.

Whinney, M., *English sculpture 1720–1830*, Victoria and Albert Museum, London, 1971.

Whittet, G.S., 'Richier casts her shadow', *Studio International*, vol. 167, no.850, February 1964, p.84.

Who's who, London, 1960–90.

Who's who in art, 6th edition, London, 1952.

Who's who in art, 10th–26th editions, Havant, 1960–94.

Williams, I.A., *The firm of Cadbury 1831–1931*, London, 1931.

(Woolner, Dawson memorial), *The Dart*, 14th October 1881.

Wykes-Joyce, M., 'Birmingham Museum and Art Gallery, exhibition', *Arts Review*, vol.41, 2nd June 1989, p.453.

Yarrington, A., 'Nelson the citizen hero: State and public patronage of monumental sculpture 1805–18', *Art History*, vol.6, no.3, September 1983, pp.315–29.

'Zen and the art of water', *Crafts*, London, no.105, July/August 1990, p.12.

Letters, in alphabetical order of the author

All letters are to UCEPSP unless marked with an asterisk

Ansell's Architects' Department, 12th March 1985.

Atherton, K., 26th February 1996.

Bentham, P., Honourable Secretary of the Master Carvers' Association, 18th March 1985.

Birmingham City Engineer's Department (re. The Beam Engine).

Bohn, P., 16th April 1985 and 30th January 1996.

Bownes, R.F., North Birmingham Christadelphian Ecclesia, 28th March 1985.

Bridgeman, J., 2nd March 1996.

Bridgwater, Mrs. B., 22nd March 1986.

Budd, O., 20th February 1996.

Butler, J.W., 9th December 1985.

Carter, S., 7th February 1996.

Cave, A., County Planner, 24th June 1985.

Clark, M., 4th February 1985.

Clement, 12th November 1985.

Conner, A., 23rd February 1996.

Copplestone, T., 12th August 1985.

Creswick, B., 25th August 1893, reproduced in Birmingham School of Art, *Committee Minutes*, 12th September 1893.*

Dartmouth, Lord, 22nd November 1821, in *Letters to William Hamper CDE 1813–30*, Birmingham Reference Library archives.*

Davies, M., 12th February 1996.

Doyle-Jones, F.W., Letters and documents on file in *Francis William Doyle-Jones, Correspondence – Sculptor of Memorial in King Edward Square*, Sutton Coldfield Reference Library.*

Frink, E., to Peter Field, Faculty of Art Office Records, 6th November 1980.*

Goodison, Sir N., Chairman of TSB, to Michael Diamond, Director of Birmingham Museums and Art Gallery, Birmingham Museums and Art Gallery archives.*

Gracechurch Centre Office, 27th October 1983.

Gray, T., 8th February 1994.

Hall, D., to Silber, E., internal memo, Birmingham City Council (re. Gas Department memorial).*

Harrison and Cox, architects, 1985.

Hickman, D., architect, author and member of the Civic Society, 13th November 1985.

Horner, I., 30th March 1985.

I'Anson, Mrs. H.,widow of Charles I'Anson, 11th July 1985.

Jaffray, J., of the Statue Committee to Mayor Alderman White, in: *Birmingham Council Proceedings 1882–1883*, 2nd October 1883, pp.648–9.*

Joseph, H.B., Allied Artists, 15th April 1985.

Joy, A.B., to the Chairman, Birmingham Central Reference Library, in: Borough of Birmingham Museums and School of Art, *Committee Minutes*, no.714, p.446: 16th April 1888.

Kings, J., 13th November 1985.

Lomax, T., 21st January 1996.

Mann, A., 22nd April 1985 and 12th August 1985.

Mitchell, M., 22nd April 1985.

Nowakowski, O., 29th January 1996.

Osborne, J., Partnership, Chartered Architects, 10th April 1985.

Patten, D., 29th January 1996.

Patterson, Professor J., 5th February 1986.

Poole, J., 13th April 1984 and 12th July 1985.

Price, Sir F., Deputy Chairman of Murrayfields, 26th June 1985.

Public Art Commissions Agency Records (re. Gormley, Haselden, Lomax, Nowakowski, Tye, Williams).*

Pye, W., CV provided by the artist for the WMCC Peace Sculpture Commission, 1984.*

Pye, W., 19th February 1996.

Pytel, W., February 1996.

Randle, A., co-founder of Midlands Arts Centre for Young People, 17th February 1986.

Reily, Revd. C.J., 12th March 1985.

Richardson, P., 20th February 1996.

Royal Birmingham Society of Artists, Secretary (re. Bloye, Spirit of Birmingham).

St. George's Church of England Comprehensive School, Headmaster, 1985.

Schwarz, H., Biography sent by the artist, n.d.

Seager, H., 6th January 1986.

Smith, R., 20th January 1996.

Thomas, R., 14th February 1996.

Tye, R., 19th January 1996.

Webster, S., specialist on W.H. Bidlake, 25th November 1985.

Weller, A., 22nd February 1984.

Wheatley Bequest, file no. 169, letter of 2nd February 1933 and 28th September 1936.*

Wiggin, H., letter to Council, 31st August 1868, in *Council Proceedings 1867–1869*, 1st September 1868.*

Withers, Canon, Cathedral House, 13th October 1983.

Woof, P., 7th February 1996.

Yates, S., Selly Oak Hospital, 1985.

Committee Minutes

Birmingham Civic Society Annual Reports, Birmingham, 1927–9.

Birmingham Civic Society Annual Reports, Birmingham, 1951–2, pp.4–5.

Birmingham Civic Society *Report of the Birmingham Civic Society 1937–1938*, Birmingham.

Birmingham Civic Society *Report of the Birmingham Civic Society 1948–1949*, Birmingham.

Birmingham Public Works *Committee Minutes 1882–1884*, 29th January 1884, p.391.

Birmingham Public Works *Committee Minutes 1884–1886*, extracts from the report of the Sir Josiah Mason Memorial Committee, p.308.

Birmingham School of Art, *Committee Minutes*, 11th October 1898, no.1637.

Birmingham School of Art, *Minutes*, 1932–3, 15th February 1933, no.4637.

Borough of Birmingham and School of Art Committee, *Annual Report*, 1886, p.52.

Borough of Birmingham Museums and School of Art Committee, *Annual Report*, 1888, p.61.

City of Birmingham, *Council Minutes* and *Proceedings of Committees*, 1892–1994.

City of Birmingham, *Council Minutes*, no.14455, 1887, p.325.

City of Birmingham, *Council Minutes 1936*, 9th November 1936, no.32953, p.8.

City of Birmingham, Public Works and Town Planning Department Report, 1st January 1915 – 31st March 1935.

Estates Committee's Report, *Birmingham Council Proceedings 1886–1887*, 1st March 1887, p.257.
Estates Committee's Report, *Birmingham Council Proceedings 1889–1890*, 21st October 1890, pp.595–6.
Free Libraries Committee's Report, *Birmingham Council Proceedings 1883–1884*, 22nd April 1884, p.303.
Handsworth Library Reports, 1890, 1891.
Handsworth Local Board Records, *The Library extension works accounts*, 1891.
Museum and Art Gallery Committee, *Minute Book, 1917–1937*.

Birmingham Register of Building Plans

Birmingham register of building plans, 1890, no.17706.
Birmingham register of building plans, 1899, no.14657.
Birmingham register of building plans, 1899, no.15138.
Birmingham register of building plans, 1900, no.15370
Birmingham register of building plans, 1900, no.17719.
Birmingham register of building plans, 1902, no.16843.
Birmingham register of building plans, 1921, no.33220.
Birmingham register of building plans, 1922, no.34109.
Birmingham register of building plans, 1922, no.34132.
Birmingham register of building plans, 1926, no.41157.
Birmingham register of building plans, 1927, no.44424.
Birmingham register of building plans, 1927, no.44512.
Birmingham register of building plans, 1930, no.51680.
Birmingham register of building plans, 1930, no.51751.
Birmingham register of building plans, 1930, no.52232.
Birmingham register of building plans, 1931, no.53541.
Birmingham register of building plans, 1933, no.57874.
Birmingham register of building plans, 1933, no.57877.
Birmingham register of building plans, 1933, no.58397.
Birmingham register of building plans, 1934, no.59946.
Birmingham register of building plans, 1934, no.60875.
Birmingham register of building plans, 1935, no.62641.
Birmingham register of building plans, 1935, no.63970.
Birmingham register of building plans, 1935, no.64474.
Birmingham register of building plans, 1936, no.64881.
Birmingham register of building plans, 1936, no.66388.
Birmingham register of building plans, 1936, no.66711.
Birmingham register of building plans, 1938, no.71366.
Birmingham register of building plans, 1938, no.71833.
Birmingham register of building plans, 1954, no.112319.

Newspapers

Aris's Gazette, 1851–70.
Aston Observer, 1975–6.
Birmingham Daily Mail, 1881–1906.
Birmingham Daily Post, 1868–1912.
Birmingham Despatch, 1902–60.
Birmingham Express and Star, 1990–4.
Birmingham Gas Department Magazine, 1919–21.
Birmingham Gazette, 1885–1965.
Birmingham Mail, 1910–96.
Birmingham Morning News, 1871.
Birmingham Post, 1883–1996.
Birmingham Sunday Mercury, 1944–81.
Birmingham Times, 1886.
Birmingham University Guild News, 1953–61.
Birmingham Weekly Post, 1897–1954.
Catholic Pictorial, 1964.
Cheltenham Examiner, 1905.
Country Life, 1974.
The Daily Telegraph, 1975–93.
Gentleman's Magazine, 1849.
The Guardian, 1978.
Illustrated London News, 1850.
The Independent, 1991–3.
The Observer, 1992.
The Spectator, 1991.
Sutton Coldfield News, 1919–22.
Sutton News, 1980.
Tamworth News and Four Shires Advertiser, 1935.
The Times, 1842–1993.
University of Birmingham Bulletin, 1971–4.
Warwickshire and Worcestershire Life, 1986.

Index

Page numbers in **bold** refer to illustrations.

Ackers, The, former site of *Peace Sculpture* (Pye) 5
Aeolus (Pye), lost, formerly near the Lucas factory,
 New John Street 168
Aesculapius (Bloye), Birmingham Chest Clinic 63–4,
 63
*Aesculapius bearing the University of Birmingham
 Coat of Arms* (Bloye), Medical School 150, **150**
Agatha, St., *Scenes from the Life of St. Agatha*
 (Martyn's), St. Agatha's church 123–4, **123**, **124**
Ahoy (Richardson and Webb), Cannon Hill Park 107,
 107
Albert, Prince (Foley), Council House xvi, 142–3, **142**
Albert Street *see* Morton's shoe and boot
 manufacturer
Aldridge Road, *see* Boar's Head public house; Perry
 Barr Greyhound Track
Alexander Sports Stadium, Perry Park, copy of
 Running Stag (Bloye) 1
Allegorical Figures (Anon), Midland Bank, Vyse
 Street 151, **151**
Allegorical Figures [Security and Providence]
 (Bridgeman & Sons), Bennett's Hill 11, **11**
Allegorical Figures (Gibbs & Canning), Digbeth
 Institute 55–6, **55**
Allegorical Figures [the virtues] (Roddis), lost,
 formerly on Colmore Row 162
*Allegories of Army, Navy, Air Force and Women's
 Services* (Toft), Hall of Memory, Centenary Square
 21–2, **21**, **22**
Allegories of Art and Industry (Bloye), Museum and
 Art Gallery, Great Charles Street entrance 62–3, **63**
*Allegories of Art and Literature, with busts of
 Michelangelo and Shakespeare* (Rowney), Moseley
 and Balsall Heath Institute 89, **89**
Allegories of Arts, Crafts and Leisure (Creswick),
 Bloomsbury public library 90, **90**
Allegories of the Arts (Creswick), UCE School of Art
 86–7, **86**
Allegories of Methodist Teaching (Gibbs & Canning),
 Methodist Central Hall 47–8, **48**
Allegories of Science and Art (Ward), Great Western
 Arcade 129–30, **129**
Allegory of Birmingham and Industry (Creswick),
 Dean and Pitman building 47, **47**
Allegory of Fame Rewarding the Arts (Williamson),
 Museum and Art Gallery pediment 32, **32**
Allegory of Hope (W. Hollins), in storage, Museum
 and Art Gallery 36
Allegory of Knowledge and Justice (Creswick),
 Sparkhill library and Building Control office 126,
 126
Allegory of Law and Order (Frith, Aumonier and
 others), Victoria Law Courts 49–50, **50**
Allen, Edward, architect 110
All Saints church, Coneyford Road, *Christ* (Bloye)
 43, **43**
All Saints church, Small Heath 43
Allied Artists 18, 62, 127, 167, 173, 181
Ancestor I (Hepworth), University Square 135, **135**
Angel Drinking Fountain (Anon), St. Philip's Square
 129
Anning Bell, Robert, mosaicist 134
Antelope public house, *Antelope* (Wright) 125–6, **125**
Aquaduct (sic) (Davies), Brindleyplace Plaza 14, **14**
Archer, Thomas, designer 113, 114
Arts, Symbols of the (Herickx), Barber Institute of
 Fine Arts 133
Arts Council, 'Art in Public Places' scheme 50–1
Arts and Crafts Movement 9, 50, 53, 82, 93, 131, 181
Ashley, H.V., architect 3, 62
Association for Business Sponsorship of the Arts
 (ABSA) 14
Assumption of the Virgin Mary (Bohn), Our Lady of
 the Assumption church 96, **97**
Aston xi
Aston Hall and Park xii, 2–3, 142
 portraits of Josiah Mason and wife xvi
 west gardens
 Pan (Bloye) 2, **2**
 Vases (Bloye) 2–3, **3**
Aston Stones (Maine), Aston University 4–5, **4**
Aston Street *see* Aston University
Aston Triangle *see* Aston University
Aston University
 campus grounds
 Aston Stones (Maine) 4–5, **4**
 Peace Sculpture (Pye) 5–6, **5**
 in front of Sacks of Potatoes public house,
 Woodcock Street, *Tipping Triangles* (Conner)
 157, **157**
 main building entrance lobby, *Science and
 Technology* (Burton) 3–4, **3**, **4**
Atherton, Kevin 183
 Iron Horse 92, **92**
 Swing 107–8, **107**
Atkinson, Robert, architect 132

Attwood, Thomas, MP 34
 Chamberlain Square, statue (Coppinger and
 Peever) xxi, 34–5, **35**
 Highgate Road, memorial statue (J. Thomas) xv,
 xvi, xxii, 34, 72–3, **72**
Auchinleck, Field Marshal Sir Claude (de Henriques),
 Five Ways Shopping Centre 18–19, **18**
Auchinleck House, *Untitled* (Copplestone) 17–18, **18**
Aumonier, William, sculptural decoration on Victoria
 Law Courts 50
Avenue Road, Handsworth *see* St. Augustine's church
Axis Design 78

Bacchanalia (Bloye), lost, formerly Golden Eagle
 public house 166, **166**
Badger, William, memorial to (Anon), St. Philip's
 Square 129
Baily, Edward, *Memorial to Sarah Russell* 67
Ball, J.L., architect 75; *see also* Lethaby & Ball
Banbury Street *see* Gun Barrel Proof House
Bangham Pit playground, playsculpture
 (J. Bridgeman) 175
Banking, Personification of (Anon), Midland Bank,
 Vyse Street 151, **151**
Bank of Scotland, 124 Colmore Row, *Eagle Crest*
 (Lethaby & Ball) 42, **42**
Bannister, Professor F.K. 136
Barber family, coat of arms 132–2
Barber, W.H. 144
Barfield, Samuel, sculptor of Leicester 30, 87
 Rose Window 85–6, **85**
Barran, Sir John, relief portrait of (Anon), on Charles
 House 64
Barrett, Oliver O'Connor 183
 *Temptation of St. Anthony and fifteen Keystone
 Heads* 138–9, **138**, **139**
Baskerville, John, printer, monument to (Patten),
 Centenary Square xii, xxi, 25, **25**
Bateman, C.E., architect 71
Bates, Harry 183
 Queen Victoria 49–50, **49**
Battle of the Gods and the Giants (Tye), ICC 29, **29**
Bayes, Gilbert 183–4
 Building of King Solomon's Temple 15, **15**
Beam Engine (City Engineer's Department),
 Dartmouth Circus 54, **54**
Bear Inn public house, *Bear and Staff* (Bloye) 125,
 125
Beatton, George A., relief portrait of (Anon), on

Charles House 64
Bell Barn Road, Lee Bank, *Gate Construction*
 (Carruthers) 8, **8**
Bell, E. Ingress, architect xix, 49, 131, 133
Bell Street *see* Market Hall
Bennett, J. and W.
 Memorial to Ann and Humphrey Evett 67
 Memorial to James Hargreaves 67
 Memorial to Mary Maria Newton 67
 Memorial to Samuel Partridge 67
Bennett's Hill
 formerly London and Lancashire Fire Insurance
 Company (Nos 18–19), *Allegorical Figures*
 (Bridgeman & Sons and Riley & Smith) xxii, 11,
 11
 see also District Bank; Midland Bank; National
 Westminster Bank; Sun Alliance Insurance office
Berkeley Street *see* Broadgate House
de Bermingham family xi, 46
Bewlay *see* Peacock and Bewlay
Bible and Hand (Protheroe), Christadelphian Hall,
 Handsworth 91, **91**
Bickenhill Lane *see* Birmingham International
 Airport
Bidlake, William Henry, architect 123–4, **123**, **124**
Birchfield Harriers stadium *see* Perry Barr
 Greyhound Track
Birdlife (Haselden), ICC 27
Birmingham Chest Clinic, *Aesculapius* (Bloye) 63–4,
 63
Birmingham Civic Society 2, 3, 30, 98–9, 145, 176
Birmingham College of Art, *Untitled* (lost) 169, **169**
Birmingham Institute of Art and Design, UCE
 Judas Figure (Frink) 51–2, **51**
 Untitled (Dalwood) 50–1, **51**
Birmingham International Airport, Bickenhill Lane,
 on main roundabout, *Take Off* (Pytel) 12, **12**
Birmingham Joint Stock Bank (formerly) *see* Lloyds
 Bank
Birmingham Museum and Art Gallery *see* Museum
 and Art Gallery
Birmingham Museums and Art Gallery (BMAG)
 181–2
Birmingham Nature Centre, *Sign for Nature Centre*
 (Carter family) 103, **103**
Birmingham Polytechnic *see* University of Central
 England
Birmingham Reference Library *see* Central Reference
 Library
Birmingham Repertory Theatre, *Sir Barry Jackson*
 (Bloye) 24, **24**
Birmingham Women's Hospital, *Mother and Child* (J.
 Bridgeman) 88, **88**

Blamires, C.H. 160
Blondin [Charles] (Richardson), Ladywood
 Middleway 78, **78**
Bloomsbury public library, *Allegories of Arts, Crafts
 and Leisure* (Creswick) 90, **90**
Bloye, William xi, xiv, xix–xx, 164, 167, 184
 *Aesculapius bearing the University of Birmingham
 Coat of Arms* 150, **150**
 Aesculapius (Birmingham Chest Clinic) 63–4, **63**
 Allegories of Art and Industry 62–3, **63**
 Antelope (as designer), public house 125–6
 Bacchanalia (lost), public house 166, **166**
 Bear and Staff, public house 125, **125**
 Blue Coat School Statues, replicas of **119**, 120
 Boar's Head, public house 1, **1**
 Boulton, Watt and Murdock 15–17, **16**
 Call, Front Line and *Return* xxii, 22–4, **23**, **24**, 60
 Capitals and Pediment Sculpture (New Oxford
 House) 154–5, **154**
 Childhood (Carnegie Welfare Institute) 59
 Christ (All Saints church) 43, **43**
 Christ (Queen's College chapel) 120, **120**
 Dancing Putti (lost), public house 162
 Engineering 135–6, **135**
 Family Group 59, **59**
 Fountain (Nude Girl) 121, **122**
 Fox and Hollybush, public house 97, **97**
 George Dawson, copy of Williamson's statue xvi,
 174–5
 Golden Eagle (lost), public house 166, **166**
 Good Shepherd and Latin Cross 20, **20**
 Huntsman and Dog, public house 71, **71**
 John Skirrow Wright, copy of Williamson's statue
 xvi, 143–4, **144**, 162
 Keystone Heads 121–2, **122**
 Lamp of Knowledge (designer) 38–9, **39**
 Library Emblem 158, **158**
 Lion Pediment and Seated Craftsmen 117–18, **117**,
 118
 Mask of Pan (lost), public house 162–3, **163**
 Maternity 75, **75**
 Mermaid 57, **57**
 Mermaid Fountain 57–8, **58**
 Mermaid public house 124
 Mother and Child and *Young Child Playing* 79, **79**
 Name Plaques, RBSA building 92–3, **93**
 Ordination 120, **120**
 Pan 2, **2**
 Putto with Grapes, public house 115, **115**
 Queen Victoria (copy by) 144–5, **145**
 Royal Oak, public house 85, **85**
 Running Stag 1, **1**
 Sermon to the Birds 81, **81**

Sir Barry Jackson 24, **24**
Spirit of Birmingham (unrealised work) 1, 176, **176**
Spirit of Knowledge 72, **72**
Sun Emblem and Lettering 10–11, **10**
Terpsichore xix, 13–14, **13**
Towers, public house 152, **152**
University Coat of Arms 109–10, **109**
Vase of Fruit (demolished) 172–3, **172**
Vases 2–3, **3**
Vulcan (lost) 161
Wheatsheaf 53, **53**
Wisdom, Fortitude, Charity and Faith xix, 153–4,
 153, **154**
Blue Coat School, Edgbaston, *Blue Coat Children*
 (Grubb), and replicas by Bloye xiii, 119–20, **119**
Boar's Head public house, *Boar's Head* (Bloye) 1, **1**
Bodkin, Thomas, Director of the Barber Institute 133
Bohn, Peter 184
 Assumption of the Virgin Mary 96, **97** *Coat of
 Arms; Agriculture and Engineering* (lost) 160
 St. Augustine's arrival in England 6, **6**
Boldmere swimming baths, Sutton Coldfield,
 Memorial to Members of Boldmere Swimming Club
 (Creswick) 158, **158**
Bordesley *see* Dowell's Almshouses
Bordesley Street *see* Polish Catholic Centre
Boulton, Matthew, engineer xii, 16, 32
 Broad Street, group statue (Bloye) 15–17, **16**
 Minerva Clock made by xii–xiii
 on panels (Creswick) 118
 St. Mary's parish church, Handsworth, monument
 to (Flaxman) 67–8, **67**
Boulton (Richard Lockwood) & Sons, Cheltenham
 184
 *Britannia and Supporters: Manufacture; the Union
 of the Arts and Sciences; Literature; Commerce*
 xix, 139–42, **139**, **140**, **141**
Bournville Junior School, *Dancers* (Creswick) 82, **83**
Bournville Lane, Cadbury factory grounds,
 Terpsichore (Bloye) xviii–xix, 13–14, **13**
Bournville Trust 81
Bradbeer, Sir Albert 96
Bridgeman, John xiv, 184–5
 Christ Ascending 104, **105**
 Compassion 56–7, **56**
 Mother and Child 88, **88**
 mural 18
 Playsculptures (various locations) 175
Bridgeman (Robert) & Sons of Lichfield 185
 Allegorical Figures 11, **11**
 Court Oak 52, **52**
 Holy Trinity, St. Peter, Virgin and Child 80
 King Richard 110–11, **111**

Madonna and Child 62
St. John the Evangelist 110
St. Martin and a Beggar 111, **111**
Scenes from the Life of St. Martin 111–12, **112**
Bridgwater, Alan xiv, 71, 185
 Mermaid (attrib.) 124, **124**
 Pilgrim's Progress 152, **152**
 St. George and the Dragon (destroyed) 172, **172**
Bright, John, MP 161
 Museum and Art Gallery, statue in storage (Joy)
 xvi, 36–7, **37**
Brindleyplace Plaza
 Aquaduct (sic) (Davies) 14, **14**
 Gates (Davies) 14
Britannia see British Gas Social Club
Britannia with Mermaid and Sea Horses (Walker),
 lost, formerly Town Hall pediment, Victoria Square
 171, **171**
Britannia and Supporters (Boulton & Sons), Council
 House 139–42, **139**
British Gas Social Club, *Gas Department War
 Memorial (Britannia)* (Weingartner) 156–7, **156**
British Steel 157
Broad Street
 in front of Registry Office, *Boulton, Watt and
 Murdock* (Bloye) 15–17, **16**
 Spirit of Birmingham (Bloye), unrealised work
 176, **176**
 see also Auchinleck House; Broadgate House;
 Central Television building; Five Ways Shopping
 Centre; Fortress House
Broadgate House, facades onto Berkeley Street and
 Gas Street, *Untitled* (Mitchell) 17, **17**
Brock, Thomas 185–6
 Queen Victoria xvi, xviii, 144–5
Bromilow, Smeeton and While, architects 152
Brookvale public house, *Putto with Grapes* (Bloye)
 115, **115**
Budd, Kenneth 186
 Old Square xxii, 45–6, **45**
Building of King Solomon's Temple (Bayes), Central
 Television building 15, **15**
Bull Forms (Copplestone), Bull Ring Shopping
 Centre 115–16, **115**
Bull Ring xxii
 Admiral Horatio Nelson (Westmacott), formerly
 outdoor market, now in store 116–17, **116**
 King Kong (Monro), destroyed (formerly
 Manzoni Gardens) 170, **170**
 on panel, exterior of Martineau Square (Schwarz)
 19
 see also Market Hall
Bull Ring Shopping Centre, *Bull Forms*

(Copplestone) 115–16, **115**
Bull's Head public house (demolished), Hockley, *Vase
 of Fruit* (Bloye) 172–3, **172**
Bull Street, *Untitled* (Schwarz) 19, **19**
Burleighfield Arts 14
Burnaby, Frederick G., memorial to (Anon) 128, **128**
Burne-Jones, Edward
 stained glass by 110, 113
 Tree of Life mosaic 52
Burney Lane, Alum Rock *see* Christ Church
Burton, A.B., of Surrey, bronze-founder 164
Burton, Esmund 186
 Science and Technology 3–4, **3**, **4**
Bush House, Broad Street, former site of *Family
 Group* (Bloye) 59
Butler *see* Crouch and Butler
Butler, James 186
 Coat of Arms 99, **99**

Cadbury factory grounds, Bournville Lane,
 Terpsichore (Bloye) xviii–xix, 13–14, **13**
Cadbury, George 13
 Friends' Meeting House, bust (Wood) 83, **83**
Cadbury, Richard 13, 83
Cader Idris, Wales (Patten), Central Reference
 Library 101, **101**
Call, Front Line and *Return* (Bloye), Hall of Memory,
 Centenary Square 22–4, **23**, **24**
Canal Boat (Pytel), lost, formerly Longboat public
 house 167, **167**
Canning *see* Gibbs & Canning
Cannon Hill Park, Edgbaston xvi, 107
 Ahoy (Richardson and Webb) 107, **107**
 Family Group (I'Anson), lost 169, **169**
 South African War Memorial (Toft) xxii, 106, **106**
 Untitled (Birmingham College of Art), lost 169,
 169
Carnegie Welfare Institute, Hockley, *Maternity*
 (Bloye) 75, **75**
Carruthers, Robert 186
 Gate Construction xx, 8, **8**
Carpenters and Diners (Creswick), Dean and Pitman
 building 46–7, **46**, **47**
Carter, Sheila and family 186–7
 Sign for Nature Centre 103, **103**
Caryatids (Rollins), demolished, formerly General
 Hospital 170–1, **171**
Caryatids (Rollins), Midland Hotel 122, **123**
Cattell Road, Bordesley, *Sleeping Iron Giant*
 (Nowakowski) 20, 21
Catterson-Smith, Robert, *Kenrick Casket* xiii, **xiii**
 (Fig.2)
Cellini (J. Chatwin), roundel, Colmore Row 41–2, **42**

Centenary Square xix, xxi, 21–9
 Forward (Mason) xxi, 26–7, **26**
 *Industry and Genius: Monument to John
 Baskerville* (Patten) 25, **25**
 Spirit of Enterprise (Lomax) 25–6, **25**
 see also Hall of Memory
Central Reference Library
 bust of Sir Barry Jackson (Dare) 24
 Cader Idris, Wales (Patten) 101, **101**
 Garrick and Shakespeare (Coade and Sealy) 38, **38**
 Royal Warwickshire Regiment War Memorial
 (Anon) 29, 37
Central Television building, *Building of King
 Solomon's Temple* (Bayes) 15, **15**
Centro 39, 40, 199
Chamberlain, John Henry 187
 canopy design for *George Dawson* 31
 Chamberlain Memorial Fountain xv, 29–31, **30**, 34
 pedestal for *James Watt* (Munro) 33
 Rose Window 85–6, **85**, **86**
Chamberlain, Joseph, mayor and MP
 *Chamberlain Square, Chamberlain Memorial
 Fountain* (John Chamberlain) xv, 29–31, **30**, 34
 Chamberlain Square, portrait medallion (Woolner)
 30, **30**
 in *Forward* (Mason) 27
Chamberlain Square
 Allegory of Fame Rewarding the Arts
 (F.J. Williamson) 32, **32**
 Chamberlain Memorial Fountain (J. Chamberlain)
 xv, 29–31, **30**
 George Dawson (Woolner) 31, **31**
 James Watt (Munro) 32–3, **33**
 John Skirrow Wright (Williamson), scrapped 29,
 161–2, **161**
 Joseph Priestley (F.J. Williamson) 33–4, **33**
 Royal Warwickshire Regiment Memorial (Anon)
 29
 Thomas Attwood (Coppinger and Peever) 34–5, **35**
Chantrey, Sir Francis 187
 Monument to James Watt 68–9, **68**, 95
 William Murdock 69, **69**
Charles House, Great Charles Street, *Relief Portraits*
 (Anon) 64, **64**
Chatwin, Julius Alfred, architect 67, 113, 114, 187
 Ghiberti and Cellini 41–2, **41**, **42**
 Keystone Heads 130, **130**
 St. Martin's church 110, 111, 112
Chatwin, Philip B., architect 110, 187
Cheatle *see* Newton and Cheatle
Chess-Pieces (Mann), Gracechurch Shopping Centre
 99–100, **100**
Children's Hearing Assessment Centre, *Mother and*

Child and Young Child Playing (Bloye) 79, **79**
Child with a Lamb (Walker), lost, formerly
 Handsworth Park 164, **164**
Christ (Bloye), All Saints church 43, **43**
Christ (Bloye), Queen's College chapel 120, **120**
Christadelphian Hall, Handsworth, *Bible and Hand*
 (Protheroe) 91, **91**
Christ Ascending (J. Bridgeman), Church of the
 Ascension 104, **105**
Christ Church, Burney Lane, Alum Rock, *Good
 Shepherd and Latin Cross* (Bloye) 20, **20**, 43
Christ Church (faced into Victoria Square), original
 site of *Angel Drinking Fountain* (Anon) 129
Church of the Ascension, Stirchley, *Christ Ascending*
 (J. Bridgeman) 104, **105**
Church of the Sacred Heart and St. Margaret Mary,
 Sacred Heart (Gibbs & Canning) 155, **155**
Church of the Saviour 31
City Arcade, Union Street, *Heads, Beasts and Figures*
 (Neatby) 93, 131, **131**
City Architects Design Team 21
City Engineer's Department, *Beam Engine* 54, **54**
Clark, Michael 187–8
 St. Joseph 108
 St. Rose of Lima 66, **67**
Coade and Sealy, Lambeth 188
 Garrick and Shakespeare 38, **38**
Coat of Arms xx
 of Aston University (Burton), removed 3 of the
 Barber family, Barber Institute
 of Fine Arts (Herickx) 132–3
 of Birmingham
 Barber Institute of Fine Arts (Herickx) 132–3
 Centenary Square, *Arts* (Mason) 27 Dean and
 Pitman building (Creswick) 47, **47**
 Electric supply station, Bordesley (Creswick)
 138, **138**
 Gun Barrel Proof House, shield (W. Hollins) 7
 Museum and Art Gallery (Bloye) 62–3, **63**
 National Westminster Bank (Lynn) 8–9, **9**
 public baths, Nechells (Creswick) 91, **91**
 Swimming baths, Balsall Heath (Hale & Son)
 88, **88**
 of the College of Food and Domestic Arts (Kings)
 127, **127**
 on the District Bank, Bennett's Hill (lost) 160
 of Polish cities (Zielinski), Polish Catholic Centre
 13
 of Sutton Coldfield, Gracechurch Shopping
 Centre (Butler) 99, **99**
 of the University of Birmingham
 Dental Hospital (Bloye) 109–10, **109**
 Medical School (Bloye) 150, **150**

Students' Union building (Bloye) 57, 58
Cockerell, C.R., architect 8
College of Food and Domestic Arts, Summer Row,
 Coat of Arms (Kings) 127, **127**
College Road, Perry Common *see* Perry Common
 public library
Colmore Circus, former site of *Gate Construction*
 (Carruthers) xx, 8
Colmore Road *see* Phoenix Chambers
Colmore Row 39–42
 Allegorical Figures (Roddis), lost 162
 buildings by Chatwin 130
 Horses (Thomason), on manufactory, lost 162
 King's Café (demolished) 131
 Ghiberti and Cellini (Chatwin), (on Nos 79–83)
 41–2, **41**, **42**
 see also Bank of Scotland; Phoenix Chambers; St.
 Philip's Square; Snow Hill Station
Commuter, The (McKenna), Snow Hill Station 39–40,
 39
Compassion (Bridgeman), Dudley Road Hospital
 56–7, **56**
Compassion (Nimptsch), Selly Oak Hospital 96, **96**
Coneyford Road, Shard End *see* All Saints church
Conner, Angela 188
 Tipping Triangles 157, **157**
Construction (Woropay), ICC 28, **28**
Convention (Perry), ICC 28, **28**
Cooke, S.N., architect xxii, 21–2, 23, 153, 154, 162
 Sun Emblem and Lettering 10–11, **10**
Cooke (S.N.) and Partners, architects 96, 110
Copnall, Edward Bainbridge 188
 Wrestlers 136–7, **136**
Coppinger, Sioban 188
 Thomas Attwood (with Peever) xxi, 34–5, **35**
Copplestone, Trewin 188–9
 Abstract with Sun 18
 Bull Forms xxii, 115–16, **115**
 Untitled 17–18, **18**
Cornwall Street, UCE School of Art extension,
 Allegories of the Arts (Creswick) 86–7, **86**
Corporation Street
 Memorial to Tony Hancock (Williams) 44–5, **44**
 Sir Walter Scott and William Shakespeare (Pepper)
 43–4, **43**, **44**
 see also Birmingham Institute of Art and Design;
 Dean and Pitman building; Gazette Building;
 Methodist Central hall; Old Square subway
 pedestrian area; Victoria Law Courts
Cossins (Jethro) and Peacock, architects 90
Council House, Victoria Square xix, xxi
 *Britannia and Supporters: Manufacture; the Union
 of the Arts and Sciences; Literature; Commerce*

(Boulton & Sons) xix, 139–42, **139**, **140**, **141**
John Skirrow Wright (Bloye) 143–4, **144** *Prince
 Albert* (Foley) xvi, 142–3, **142**
Queen Victoria (Woolner) 143, **143**
Court Oak public house, Court Oak Road,
 Harborne, *Court Oak* (Bridgeman & Sons) 52, **52**
Coventry Road, Sheldon *see* Good Companions
 public house (Small Heath); Wheatsheaf Hotel
Cox, George Bernard, architect 6, 52, 62, 96, 155
 Holy Trinity, designer of panels 80
Crane, Walter, designer, spandrel figures on Victoria
 Law Courts xix, 50
Craze, Romilly B., architect 104
Creswick, Benjamin xi, xiii–xiv, xix, 189
 Allegories of the Arts xiv, 86–7, **86**
 Allegories of Arts, Crafts and Leisure 90, **90**
 Allegory of Birmingham and Industry 47, **47**
 Allegory of Knowledge and Justice 126, **126**
 Birmingham Coat of Arms (Electric supply
 station, Bordesley) 138, **138**
 Birmingham Coat of Arms (public baths,
 Nechells) xx, 91, **91**
 Carpenters and Diners 46–7, **46**, **47**
 Dancers 82, **83**
 Elves and the Shoemaker 159, **159**
 *Memorial to Members of Boldmere
 Swimming Club* 158, **158**
 Scenes from Birmingham's Industrial Past 118, **118**
Cropredy Road, West Heath *see* St. John Fisher
 church
Cross (Poole), St. John the Baptist church 71, **71**
Cross Guns Inn, Washwood Heath, *Cross Guns*
 (Pytel), lost 173, **173**
Crouch and Butler, architects 47
Crown Courts (outside of), Newton Street, *Wattilisk*
 (Woropay) 94–5, **94**
Custard Factory, Gibb Street, *Dragon* (Gray) 61, **61**
Cyclad (Weller), lost, formerly Winterbourne House,
 University of Birmingham 163, **163**

Dalwood, Hubert 189
 Untitled 50–1, **51**
Dancers (Creswick), Bournville Junior School 82,
 83
Dancing Putti (Bloye), lost, formerly on Good
 Companions public house 162
Dare, Daphne, bust of Sir Barry Jackson 24
Dartmouth Circus (on roundabout island), Aston,
 Beam Engine (City Engineer's Dept) 54, **54**
Dartmouth Middleway, *White Curl* (Gregory) 55, **55**
Davies, Miles 189–90
 Aquaduct (sic) 14, **14**
 Gates 14

Dawson, George, preacher and politician 31, 174
　　Chamberlain Square, statue (Woolner) 31–2, **31**,
　　　174
　　Small Heath Park, formerly Chamberlain Square
　　　(Williamson), scrapped xvi, 29, 174–5, **174**,
　　　bronze copy of bust by Bloye (stolen) 174–5
de Henriques, Fiore 190
　　Auchinleck, Field Marshal Sir Claude 18–19, **18**
Deacon, J.R., of Lichfield 80
Dean, A.R., house furnishers 46
Dean and Pitman building, Corporation Street
　　Allegory of Birmingham and Industry (Creswick)
　　　47, **47**
　　Carpenters and Diners (Creswick) 46–7, **46**, **47**
Dhanjal, Avterjeet 190
　　Remains of a Pyramid 114
Digbeth, derivation of name 61
Digbeth Institute, High Street, *Allegorical Figures*
　　(Gibbs & Canning) 55–6, **55**
District Bank, Bennett's Hill, *Coat of Arms;
　　Agriculture and Engineering* (Bohn) 160
Doultons 93, 131
Dowell's Almshouses, Warner Street, Bordesley,
　　former site of *Allegory of Hope* (W. Hollins) 36
Doyle-Jones, Francis 190
　　War Memorial 77–8, **77**
Dragon (Gray), Custard Factory, Digbeth 61, **61**
Drury, Edward 190–1
　　King Edward VII 134, **134**
Dudley Road Hospital, Winson Green, *Compassion*
　　(J. Bridgeman) 56–7, **56**

Eagle Crest (Lethaby & Ball), emblem of the Eagle
　　Insurance Company, Bank of Scotland, Colmore
　　Row 42
Easy Row (formerly) *see* Woodman public house
Edgbaston Park Road *see* University of Birmingham,
　　Winterbourne House
Edmund Street *see* Louisa Ryland House
Edward VI Grammar School, New Street 72
Edward VII, King, representations of
　　Aston Webb building (Drury) 134, **134**
　　formerly in Highgate Park (Toft), lost 145, 165,
　　　165
Edwards of Ruabon, terracotta manufacturer 49, 50
Electric supply station, Upper Trinity Street,
　　Birmingham Coat of Arms (Creswick) 138, **138**
Electricity substation, Summer Lane, *Cartouche*
　　(Gibbs & Canning) 127, **127**
Elkington, bronze-caster xiii, xviii, 103
Elliot, Son and Boyton, Waterloo Street, *Satan*
　　(Gleichen), in store 173–4, **174**
Elves and the Shoemaker (Creswick), lost, formerly

in Albert Street 159, **159**
Engineering (Bloye), Mechanical Engineering
　　Department 135–6, **135**
Engineering (Bohn), lost, formerly on District Bank,
　　Bennett's Hill 160

Epstein, Jacob, sculptor 13, 57, 59, 96, 139
Evans, John, chief modeller at Gibbs & Canning 191
　　Allegorical Figures 56
　　Allegories of Methodist Teaching and *Events in the
　　　Life of John Wesley* 48
　　Sacred Heart, Church of the Sacred Heart and St.
　　　Margaret Mary 155

Face to Face (Smith), Park Circus 102–3, **103**
Family Group (Bloye), Louisa Ryland House 59, **59**
Family Group (I'Anson), in store in Midlands Art
　　Centre 169, **169**
Farmer & Brindley 130, 191
　　Reredos (St. Martin's church) 112–13, **113**
Fire Station, Garrett's Green Lane, *Fire Fighters*
　　(Pancheri) 60, **60**
Firth Rixson Castings of Wednesbury 146
Fisher, St. John, Bishop of Rochester, statue of (J.
　　Jones), St. John Fisher church, West Heath 53, **53**
Five Ways, in front of Swallow Hotel, *Joseph Sturge*
　　(Thomas) 70, **70**
Five Ways roundabout, *Impulse* (Mann) xx, 59–60, **59**
Five Ways Shopping Centre
　　Abstract with Sun (Copplestone) 18
　　Auchinleck, Field Marshal Sir Claude (de
　　　Henriques) 18–19, **18**
　　mural (John Bridgeman) 18
Flapper and Firkin *see* Longboat public house
Flaxman, John 191
　　Monument to Matthew Boulton 67–8, **67**
Foley, John Henry 185, 191
　　Prince Albert xvi, 142–3, **142**, 143
Fortress House (dismantled), Broad Street, *Vulcan*
　　(Bloye) 161
Forward (Mason), Centenary Square 26–7, **27**
Fountain Court barristers' chambers, *Fountain (Nude
　　Girl)* (Bloye) 121, **122**
Fountain with Figures (Messenger & Sons),
　　destroyed, formerly in Market Hall 160
Fox Hollies Inn, Acock's Green, *Fox and Hollybush*
　　(Bloye) 97, **97**
Friends' Meeting House, Bournville village green,
　　George Cadbury (Wood) 82–3, **83**
Frink, Dame Elizabeth 192
　　Judas Figure 51–2, **51**
Frith, W.S. 134, 192
　　Justice 50, **50**

Front Line see Call, Front Line and Return

Galton, Samuel, portrait (Budd) 46
Garrett's Green Lane, Yardley *see* Fire Station
Garrick (Coade and Sealy), Central Reference Library
　　38, **38**
Gas Department War Memorial (Britannia)
　　(Weingartner), Woodacre Road 156, **156**
Gas Street *see* Broadgate House
Gate Construction (Carruthers), Bell Barn Road 8, **8**
Gates (Davies), Brindleyplace Plaza 14
Gazette Building, Corporation Street, former site of
　　Satan (Gleichen) 173
General Dispensary, Union Street, former site of
　　Hygeia (W. Hollins) 36
General Hospital (demolished), Steelhouse Lane,
　　Caryatids (Rollins) 170–1, **170**
George I, Equestrian Statue of King (van Nost the
　　Elder), Barber Institute of Fine Arts xvi, 131–2, **132**
George IV (Thomason), unknown location 175
Ghiberti (J. Chatwin), roundel, Colmore Row 41–2,
　　41
Gibb Street, Digbeth *see* Custard Factory
Gibbs & Canning 191, 192
　　Allegorical Figures 55–6, **55**
　　Allegories of Methodist Teaching (Gibbs &
　　　Canning) 47–8, **48**
　　Cartouche 127, **127**
　　Events in the Life of John Wesley 48, **48**
　　Sacred Heart 155, **155**
Gibson, John, architect 8
Gilbert, Walter 192–3
　　Gas Department War Memorial (Britannia) 156–7,
　　　156
Gill, Eric xiv, xix, 38, 93, 118, 166, 184
Gillespie (David) and Associates, manufacturers of
　　Untitled (Schwarz) 19
Gleichen, Countess Feodora 193
　　Satan (in store) 173–4, **174**
Golden Eagle public house (demolished)
　　Bacchanalia (Bloye), lost 166, **166**
　　Golden Eagle (Bloye), lost 166, **166**
Gollins and Smeeton of Birmingham, architects 139
Good Companions public house (demolished)
　　Dancing Putti (Bloye), lost 162
　　Mask of Pan (Bloye), lost 162–3, **163**
Good Shepherd and Latin Cross (Bloye), Christ
　　Church, Alum Rock 20, **20**
Gore, Charles, Bishop of Birmingham, statue (Stirling
　　Lee), St. Philip's Square xvi, 40, **40**
Gormley, Antony 193
　　Iron:Man xxi, 21, 144, 146, **146**
Gosta Green, Aston University 3

see also Birmingham Institute of Art and Design
Gough family 1
Gough-Calthorpe family 1
Gracechurch Shopping Centre, Sutton Coldfield
　Chess-Pieces (Mann) 99–100, **100**
　Coat of Arms (Butler) 99, **99**
Grandjean, Lee 194
　Untitled 76–7, **77**
Gravelly Hill, Erdington *see* St. Mary and St. John's
　church
Gray, Tawny 194
　Dragon 61, **61**
Grazebrook & Whitehouse foundry 54
Great Charles Street *see* Birmingham Chest Clinic;
　Charles House; Museum and Art Gallery
Great Hampton Row, Hockley *see* St. George's
　Church of England Comprehensive School; St.
　George's Gardens
Great Hampton Street *see* Pelican Works
Great Western Arcade, Temple Row, *Allegories of
　Science and Art* (Ward) 129–30, **129**
Green Man public house, Harborne, *Huntsman and
　Dog* (Bloye) 71, **71**
Greenwood, Sydney, architect 115
Gregory Avenue, Weoley Castle *see* Our Lady and St.
　Rose of Lima church
Gregory, Suzi 194
　White Curl 55, **55**
Group of Trophies (Hollins), Gun Barrel Proof House
　7, **7**
Grubb, Edward xiii, 194
　Blue Coat Children 119–20, **119**
Grubb, Samuel xiii
Guardians (Mistry), Victoria Square 147–50, **149**
Gun Barrel Proof House, Banbury Street, *Group of
　Trophies* (W. Hollins) 7, **7**

Hagley Road *see* Liberty's night club
Hale & Son, *Birmingham Coat of Arms* xx, 88, **88**
Hale, William, *Allegories of Art and Literature, with
　busts of Michelangelo and Shakespeare* 89, **89**
Hall of Memory, Centenary Square xxii
　*Allegories of Army, Navy, Air Force and Women's
　Services* (Toft) 21–2, **21**, **22**
　Call, Front Line and Return (Bloye) 22–4, **23**, **24**
Hamstead Road, Handsworth *see* Handsworth Park;
　St. Mary's parish church
Hancock, Tony, comedian, memorial to (Williams),
　Corporation Street xxii, 44–5, **44**
Handsworth Park, *Child with a Lamb* (Walker), lost
　164, **164**
Handsworth public library, *Scenes from
　Birmingham's Industrial Past* (Creswick) 118, **118**

Harborne Road *see* Five Ways
Hardman, John, stained glassmaker 108
Harman, John, Bishop Vesey 100
　arms of (Butler) 99, **99**
Harper, Ewen H. and J., architects 41, 48, 79, 127
Harris, A.E., photographs as basis for relief portraits
　(Anon) on Charles House 64
Harris (J. Seymour) and Partners, architects 17
Harris (J. Seymour) Partnership, architects 19
Harrison, Arthur, architect 56, 91, 96, 126
Harvey, W. Alexander, architect 13, 82
Harvey and Wicks, architects 81
Haselden, Ron 194
　Birdlife xx, 27
Hawkesley Farm Moat Estate playground,
　playsculpture (J. Bridgeman) 175
Heap, John, memorial to (Anon), St. Philip's Square
　129
Hearne, C.B., relief portrait of (Anon), on Charles
　House 64
Hebe (R. Thomas), Holloway Circus roundabout 74,
　74
Hector, Edmund, surgeon, portrait (Budd) 46
Henman, William, architect 122
Hepworth, Dame Barbara 65, 194–5
　Ancestor I 135, **135**
　on John Lewis, London xx
　Two Figures 58, **58**
Heraldic Shields (Herickx), Barber Institute of Fine
　Arts 132–3, **132**
Herickx, Gordon 97, 195
　Heraldic Shields 132–3, **132**
　Symbols of the Arts 133, **133**
Hickman, Douglas, architect 36
Highfield Road *see* Yardley Wood Public Library
Highgate Park, Sparkbrook, *King Edward VII* (Toft),
　lost 165, **165**
Highgate Road, Sparkbrook *see* Highgate Park;
　Larches Green
High Street, Harborne *see* Green Man public house;
　St. John the Baptist church
Hill, Matthew Davenport, bust of (P. Hollins) 75
Hill, Sir Rowland, statue of (P. Hollins) xv, xvi, 75–6,
　76, and bronze railing for (lost) xv
Hillcrest School 114
Hills, John Walter, relief portrait of (Anon), on
　Charles House 64
Hill Street *see* Golden Eagle public house
Hirst, T.J., architect 115
Hobbiss, Holland, architect 20, 53, 85, 115, 117, 120,
　124, 125, 152, 161
Hobbiss and Holland and Partners 121
Hockley Circus, *Untitled* (Mitchell) xx, 73, **73**

Hollins, Peter xiii, 36, 69, 113, 195
　Four Baroque Window Surrounds 113–14, **114**
　Matthew Davenport Hill, bust of 75
　Memorial to Joseph Grice 67
　Memorial to Nathaniel Gooding Clarke 67
　Memorial to Thomas Fletcher 67
　Memorial to Thomas Unett 128
　Sir Robert Peel xiii, xv, xviii, 103–4, **104**
　Sir Rowland Hill xv, 75–6, **76**
　William Scholefield 35
Hollins, William xiii, 69, 113, 114, 195–6
　Allegory of Hope 36
　Group of Trophies 7, **7**
　Hygeia 35–6, **36**
　Memorial to John Freer 67
　St. Mary's 67
Holloway Circus, *Hebe* (R. Thomas) 74, **74**
Holy Trinity R.C. church, *Holy Trinity, St. Peter,
　Virgin and Child* (Bridgeman & Sons) 80
Holyoak, Joe, architect 78
Horner, Ian 196
　Liberty (lost) 163–4, **163**
Horses (Thomason), lost, formerly on Colmore Row
　162; *see also Iron Horse* (Atherton)
Horton, John, architect 7
House, Michael 25
Howles, L.A., designer 74
Hunter's Road, Hockley *see* Carnegie Welfare
　Institute
Huntsman and Dog (Bloye), Green Man public house
　71, **71**
Hurst Street *see* Post Office
Hussey, R.C. 196
　Monument to Thomas Rickman 65, **65**
Hutton, William, historian 101, 119
Hygeia (W. Hollins), in storage, Museum and Art
　Gallery 35–6, **36**

I'Anson, Charles 196
　Family Group (in store) 169, **169**
Icarus (Lamba and Phillips), Norman Street 95, **95**
Impulse (Mann), Five Ways roundabout 59–60, **59**
Industry and Genius: Monument to John Baskerville
　(Patten), Centenary Square 25, **25**
Industry and Manufacturers in Birmingham (Lynn),
　National Westminster Bank, Bennett's Hill 9–10, **10**
International Convention Centre (ICC) xix, xxi, 27
　Battle of the Gods and the Giants (Tye) 29, **29**
　Birdlife (Haselden) xx, 27
　Construction (Woropay) 28, **28**
　Convention (Perry) 28, **28**
Ironbridge Museum (Shropshire), panels from
　Dowell's Almshouses 36

Iron Horse (Atherton), New Street Station platform 92, **92**
Iron:Man (Gormley), Victoria Square 146, **146**
Islington Row, *Untitled* (Copplestone) 18

Jackson, Sir Barry (Bloye), Birmingham Repertory Theatre 24, **24**
James, Bernard Vincent, architect 96
Jaray, Tess xxi, 21, 26
Jewellery Business Centre, *Gates* (Johnson) 121, **121**
John Bright Street, *Untitled* (Grandjean) 76–7, **76**
Johnson, Dr, portrait, Old Square (Budd) 46
Johnson, Michael, *Gates to Jewellery Business Centre* 121, **121**
Jones, Jonah 196
 St. John Fisher 53, **53**
Joseph, Henry 127, 173, 181
Joy, Albert 196–7
 John Bright 36–7, **37**
Judas Figure (Frink), Birmingham Institute of Art and Design 51–2, **51**

Katyn House (Millennium House) *see* Polish Catholic Centre
Kelly and Surman, architects 71, 167
Kenny, Thomas, builder 46
Kenrick Casket (Catterson-Smith) xiii, *xiii* (Fig.2)
Kent's Moat Estate playground, *Swan* and *Fledgling* playsculptures (J. Bridgeman) 175
Keyle (of Bridgeman & Sons), tympanum reliefs on Holy Trinity church
Keystone Heads (Barrett), Viceroy Close 138–9, **139**
Keystone Heads (Bloye), Police Station, Steelhouse Lane 121–2, **122**
Keystone Heads (Chatwin), Lloyds Bank, Temple Row West 130, **130**
King & Co. of Stourbridge, *Rose Window*, UCE School of Art 85–6, **85**
King Edward Square, Sutton Coldfield, *War Memorial* (Doyle-Jones) 77–8, **77**
King Kong (Monro), destroyed, formerly Bull Ring xx–xxi, **170**
Kings, Raymond xiv, 16, 57, 58, 197
 Coat of Arms 127, **127**
 Madonna and Child 62, **62**
 St. John 61–2, **61**
 Squirrel and Acorns (lost) 167, **167**
Kingstanding, St. Mark's, cross (Poole) 71
Kingston Row *see* Longboat public house
Kinloch-Cooke, Clement, relief portrait of (Anon), on Charles House 64

Ladywood Community Centre, *Untitled* (Poole) 79–80, **79**
Ladywood Middleway, *Blondin* (Richardson) 78, **78**; *see also* Squirrel public house
Lamba, Juginder 197
 Icarus 95, **95**
Lamp of Knowledge (Wright), Perry Common public library 38–9, **39**
Lancaster Street *see* Children's Hearing Assessment Centre
Langley, Walter, watercolour of fountain in Market Hall 160, **160**
Larches Green, Sparkbrook, *Thomas Attwood* (J. Thomas) 72–3, **72**
Latham, George Kinsey 197
Ledbury Close *see* Ladywood Community Centre
Legal and General Assurance Building, Waterloo Street, *Wisdom, Fortitude, Charity and Faith* (Bloye) xix, 153–4, **153**, **154**
Lethaby & Ball, *Eagle Crest* 42, **42**
Liberty's night club, Hagley Road, *Liberty* (Horner), lost 163–4, **163**
Library Emblem (Bloye), South Yardley public library 158, **158**
Lichfield Road, Sutton Coldfield *see* Holy Trinity R.C. church
Linden Road *see* Bournville Junior School; Friends' Meeting House; St. Francis of Assisi church
Lines, Samuel, artist, memorial in St. Philip's Square 130
Lion Pediment (Bloye), Supreme Works 117–18, **117**
Liverpool, St. George's Hall (Cockerell and Nicholl) xix, 141
Lloyd the Banker 46
Lloyd, James 75
Lloyd, Miss 46
Lloyds Bank 146
 Temple Row West, *Keystone Heads* (J.A. Chatwin) 130, **130**
Lomax, Tom 21, 197–8
 Spirit of Enterprise 25–6, **26**
London and City Bank (former) 151
London and Lancashire Fire Insurance Company (former) *see* Bennett's Hill
Longboat public house (renamed Flapper and Firkin), *Canal Boat* (Pytel), lost 167, **167**
Longbridge Lane *see* St. John's church
Louisa Ryland House, Edmund Street, *Family Group* (Bloye) 59, **59**
Loxley, W.E. 198
 Bible and Hand 91, **91**
Lozells Road *see* Royal Oak public house
Lucas, A.E., *First World War Memorial* 112
Lucas factory, New John Street, Hockley

Aeolus (Pye), lost 168
Monument to the Lucas Factory (Anon) 92
Lynn, Samuel F. 198
 Birmingham Coat of Arms and Supporters xx, 8–9, **9**
 Industry and Manufacturers in Birmingham 9–10, **10**

McFarlane, Eleanor 114
McKenna, John 199
 The Commuter 39–40, **39**
Madonna and Child (Kings), St. Mary and St. John's church, Erdington 62, **62**
Maine, John 198
 Aston Stones 4–5, **4**
 Six Markers on the Foreshore, in Portsmouth 5
Manchester Town Hall, statue of John Bright (Joy) 37
Mann, Alex 198
 Chess-Pieces 99–100, **100**
 Impulse xx, 59–60, **59**
Mansell and Mansell, architects, Queen's Chambers 102
Manzoni Gardens *see* Bull Ring
Margaret Street *see* University of Central England, School of Art
Market Hall, Bull Ring, *Fountain with Figures* (Messenger & Sons), destroyed 160, **160**
Martin of Tours, St. 111
 St. Martin and a Beggar (Bridgeman & Sons) 111, **111**
 Scenes from the Life of St. Martin (Bridgeman & Sons) 111–12, **112**
Martin, William, architect xiv, 86
Martineau Square, *Untitled* (Schwarz) 19, **19**
Martyn (H.H.) of Cheltenham 145, 156
 Christ in Majesty and Scenes from the Life of St. Agatha 123–4, **123**, **124**
Mask of Pan (Bloye), lost, formerly on Good Companions public house 162–3, **163**
Mason, Sir Josiah, industrialist 27
 statue of (Williamson) xvi, 98–9, **98**
Mason, Newhall Street, bronze-caster xiii, xviii, 103
Mason, Raymond 198–9
 Forward xxi, xxii, 26–7, **27**
Masonic Temple (former) *see* Central Television building
Maternity (Bloye), Carnegie Welfare Institute 75, **75**
Medical School *see* University of Birmingham
Melvina Road, Nechells, *Youth* (Seager) 87, **87**
Merilion, John 199
 Pedestrian Circulation (lost) 168, **168**
 Untitled (lost) 168, **168**
Mermaid (Bloye), Students' Union building 57, **57**

Mermaid Fountain (Bloye), Students' Union building 57–8, **58**

Mermaid public house, Sparkhill, *Mermaid* (Bridgwater, attrib.) 124, **124**

Messenger & Sons, *Fountain with Figures* (destroyed), formerly Market Hall 160, **160**

Metchley Park Road, Edgbaston *see* Birmingham Women's Hospital

Methodist Central Hall, Corporation Street xxii
 Allegories of Methodist Teaching (Gibbs & Canning) 47–8, **48**
 Events in the Life of John Wesley (Gibbs & Canning) 48, **48**

Michelangelo, bust of (Rowney), Moseley and Balsall Heath Institute 89, **89**

Midland Arts Centre 107

Midland Bank, Bennett's Hill 65

Midland Bank, Vyse Street, *Personifications of Banking, with relief Allegorical Figures* (Anon) 151, **151**

Midland Hotel, Stephenson Street, *Caryatids* (Rollins) 122, **123**

Midlands Art Centre, Cannon Hill Park 169
 Family Group (I'Anson), in store 169, **169**

Millennium House *see* Polish Catholic Centre

Millpool Hall Estate playground, playsculpture (J. Bridgeman) 175

Mistry, Dhruva 199
 River, Youth, Guardians and Object (Variations), Victoria Square xxi, 144, 147–50

Mitchell and Bridgewater of London, architects 139

Mitchell and Butler's 97, 115, 125, 152, 162, 173

Mitchell, William 200
 Untitled, Broadgate House 17, **17**
 Untitled, Hockley Circus xx, 73, **73**

Monro, Nicholas 200
 King Kong (destroyed) xx–xxi, 170, **170**

Morris, William, stained glass by 113

Morton's shoe and boot manufacturer, formerly in Albert Street, *Elves and the Shoemaker* (Creswick), lost 159, **159**

Moseley and Balsall Heath Institute, *Allegories of Art and Literature, with busts of Michelangelo and Shakespeare* (Rowney) 89, **89**

Moseley Road, panels from Dowell's Almshouses on flats 36

Moseley Road, Balsall Heath *see* Swimming baths

Moseley Road, Moseley *see* Moseley and Balsall Heath Institute

Mother and Child (Bloye), Children's Hearing Assessment Centre 79, **79**

Mother and Child (J. Bridgeman), Birmingham Women's Hospital 88, **88**

Mother and Child (Zielinski), Polish Catholic Centre 12–13, **13**

Munro, Alexander 200
 James Watt 32–3, **33**

Murdock, William, inventor 69
 Broad Street, group statue (Bloye) 15–17, **16**
 Museum of Science and Industry, bust (Papworth) 69
 St. Mary's parish church, monument (Chantrey) 69, **69**

Museum and Art Gallery
 Chamberlain Square, *Allegory of Fame Rewarding the Arts* (F.J. Williamson) 32, **32**
 Feeney Gallery extension, Great Charles Street, *Allegories of Art and Industry* (Bloye) 62–3, **63**
 in storage
 Allegory of Hope (W. Hollins) 36
 Hygeia (W. Hollins) 35–6, **36**
 John Bright (Joy) 36–7, **37**
 William Scholefield (P. Hollins) 35

Museum of Science and Industry, bust of Murdock (Papworth) 69

National Westminster Bank, Bennett's Hill
 Birmingham Coat of Arms and Supporters (Lynn) 8–9, **9**
 Industry and Manufacturers in Birmingham (Lynn) 9–10, **10**

Nature Centre *see* Birmingham Nature Centre

Neatby, William 200–1
 Heads, Beasts and Figures 131, **131**
 St. George and the Dragon 93, **94**

Nechells Park Road *see* Public baths

Nechell's Parkway *see* Bloomsbury public library

Nelson, Admiral Horatio, statue (Westmacott), Bull Ring xv, xvi, xxii, 116–17, **116**, **117**

Nevill House, Waterloo Street, decoration (Bloye) 155

Newhall Street
 Board of Guardians building (Ward) 130
 St. George and the Dragon (Neatby) 93, **94**

New Inn Road *see* Christadelphian Hall

New John Street, Hockley
 Aeolus (Pye), lost 168
 Monument to the Lucas Factory (Anon) 92

Newman, Winton, architect 3, 62

New Oxford House, Waterloo Street, *Capitals and Pediment Sculpture* (Bloye) 154–5, **154**

New Street
 Post Office, former site of *Sir Rowland Hill* (P. Hollins) 75
 see also Edward VI Grammar School; Pallasades; Royal Birmingham Society of Artists building;
 Theatre Royal

New Street Shopping Centre *see* Pallasades

New Street Station
 Iron Horse (Atherton) 92, **92**
 on panel, exterior of Martineau Square (Schwarz) 19

Newton and Cheatle, architects 93, 131

Newton Street, *Wattilisk* (Woropay) 94–5, **94**

Nicholls, Raymond 168

Nimptsch, Uli 201
 Compassion xxii, 96, **96**

Nineteenth Hole public house *see* Squirrel public house

Norman Street, Winson Green, *Icarus* (Lamba and Phillips) 95, **95**

Norris, E. Bower, architect 53

Norrish, Frank, architect 79

Nottingham, University of, cast of *Untitled* (Dalwood) 51

Nowakowski, Ondre 201
 Sleeping Iron Giant 20, 21

Nude Girl with Hat (Sindall), University of Birmingham 137, **137**

Oak Tree Lane, Selly Oak *see* Selly Oak Hospital

Object (Variations) (Mistry), Victoria Square 147–50, **149**

Old Central Library, former site of *George Dawson* (Woolner) 31

Old Oscott Hill, Kingstanding *see* Our Lady of the Assumption church

Old Square subway pedestrian area, *Old Square* (Budd) xxii, 45–6, **45**

Olton Boulevard East, Acock's Green *see* Fox Hollies Inn

Ordination (Bloye), Queen's College chapel 120, **120**

Orphanage Road, Erdington, *Sir Josiah Mason* (Williamson) 98–9, **98**

Osborne, F.J., architect 1, 38, 43, 63, 72, 138, 166

Osborne, J.P., architect 158, 173

Our Lady of the Assumption church, Kingstanding, *Assumption of the Virgin Mary* (Bohn) 96, **97**

Our Lady and St. Rose of Lima church, Weoley Castle, *St. Rose of Lima* (Clark) 66, **67**

PACA *see* Public Art Commissions Agency

Pallasades, New Street
 Pedestrian Circulation (Merilion), lost 168, **168**
 Untitled (Merilion), lost 168, **168**

Pan, representations of
 Aston Hall gardens (Bloye) 2, **2**
 Good Companions public house, *Mask of Pan* (Bloye), lost 162–3, **163**

Pan, Marta, artist 144
Pancheri, Robert 201
　　*Elijah, Isaiah, John the Baptist, Ezekiel, and
　　　Jeremiah* 84, **84**
　　Fire Fighters 60, **60**
Papworth, E.G., sculptor 98
　　bust of Murdock 69
Parade *see* Gracechurch Shopping Centre
Paradise Circus *see* Trafalgar House
Paradise Place *see* Central Reference Library
Paradise Street
　　Post Office, former site of *Sir Rowland Hill*
　　　(P. Hollins) 75
　　see also Queen's Chambers
Park Circus, Aston, *Face to Face* (Smith) 102–3, **102**
Parlanti, foundry in London, casting of *South African
　　War Memorial* statues 106
Paterson, Dennis, architect 100
Patten, David 201
　　Cader Idris, Wales 101, **101**
　　*Industry and Genius: Monument to John
　　　Baskerville* xxi, 25, **25**
Peace Sculpture (Pye), Aston University 5–6, **5**
Peacock and Bewlay, architects 136, *and see* Cossins
　　and Peacock
Pedestrian Circulation (Merilion), lost, formerly
　　Pallasades, New Street 168, **168**
Pedley, Joseph, mason 114
Peel, Sir Robert, statue of (P. Hollins), Police
　　Training Centre, Edgbaston xiii, xv, xvii–xviii,
　　103–4, **104**
Peever, Fiona, *Thomas Attwood* (with Coppinger)
　　xxi, 34–5, **35**
Pegram, Henry, *Beethoven, Virgil, Michelangelo,
　　Plato, Shakespeare, Newton, Watt, Faraday and
　　Darwin* 133–4, **133**
Pegram, Henry Alfred 201–2
Pelican Works, Great Hampton Street, *Pelican*
　　(Anon) 66, **66**
Pepper, G.E., architect, *Sir Walter Scott and William
　　Shakespeare* 43–4, **43, 44**
'per cent for art' scheme xxi, 21, 27
Percy Thomas Partnership 27
Perry Barr Greyhound Track, *Running Stag* (Bloye)
　　1, **1**
Perry Common public library, *Lamp of Knowledge*
　　(Wright and Bloye) 38–9, **39**, 72
Perry, Richard 202
　　Convention 28, **28**
Perryman, Norman, *The Mahler Experience*, painting
　　in ICC 27
Pershore Road, Edgbaston *see* Birmingham Nature
　　Centre; Police Training Centre

Petherbridge, Deanna, mural on Symphony Hall 27
Phillips, Tony, *Icarus* 95, **95**
Phoenix Chambers, Colmore Row, *Phoenix* (Anon)
　　41, **41**
Pilgrim's Progress (Bridgwater), Sparkhill Methodist
　　church 152, **152**
Pineapple Grove *see* Church of the Ascension
Pitman's Birmingham Vegetarian Hotel and
　　Restaurant 46
Playsculptures (J. Bridgeman), various playgrounds
　　175
Plough and Harrow Road, Ladywood *see* St.
　　George's Church of England School
Police Station, Steelhouse Lane, *Keystone Heads*
　　(Bloye) 121–2, **122**
Police Training Centre, Edgbaston, *Sir Robert Peel*
　　(P. Hollins) xiii, xv, xvii–xviii, 103–4, **104**
Polish Catholic Centre (Katyn House), *Mother and
　　Child* (Zielinski) 12–13, **12**
Poole, John 202
　　Cross 71, **71**
　　St. Francis' Canticle to the Sun 81–2, **82**
　　Untitled 79–80, **79**
portraits, in relief, on Charles House 64, **64**
Post Office, Hurst Street, *Sir Rowland Hill* (P.
　　Hollins) 75–6, **76**
Priestley, Joseph, minister and scientist, statue of
　　(Williamson), Chamberlain Square 33–4, **33**
Protheroe, J., *Bible and Hand* 91, **91**
Public Art Commissions Agency (PACA) 27, 44, 103,
　　146, 182
Public baths, Nechells Park Road, *Birmingham Coat
　　of Arms* (Creswick) xx, 91, **91**
Pugin, A.W.N. 202
　　*Saints Augustine, Chad, Swithin, Wulstan, Thomas
　　　and Hugh, and Tympanum Relief of the Virgin
　　　and Child* 108–9, **108**
Pugin, Edward W. 202–3
　　Tomb of Bishop Walsh 109, **109**
Pye, William 203
　　Aeolus (lost) 168
　　Peace Sculpture 5–6, **5**
Pytel, Walenty 203
　　Canal Boat (lost) 167, **167**
　　Cross Guns (lost) 173, **173**
　　Take Off 12, **12**

Queen's Chambers, Paradise Street, *Queen Victoria
　　Enthroned and Girl with Snake* (Anon) 102, **102**
Queen's College chapel
　　Christ (Bloye) 120, **120**
　　Ordination (Bloye) 120, **120**
Queen's Ride, Edgbaston *see* Cannon Hill Park

Ratcliffe Place (now Chamberlain Square, q.v.)
　　James Watt (Munro) 33
　　statue of Mason 98
Rathcavan, Lord, relief portrait of (Anon), on Charles
　　House 64
Remains of a Pyramid (Dhanjal), formerly Sennely's
　　Park 114
Renton Howard Wood Levine, architects 27
Reredos see St. Martin's church
Return see Call, *Front Line and Return*
Richard, King (Bridgeman & Sons), St. Martin's
　　church 110–11, **111**
Richardson, Paul 203–4
　　Ahoy 107, **107**
　　Blondin 78, **78**
Rickman, Thomas, architect
　　monument to (Hussey) 65, **65**
　　RBSA building 93
　　St. Mary's, chapel 69
Riley & Smith, architects, *Allegorical Figures* 11, **11**
River ('The Floozie in the Jacuzzi') (Mistry), Victoria
　　Square xxi, 147–50, **147**
Roberts, J.A., architect 73
Roddis, John 30–1, 130, 140, 142, 204
　　Allegorical Figures (lost) 162
　　frieze on pediment of Museum and Art Gallery 32,
　　　32
Rollins, John
　　Caryatids 122, **123**
　　Caryatids (demolished) 170–1, **171**
Rollins, John Wenlock 204
Rose of Lima, St., statue of (Clark) 66, **67**
Rose Window (J. Chamberlain), UCE School of Art,
　　Margaret Street 85–6, **85**
Rossoff, Bianca, *Untitled* xx, 100–1, **101**
Rouw, Peter, the Younger 113
　　wax model of Boulton 68
Rowney, *Allegories of Art and Literature, with busts
　　of Michelangelo and Shakespeare* 89, **89**
Royal Academy of Art (RA) 182
Royal Birmingham Society of Artists building, New
　　Street, *Name Plaques* (Bloye) 92–3, **93**
Royal Oak public house, Lozells Road, *Royal Oak*
　　(Bloye) 85, **85**
Royal Warwickshire Regiment, memorial (Lucas), St.
　　Martin's church 112
Royal Warwickshire Regiment War Memorial (Anon),
　　formerly Chamberlain Square, now Central
　　Reference Library 29, 37
Running Stag (Bloye), Perry Barr Greyhound Track
　　1, **1**
Ryland, Louisa Anne xvi, 107; *see also* Louisa Ryland
　　House

Sacks of Potatoes public house *see under* Aston University

Sacred Heart (Gibbs & Canning), Church of the Sacred Heart and St. Margaret Mary 155, **155**

St. Agatha's church, Sparkbrook, *Christ in Majesty and Scenes from the Life of St. Agatha* (Martyn's) 123–4, **123**, **124**

St. Augustine's church, Handsworth, *St. Augustine's arrival in England* (Bohn) 6, **6**

St. Chad's Cathedral 108–9
 Saints Augustine, Chad, Swithin, Wulstan, Thomas and Hugh, and Tympanum Relief of the Virgin and Child (A.W.N. Pugin) 108–9, **108**
 Tomb of Bishop Walsh (E.W. Pugin) 109, **109**

St. Chad's Circus, *Swing* (Atherton) 107–8, **107**
 see also University of Birmingham Dental Hospital

St. Francis of Assisi church, Bournville
 St. Francis' Canticle to the Sun (Poole) 81–2, **82**
 Sermon to the Birds (Bloye) 81, **81**

St. George and the Dragon (Bridgwater), Victoria Square 172, **172**

St. George and the Dragon (Neatby), Newhall Street 93, **94**

St. George's Church of England Comprehensive School, Hockley, *Untitled* (Slann) 65, **65**

St. George's Church of England School, Ladywood, *Untitled* (Salter) 105, **105**

St. George's Gardens, *Monument to Thomas Rickman* (Hussey) 65, **65**

St. George's Road, Balsall Heath *see* St. John the Evangelist church

St. John (Kings), St. Mary and St. John's church, Erdington 61–2, **62**

St. John the Baptist church, Harborne, *Cross* (Poole) 71, **71**

St. John the Evangelist church, Balsall Heath, *St. John the Evangelist* (Bridgeman & Sons) 110

St. John Fisher church, West Heath, *St. John Fisher* (J. Jones) 53, **53**

St. John's church, Longbridge Lane, *Elijah, Isaiah, John the Baptist, Ezekiel, and Jeremiah* (Pancheri) 84, **84**

St. Martin's church, Bull Ring 72, 110–13
 First World War Memorial (Lucas) 112
 King Richard (Bridgeman & Sons) 110–11, **111**
 Reredos (Farmer & Brindley) 112–13, **113**
 St. Martin and a Beggar (Bridgeman & Sons) 111, **111**
 Scenes from the Life of St. Martin (Bridgeman & Sons) 111–12, **112**

St. Martin's House, Smallbrook Queensway, *Bull Forms* (Copplestone) 115, **116**

St. Martin's Lane *see* St. Martin's church

St. Mary and St. John's church, Erdington
 Madonna and Child (Kings) 62, **62**
 St. John (Kings) 61–2, **61**

St. Mary's parish church, Handsworth 67–9
 Monument to James Watt (Chantrey) 68–9, **68**
 Monument to Matthew Boulton (Flaxman) 67–8, **67**
 William Murdock (Chantrey) 69, **69**

St. Peter's School, Bromsgrove, wood carving 62

St. Philip's Cathedral 113–14
 Four Baroque Window Surrounds (P. Hollins) xii, 113–14, **114**
 on panel, exterior of Martineau Square (Schwarz) 19
 churchyard

St. Philip's Square, *Bishop Gore* (Stirling Lee) xvi, 40, **40**
 Temple Row
 Angel Drinking Fountain (Anon) 129
 Memorial to F.G. Burnaby (Anon) 128, **128**
 Memorial to John Heap and William Badger (Anon) 129
 Memorial to Thomas Unett (P. Hollins) 128
 west side, *Memorial to Members of the Lines Family* 130, **130**
 see also St. Philip's Cathedral

St. Rose of Lima (Clark), Our Lady and St. Rose of Lima church, Gregory Avenue 66, **66**

Salter, Jeffrey, *Untitled* 105, **105**

Salviate Burke and Co. of Venice, mosaicists 30

Salviati, mosaicist 139, 140

Sandy and Norris (Stafford), architects 53, *and see* Norris, E. Bower

Sapcote (William) and Co., builders 86

Satan (Gleichen), in store, formerly Gazette Building, Waterloo Street 173–4, **174**

Saul, Thomas, builder 38

Savage, Rupert, architect 15

Scenes from Birmingham's Industrial Past (Creswick), Handsworth public library 118, **118**

Scholefield, James, MP 34

Scholefield, William, mayor and MP 46
 bust of (P. Hollins), in storage, Museum and Art Gallery 35

Schwarz, Hans 204
 Untitled 19, **19**

Science and Technology (Burton), Aston University 3–4, **3**, **4**

Scott, Adrian Gilbert, architect, Our Lady and St. Rose of Lima church 66

Scott, Sir Walter (Pepper), portrait relief, Corporation Street 43–4, **43**

Scottish Provident Institution (formerly), Colmore Row, *Allegorical Figures* (Roddis) 162

Seager, Harry 204–5
 Youth 87, **87**

Sealy, John *see* Coade and Sealy

Seated Craftsmen (Bloye), Supreme Works 117–18, **118**

Selly Oak Hospital, *Compassion* (Nimptsch) 96, **96**

Sennely's Park, Bartley Green, *Remains of a Pyramid* (Dhanjal) 114

Sermon to the Birds (Bloye), St. Francis of Assisi church 81, **81**

Shakespeare
 Central Reference Library, portrait medallion (Coade and Sealy) 38, **38**
 Corporation Street, portrait relief (Pepper) 43–4, **44**
 Moseley and Balsall Heath Institute, bust (Rowney) 89

Sheppard-Fidler, A.G., architect 60, 175

Siddons, F.R., *Coat of Arms; Agriculture and Engineering* (designer) 160

silversmithing and silversmiths 41–2

Sindall, Bernard 205
 Nude Girl with Hat 137, **137**

Slade Road, Erdington *see* Brookvale public house

Slann, Graham, *Untitled* 65, **65**

Sleeping Iron Giant (Nowakowski), Cattell Road 20, 21

Small Heath Park, *George Dawson* (Williamson), scrapped, and copy by Bloye (stolen) 174–5, **174**

Smallbrook Queensway *see* Bull Ring Shopping Centre

Smith, Ray 205
 Face to Face 102–3, **103**

Smith (W.H.) & Son 43, **44**

Snow Hill Station, *The Commuter* (McKenna) 39–40, **39**

Soho Road, Handsworth *see* Handsworth public library; Supreme Works

Somerset Road, Edgbaston *see* Blue Coat School; Queen's College chapel

South African War Memorial (Toft), Cannon Hill Park 106, **106**

Southall, Joseph, *Corporation Street, Birmingham* (fresco mural painting) xiv, *xiv* (Fig.3)

South Yardley public library, *Library Emblem* (Bloye) 158, **158**

Sparkhill library and Building Control office, *Allegory of Knowledge and Justice* (Creswick) 126, **126**

Sparkhill Methodist church, Warwick Road, *Pilgrim's Progress* (Bridgwater) 152, **152**

Spencer Street *see* Jewellery Business Centre
Spirit of Birmingham (Bloye), unrealised work for
 Broad Street 1, 176, **176**
Spirit of Enterprise (Lomax), Centenary Square 25–6,
 26
Spirit of Knowledge (Bloye), Yardley Wood public
 library 72, **72**
Spurrier, William, silversmith 41–2
Squirrel public house (now The Nineteenth Hole),
 Squirrel and Acorns (Kings), lost 167, **167**
Steelhouse Lane *see* Fountain Court barristers'
 chambers; General Hospital; Police Station
Stephenson Street *see* Midland Hotel
Stirling Lee, Thomas 205
 Bishop Gore 40, **40**
Stratford Road, Sparkbrook *see* St. Agatha's church
Stratford Road, Sparkhill xix, *and see* Antelope public
 house; Bear Inn public house; Mermaid public
 house; Sparkhill library and Building Control office
Sturge, Joseph, memorial to (J. Thomas) xv, xvi, 70, **70**
Suffolk Queensway (formerly Easy Row) *see*
 Woodman public house
Summer Lane *see* Electricity substation
Summer Row *see* College of Food and Domestic Arts
Sun Alliance Insurance office, Bennett's Hill, *Sun
 Emblem and Lettering* (Bloye and Cooke) 10–11, **10**
Supreme Works, Handsworth, *Lion Pediment and
 Seated Craftsmen* (Bloye) 117–18, **117**, **118**
Surman *see* Kelly and Surman
Sutton Coldfied xi, xiii, 99–100
Sutton Manor Arts Centre, cast of *Judas Figure*
 (Frink) 52
Swallow Hotel, Five Ways, in front of, *Joseph Sturge*
 (J. Thomas) 70, **70**
Swimming baths, Moseley Road, *Birmingham Coat
 of Arms* (Hale & Son) xx, 88, **88**
Swing (Atherton), St. Chad's Circus 107–8, **107**

Take Off (Pytel), Bickenhill Lane 12, **12**
Taylor, John, enamel manufacturer xii
Technology see Science and Technology
Temple Row *see* Great Western Arcade; St. Philip's
 Square
Temple Row West, west side of St. Philip's Square,
 Memorial to Members of the Lines Family 130; *see
 also* Lloyds Bank
Temptation of St. Anthony (Barrett), Viceroy Close
 138, **138**
Terpsichore (Bloye), Cadbury factory grounds 13–14,
 13
Tew Park, replica of Flaxman's bust of Boulton 68
Theatre Royal, New Street (former site), *Garrick and
 Shakespeare* (Coade and Sealy) xix, 38, **38**

Thomas, John 205–6
 Joseph Sturge xv, xvi, 70, **70**
 Thomas Attwood xv, xxii, 34, 72–3, **72**
Thomas, Robert 206
 Hebe 74, **74**
Thomason, Sir Edward 206
 George IV (unknown location) 175
 Horses (lost) 162
Thomason, Yeoville, architect xix, 139
3F Studios 107
Tipping Triangles (Conner), Aston University 157,
 157
Toft, Albert 206
 *Allegories of Army, Navy, Air Force and Women's
 Services* xxii, 21–2, **21**, **22**
 King Edward VII (lost) 165, **165**
 South African War Memorial xxii, 106, **106**
Towers public house, Walsall Road, *Towers* (Bloye)
 152, **152**
Town Hall, Victoria Square, *Britannia with Mermaid
 and Sea Horses* (Walker), lost 171, **171**
Townswomen's Guilds, *Diamond Jubilee Tapestry*,
 ICC 27
Trafalgar House, Paradise Circus, *Untitled* (Rossoff)
 100–1, **100**
TSB bank 146
Turves Green playground, playsculpture (J.
 Bridgeman) 175
Twist, W. Norman, architect xxii, 21–2, 23, 155
Two Figures (Hepworth), University of Birmingham
 58, **58**
Tye, Roderick 206–7
 Battle of the Gods and the Giants 29, **29**

UCE *see* University of Central England
Unett, Thomas, memorial to (P. Hollins), St. Philip's
 Square 128
Union Street *see* City Arcade; General Dispensary
United Kingdom Temperance and General Provident
 Institution, coat of arms (Butler) 99
University of Aston *see* Aston University
University of Birmingham, Edgbaston
 Aston Webb building, *King Edward VII* (Drury)
 134, **134**
 Barber Institute of Fine Arts
 *Equestrian Statue of King George
 I* (van Nost the Elder) 131–2, **132**
 Heraldic Shields (Herickx) 132–3, **132**
 Symbols of the Arts (Herickx) 133, **133**
 Dental Hospital, *University Coat of Arms* (Bloye)
 109–10, **109**
 Great Hall, *Beethoven, Virgil, Michelangelo, Plato,
 Shakespeare, Newton, Watt, Faraday and*

 Darwin (Pegram) 133–4, **133**
 Mechanical Engineering Department
 Engineering (Bloye) 135–6, **135**
 Wrestlers (Copnall) 136–7, **136**
 Medical School, *Aesculapius bearing the
 University of Birmingham Coat of Arms* (Bloye)
 150, **150**
 on panel, exterior of Martineau Square (Schwarz)
 19
 outside Staff House, *Nude Girl with Hat* (Sindall)
 137, **137**
 Students' Union building
 Mermaid (Bloye) 57, **57**
 Mermaid Fountain (Bloye) 57–8, **58**
 University Square, *Ancestor I* (Hepworth) 135,
 135
 Vale halls of residence grounds, *Two Figures*
 (Hepworth) 58, **58**
 Winterbourne House, Edgbaston Park Road,
 Cyclad (Weller), lost 163, **163**
 see also Queen's Chambers
University of Central England, Institute of Art and
 Design
 Judas Figure (Frink) 51–2, **51**
 Untitled (Dalwood) 50–1, **51**
University of Central England, School of Art
 Allegories of the Arts (Creswick) xiv, 86–7, **86**
 Rose Window (Chamberlain; Barfield, and King &
 Co) 85–6, **85**, **86**
University Road 131–7
Upper Trinity Street *see* Electric supply station

van Nost the Elder, John 207
 Equestrian Statue of King George I xvi, 131–2, **132**
Vase of Fruit (Bloye), lost, formerly Bull's Head
 public house 172–3, **172**
Vases (Bloye), Aston Hall gardens 2–3, **3**
Vesey, Bishop *see* Harman, John
Viceroy Close, *Temptation of St. Anthony and fifteen
 Keystone Heads* (Barrett) 138–9, **138**, **139**
Victoria, Queen, representations of xvi
 Council House (Woolner) 143, **143**
 Queen's Chambers, *Queen Victoria Enthroned
 and Girl with Snake* (Anon) 102, **102**
 Victoria Law Courts (Bates) 49–50, **49**
 Victoria Square (original by Brock; copy by
 Bloye) 144–5, **145**, 165
Victoria Law Courts, *Queen Victoria and related
 Allegory of Law and Order* xix, 49–50, **49**, **50**
Victoria Square xix, xxi, 144–50
 arms in relief xx
 Britannia with Mermaid and Sea Horses (Walker),
 lost 171, **171**

Iron:Man (Gormley) 144, 146, **146**
King Edward VII (Toft), formerly in, now lost 165
Queen Victoria (Brock; copy by Bloye) 144–5, **145**
River, Youth, Guardians and Object (Variations)
 (Mistry) xxi, 144, 147–50, **147**, **148**, **149**
St. George and the Dragon (Bridgwater),
 destroyed 172, **172**
 see also Council House
Villa Road, Hockley *see* Bull's Head public house
Vincent Drive, Edgbaston *see* University of
 Birmingham, Medical School
Vriendt, Albrecht Frans Lieven de, *Stations of the
 Cross* 108
Vulcan (Bloye), lost, Fortress House 161
Vyse Street *see* Midland Bank

Walker, John P. 207
 Britannia with Mermaid and Sea Horses (lost) 171,
 171
 Child with a Lamb (lost) 164, **164**
Walsall Road, Perry Barr *see* Towers public house
Walsh, Bishop 108
 Tomb of (E.W. Pugin) 109, **109**
Ward, William Henry 207
 Allegories of Science and Art 129–30, **129**
war memorials
 First World War Memorial (Lucas), St. Martin's
 church 112
 Gas Department War Memorial (Britannia)
 (Weingartner) 156–7, **156**
 War Memorial (Doyle-Jones), King Edward
 Square 77–8, **77**
Warwick Road *see* Sparkhill Methodist church
Washwood Heath Road *see* Cross Guns Inn
Waterhouse, Alfred 49
Waterloo Street *see* Elliot, Son and Boyton; Legal and
 General Assurance Building; Nevill House; New
 Oxford House
Watt, James, engineer xv, 32
 Broad Street, group statue (Bloye) 15–17, **16**
 Chamberlain Square, statue (Munro) 32–3, **33**
 Crown Courts, *Wattilisk* (Woropay) 94–5, **94**
 Handsworth public library, on *Scenes from
 Birmingham's Industrial Past*, panels (Creswick)
 118
 St. Mary's parish church, Watt Chapel, monument
 (Chantrey) 16, 68–9, **68**, 95

University of Birmingham, as portrait figure
 (Pegram) 133–4, **133**
Watt, James jr 2
Wattilisk (Woropay), outside Crown Courts, Newton
 Street 94–5, **94**
Waverley Park *see* Small Heath Park
Webb, Aston, architect xix, 49, 50, 131, 133, 186
Webb, Caroline, *Ahoy* 107, **107**
Weedon (Harry) Partnership, architects 99, 100
Weingartner, Louis, *Gas Department War Memorial
 (Britannia)* 156–7, **156**
Weller, Antony 207
 Cyclad (lost) 163, **163**
Wesley, Events in the Life of John (Gibbs & Canning),
 Methodist Central Hall 48
West Midlands Arts 182
Westley, William, architect 46
Westmacott, Richard 113, 207
 Admiral Horatio Nelson, in store xv, xxii, 116–17,
 116, **117**
Wheatley, Richard 16, 164
Wheatsheaf Hotel, *Wheatsheaf* (Bloye) 53, **53**
While, George H. 152
 designer, *Elijah, Isaiah, John the Baptist,
 Ezekiel, and Jeremiah* (Pancheri) 84, **84**
White, Thomas 207–8
White Curl (Gregory), Dartmouth Middleway 55, **55**
Wicks *see* Harvey and Wicks
Wilkes, John, lock-maker, portrait (Budd) 46
Williams, Bruce 208
 Memorial to Tony Hancock xxii, 44–5, **44**
Williamson, Francis John 208
 Allegory of Fame Rewarding the Arts 32, **32**
 George Dawson (scrapped), formerly Chamberlain
 Square xvi, 29, 31, 174–5, **174**
 John Skirrow Wright (scrapped), formerly
 Chamberlain Square xvi, 29, 144, 161–2, **161**
 Joseph Priestley xvi, 33–4, **33**
 Sir Josiah Mason xvi, 98–9, **98**
Winterbourne House *see under* University of
 Birmingham
Wisdom, Fortitude, Charity and Faith (Bloye),
 Waterloo Street 153–4, **153**, **154**
Withering, Dr, portrait (Budd) 46
Witton Road, Aston *see* Church of the Sacred Heart
 and St. Margaret Mary

Wood, Francis 208–9
 George Cadbury 83, **83**
Wood, Kendrick and Reynolds, architects 97
Woodacre Road, Erdington *see* British Gas Social
 Club
Woodcock Street *see* Aston University
Woodman public house (demolished), Suffolk
 Queensway, *Woodman and Dog* (Anon), lost 171
Woof, Paula, artist 78
Woolner, Thomas 209
 George Dawson, Chamberlain Square 31–2, **31**
 Joseph Chamberlain portrait medallion on
 Memorial Fountain, Chamberlain Square 30, **30**
 Queen Victoria 142, 143, **143**
workshops in Birmingham xi–xiv
Woropay, Vincent 209
 Construction 28, **28**
 Wattilisk 94–5, **94**
Wrestlers (Copnall), Mechanical Engineering
 Department 136–7, **136**
Wright, John Skirrow 161
 Chamberlain Square (formerly Victoria Square),
 statue (Williamson), scrapped xvi, 29, 144, 161–2,
 161
 Council House, bronze bust by Bloye, copying
 Williamson 143–4, **144**, 161–2
Wright, Tom 209
 Antelope 125–6, **125**
 Lamp of Knowledge (carver) 38–9, **39**
Wyatt family, architects 36
Wyatt, Samuel, architect 38
Wyndlay Lane, Sutton Coldfield *see* Boldmere
 swimming baths

Yardley District Council public office (formerly) *see*
 Sparkhill library and Building Control office
Yardley Road *see* South Yardley public library
Yardley Wood Public Library, *Spirit of Knowledge*
 (Bloye) 72, **72**
Young Child Playing (Bloye), Children's Hearing
 Assessment Centre 79, **79**
Youth (Mistry), Victoria Square 147–50, **148**
Youth (Seager), Melvina Road 87, **87**

Zielinski, Tadeuz 209
 Mother and Child 12–13, **13**